1850

W9-BGL-119

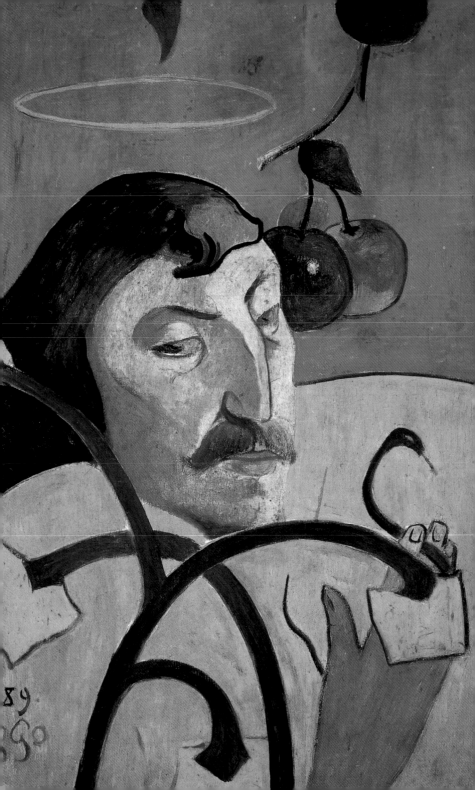

ArtBook

Gauguin

El cuadro
es una superficie
cubierta
de color

ELECTA BOLSILLO

Sumario

Guía de consulta

La colección Pocket Arte presenta la vida y las obras de los artistas en el contexto cultural, social y político de su tiempo. Para ofrecer al lector un instrumento adaptado a las exigencias de información y estudio, grato y fácil de consultar, el argumento de cada volumen se ha dividido en tres grandes secciones, que se reconocen gracias a las bandas laterales de diferentes colores: amarillo para las páginas dedicadas a la vida y las obras del artista; azul para las partes relativas al contexto histórico y cultural; rosa para el análisis de las grandes obras. Cada doble página profundiza en un tema específico, con un texto introductorio y varias ilustraciones comentadas. De ese modo, el lector puede elegir libremente el método y la secuencia de la lectura, siguiendo el desarrollo de los capítulos o bien creando trayectorias personalizadas. Completan la información el índice de lugares y el índice de nombres, también ilustrados, para hacer más inmediata la identificación de obras, protagonistas y localidades geográficas.

■ En la página 2: Paul Gauguin, *Autorretrato-caricatura*, 1889, Washington, National Gallery of Art.

1848-1885

La formación pictórica

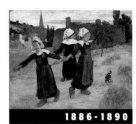

1886-1890

Bretaña y otros temas

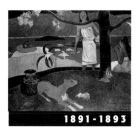

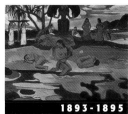

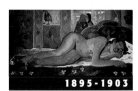

Índices

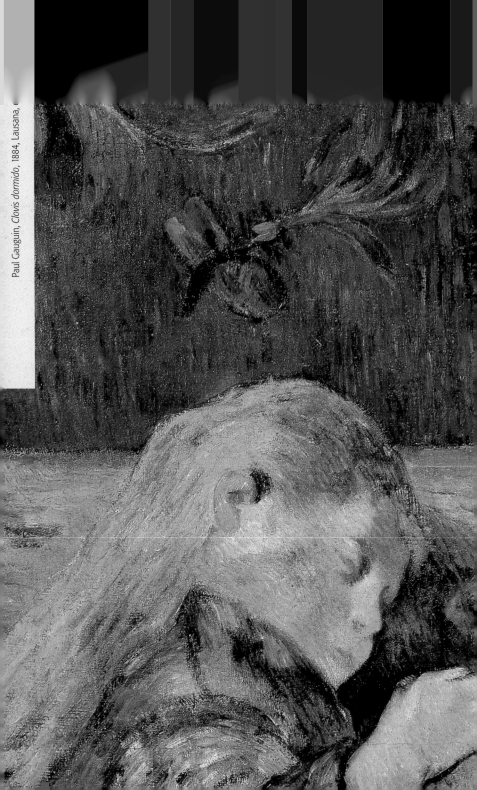

La formación pictórica

1848-1871: la infancia y la juventud

Eugène Henri Paul Gauguin nació en París, en la calle Notre-Dame-de-Lorette n. 52, en el barrio de Montmartre, el 7 de junio de 1848. La familia de la madre, Aline Chazal, pertenecía a la nobleza española que se trasladó a Perú en tiempos de la conquista de América. Su padre, Clovis, era un periodista y cronista político de "Le National". En octubre de 1851, previendo la toma del poder por parte de Luis Napoleón, contra el que se había alineado, partió con su familia para Perú. No obstante, durante la travesía sufrió un auenerismo y una crisis de rabia y murió. Aline Gauguin, con sus hijos Paul y Marie, dos años mayor, fueron acogidos por su tío Pío Tristán, rico prohombre de Lima. En 1855, después de la muerte de su suegro, la madre decidió regresar a Orleans con su tío Isidoro; más tarde se trasladó a París. Paul estudió en un colegio de Orleans, pero el paso de la lengua española a la francesa le creó no pocos problemas y los resultados escolares fueron decepcionantes. De ese modo, en 1865 se embarcó como marinero. En 1867 murió su madre y le fue confiado como tutor Paul Gustave Arosa. Tras concluir el servicio militar, regresó a París, donde, gracias a los contactos de Arosa, fue contratado en la agencia de cambio Bertin.

■ Hábil hombre de negocios, discreto fotógrafo de arte y buen conocedor de la pintura moderna, Gustave Arosa había conocido de niño a la madre de Gauguin. Culto y sensible, fue uno de los primeros en interesarse seriamente en los impresionistas y en incluir obras suyas en su colección.

■ Cultura Moche, Perú. Botella con asa y pitón, Lima, Museo Arqueológico Rafael Larco Herrera. Gauguin estaba orgulloso de sus orígenes y estaba convencido de que por sus venas corría sangre inca.

■ Guyon, *Una terraza en Argel,* colección privada. En 1870 estalló la guerra franco-prusiana. Gauguin participó en acciones bélicas en el Mediterráneo, en particular en Argel.

■ Gauguin pintó este *Retrato de la madre* (Stuttgart, Staatsgalerie) en 1890, a los 23 años de su muerte. El artista usó como modelo una fotografía juvenil, acentuando el aspecto exótico. Sus relaciones con ella eran afectuosas y en los *Escritos de un salvaje* nos ha dejado una imagen conmovedora.

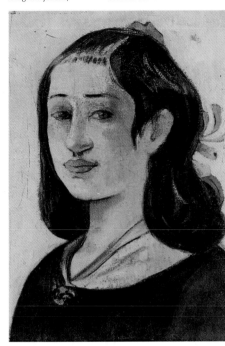

■ La abuela materna, Flora Tristán y Moscoso fue una escritora, periodista y militante socialista. En 1838 escribió *Las peregrinaciones de un paria,* su autobiografía. Murió en 1844 a manos de su marido, el grabador André Chazal.

■ François Etienne Musin, *La rada de Calais,* colección privada. Gauguin se embarcó primero en el "Luzitano", después en el "Chili" y posteriormente en el "Jérôme-Napoléon".

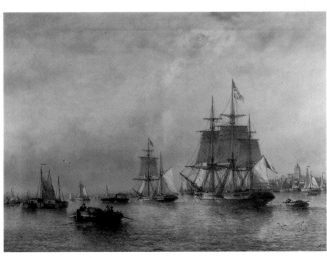

EL CONTEXTO HISTÓRICO Y ARTÍSTICO

1848-1885

La Francia de Napoleón III

La revolución de febrero de 1848 había provocado la caída de Luis Felipe y el nacimiento de la Segunda República. El 10 de diciembre de ese mismo año, todavía conmocionados por los enfrentamientos obreros del mes de junio, los franceses eligieron presidente a Luis Bonaparte, que después del golpe de Estado del 2 de diciembre de 1851 transformó la república en un imperio, asumiendo el nombre de Napoleón III. En política interior propició un grandioso programa de construcciones públicas, en particular en París, según los planos del prefecto Haussmann. En pocos decenios 60.000 nuevas edificaciones, entre ellas grandes palacios públicos unidos por amplios bulevares, la convirtieron en una auténtica metrópoli. La política colonial le llevó a la conquista de Nueva Caledonia, Argelia, Senegal y Camboya, y a costosas intervenciones en China, Siria y Méjico. A pesar de las victorias militares en las guerras de 1859 y 1866 contra los austríacos, su política exterior no alcanzó los resultados esperados. Las relaciones con Italia se enfriaron como consecuencia de su defensa del Estado Pontificio, y los diversos intentos por controlar Luxemburgo, así como la expedición a Méjico fracasaron. Finalmente, el conflicto de 1870 con los prusianos marcó su derrota definitiva.

■ *Inauguración del Canal de Suez*, 1869, Milán, Civica raccolta di stampe Bertarelli. Entre 1859 y 1864 Francia promovió la construcción del Canal de Suez. Fue una obra de gran importancia técnica y de notables consecuencias económicas y políticas.

■ Angelo Inganni, *Los zuavos en la fortificación de San Giovanni de Brescia*, Brescia, Musei civici d'arte e storia. Napoleón III trató de sustituir a los austríacos en el control político de Italia, pero sólo consiguió anexionarse Niza y Saboya.

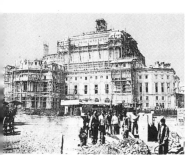

■ En julio de 1862 se inició la construcción de la Ópera, proyectada por el arquitecto Garnier. Fue inaugurada el 15 de diciembre de 1875. Durante el asedio de París de 1871 el edificio sirvió de depósito de víveres y durante la Comuna, de refugio a los miembros del gobierno Thiers.

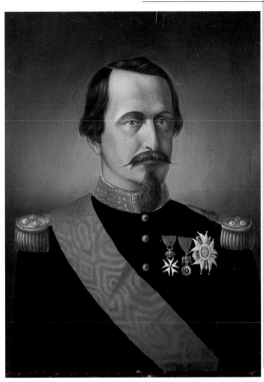

■ Napoleón III nació en 1808. En 1840 trató en vano de hacerse proclamar emperador. Después de Sedán marchó a Inglaterra, donde murió en 1873.

■ Una de las primeras máquinas fotográficas, una Waston Acme, realizada a principios del siglo XX en Londres.

Fotografía y pintura

En 1839 Louis-Jacques Mandé Daguerre dio a conocer su procedimiento, la daguerrotipia, primer paso en la invención de la fotografía. Pronto fue mejorada y se difundió por toda Europa. Desde el principio quedó claro que no sólo constituía una notable innovación técnica, sino también una renovación ideológica y cultural, que transformaría radicalmente el propio modo de pintar y de entender la pintura.

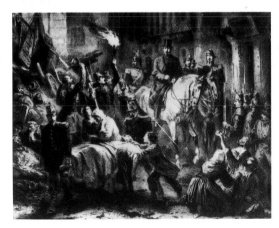

■ *Luis Napoleón visita las barricadas después del golpe de Estado del 2 de diciembre de 1851,* París, Bibliothèque Nationale. Para conquistar el poder, el futuro Napoleón III se liberó de la oposición republicana; para ello, redujo el cuerpo electoral, controló la imprenta y se alió con los católicos.

1872-1878: los inicios como pintor

En 1872 Gauguin empezó a trabajar con el agente de cambio Bertin, del que recibía, además de un sueldo mensual, una pequeña participación en los beneficios, lo que le permitía llevar un buen tren de vida. Entre sus colegas de trabajo estaba Emile Schuffenecker, un alsaciano que se hizo amigo suyo y compartió con él las primeras aproximaciones a la pintura. Paul visitaba las muestras y los museos, discutía de arte con Emile, Arosa y el marchante Paul Durand-Ruel; adquirió algunas pinturas de Cézanne, Sisley, Monet, Manet, Renoir, Pissarro y otros impresionistas. Fue entonces cuando comenzó a pintar, primero bajo la guía de la hija de Arosa, Marguerite; más tarde, con Schuffenecker, siguió los cursos del académico Colarossi. A través de Arosa conoció a una joven danesa, Mette Sophie Gad, con la que se casó al año siguiente, el 22 de noviembre. En 1874 nació Emile, al que siguieron Aline en 1877, Clovis en 1879, Jean-René en 1881 y Paul en 1883. Entre 1873 y 1874 realizó algunas naturalezas muertas y algunos paisajes, uno de los cuales fue expuesto en el Salón de 1876.

■ A los 25 años Gauguin era un hombre de buena estatura, robusto y ancho de espaldas; no era guapo, pero la mirada enérgica y penetrante despertaba admiración y le confería una indudable fascinación.

■ *Paisaje,* 1873, Cambridge, Fitzwilliam Museum. Las primeras pinturas guardan todavía una gran similitud con los modos de Corot y los paisajes de la escuela de Barbizon, nombre que deriva de la localidad homónima cerca de Fontainebleau, donde diversos artistas trataron de redescubrir la tradición paisajística holandesa e inglesa.

■ *Sotobosque,* 1873, colección particular. La disposición es un poco estática y la mano no trabaja aún con seguridad, aunque pronto lo hará.

■ Mette Sophie Gad tenía 23 años cuando conoció a Gauguin; pronto se enamoró de ese joven y prometedor empleado que, a sus ojos, podía ocupar el puesto de su padre, desaparecido poco antes.

■ *Mette cosiendo,* 1878 aproximadamente, Zurich, colección Bührle. Los primeros años de matrimonio fueron tranquilos y serenos, tanto por el trabajo, que se presentaba rico en satisfacciones, como por la vida familiar. Así lo testimonia el ambiente de paz doméstica y quietud de esta pintura.

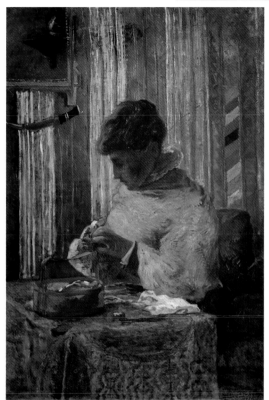

■ *Paisaje de otoño,* 1877, colección particular. Aunque en esta pintura Gauguin extiende todavía los colores de manera tradicional, se advierten ya las primeras influencias del arte de Pissarro, al que había conocido poco antes, y de las telas impresionistas.

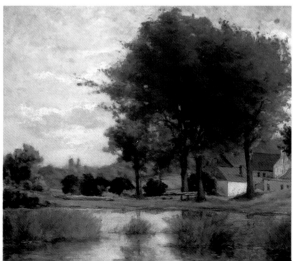

El Sena con el puente de Jena

En la época de *El Sena junto al puente de Jena* (1875, París, Musée d´Orsay), la pintura sólo era para Gauguin un pasatiempo. Nadie hubiera podido imaginar que acabaría transformando completamente su vida.

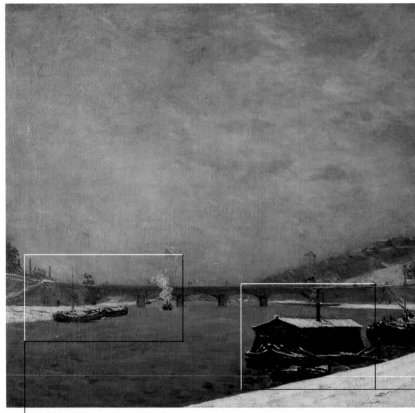

■ Gauguin no se aproxima a la naturaleza a través de las abstracciones intelectuales y literarias de las tradición dieciochesca, sino de manera inmediata y espontánea, aunque todavía está lejos del panteísmo de los paisajes tahitianos.

■ El tema y el estilo de la composición son similares a los utilizados por los impresionistas, sobre todo por Armand Guillaumin y el holandés Jongkind, cuyas exposiciones seguía Gauguin y cuyas pinturas compraba.

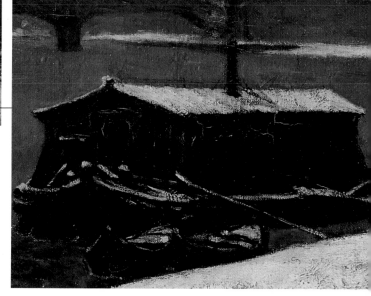

■ En estos primeros ejercicios la paleta de Gauguin está constituida por colores fríos y un poco pastosos que dan una impresión de profundidad, vastedad e inmovilidad. Las pinceladas están extendidas con orden; el dibujo es cuidado y preciso.

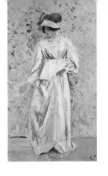

Camille Pissarro

Hijo de un judío portugués y de una criolla, Camille Pissarro nació en 1830 en St. Thomas, en las Antillas, y murió en París en 1903. A partir de 1855 estudió en la Ecole des Beaux-Arts y en la Académie Suisse, donde conoció a Claude Monet. Aunque fue admitido en el Salón de 1859, polemizó con el rígido academicismo oficial, hasta el punto de que en 1863 prefirió exponer en el Salon des Refusés junto a Manet, Jongkind, Cézanne y Guillaumin. A partir de 1866 se convirtió en uno de los habituales del Café Guerbois, lugar de encuentro de los impresionistas. Su influencia fue decisiva. Desde las primeras muestras, se convirtió, junto con Monet, en uno de los blancos preferidos de la crítica anti-impresionista. A pesar de la sencillez e inocencia de sus temas, fue criticado ásperamente por las innovaciones estilísticas, la supresión de las sombras y el uso revolucionario de los colores. En 1870, como consecuencia de la invasión prusiana, se refugió en Londres, donde conoció a Durand-Ruel, que se convirtió en marchante suyo y de otros impresionistas. En 1872 pinta en Pontoise, en 1884 en Eragny y desde 1896 hasta su muerte en París. Durante esos años participó en todas las muestras impresionistas y asumió el papel de maestro para muchos jóvenes artistas, entre ellos Seurat, Signac y Gauguin, a los que inculcó el amor por la naturaleza y el gusto por el paisaje y la pintura *en plein air,* de la que se convirtió en uno de los defensores más genuinos y convincentes. Durante un breve período experimentó con la técnica del divisionismo, pero, en lo sustancial, permaneció fiel a las teorías impresionistas.

■ Pissarro, *La recogida del heno en Eragny*, 1891, colección particular. Esta pintura nos comunica el amor por la tierra y las pequeñas aldeas campesinas, en las que la vida transcurre con quietud y tranquilidad, dominada por el ritmo lento de las estaciones. La luz se distribuye de manera homogénea y se refleja en las breves pinceladas, con reflejos apenas velados.

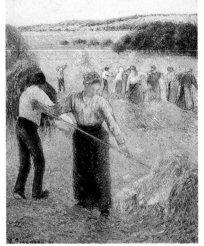

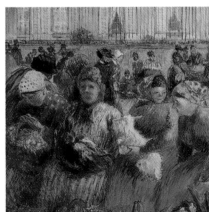

■ Pissarro, *Retrato de Jeanne*, 1897 aprox., colección particular. El artista afrontó varios temas, desde los sencillos, de inspiración popular, a las composiciones más refinadas y elegantes.

■ Pissarro, *Campesina sentada*, 1880, colección particular. Pissarro se inspiró en el arte de Delacroix y Corot, con los que comparte el rechazo por la imitación ciega de los antiguos, impuesta por la Ecole des Beaux-Arts.

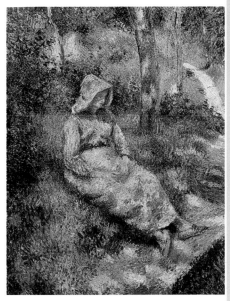

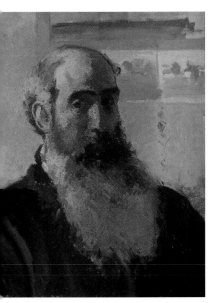

■ Pissarro, *Autorretrato*, 1873, París, Musée d'Orsay. Pissarro conoció a Gauguin en 1874, pero no lo trató con regularidad hasta 1878. Extrovertido y elocuente, despertó sus simpatías y se convirtió en su primer maestro verdadero.

■ Pissarro, *El puerto de Dieppe*, 1902, colección particular. Su aprendizaje pictórico fue largo y fatigoso: pasó mucho tiempo antes de que alcanzara el éxito. Trabajó en Pontoise y Louveciennes, localidades menos caras que París.

■ Pissarro, *El mercado de los huevos*, 1894, colección particular. Gauguin quedó muy impresionado por la forma en que Pissarro retrataba a los campesinos.

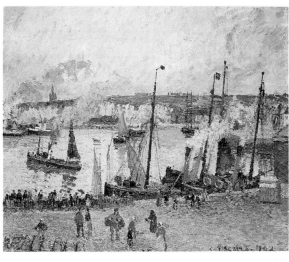

1879-1881:
las primeras muestras

En 1879, después del nacimiento de Clovis, Gauguin se trasladó con su familia a un apartamento más grande, desde rue des Fourneaux a rue Carcel 8, donde logró organizar una pieza como taller. Ese mismo año fue invitado a exponer una escultura en la cuarta exposición de los impresionistas; pasó el verano en Pontoise con Pissarro, bajo cuya guía perfeccionó la pintura de paisajes campestres. En 1880, en la quinta muestra de los impresionistas, presentó siete pinturas y un busto, a pesar de la oposición de Renoir y Monet, que le consideraban todavía un diletante; esa participación le dio ánimos y aumentó su propia estima. Al año siguiente trabajó de forma aún más intensa y expuso ocho cuadros y dos esculturas que merecieron por primera vez la atención de los críticos; en cambio, los doce cuadros presentados en 1882 recibieron juicios poco lisonjeros y fueron considerados menos innovadores que los precedentes. Entre tanto, su mujer Mette seguía con creciente preocupación la transformación de ese pasatiempo inocente en una pasión que le absorbía cada vez más. Trató en vano de oponerse y de reconducirlo a sus deberes de marido y de padre; no obstante, sus protestas obtuvieron el efecto contrario y abrieron una brecha que acabaría por alejarlos de manera irreparable.

■ El esquema de este *Retrato del escultor Aubé con su hijo* (1882, París, Musée du Petit Palais) es insólito, ya que contrapone dos imágenes diferentes, enlazadas mediante el vaso de cerámica del centro.

■ *Jardín bajo la nieve*, 1879, Budapest, Szépmüvészeti Mùzeum. El tema de la nieve era muy apreciado por los impresionistas, por lo que Gauguin quiso estar a su altura.

■ *La cantante Valérie Roumy*, 1880, Copenhague, Ny Carlsberg Glyptotek. Este medallón en madera pintada muestra la influencia de las bailarinas de Degas.

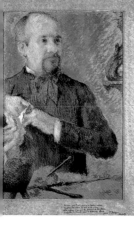

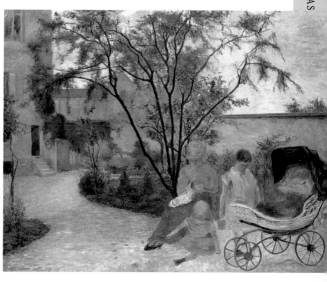

■ *Jardín en Vaugirard*, 1881, Copenhague, Ny Carlsberg Glyptotek. Gauguin retrató a su mujer Mette y a sus hijos en el jardín de rue Carcel, en el barrio de Vaugirard. Al fondo se ve la iglesia neorrománica de Saint-Lambert. Las pinceladas son breves e irregulares, a la manera de Camille Pissarro.

■ *Los hortelanos de Vaugirard*, 1879, Northampton (Massachussets), Smith College Museum of Art. Respecto a las pinturas precedentes, las pinceladas son más irregulares y los colores más claros e intensos; el esquema realista se aproxima a Pissarro.

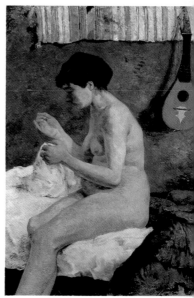

■ *Suzanne cosiendo*, 1880, Copenhague, Ny Carlsberg Glyptotek. Presentada en la sexta muestra impresionista, de 1881, esta pintura representa a la niñera de sus hijos. Fue la primera obra que mereció la atención de la crítica, en particular de Huysmans, que alabó su intensidad y su realismo, y agradó muchó a Degas.

1848-1885

El impresionismo

El impresionismo nació en torno a 1860, año en que Monet, Pissarro, Guillaumin y Cézanne se conocieron en la Académie Suisse de París; en 1862 Monet, Renoir, Bazille y Sisley se reunieron en el estudio de Gleyre, iniciando un decenio de encuentros (en el Café Guerbois, en el Café de la Nouvelle Athéne, en los salones parisinos y, más tarde, en Argenteuil) y de profundos desencuentros con los críticos y los académicos, que culminaron en 1874 con la primera muestra en el estudio del fotógrafo Nadar. En esa ocasión fue acuñado el término "impresionistas", a partir del título de una pintura de Monet, *Impresión, el sol se alza*. Esa muestra fue seguida por otras siete, acogidas con una cierta aprobación de la crítica y un creciente éxito de público. Más allá de las diferencias personales, lo que les unía era el deseo de abandonar definitivamente la enseñanza tradicional de las Academias, basada de manera casi exclusiva en el estudio de los antiguos. Ellos, por el contrario, siguieron la lección de los naturalistas, de Courbet, de Corot y de Delacroix, salieron del taller y pintaron paisajes *en plein air*, en los que el dibujo tendía a desaparecer y el color adquiría autonomía, hasta convertirse en el único elemento expresivo capaz de comunicar emociones y sensaciones.

■ Aun siendo un óptimo pintor de paisajes, Pierre-Auguste Renoir se especializó en figuras femeninas, sensuales y lozanas, a la manera de Tiziano y Rubens, y en escenas de la vida cotidiana, como esta famosísima pintura, *El Molino de la Galette*, dedicada a una de las muchas fiestas con baile de Montmartre (1876, París, Musée d'Orsay).

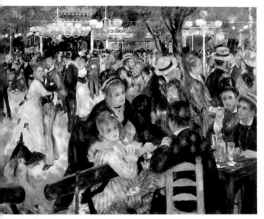

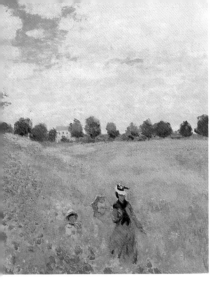

■ Edgar Degas, *La clase de baile*, 1873-75, París, Musée d'Orsay. Degas se apasionó por el mundo del teatro, y en particular por las bailarinas, a las que retrató con gracia, elegancia e incomparable poesía. Rara vez las muestra bailando; prefiere retratar su intimidad, sus gestos cotidianos.

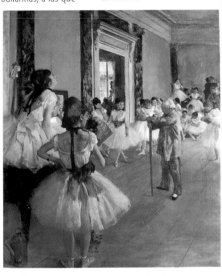

■ Claude Monet, *Las amapolas*, 1873, París, Musée d'Orsay. Las figuras son simples siluetas, y el cuadro está dominado por las manchas rojas de las amapolas.

■ Con esta *Nueva Olympia* (1873-74, París, Musée d'Orsay) Paul Cézanne quiso rendir homenaje a la *Olympia* de Manet, pero con un equilibrio más severo y un uso diferente de los colores.

■ Edouard Manet, *Desayuno en la hierba*, 1863, París, Musée d'Orsay. Rechazada en el Salón, fue expuesta en el Salon des Refusés, donde escandalizó al público y a los críticos, sorprendidos por las numerosas revoluciones técnicas.

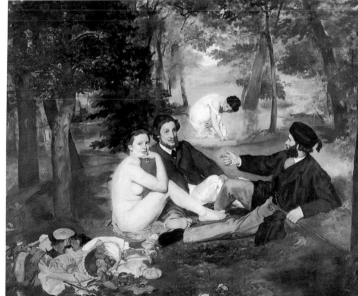

Interior de rue Carcel

Interior de la casa del artista, en rue Carcel, París, 1881, Oslo, Nasjonalgalleriet. Adviértase la elección anticonvencional y osada de poner en primer término el gran ramo de clavelillos, dejando en el fondo a los dos protagonistas.

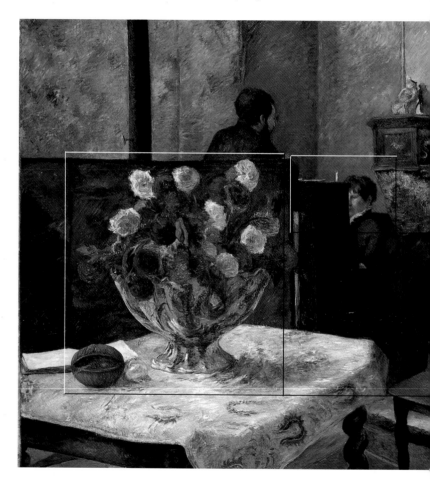

■ La atención a los detalles, representados de modo convencional, revela que el artista todavía estaba ligado al naturalismo y al realismo que había aprendido de sus maestros.

■ La pintura fue presentada en 1882, en la VII muestra impresionista y suscitó un moderado interés por parte de la crítica. Gauguin trató de transmitir a su mujer su pasión por el arte, pero

se encontró con un carácter frío y calculador. En las numerosas cartas que le escribió después, le reprochó que sólo se interesara por "tonterías relativas al dinero y a la ropa y por murmurar sobre los vecinos".

■ Como en otras naturalezas muertas de ese período, las pinceladas son breves y pastosas, y los colores se funden para acentuar la profundidad de la estancia.

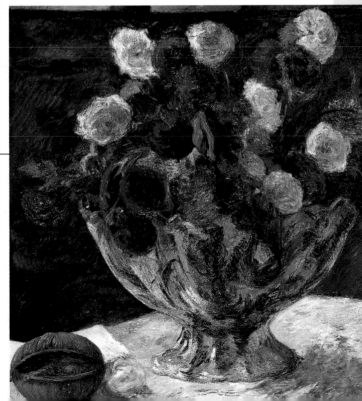

1882-1885: Rouen y Copenhague

En enero de 1883, a causa de la crisis financiera de la *Union Générale*, Gauguin perdió su puesto de trabajo y decidió, no sin la oposición de su mujer, dedicarse de lleno a la pintura. En noviembre se trasladan a Rouen, en Normandía, en parte porque la vida era menos cara que en París, en parte para seguir el ejemplo de Pissarro. Las esperanzas de éxito fueron ilusorias, dado que el ambiente no captó su arte innovador: los cuadros no se vendían y muy pronto los ahorros se agotaron. Al cabo de ocho meses, Mette, desilusionada de la incapacidad de su marido para garantizarle una vida digna, regresó con sus cinco hijos a Copenhague, junto a su familia. Paul la siguió, esperando encontrar un ambiente más favorable para sus pinturas, pero también allí la desilusión fue profunda: una exposición, organizada en la Sociedad de Amigos del Arte, fue ignorada y cerró al cabo de cinco días. Decidió entonces trabajar como representante; el fracaso de esa tentativa provocó su regreso a Francia y la separación de su familia.

■ Se trata de una de las últimas imágenes de Gauguin con su mujer. Fue tomada en 1885, en su vivienda de la calle Gammel Kongevej de Copenhague, donde la familia de ella le acogió con frialdad, mostrando incluso su preferencia por su cuñado Fritz Thaulow, pintor mediocre, pero de éxito.

■ *Retrato de Mette en traje de noche*, 1884, Oslo, Nasjonalgalleriet. El esquema es impresionista, pero muestra una cierta frialdad y comunica una sensación de ausencia y distancia.

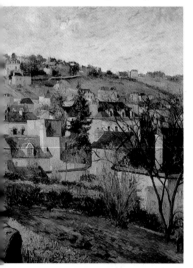

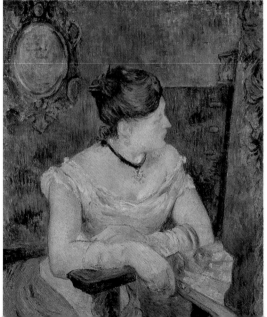

■ *Tejados azules en Rouen*, 1884, Winterthur, colección particular. También en Rouen el artista encontró un ambiente hostil.

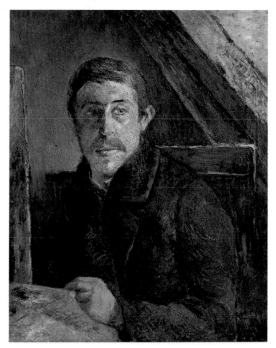

■ En este *Autorretrato ante el caballete* (1885, colección particular), el artista se coloca en un espacio angosto. Parece algo desalentado y luce una mirada incierta.

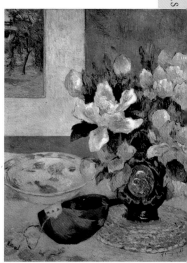

■ *Naturaleza muerta con mandolina*, 1885, París, Musée d'Orsay. Gauguin incluyó dos elementos muy queridos: la mandolina, que tocaba, y en el fondo un cuadro de Pissarro o quizás de Guillaumin, perteneciente a su colección.

■ *Patinadores en el parque de Frederiksberg*, 1884 Copenhague, Ny Carlsberg Glyptotek. "En este momento carezco de valor y de recursos... Todos los días me pregunto si no sería mejor ir al granero y ponerme una soga al cuello. Sólo la pintura me detiene".

Francia: la Tercera República

■ Teórico del socialismo francés, Pierre Joseph Proudhon combatió la propiedad privada y defendió una nueva sociedad igualitaria, respetuosa con la libertad y los derechos de los ciudadanos.

El 1 de septiembre de 1870, los prusianos, después de haber derrotado a los franceses en Sedán, asediaron París, que se rindió en enero del año siguiente: Francia tuvo que ceder Alsacia y gran parte de la Lorena. El imperio de Napoleón III dejó su puesto a la Tercera República, pero la situación no se normalizó. El 18 de marzo, en París, una sublevación popular contra el gobierno Thiers expulsó a las tropas regulares y propició la aparición de la Comuna, primer episodio verdaderamente significativo de la lucha de clases. La represión gubernamental fue violenta: veinte mil muertos y trece mil condenados, de los cuales 270 fueron ajusticiados y 7500 obligados a un exilio forzoso. Dentro de la Asamblea, ocupada en la discusión de las leyes constitucionales, los republicanos tuvieron que defenderse de las tentativas de los monárquicos de devolver el trono a los Borbones. Después de 1884, con el gobierno de Julio Ferry, la situación interna lentamente se normalizó. No obstante, no faltaron los escándalos políticos y los motivos de tensión, como las leyes anticlericales, encaminadas a conseguir una educación laica, y el movimiento encabezado por Ernesto Boulanger, que en 1889 estuvo a punto de repetir el golpe de Estado de Napoleón III. En política exterior, la expansión colonial dio grandes pasos y se vio reforzada por expediciones militares a África (Congo, Túnez) y a Asia (Tonquín, Anam, Laos).

■ Poeta, novelista y máximo representante del romanticismo, Victor Hugo participó con pasión en la vida política francesa. Amigo de Luis Felipe y más tarde republicano, después del golpe de Estado de Napoleón III pasó 19 años en el exilio. Con la república recobró su papel de guía, admirado y honrado.

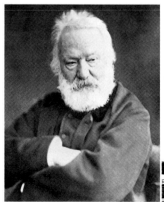

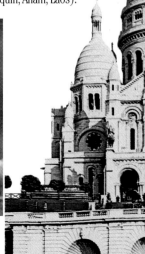

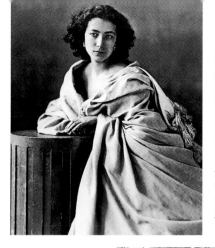

■ Pseudónimo de Henriette Rosine Bernard, Sarah Bernhardt (1844-1923), fotografiada aquí por Félix Nadar, fue la actriz más célebre de su tiempo. Debutó en la Comédie en 1872 y alcanzó muy pronto una sólida reputación, interpretando textos clásicos y obras de escritores contemporáneos, en particular los dramas de Victorien Sardou.

■ *Napoleón III prisionero*, París, Musée Carnavalet. En Sedán, las tropas de Moltke, humillaron a las de Mac-Mahon: unos cien mil franceses, entre ellos el propio emperador, fueron hechos prisioneros. El 4 de septiembre el pueblo parisino, guiado por Gambetta y Julio Favre, proclamó la República.

■ La iglesia del Sagrado Corazón se alza en la cima de la colina de Montmartre, llamada "La Butte". Fue iniciada en 1876, por suscripción nacional, y fue consagrada en 1919. Los proyectistas (entre ellos Abadie y Magne) adoptaron un estilo compuesto de elementos románicos y bizantinos.

El socialismo en Francia

En 1848 apareció el Manifiesto del Partido comunista de Marx y Engels, punto de partida para la difusión de las ideas socialistas en Francia. En 1864 nació la Primera Internacional de los trabajadores, que propició la aparición de la Comuna. Después de 1884, año en que volvió a reconocerse la libertad de asociación, el movimiento obrero se dividió en diversas corrientes, como los marxistas de Guesde, los reformistas de Brousse y Allemane y los revolucionarios de Blanqui. En 1892 nació la Confederación General del Trabajo y en 1899 se creó la Segunda Internacional, que al año siguiente adoptó el 1 de mayo como jornada de los trabajadores. Finalmente, en 1905, bajo la presión de los marxistas y por iniciativa de Jean Jaures, se constituyó el Partido Socialista Unificado.

27

1848-1885

Vacas en el abrevadero

Cuando Gauguin pintó esta tela (1885, Milán, Galleria d´arte moderna) poseía ya un estilo personal y había terminado definitivamente su largo y paciente período de aprendizaje.

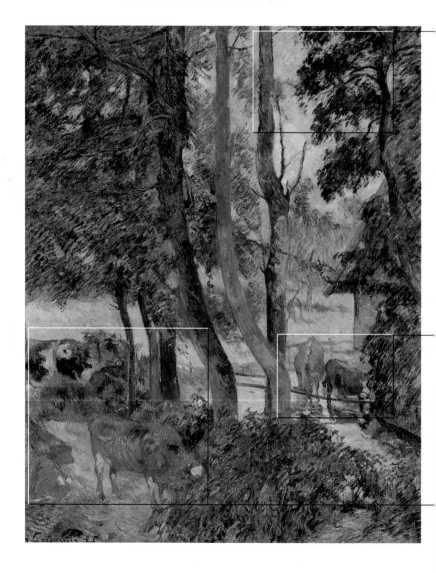

■ La vista está escindida y dominada por los troncos, que dividen la composición en dos partes: la más clara, iluminada por el sol, y la más oscura, en sombras, separadas por los reflejos del agua, algo más luminosos. La espesa y viciosa vegetación desempeña un papel no marginal y preludia tanto las obras bretonas como las que pintará en Polinesia.

■ Las vacas que abrevan tranquilamente en la poza de agua infunden a la escena una sensación de paz y de serenidad, que recuerda las composiciones clásicas y elegíacas de los grandes paisajistas flamencos del siglo XVII, en los que, en parte, parece inspirarse. También merece subrayarse la óptima ejecución de los efectos luminosos del agua.

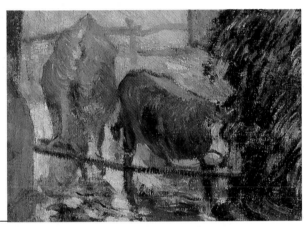

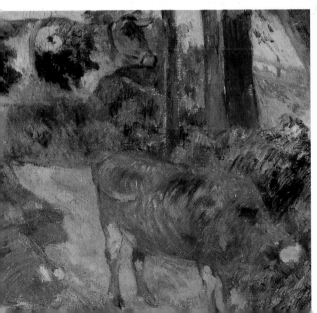

■ Gauguin extiende el color con pinceladas amplias y planas, sacrificando las exigencias de profundidad a los efectos escenográficos y decorativos. Realiza una composición uniforme, carente de contrastes marcados, con una división neta de las sombras y un uso limitado del claroscuro. La presencia de los animales es discreta, pero al mismo tiempo tranquilizadora, muy alejada del simbolismo inquietante de las obras tahitianas.

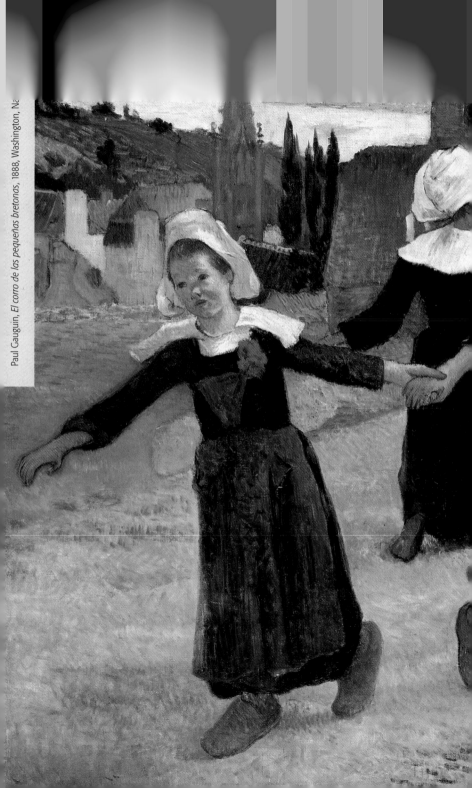

1885-1886: de París a Pont-Aven

En junio de 1885, Gauguin dejó a su familia en Dinamarca y regresó a París, llevando consigo a su hijo Clovis, de seis años. Primero buscó la hospitalidad de Schuffenecker y luego se hospedó en casa de una viuda, Mère Fourel; confió a su hijo Clovis a su hermana Marie y se unió a Pissarro y Degas en Dieppe, pero se hallaba en tal estado de agitación nerviosa, que se peleó con ambos. De nuevo en París, se encontró sin dinero y además con Clovis enfermo; vendió dos cuadros de su colección y se dedicó a pegar carteles por cinco francos al día. En mayo de 1886 participó en la octava y última muestra impresionista. Dos meses después encontró el dinero suficiente para realizar un viaje, programado desde hacía meses, a Bretaña. Se estableció en Pont-Aven, donde se alojó en la pensión de Marie-Jeanne Gloanec. Allí coincidió con varios pintores, entre ellos Charles Laval, que se convirtió en su discípulo más devoto, y el joven Emile Bernard, que contaba entonces con dieciocho años. Se pasaba todo el día pintando y ocupaba la noche en largas discusiones, en las que poco a poco acabó por imponerse, gracias a su fuerte y decidida personalidad.

■ En aquel entonces Pont-Aven contaba con 1500 habitantes, dos albergues y la pensión Gloanec, modesta pero muy acogedora, con una excelente cocina y unos precios bastante asequibles (75 francos por un mes de pensión completa).

■ *El baño en el molino del Bois d'Amour*, 1886, Hiroshima, Museum of Art. El tema de los desnudos en el paisaje era un clásico de los impresionistas, en concreto de Cézanne. Gauguin aceptó el reto y demostró haber aprendido la lección.

■ Una de las causas que llevó a Bretaña a Gauguin fue el hecho de que la región hubiese conservado intactas sus tradiciones.

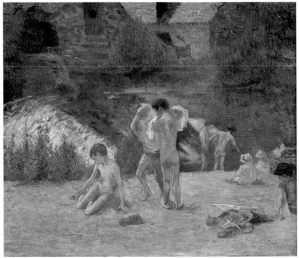

■ Este *Autorretrato* de 1886 (Washington, National Gallery of Art), en el que Gauguin lleva con orgullo un chaleco bretón recamado, fue dedicado inicialmente a Laval. Después, las relaciones entre los dos artistas se resquebrajaron y Gauguin se lo dedicó a Eugène Carrière. El pintor odiaba París y estaba orgulloso de encontrarse en Bretaña. En una carta dirigida a Schuffenecker escribió: "usted prefiere París; yo amo el campo, pues allí encuentro lo salvaje, lo primitivo".

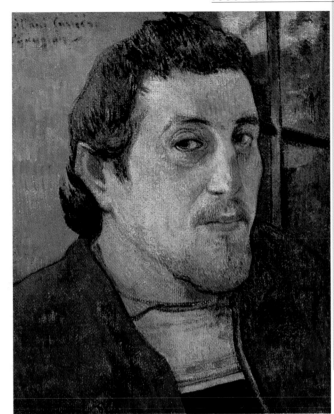

■ *Mujer con moño*, 1886, Tokio, Bridgeston Museum of Art. En este elegante y delicado retrato aparece uno de sus primeros vasos de cerámica (en la actualidad perdido), representado también en la *Naturaleza muerta con el perfil de Laval* y esbozado en una carta a su mujer.

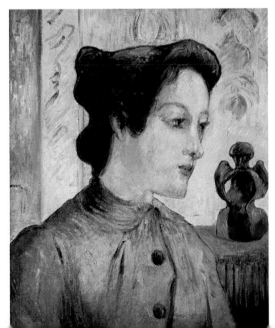

¿Por qué en Bretaña?

La decisión de trasladarse a Pont-Aven, siguiendo el consejo del pintor Jobbé-Duval, no fue casual. Desde hacía veinte años, ese típico puerto de Finistère había atraído a numerosos pintores, sobre todo extranjeros. Además, a Gauguin le influyó la lectura del *Voyage en Bretagne* de Flaubert. Por tanto, su decisión no se debió sólo a razones económicas, sino al deseo de conocer una tierra ligada a sus tradiciones populares, en la que encontrar nuevos motivos de inspiración. A sus ojos, Bretaña aparecía como una tierra salvaje y misteriosa, donde todavía podían encontrarse los mitos y las leyendas del pasado.

1886-1890

La danza de las cuatro bretonas

Es el cuadro más importante de este período, debido al novedoso estilo de la composición y a las innovaciones estilísticas, como el uso decorativo de las cofias blancas y de las variopintas faldas (1886, Munich, Neue Pinakothek).

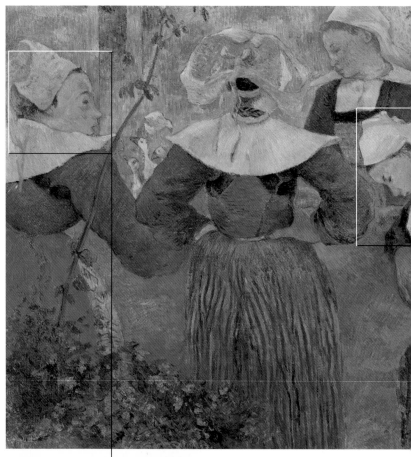

■ El marcado contorno y la elección de colores tenues, casi pasteles, carentes de sombras y de claroscuros, hacen que el rostro de la bella bretona carezca de profundidad. De ese modo, la figura pierde su connotación realista y se transforma en un puro elemento decorativo. Este tipo de pintura, en principio poco comprendida y poco aceptada, constituirá la base de las refinadas y complejas representaciones del art nouveau.

■ La presencia de los artistas no había cambiado las costumbres de los habitantes de Pont-Aven, que habían aprendido a posar con naturalidad, y encontraban grata y rentable esa actividad.

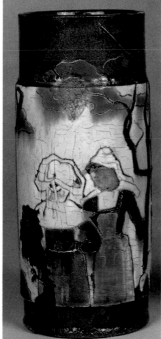

■ *Joven bretona*, 1888, colección particular. Al artista le gustaban las muchachas bretonas, de belleza sencilla y algo tosca, muy alejadas de las sofisticadas modelos parisinas.

■ *Vaso decorado con escenas bretonas*, 1886-87, Bruselas, Musées Royaux d'Arts et d'Histoire. Gauguin acentuó la decoración de las figuras, sirviéndose de contornos grabados y resaltados con oro.

1887: primer viaje a Martinica

El 10 de abril de 1887, en compañía de Charles Laval, Gauguin decidió dejar Francia, donde consideraba que no tenía posibilidades de hacer carrera con rapidez, y se marchó a "vivir como un salvaje" y a trabajar en una isla del golfo de Panamá, Toboga, donde había hecho escala veinte años antes y donde esperaba recibir la ayuda de su cuñado Uribe. Al llegar a Colón el 30 de abril, encontró un ambiente hostil, bastante diferente del que había conocido; además, Laval cayó enfermo de malaria. Desilusionados y casi sin dinero –hasta el punto de que Gauguin se vio obligado a trabajar como cavador en las obras del Canal de Panamá–, en la primera semana de junio se trasladaron a la vecina isla de Martinica. Tras desembarcar en Port-de-France, se establecieron en los alrededores de St. Pierre, en la costa noroccidental de la isla. Desgraciadamente, en el mes de julio Gauguin también cayó enfermo de malaria, enfermedad que se complicó con graves manifestaciones de disentería y desarreglos hepáticos, por lo que en noviembre se vio obligado a declararse vencido y a regresar a la patria. Pobre y enfermo, encontró las energías físicas y mentales necesarias para realizar numerosos dibujos y pintar una docena de telas. Se aproximó entonces por primera vez al primitivismo, cortando definitivamente el cordón umbilical que lo ligaba a los impresionistas.

■ A principios de 1887, escribió a Mette: "Lo que más deseo es escapar de París, un verdadero desierto para el que es pobre. Mi fama de artista crece día a día; no obstante, a veces paso tres días seguidos sin comer, con gran daño para mi salud y sobre todo para mi energía".

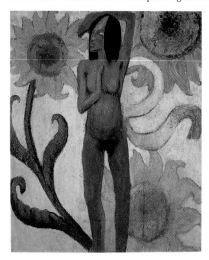

■ *Mujer del caribe*, 1889, colección particular. A Gauguin le impresionó la belleza de las mujeres de Martinica y las retrató en muchas pinturas.

■ Martinica es una isla de las Pequeñas Antillas. Esa posesión francesa se consideraba entonces un verdadero paraíso.

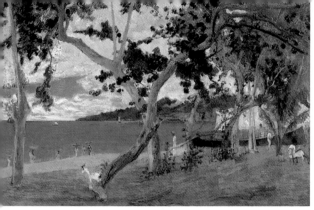

1886-1890

■ *A la orilla del mar*, 1887, Copenhague, Ny Carlsberg Glyptotek. Gauguin escribió a Schuffenecker: "Por debajo de nosotros se extiende el mar y una playa de arena en la que bañarse, y por todas partes hay cocoteros y otros árboles frutales, espléndidos para un paisajista".

■ *A la orilla del mar*, 1887, París, colección particular. Sin preocuparse de las reacciones escandalizadas (y algo racistas) de los residentes blancos, Gauguin elige deliberadamente vivir con la población local.

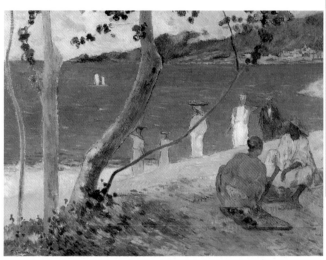

■ *La recogida de los mangos*, 1887, Amsterdam, Van Gogh Museum. A Theo van Gogh le impresionó esta tela, una de las más bellas de las realizadas en Martinica, y quiso adquirirla para sí.

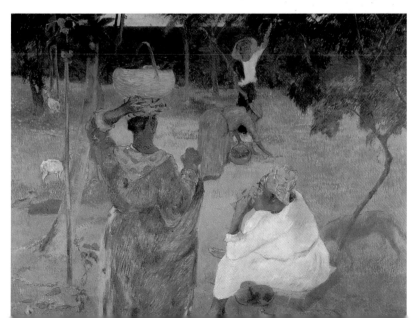

37

Ir y venir

A propósito de esta pintura (1887, Madrid, colección Thyssen-Bornemisza) Gauguin dijo: "Los rostros de la gente es lo que más me atrae; cada día es un continuo ir y venir de negras".

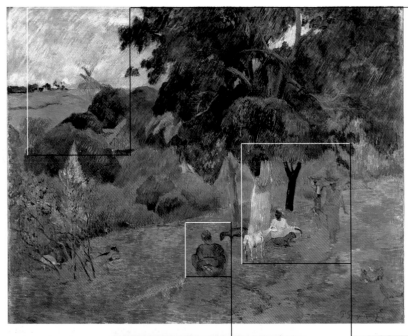

■ Su atención a los habitantes de la isla no es superficial: los observa mientras trabajan en los campos, en los instantes de reposo y durante las fiestas. Estudia su vestido y sus costumbres; mira cómo hablan, cómo gesticulan o cómo mueven el cuerpo, y se esfuerza por entrar en sus pensamientos, para comprenderlos mejor, para no ser considerado un extranjero, sino casi uno de ellos.

■ Al regresar a Francia, Gauguin mostró con orgullo sus pinturas de Martinica. En enero de 1888 el crítico Félix Fénéon le dedicó una larga y lisonjera recensión: "De carácter bárbaro y melancólico, con poco ambiente, coloreados con toques diagonales que van de derecha a izquierda, estos cuadros soberbios parecen un compendio de la obra del señor Paul Gauguin".

■ La naturaleza es la protagonista de los cuadros de la Martinica, una naturaleza lujuriante y salvaje que Gauguin admiró con sorprendida emoción y que le hizo sentirse en el paraíso. A pesar de la enfermedad y las dificultades económicas, su pintura se muestra más luminosa y llena de vitalidad que nunca.

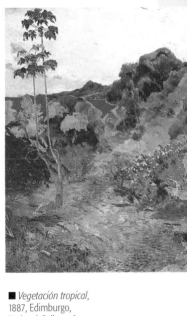

■ *Vegetación tropical*, 1887, Edimburgo, National Gallery of Scotland. En la pintura se ve la bahía de Saint-Pierre, con el volcán Pelée al fondo. La ciudad ha sido tapada por la lujuriante vegetación para dar la impresión de una naturaleza salvaje y no contaminada.

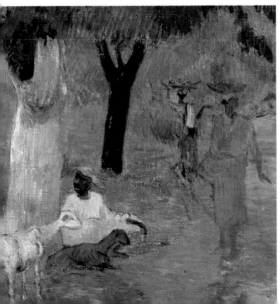

1888: Pont-Aven

Tras regresar a París a mediados de noviembre de 1887, Gauguin se hospedó en casa de Schuffenecker, donde conoció a Theo van Gogh, director de la galería Boussod, a Valadon, el primer marchante de arte que se interesó seriamente en su arte, y al hermano de Theo, Vincent. Este último, después del fracaso de su experiencia evangélica, estaba dispuesto a dedicarse de lleno a la pintura. Alentado por el hecho de que Theo van Gogh vendiera algunas de sus pinturas, el 26 de enero de 1888 Gauguin, que sufrió siempre del estómago, partió para su segunda estancia en Pont-Aven, instalándose de nuevo en la pensión Gloanec. Allí perfeccionó, junto a Emile Bernard, el llamado estilo sintético y *cloisonniste*: sintético porque simplificaba la realidad, al no pintar ya del natural, sino de memoria; *cloisonniste*, por la línea continua que delimitaba el color en las vidrieras góticas. A diferencia del naturalismo de los impresionistas, quería "pintar no ya poniéndose frente al objeto, sino extrapolándolo a partir de la imaginación". El artista ya no está obligado a respetar la forma y los colores de la realidad, sino que puede expresar libremente la síntesis elaborada por las propias emociones.

■ Foto de Paul Gauguin en Pont-Aven en 1888. En el verano de ese mismo año, Gauguin se enamoró de la hermana menor de Bernard, Madeleine, pero ésta prefirió a su alumno y amigo Laval.

■ *Naturaleza muerta "Fête Gloanec"*, 1888, Orleans, Musée des Beaux-Arts. El 15 de agosto Gauguin donó esta pintura a Marie Jeanne Gloanec. Para superar su desconfianza, lo firmó con el nombre de la hermana de Bernard, Madeleine B., y declaró que era la "obra de una diletante".

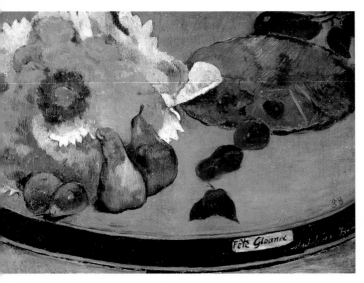

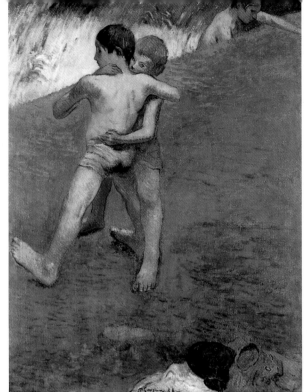

■ *Niños luchando*, 1888, Lausana, colección Josefowitz. "Acabo de terminar una lucha bretona que seguramente le gustará... Dos muchachos en calzones cortos... y otro arriba a la derecha saliendo del agua. Un prado verde. Puro veronese que se rebaja hasta el amarillo cromo sin ejecución, como en los *crèpons* japoneses".

■ *Naturaleza muerta con tres perritos*, 1888, Nueva York, The Museum of Modern Art. En una carta a su hermano, Vincent van Gogh escribía que Gauguin quería dedicarse a la "pintura infantil". Los modelos son las estampas japonesas y los libros ingleses para niños.

■ *Paisaje bretón con cerdos*, 1888, Los Ángeles, colección Mrs. Lucille Ellis Simon. Se trata de una vista de Pont-Aven, con la colina de Santa Margarita al fondo. El uso de los colores claros y el esquema de la composición son tradicionales y están ligados todavía al impresionismo.

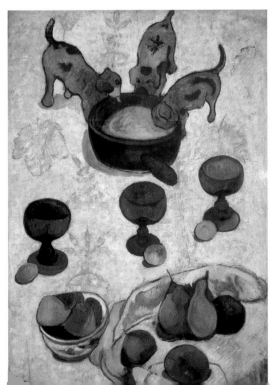

41

Emile Bernard

Emile Bernard nació en Lille el 28 de abril de 1868. Como alumno de Cormon y compañero de Toulouse-Lautrec, se dedicó desde muy joven a la pintura. Dotado de un talento poco común, se aproximó al impresionismo. A finales de 1886 realizó un viaje a Bretaña, donde conoció a Gauguin. De vuelta en París, hizo amistad con Vincent van Gogh, con el que expuso en 1887. Su papel fue muy importante, ya que trató de limar las asperezas de carácter de sus dos difíciles amigos. Además, Bernard fue el primero en representar los temas de sus cuadros con amplios trazos de colores vivaces, encerrados dentro de contornos seguros. Ese procedimiento influyó en las obras de Van Gogh y Gauguin. Después de 1891 Bernard siguió pintando sólo en Pont-Aven, alternando largos viajes a Italia y Egipto. En ese último país pasó casi diez años, se casó con una libanesa, Henenah Saati, y tuvo cinco hijos. En 1901, tras enamorarse de la hermana del poeta Paul Fort, Andrée, dejó Egipto y abandonó a su mujer. Siguió viajando entre Bretaña y Venecia hasta su muerte, acaecida en París el 16 de abril de 1941.

■ Emile Bernard, *Mujeres bretonas entrando en la iglesia*, 1892, colección particular. Las figuras femeninas son reducidas a puros motivos decorativos y los rasgos de los rostros están simplificados.

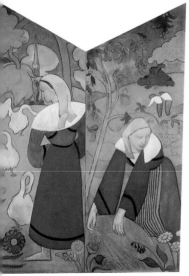

■ Emile Bernard, *Las cuatro estaciones* (det.), 1891, colección particular. Este biombo fue realizado a petición del belga Eugène Boch.

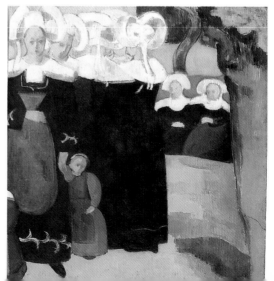

■ Emile Bernard, *Bretonas con paraguas* (det.), 1892, colección particular. El sol exalta los colores de la composición; no obstante, no hay sombras, lo que comunica una sensación de irrealidad.

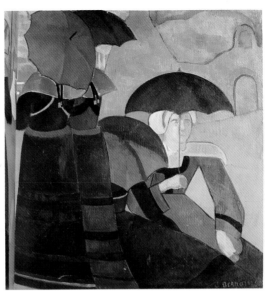

■ Emile Bernard, *Rue Rose en Pont-Aven*, 1892, París, Didier Imbert Fine Art. Por lo común era una calle muy animada, pero Bernard la pinta desierta, como queriendo señalar su estado de aislamiento moral después de la marcha de Gauguin para Tahití.

■ Emile Bernard, *Dos bañistas bajo un árbol*, 1889 (det.), París, Galerie Daniel Malingue. En este caso se ocupa del tema de las bañistas, tan caro a Cézanne. El cuerpo desnudo resalta sobre el fondo verde del prado. El artista se sirve de pinceladas densas y pastosas para capturar y reflejar el máximo de luz.

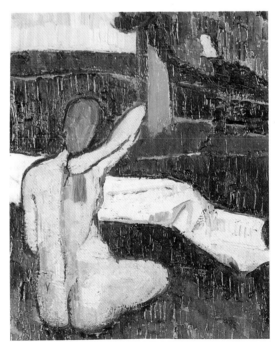

La visión después del sermón

Gauguin ofreció *La visión después del sermón* (1888, Edimburgo, National Gallery of Scotland) al párroco de la aldea de Nizon, pero éste la rechazó. La pintura marca el paso del impresionismo al simbolismo.

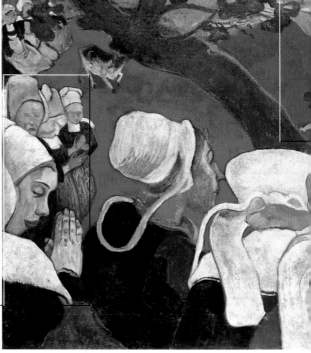

■ En una carta a Vincent van Gogh, Gauguin había descrito y comentado esta pintura: "Creo haber alcanzado en los rostros una gran sencillez rústica y supersticiosa. El conjunto es muy austero". Dispuso la visión desde lo alto, como en las estampas japonesas, y eliminó la perspectiva tradicional, para dar más fuerza a la imagen.

■ La posición de Jacob y del ángel está tomada de una estampa de Hokusai. En ésta y en otras obras de Bretaña, y en mayor medida en las realizadas en Polinesia, Gauguin se sintió atraído por las expresiones de religiosidad popular: una mezcla de fe y superstición, donde los dogmas no eran aceptados de forma racional, sino percibidos emocionalmente.

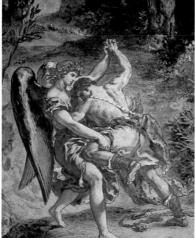

■ En la misma carta Gauguin había dibujado un boceto de la pintura, indicando sus colores de manera sumaria: "Para mí en este cuadro el paisaje y la lucha sólo existen en la imaginación de la gente que reza tras el sermón, lo que se consigue gracias al contraste entre la gente-naturaleza y la lucha, con su paisaje no-natural y desproporcionado".

■ Eugène Delacroix, *La lucha de Jacob con el Ángel*, 1860, París, iglesia de Saint-Sulpice, capilla de los Santos Ángeles. La pintura representa un paisaje del Génesis (32, 23-31), visto como símbolo de las luchas interiores que se desarrollan en la conciencia del cristiano. Esa referencia se encuentra también en la novela de Víctor Hugo *Los miserables*. De hecho, Gauguin acababa de leerla y se había identificado con su protagonista (véanse pp. 50-51).

La escuela de Pont-Aven

■ Alumno y mecenas de Gauguin (le pagó la pensión a cambio de unas lecciones de pintura), Jacob Meyer de Haan se especializó en el tema de la *Naturaleza muerta*, como ésta, con la jarra azul y las peras, de 1890 (colección particular), que recuerda los colores cálidos e intensos usados por los flamencos del siglo XVII.

Aunque de breve duración, la estancia de Gauguin en Bretaña fue muy importante: revolucionó y transformó radicalmente el modo tradicional de pintar e inició lo que se llamó "escuela de Pont-Aven". Cuando llegó allí, Paul ya era conocido por sus exposiciones y fue acogido como un representante del impresionismo; muy pronto los otros pintores advirtieron que su arte se estaba alejando de aquellos cánones para adentrarse por un camino nuevo, el de la pintura sintética y *cloisonniste*. En septiembre de 1888 llegó a Pont-Aven el joven Paul Sérusier, alumno de la Académie Julian de París, y le pidió a Gauguin que le diera lecciones de pintura. Junto a Bernard, al que se considera justamente el creador de ese nuevo estilo, Sérusier fue el más fiel y sincero difusor de su pintura. Más tarde se le unieron otros artistas, y juntos formaron, en pleno fervor teórico y creativo, un grupo diverso y cosmopolita, que incluía a los franceses a Charles Laval, Ernest Chamaillard y Ferdinand du Puigaudeau, al danés Mogens Ballin, a los holandeses Jan Verkade y Jacob Meyer de Haan, al suizo Cuno Amiet y al inglés Robert Bevan.

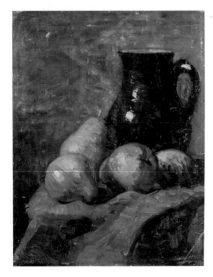

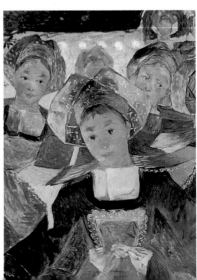

■ Ferdinand du Puigaudeau, *Muchachas bretonas con linternas*, 1896 (det.), París, Didier Imbert Fine Art. Iluminadas por linternas chinas, bajo un cielo oscuro, las muchachas bretonas bailan durante una de las muchas fiestas que animaban las noches de verano. Las cofias de encaje tienen una ligereza transparente.

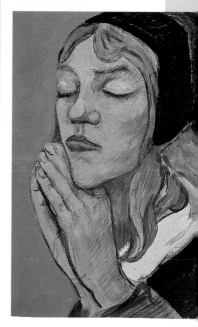

■ Charles Laval, *La valla*, c. 1890, colección particular. Se reproducen los edificios de la granja de Kernévénas en Le Pouldou, desde el mismo punto de observación usado por Gauguin en una tela de 1889.

■ Paul Sérusier, *Bretona rezando*, 1892, París, Galerie Daniel Malingue. La pintura fue realizada sobre cartón, como se advierte en el rostro y en las manos, que han conservado su color.

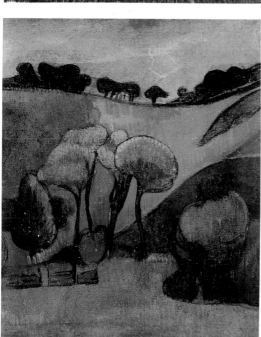

■ Cuando Jan Verkade se encontraba en Saint-Nolff, Mogens Ballin fue varias veces a visitarle para pintar los paisajes circundantes, que consideraba muy emocionantes. Un ejemplo es este *Paisaje bretón* (1892, colección particular, det.).

47

1888: en Arles con Van Gogh

El 20 de febrero de 1888, Vincent van Gogh se trasladó a Arles, en Provenza. En el mes de mayo escribió a Gauguin, proponiéndole que fuera a pintar con él. Durante nueve semanas vivieron y trabajaron juntos, realizando cada uno una veintena de cuadros. Pasaban casi todos los días al aire libre, en el campo, dibujando y pintando, y por la noche se reunían para confrontar sus trabajos y discutir encarnizadamente, tratando de imponer las tesis propias sobre las del contrario. Era un equilibrio inestable y sus diferencias de carácter terminaron por alejarles de manera inexorable. Van Gogh, temiendo perder a su amigo y volver a caer en la soledad, comenzó a atormentarle con escenas histéricas de celos. El 23 de diciembre, después de una nueva pelea, Gauguin decidió marcharse. En su desesperación, Van Gogh se cortó el lóbulo de la oreja izquierda por la noche y se lo entregó a Rachel, una prostituta a la que solía visitar; aterrado, Gauguin regresó a París y no volvió a verlo.

■ *Ancianas en el jardín del hospital de Arles*, 1888, Chicago, The Art Institute. Próxima a la lección del *cloisonnisme*, esta pintura impresiona por la callada dignidad de las cuatro mujeres, sus andares graves y sus gestos mesurados, casi teatrales.

■ *Granja en Arles*, 1888, Indianapolis, Museum of Art. En los primeros cuadros de Arles, Gauguin retrató los campos circundantes y el trabajo de los campesinos.

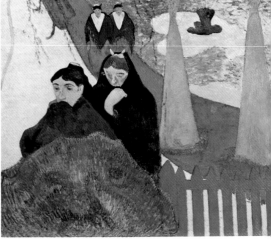

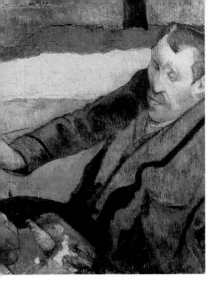

■ *Van Gogh pintando los girasoles*, 1888, Amsterdam, Van Gogh Museum. Se evidencian con cruel precisión las marcas físicas de su desequilibrio mental. "Sin duda soy yo", exclamó Van Gogh, "pero loco".

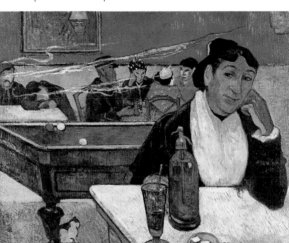

■ *Les Alyscamps*, 1888, París, Musée d'Orsay. La necrópolis cristiana de Alyscamps, con la cúpula de la capilla de Saint- Honorat al fondo, es uno de los lugares preferidos de los dos artistas; de hecho, les inspiró la relización de varias pinturas. El estilo de la composición y el uso de colores particularmente brillantes manifiestan el esquema "sintético", adoptado por Gauguin en Bretaña.

■ *Madame Ginoux*, 1888, Moscú, Museo Pushkin. En este homenaje-confrontación con su amigo Vincent, Gauguin afronta un tema que no le resulta próximo, y lo hace buscando la inspiración en Cézanne.

Siempre habrá amistad entre nosotros

El vínculo artístico y humano entre Gauguin y los hermanos Van Gogh se transparenta en sus cartas, una buena parte de las cuales se ha conservado y se ha publicado recientemente. Aunque sólo constituyen una parte de las que intercambiaron y no siempre resulta fácil establecer con precisión su cronología, ofrecen una documentación fundamental para comprender la personalidad de los tres amigos, las virtudes y defectos de su carácter, la maduración y evolución de su pintura.

Los miserables

Gauguin realizó esta tela (1888, Amsterdam, Van Gogh Museum) en respuesta a los apremiantes requerimientos del propio Van Gogh, que tanto a él como a otros pintores de Pont-Aven les había pedido que le enviaran un autorretrato.

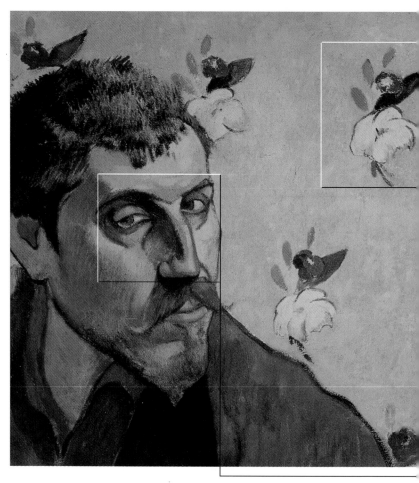

■ Gauguin se inspiró en la descripción que Víctor Hugo hace de Jean Valjean, protagonista de *Los miserables*. Se identificaba con Jean, ya que también él se sentía perseguido por la sociedad.

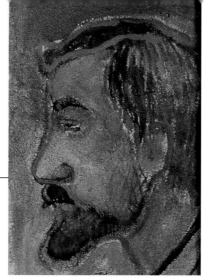

■ También Emile Bernard envió su autorretrato a Vincent van Gogh y también quiso añadir el rostro de su amigo en el fondo. A Van Gogh le gustó mucho el regalo y aunque escribió a su hermano Theo que prefería el de Bernard, pagó su deuda enviando a Gauguin un *Autorretrato* (que se conserva en el Fogg Art Museum de Cambridge, Massachusetts).

■ En la misma carta a Vincent van Gogh, Gauguin explicaba que "el dibujo de los ojos y de la nariz, similares a las flores de las alfombras persas, se basa en un arte abstracto y simbólico, mientras el fondo juvenil, con flores infantiles, hace referencia a nuestra virginidad artística". En efecto, el artista estaba experimentando con algunas soluciones decorativas, de las que se servirá más tarde en las cerámicas y en las pinturas polinesias.

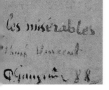

Escribió a Vincent: "La sangre hirviente inunda el rostro; los tonos de fuego de fragua que rodean los ojos hacen referencia a la lava incandescente que enciende nuestra alma de pintores".

51

Vincent van Gogh

■ *Madame Ginoux*, 1890, Sao Paulo, Museu de Arte. Este retrato, que repetía con pocas variantes el de Gauguin de unos meses antes, era para Van Gogh un nostálgico recuerdo de su feliz colaboración y al mismo tiempo una triste invitación a hacerla revivir.

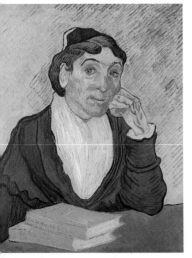

■ Van Gogh, *Les Alyscamps*, 1888, Otterlo, Kröller-Müller Museum. La disposición de las figuras recuerda las estampas japonesas.

Vincent Willem van Gogh nació el 30 de marzo de 1853 en Groot Zundert, una aldea del Brabante holandés. Tras dejar la escuela, es contratado en la sucursal de la compañía Goupil en La Haya, que se dedicaba al mercado del arte contemporáneo. Allí trabajó hasta 1876. Fue profesor de francés en Inglaterra, predicador en una comunidad de obreros, librero en Dordrecht y de nuevo predicador en Bélgica. En octubre de 1880 se inscribió en la Academia de Bellas Artes de Bruselas y comenzó a dibujar y pintar en Nuenen, Amberes y París, donde conoció a los pintores impresionistas, que exponían sus cuadros en la galería de su hermano Theo. El período de Arles fue el más intenso, pero también el más tormentoso. Descubrió los colores y la luz del Mediterráneo, realizó algunas de sus obras maestras, pero también vio desvanecerse sus sueños y sus proyectos, en particular el de una colaboración estable con Gauguin. Después de la partida definitiva de Paul, su salud mental empeoró y fue ingresado en un sanatorio de Saint-Rémy-de-Provence. El 16 de mayo de 1890 se trasladó a la casa de su hermano en París y tres días después a Auvers-sur-Oise, pequeña localidad frecuentada por artistas. Los cuidados del doctor Gachet parecieron comunicarle nuevos bríos, hasta el punto de que pintó unos ochenta cuadros en poco más de dos meses. Pero el 27 de julio de 1890, encontrándose como de costumbre en el campo, adonde había ido para pintar, se pegó un tiro. Murió después de tres días de agonía, a la edad de 37 años. Seis meses después, el 25 de enero, murió también su hermano Theo.

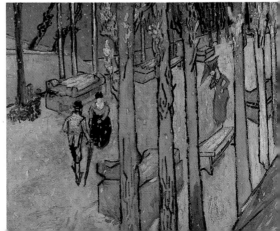

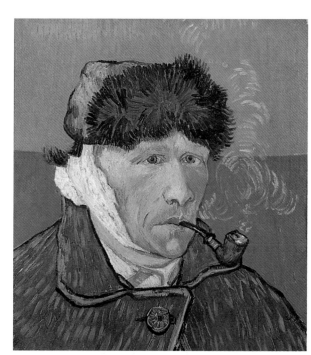

■ Van Gogh realizó este *Autorretrato* (1889, colección particular) poco después de salir del hospital, delante del espejo, como demuestra la inversión de la venda en la oreja mutilada: la derecha en lugar de la izquierda.

■ Van Gogh, *El sillón de Gauguin*, 1888, Amsterdam, Van Gogh Museum. El artista no se resignó nunca a la partida de Gauguin y quiso representar el vacío dejado en su vida. Era una verdadera petición de ayuda, que revelaba toda la angustia que le oprimía y que le llevaría al suicidio.

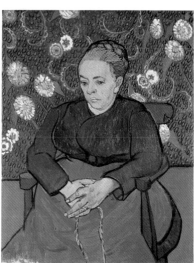

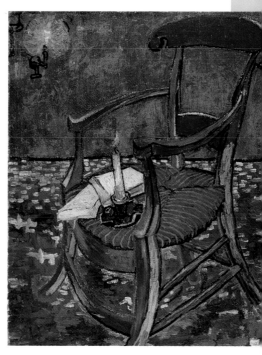

■ Van Gogh, *Retrato de Madame Roulin*, 1889, Amsterdam, Stedelijk Museum. "Creo que si se pusiese ese cuadro tal como está en una barca de pescadores, aunque fuera en Islandia, a todos les parecería que se trata de una mujer que canta una nana".

1889-1890: Le Pouldu

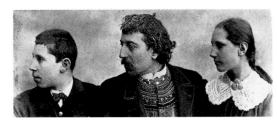

En febrero de 1889, Gauguin se marchó por tercera vez a Pont-Aven. En mayo se encontraba de nuevo en París, para exponer con el grupo impresionista y sintético en el local de Volpini; después regresó a Pont-Aven, pero a finales de junio, molesto por la afluencia de turistas, se trasladó con Sérusier a la ciudad cercana de Le Pouldu. Se alojaron primero en el albergue Destais y después en la Buvette de la Plage de Marie Henry, donde se les unieron Meyer De Haan y otros pintores. En octubre de 1889, Gauguin y De Haan decoraron con frescos y pinturas el comedor de la posada en la que se hospedaban. En junio de 1890 seguía en Le Pouldu; allí le alcanzó la noticia de la muerte de Vincent van Gogh. Dibujaba y pintaba con intensidad y pasión, perfeccionando su estilo en contacto con una naturaleza salvaje y de fuertes contrastes. Las ventas de sus cuadros eran muy escasas y la situación empeoró con la muerte de Theo van Gogh. Además, la familia De Haan, que pagaba a su hijo el alquiler de la posada, dejó de enviarle dinero y le obligó a regresar a Holanda. El 7 de noviembre de 1890 Gauguin regresó a París para pasar el invierno.

■ En marzo de 1891 Gauguin (en esta foto con sus hijos Emile y Aline), se reunió con su familia en Copenhague, antes de partir para Tahití: fue la última vez que se vieron.

■ En este retrato, un poco cruel, de *La familia Schuffenecker* (1889, París, Musée d'Orsay) Gauguin unió algunos elementos impresionistas con su nuevo estilo sintético, que se estaba formando lentamente en esos años.

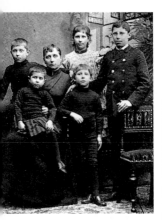

■ Gauguin siguió escribiendo regularmente a su mujer, aquí fotografiada con sus cinco hijos en 1889, informándole de sus progresos en pintura y fantaseando sobre su futuro.

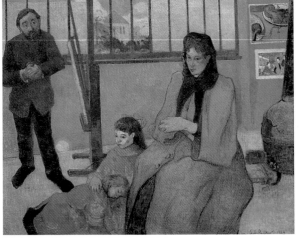

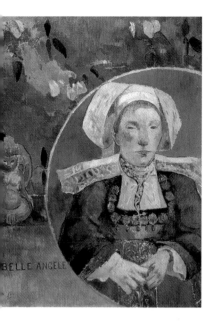

■ *La belle Angèle*, 1889, París, Musée d'Orsay. Gauguin quedó muy satisfecho del resultado de esta pintura y estaba convencido de que "nunca un retrato había quedado tan bien como éste". Por su parte, la protagonista Angèle Satre, mujer de un notable de Pont-Aven, rechazó el cuadro indignada, considerando no sólo que había quedado fea, sino incluso que había sido ridiculizada. Dos años después la pintura fue admirada y adquirida por

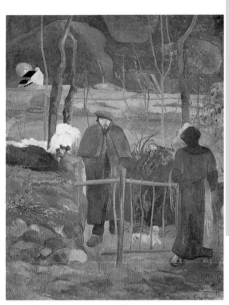

■ Al retratarse como *Cristo en el huerto de los olivos* (1889, West Palm Beach, Norton Gallery of Art), Gauguin quiso manifestar su inquietud religiosa y dar una interpretación atormentada de sí mismo.

■ *Buenos días, señor Gauguin*, 1889, Praga, Nàrodnì Galerie. André Gide, de veinte años entonces, llegó a Le Pouldu y se quedó impresionado por las pinturas de la posada de Marie Henry, en particular por ésta, que dominaba una de las puertas.

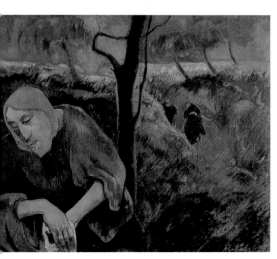

Sintetismo

Aunque se debe a Bernard la invención del estilo sintético y *cloisonniste*, Gauguin fue uno de sus intérpretes más geniales y su mejor difusor. El espacio de la tela ya no debía reproducir la naturaleza, sino la impresión que ésta suscitaba en la memoria. De ese modo, el artista podía olvidar la perspectiva, los matices, las sombras y el claroscuro, para extender los colores sobre superficies planas, delimitadas por contornos netos. Estamos en los inicios de ese largo camino que llevará al nacimiento del arte abstracto.

La pérdida de la virginidad

Este cuadro (1890-91, Norfolk, Chrysler Museum), rico en referencias pictóricas, desde la *Olympia* de Manet al *Cristo muerto* de Holbein, y de citas literarias, se convierte en el manifiesto del nuevo arte simbolista.

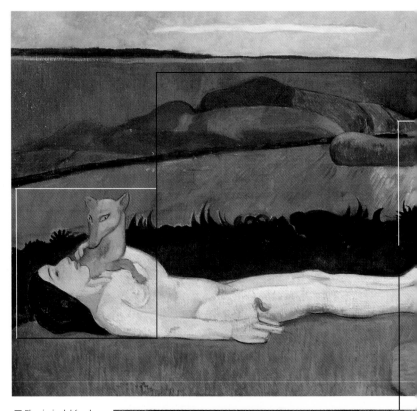

■ El paisaje del fondo, por el que se ve avanzar al cortejo nupcial, es el de Le Pouldu, sintetizado en planos de colores irreales, divididos por líneas negras horizontales, que separan los tonos fríos de azul, verde y marrón violáceo, creando una atmósfera onírica.

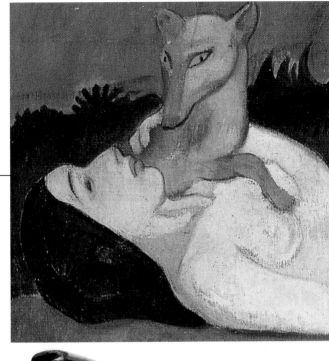

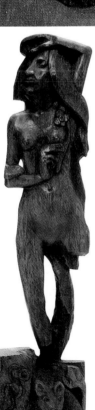

■ *La lujuria*, 1890, Frederikssund, Willumsens Museum. Se trata de una segunda versión en madera de encina y de pino, pues la primera, realizada en terracota, se rompió. A los pies de la muchacha hay una zorra, que en la simbología de Gauguin representa lo salvaje y lo perverso. Mientras los impresionistas celebraban a la naturaleza en su plenitud, Gauguin prefería explorar los misterios del inconsciente. Trasladó a sus pinturas las ansias, los temores y las visiones fantásticas.

■ La pintura también es conocida con el título de *El despertar de la primavera*. La muchacha tendida es Juliette Huet, una joven modista que le presentó Daniel De Monfreid y que durante algunos meses se convirtió en su amante. La posición de la muchacha recuerda la de la pintura de Bernard *Madeleine nel bois d'amour*. En la mano derecha tiene una flor roja cortada, mientras con la izquierda sujeta a una zorra, que a su vez apoya una pata en su seno, en una evidente postura erótica.

La pintura simbolista

■ Lucien Lévy-Dhurmer, *Eva*, 1896 París, colección Michel Périnet. Hábil en las pinturas a pastel, se distinguió por los temas fantásticos, los expresivos retratos y una serie de paisajes mediterráneos llenos de poesía.

Precursores de los surrealistas, seguidores de Edgar Allan Poe, Baudelaire, Flaubert, Wagner y Burne Jones, los simbolistas no constituyeron un verdadero movimiento cultural unitario, no fundaron ninguna escuela y no adoptaron ni siquiera un estilo o una técnica similares. Sólo recientemente la crítica ha adoptado el término "simbolismo" para identificar algunos elementos comunes en las obras de artistas bastante diferentes en cuanto a formación y mentalidad. Esa nueva dirección artística comenzó a difundirse en Francia a finales del siglo XIX, paralelamente al nacimiento y a la difusión del decadentismo. La novela de Huysmans *A rebours*, de 1884, contenía precisas referencias a las pinturas de Moreau y Bresdin, entendidas como una superación del naturalismo en favor de un arte capaz de expresar los valores ideales y espirituales. Del mismo modo, el ensayo de Bergson *Essais sur les données immédiates de la conscience* dio un espesor filosófico a esa nueva concepción estética, difundida también en numerosas revistas. La muestra de Gauguin y de Bernard en el café Volpini, en 1889, fue considerada como un acontecimiento importante para la pintura simbolista y tuvo una notable influencia en los decenios posteriores.

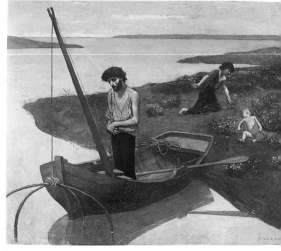

■ Pierre Puvis de Chavannes, *El pescador pobre*, 1881, París, Musée du Louvre. Fue considerado como uno de los manifiestos del simbolismo. El Estado francés lo compró en 1887 y lo expuso en el Musée du Luxembourg, donde fue estudiado por toda una generación de jóvenes artistas.

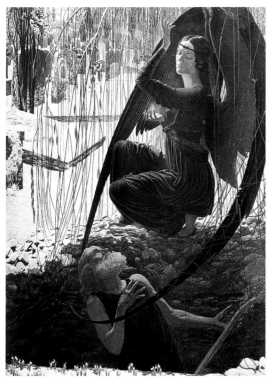

■ Carlos Schwabe, *La muerte y el sepulturero*, 1895-1900, París, Musée du Louvre. Nació en Alemania, aunque trabajó en Suiza. Se le comparó con Durero por el sentido trágico y misterioso de la muerte y por las ilustraciones fantásticas y de carácter místico.

■ Odilon Redon, *Retrato de Gauguin*, 1904, París, Musée du Louvre. Alumno de Corot y amigo de Gauguin y de los nabis, Redon fue el precursor y el mayor representante de la corriente simbolista, debido a su estilo incisivo y muy original.

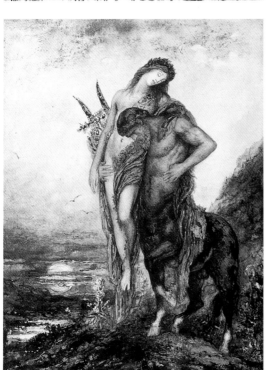

■ Gustave Moreau, *El poeta y el centauro*, 1870 aprox., París, Musée Moreau. Fue el último gran artista decadente, continuador de la tradición romántica y autor de obras complejas y visionarias.

La cerámica
y las esculturas en madera

En 1886, con ocasión de la última muestra de los impresionistas, Gauguin conoce al entallador Bracquemond y a Ernest Chaplet, un hábil ceramista que le enseñó los trucos en el uso del gres esmaltado y las técnicas japonesas de cocción al fuego vivo. Gauguin se apasionó con el tema y en poco más de un año realizó más de cincuenta ejemplares. Más tarde, se dedicó a la escultura en madera y a la fundición en bronce, tareas en la que demostró una notable pericia y una fecunda imaginación. Sus trabajos expresaban la búsqueda de formas insólitas y originales, quizás demasiado extravagantes para los gustos del público de aquel entonces. De hecho, causaron una gran impresión y juicios lisonjeros por parte de la crítica, pero escasos beneficios, muy por debajo de sus expectativas. En el terreno de la escultura el artista sufrió influencias diferentes: las culturas precolombinas y el arte japonés, las novedades del *Arts and Crafts Mouvement* y los modelos neoclásicos. Estaba tan orgulloso de sus creaciones, que las incluyó, a veces en primer término, en muchas de sus pinturas, como por ejemplo en *Naturaleza muerta con estampa japonesa*, de 1889 (Teherán, Museo de Arte Moderno), o en *Naturaleza muerta con perfil de Laval*, de 1886-87 (Lausana, colección Josefowitz).

■ *Jarrón con forma de mujer*, 1889, Dallas, Museum of Art. La representada es la mujer de Schuffenecker, que a menudo le fue hostil. Gauguin le devolvió la moneda retratándola con unas orejas puntiagudas de "fauno" y una serpiente enrollada en la cabeza como sombrero.

■ *Jarrón con figura de mujer bretona*, 1886-87, Copenhague, Kunstindustrimuseet. Gauguin se desentendió de los posibles usos de los jarrones y se concentró en los aspectos decorativos, creando formas insólitas e innovadoras para aquellos tiempos.

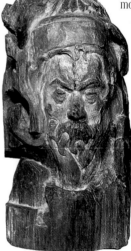

■ *Busto de M. de Haan*, 1889, Ottawa, National Gallery of Canada. Gauguin realizó esta escultura en madera para el comedor de la Posada Henry.

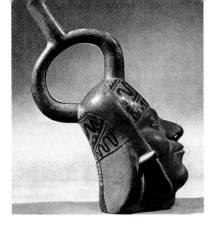

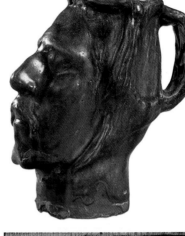

■ Cultura Moche, Perú, *Jarrón con forma de cabeza humana,* Nueva York, The Metropolitan Museum of Art. Las culturas precolombinas influyen en Gauguin, que las conoció en Lima; la madre poseía una colección que se había llevado a Francia.

■ *Jarrón con autorretrato,* 1889, Copenhague, Kunstindustrimuseet. Uno de los muchos jarrones con forma de cabeza humana, síntesis de los jarrones populares antropomorfos peruanos.

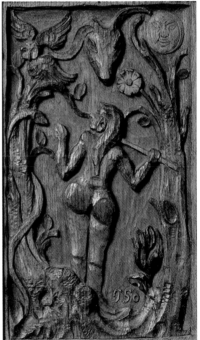

■ *Desnudo de mujer de pie,* 1890-91, colección particular. El esquema de esta escultura es tradicional; posee la gracia de las bailarinas de Degas.

■ *Eva y la serpiente,* 1889-1890, Copenhague, Ny Carlsberg Glyptotek. Los relieves en madera desempeñaron un papel muy importante en sus búsquedas estéticas.

Autorretrato con Cristo amarillo

En este autorretrato (1889-90, colección particular)
Gauguin se representó a sí mismo sobre un fondo
en el que aparecen dos obras realizadas en esos
años, de las que se sentía orgulloso y que repre-
sentaban su doble naturaleza, espiritual y salvaje.

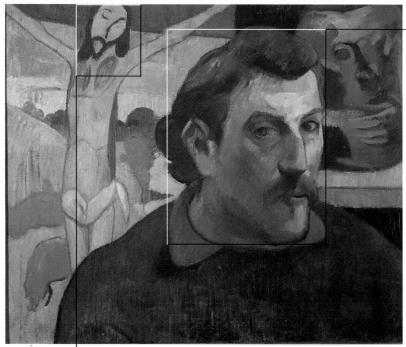

■ En esta pintura,
Gauguin simplificó aún
más las formas, hasta el
punto de dar al rostro
de Cristo una
configuración abstracta,
como puede verse en la
nariz y en la barba.

■ *Jarrón con
autorretrato en forma de
cabeza grotesca*, 1889,
París, Musée d'Orsay.
Este jarrón de tabaco
debía ser un don de
amor para Madeleine
Bernard, pero la
muchacha lo rechazó.

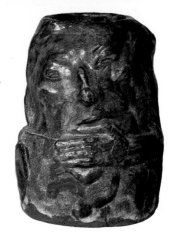

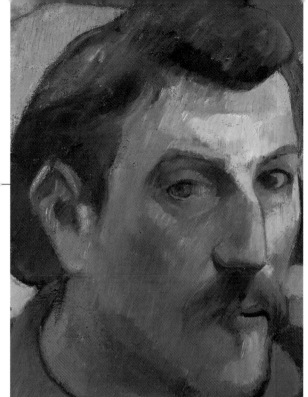

■ En los numerosos autorretratos que realizó, Gauguin posó casi siempre de tres cuartos: de ese modo destacaba la nariz aquilina, el mentón cuadrado, la complexión maciza, los cabellos largos y desordenados para dar una imagen de pintor salvaje y libre de todo prejuicio. Al mismo tiempo, los ojos claros y profundos indicaban la fuerte personalidad, todavía en busca de una identidad propia, pero decidida a no dejar de intentarlo todo para realizar sus aspiraciones más profundas.

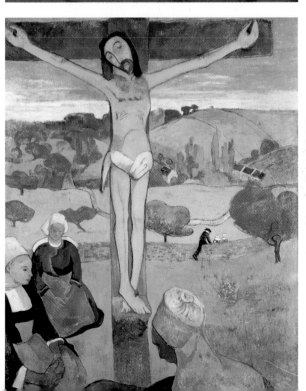

■ *El cristo amarillo* (1889, Buffalo, Albright-Knox Art Gallery) se inspira en un crucifijo de madera expuesto en la capilla de Trémalo, cerca de Pont-Aven. Esta pintura (en el *Autorretrato* aparece invertida, porque está reflejada en un espejo) constituye uno de los ejemplos más claros del sintetismo y del primitivismo bretón, muy próximo a las pinturas de Bernard, hasta el punto de que éste se sintió (con razón) plagiado.

La Exposición Universal de París de 1889

■ Robert Delaunay, *La Torre Roja*, 1928, colección particular. Proyectada por Gustave Alexandre Eiffel, fue erigida para celebrar la Exposición Universal de 1889, como símbolo de la naciente civilización industrial. De 300 metros de altura, fue terminada en 17 meses.

La Exposición Universal de París de 1889 se inauguró el 6 de mayo y permaneció abierta seis meses exactos. Para conmemorar el centenario de la Revolución de 1789, los parisinos quisieron asombrar al mundo entero con una exhibición en verdad grandiosa. Se erigieron gigantescos pabellones de metal, como por ejemplo la Galería de las Máquinas, hoy desaparecida, y la Torre Eiffel, símbolo del triunfo de la arquitectura de hierro, que se convirtió en el emblema de la naciente civilización industrial. Entre las diversas manifestaciones se organizó una retrospectiva de arte, llamada "Centenaria", que presentaba obras de los mayores pintores franceses del período comprendido entre 1789 y 1889, desde David a los impresionistas (Monet, Pissaro y Cézanne). El italiano Volpini, director del Grand Café, un lujoso bar parisino, había obtenido la licencia de una cervecería en el interior de la Exposición, en el edificio dedicado a las Bellas Artes, precisamente bajo la Torre Eiffel. Emile Schuffenecker se puso de acuerdo con Volpini para decorar las paredes del local con cuadros de un nuevo grupo, denominado para la ocasión "Grupo impresionista y sintético". Se expusieron 17 obras de Gauguin y otras de Schuffenecker, Bernard, Laval, Léon Fauché, Louis Roy, Georges-Daniel de Monfreid y Louis Anquetin. Theo van Gogh no quiso enviar las obras de Vincent porque consideraba que esa muestra era un remedo humillante de la exhibición oficial, a la que su hermano no había sido invitado. La muestra pasó casi desapercibida, tanto para el público como para la crítica, a excepción hecha de algunos jóvenes, los futuros nabis.

■ Exposición de 1878, Le Trocadero, París, Musée Carnevalet. Con el paso de los años, los pabellones se hicieron cada vez más grandes, en un intento de asombrar a los visitantes extranjeros y hacer alarde de la superioridad tecnológica francesa.

■ La Exposición Universal de 1867, Milán, Cívica raccolta di stampe bertarelli. Las exposiciones constituyeron una gran ocasión para conocer, confrontar y comprender los diferentes usos y costumbres de los europeos.

■ Una imagen de la Exposición de 1889. La afluencia de público fue muy elevada en todas las ediciones y contribuyó a convertirlas en iniciativas de importancia internacional.

■ Entrada al Kampong javanés en la Exposición de 1889. La presencia de obras de arte de culturas no europeas suscitó una gran curiosidad, así como un interés más serio y profundo por parte de artistas y estudiosos.

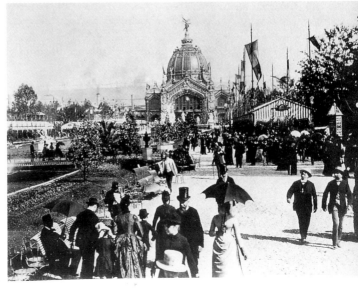

65

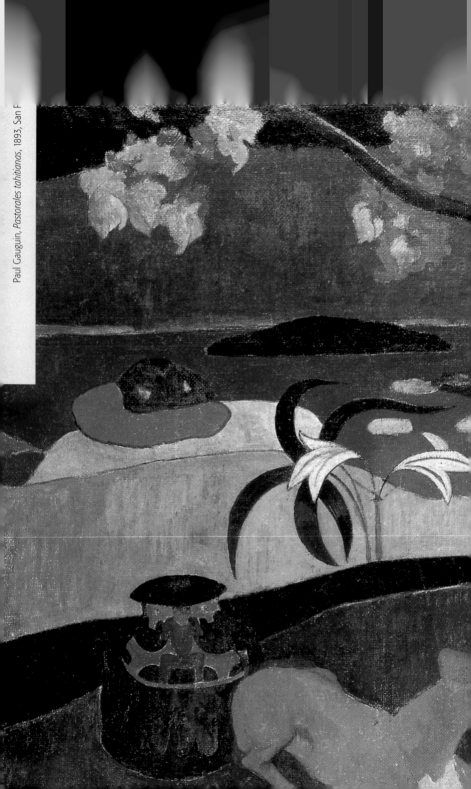

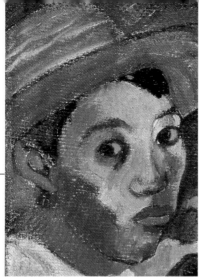

■ Tras desvanecerse su intención de hacer carrera como retratista entre los colonos europeos, Gauguin se volvió hacia los indígenas, los únicos que le habían acogido y aceptado. Este muchacho, de mirada algo cohibida y melancólica, fija la vista directamente en el espectador, como tratando de captar su atención. El rostro está en sombras, mientras la camisa parece reflejar los colores vivaces de las flores.

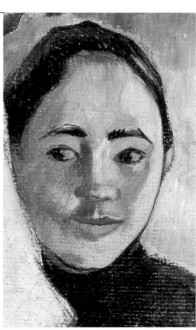

■ La joven muchacha (en general todas las figuras femeninas) luce una mirada más vivaz y atenta y es mucho más expresiva que los pocos retratos masculinos realizados en Polinesia. También en este caso la pintura está precedida de una gran cantidad de dibujos a lápiz, pasteles y aguadas, de los que Gauguin se servía como estudios preparatorios, junto a lo que llamaba "pequeño museo", es decir, una serie de reproducciones de obras de arte de épocas y civilizaciones diversas, que había llevado consigo desde París.

La colonización del Pacífico

Los primeros colonizadores europeos que arribaron a las islas del Pacífico, después del viaje de Magallanes de 1521, fueron los portugueses y los españoles, seguidos por los holandeses, que organizaron la Compañía de las Indias Orientales poco después de 1600. En 1606 se descubrió Tahití y se inició la explotación de sus plantaciones de cocoteros, algodón, café y caña de azúcar. Una exploración sistemática sólo se produjo a principios del siglo XVIII, y fue obra de varios navegantes, entre ellos el francés Louis Antoine Bougainville y el inglés James Cook en sus tres viajes, realizados entre 1768 y 1779. A las expediciones científicas se unieron los misioneros, empeñados en transmitir la religión y la cultura europeas. Al mismo tiempo, llegaron a Europa los primeros testimonios de la civilización y la cultura oceánica y nacieron los primeros museos etnográficos: en 1878 se inauguró en París el Musée des Missions Ethnographiques, seguido del Musée d'Ethnographie, en el Palacio del Trocadéro. En los decenios siguientes, Francia e Inglaterra intensificaron su expansión colonial, llegando a controlar casi todos los archipiélagos del Pacífico. Aumentaron las plantaciones con la introducción de nuevas plantas, como el trigo y los cítricos; además, se importaron animales domésticos, antes totalmente ausentes.

■ Robert Bénard, *La llegada de Cook a las islas Tonga*. Es interesante advertir que el autor del grabado ha fundido el "mito de la edad primitiva" con el "mito de la antigüedad", dando a los nativos ropas absolutamente irreales, como si Cook hubiese desembarcado en la antigua Grecia.

■ El pabellón de Tahití en la Exposición Universal de París de 1900. Paralelamente a la intensificación de las muestras, nació y se difundió el coleccionismo de objetos de arte importados de Oceanía, promovido y apoyado por algunas galerías especializadas.

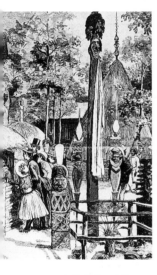

■ En la Exposición Universal de París de 1889, fueron reconstruidas en el Campo de Marte aldeas de Tahití y de Nueva Caledonia. Por primera vez, los objetos fueron vistos y estudiados en su ambiente real.

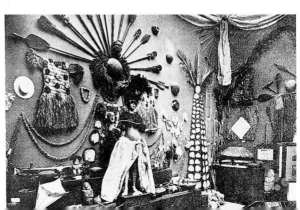

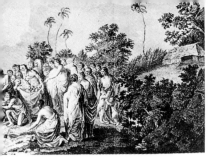

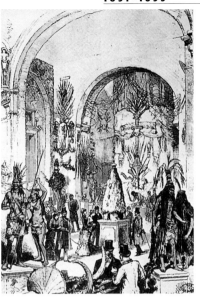

■ En esta cubierta de un libro para niños de 1901, se representa la carrera de las potencias europeas para repartirse las colonias, a menudo presentada como una obra de civilización.

■ Fundado en 1879, bajo la dirección de Hamy, el Musée d'Ethnographie de París, reproducido aquí en una estampa de la época, fue abierto al público en abril de 1882.

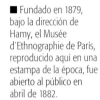

El racismo

En el siglo XIX el racismo en Europa se desarrolló en torno a las teorías de Joseph Arthur de Gobineau, con su *Ensayo sobre la desigualdad de las razas humanas*, editado entre 1853 y 1855. En 1899 se publicó el libro *Los fundamentos del siglo XIX*, de Houston Stewart Chamberlan, que releyó el darwinismo en clave sociológica. La difusión de esas teorías justificó las conquistas coloniales, que en 1900 controlaban el 90,4 % de África y el 98 % de Oceanía.

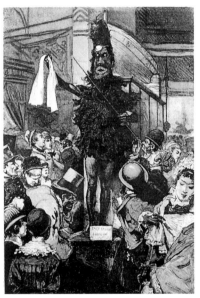

■ En este grabado puede verse a un modelo con la máscara de un jefe Kanaka (Nueva Caledonia) en la Exposición Universal de París de 1878. Los objetos presentados en las Exposiciones de 1878 y 1879 constituyeron el núcleo inicial de las colecciones del Musée d'Ethnographie de París.

73

1891-1893

Mataïea

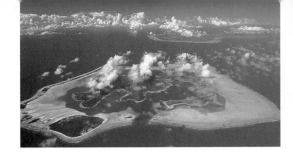

Desilusionado de Papeete, demasiado contaminada por los europeos, y debilitado por una estancia en el hospital a causa de una bronquitis mal curada, Gauguin buscó un ambiente aún puro y salvaje, primero en Pacca y después en Mataïea, en la parte meridional de la isla. Había alquilado una *fare*, una cabaña de bambú con el techo de hojas de palma, inmersa en la vegetación tropical, delante de una laguna azul. Con él estaba Titi, una joven mestiza que muy pronto regresó a Papeete, sustituida por Teha´amana. Gauguin se documentó leyendo el libro de Moerenhout *Viajes por las islas del Gran Océano*, rico en informaciones sobre los ritos de los maoríes, del que se sirvió en sus pinturas y en sus libros, *Antiguo culto maorí* y *Noa Noa*. Pintaba mucho, pero se sentía angustiado por el hecho de que ninguno de los cuadros que había enviado a París se hubiera vendido. Sólo de Monfreid le enviaba dinero con regularidad.

■ Las tierras emergidas que componen los cinco archipiélagos de la Polinesia francesa son de dos tipos: islas altas de origen volcánico e islas bajas, llamadas *motu*, que constituyen los atolones de origen coralino.

■ *la orana Maria, Ave María*, 1891-92, Nueva York, The Metropolitan Museum of Art. A diferencia de los otros distritos, en el de Mataïea los habitantes eran católicos; quizás por ello quiso pintar a Jesús y a María como "tahitianos".

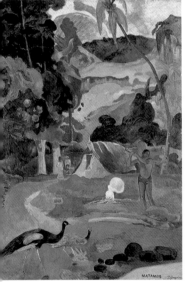

■ *Paisaje con pavos*, 1892, Moscú Museo Pushkin. Puede verse la cabaña que Gauguin había alquilado: por un lado daba al mar y por otro a las montañas.

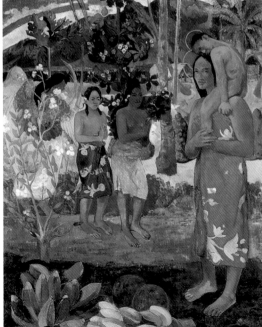

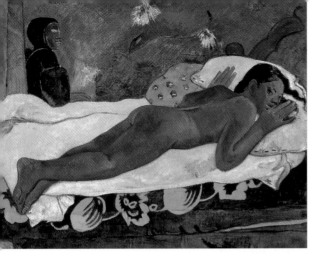

■ *Manao tupapau, El espíritu de los muertos vela*, 1892, Buffalo, Albright-Knox Art Gallery. Es una obra compleja y rica en simbolismos, que tiene su origen en una visión espectral de Teha´amana y en su miedo irracional a la oscuridad, que su imaginación poblaba de fantasmas.

■ *Arearea, Jocosidad*, 1892, París, Musée d'Orsay. La pintura puede considerarse parte de un tríptico ideal que incluye también *Érase una vez* y *Pastorales tahitianas*. Al fondo se ven algunas danzadoras de *tamuré*, delante de la diosa de la luna, Hina. La presencia del perro anaranjado en primer plano dejó estupefactos y perplejos a los críticos franceses, que vieron el cuadro en la muestra celebrada en 1893.

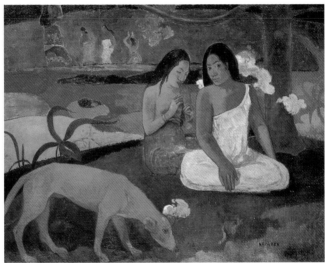

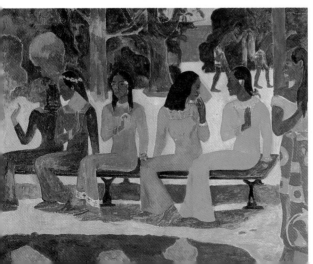

■ *Ta matete, El mercado*, 1892, Basilea, Kunstmuseum. La postura de las mujeres está tomada de un fresco egipcio que decoraba una tumba tebaica de la dinastía XVIII, hoy en el British Museum, del que Gauguin poseía una fotografía. Además, puede relacionarse, aunque como una imagen especular, con un friso egipcio conservado en el Louvre.

¿Qué? ¿Estás celosa?

Aha oe feii (1892, Moscú, Museo Pushkin) es en apariencia un cuadro hecho de un tirón. En realidad, fue proyectado con atención, como muestran los dibujos preparatorios, en particular los de la figura tendida, añadida posteriormente.

■ Gauguin confió a los colores la tarea de representar el simbolismo de esta composición. Es un descubrimiento fundamental que tendrá una gran influencia en la pintura posterior, en particular en el nacimiento del arte abstracto.

■ La postura de la mujer en primer plano, de complexión sólida y maciza, casi escultural, es estudiada con mucho detalle. La curva de la nariz y los labios cerrados revelan un carácter firme y decidido. A pesar de estar de perfil tiene el ojo vuelto hacia el espectador, con una mirada a un tiempo ingenua y maliciosa. La corona de flores blancas se contrapone al negro de los cabellos; de la misma manera, la piel oscura se destaca netamente del rosa intenso de la playa.

■ El diálogo entre las dos protagonistas, tendidas despreocupadamente en una playa soleada, no parece real, pero es evocado y sugerido por sus posturas sosegadas. La posición de la muchacha tumbada es insólita y sugiere la búsqueda de nuevas soluciones.

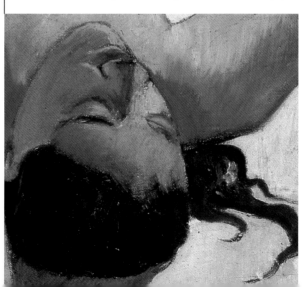

El arte en Oceanía:
entre la naturaleza y la magia

■ *Dea Kawe*, Nukuoro, Islas Carolinas, Auckland Institute and Museum. Las representaciones de las divinidades son raras, ya que muchas fueron destruidas por los misioneros en su obra de evangelización.

En el poblamiento de Oceanía, que se prolongó durante siglos, participaron poblaciones de culturas diversas que dieron vida a civilizaciones y formas de arte diferentes. Es posible identificar tres grandes áreas. En Australia las poblaciones aborígenes elaboraron un complejo conjunto de creencias religiosas, representadas por esculturas y decoraciones talladas y pintadas, que estaban dotadas de numerosos significados simbólicos, diferentes según los grupos y a menudo reservados a los iniciados en el culto. La segunda área es la Melanesia, el grupo de archipiélagos al noreste de Australia; aquí, los indígenas representaban a los antepasados o a los espíritus con forma humana o animal. Utilizaban una técnica avanzada en los objetos hechos a mano, incluso en los de uso cotidiano, así como en el entallado, en el grabado, en el trenzado y en las decoraciones con plumas de ave. El centro más importante era Nueva Guinea, con más de 700 lenguas diversas y nueve subgrupos estilísticos diferentes, en particular el área del río Sepik y del Massim, donde se construían las grandes canoas ceremoniales con proas ricamente decoradas. Finalmente, la Polinesia y la Micronesia, donde las diversas clases sociales se representaban con una variedad de insignias de rango (ramos ceremoniales, cetros, mantos y sombreros, amuletos y broches), decoradas con figuras humanas o motivos geométricos.

■ *Figura*, Montes Torricelli, Papua, Nueva Guinea, Berna, colección Brignoni. Esas esculturas a menudo eran custodiadas en las grandes casas ceremoniales, llamadas casas de los hombres, centro de la vida social y religiosa de la población de Nueva Guinea.

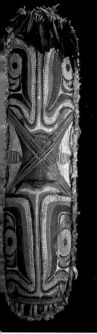

■ Pintado sobre madera con colores vivaces y decorado con fibras y plumas, este escudo Sulka es una de las mejores expresiones artísticas de los habitantes de las islas de Nueva Bretaña (Ginebra, Musée Barbier-Mueller).

■ *Ídolo con perla*, c. 1892, París, Musée d´Orsay. Buen conocedor de las religiones orientales, Gauguin funde dos culturas diferentes: da al ídolo un rostro polinesio, mientras la postura es la de Buda. La perla en la frente alude al ojo de la visión interior.

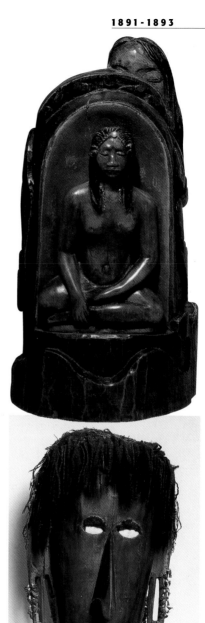

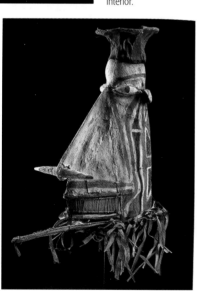

■ Todos los elementos de esta típica máscara ceremonial de las islas Witu, Nueva Bretaña (Ginebra, Musée Barbier-Mueller) tenían un significado y una función precisa.

■ Por lo común, estas máscaras de las islas Saibai, Papua, Nueva Guinea (Nueva York, colección Friede), representaban a los antepasados totémicos o a los seres sobrenaturales.

Erase una vez

Matamua, 1892, Madrid, Colección Thyssen- Bornemisza. El título de la pintura alude con nostalgia a la época en que la isla era un lugar sin contaminar, antes de la llegada nociva de los colonizadores europeos.

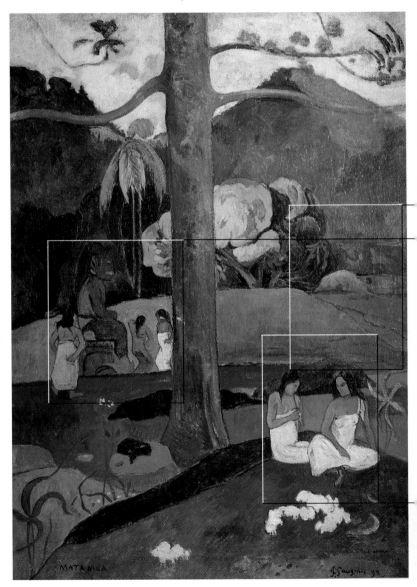

■ Junto al gran mango "próximo a la montaña que cierra la grandiosa caverna", se ve la vivienda de Gauguin, ya retratada en *Paisaje con pavos* (p. 74) y en otras telas. Para poder pintar mejor esos lugares, necesitaba identificarse con el ambiente, no ser un espectador externo, sino vivirlo y sentirlo directamente.

■ En Tahití, Gauguin buscó en vano esculturas de divinidades antiguas; los únicos testimonios eran los relatos orales y el libro de Moerenhout. Ésta es la diosa de la luna Hina (véase también *Arearea*, p. 75). De su vínculo con Taaroa, dios supremo y creador, nació Fatou, el genio que había animado la tierra. Su culto estaba ligado al tema de la muerte y la resurrección.

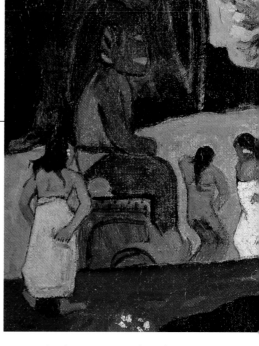

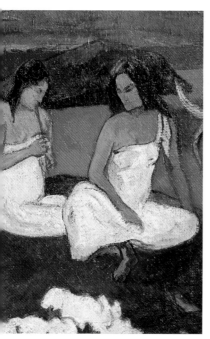

■ La atmósfera de sacralidad y la evocación imaginaria de los antiguos rituales está subrayada por la mujer que toca la flauta de caña, en lengua maorí *vivo*. En *Noa Noa* Gauguin recuerda haberse dormido varias veces, en las noches tranquilas y silenciosas, acompañado por el sonido de este instrumento y haberlo asociado a sus sueños más bellos. Esas dos mujeres aparecen también en *Arearea* (p. 75).

Las primeras muestras de los nabis

EL CONTEXTO HISTÓRICO Y ARTÍSTICO

Mientras Gauguin se encontraba en Tahití, en Francia su arte era seguido por un grupo de artistas de la segunda generación simbolista, llamados nabis. Todo comenzó en 1888, cuando Paul Sérusier mostró a sus compañeros de la Academia Julian un pequeño paisaje, que había pintado en la tapadera de una caja de cigarros en Pont-Aven, siguiendo las indicaciones de Gauguin. Esos jovenes estudiantes, en su mayor parte nacidos entre 1860 y 1870, que se habían conocido en el instituto Condorcet y en la Ecole des Beaux-Arts, formaron un grupo compacto y homogéneo que pasaba de la pintura a la literatura, de las artes decorativas al teatro. Uno de ellos, Auguste Cazalis, los bautizó como nabis, del hebreo *Nabiim*, que significa profetas, inspirados; un término que, como dijo Maurice Denis, "hacía de nosotros una suerte de iniciados, una sociedad secreta de apariencia mística". Se reunían en el estudio de Ranson o en la redacción de la "Revue Blanche". Desde 1890 a 1900, año en que su coexión comenzó a resquebrajarse, expusieron en el Salon des Indépendants, donde suscitaron polémicas y controversias, en el Salon de l'art nouveau (del que se consideraban precursores) y en otras muestras.

■ Paul Ranson, *Paisaje nabi*, 1890, Lausana, colección Josefowitz. Cazalis había dado sobrenombres a los otros nabis: Ranson, por ejemplo, era el "nabi japonard".

■ Paul Sérusier, *Melancolía, c.* 1890, París, colección Boutaric. Además de los sobrenombres, Sérusier era el "nabi de la barba rutilante", en las reuniones se usaba una jerga esotérica.

■ Aristide Maillol, *Mujer con echarpe*, 1919-20, colección particular. Estas esculturas de gusto clásico inspiraron a Matisse.

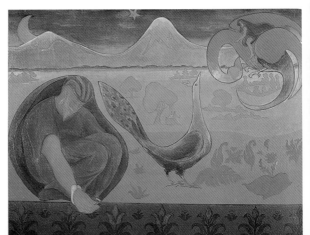

■ Pierre Bonnard, *La muchacha y el gato*, 1906, colección particular. Su muestra personal de 1896 suscitó comentarios negativos de Pissarro y marcó la ruptura definitiva con los impresionistas.

■ Felix Vallotton, *Mujer escribiendo en un interior*, 1904, colección particular. Llamado "nabi extranjero" por ser suizo, Vallotton se unió al grupo en 1892 y alcanzó relevancia en las muestras organizadas por Vollard en 1897-98.

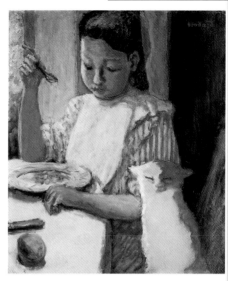

■ Edouard Vuillard, *Los hermanos Bernheim*, 1912, colección particular. Vuillard era el "nabi gouave" a causa de su larga barba, mientras Maurice Denis era el "nabi de las bellas imágenes".

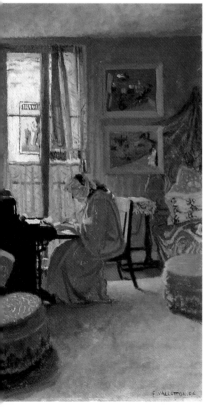

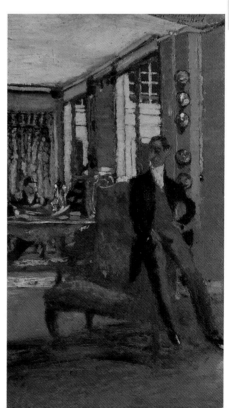

EL CONTEXTO HISTÓRICO Y ARTÍSTICO

Teha'amana

Poco después de su llegada a Mataïea, Gauguin exploró la costa oriental de Tahití, la más salvaje. Durante el viaje, un indígena del distrito de Fa'aone le invitó a su cabaña para que descansase. Le ofrecieron frutas del árbol del pan, plátanos salvajes y cangrejos de mar. Cuando le preguntaron que adónde se dirigía respondió cándidamente que iba a Hitia'a, el distrito más próximo, "para encontrar una mujer". La mujer del indígena le dijo: "si quieres, yo puedo procurarte una: mi hija". Probablemente pensaba que era uno de esos ricos y extravagantes europeos que buscaban lo exótico en aquellas islas. De ese modo, conoció a Teha'amana, una muchacha de trece años (él tenía 43). Fascinado por su belleza, Gauguin le pidió que fuese su mujer, siguiendo la fórmula tahitiana que probablemente le había enseñado Suzanne Bambridge. Como contó él mismo en *Noa Noa*: "La saludé. Ella sonrió y yo me senté a su lado. "¿No tienes miedo de mí?", pregunté. "No". ¿Quieres vivir para siempre en mi cabaña?" "Sí". "¿Has estado enferma alguna vez?" "No". Eso fue todo".

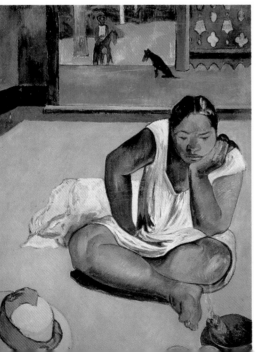

■ *La enfadada*, 1891, Worcester, Art Museum. Teha'amana, rebautizada como Tehura, fue su *vahiné*, su mujer y su modelo en algunos de sus cuadros más bellos, gracias a su capacidad expresiva poco común.

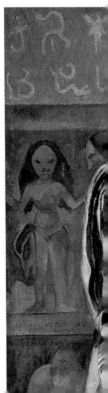

■ *Teha'amana tiene numerosos antepasados*, 1893, Chicago, Art Institute. La presencia tranquilizadora de la muchacha, la Eva primitiva de sus sueños, hizo de esos meses uno de los períodos más felices de su vida y uno de los momentos de mayor creatividad artística.

■ *Faaturuma, Melancólica*, 1891, Kansas City, Nelson-Atkins Museum of Art. El rostro absorto de Teha'amana y su postura reproducen a la perfección la imagen de una mujer melancólica y soñadora. La tonalidad morena de la piel contrasta con el rojo intenso del traje, que a su vez destaca sobre el fondo azul.

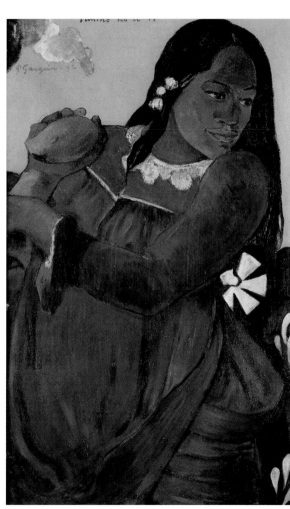

■ *Vahine no te vi, Mujer con mango*, 1892, Baltimore, Museum of Art. En la tradición tahitiana el mango es el símbolo de la fecundidad; aquí constituye un homenaje evidente a la inminente maternidad de Teha'amana.

¿Adónde vas?

Ea haere ia oe?, 1893, San Petersburgo, Ermitage. El título sugiere un diálogo silencioso entre las protagonistas y subraya una situación normal y cotidiana, que para Gauguin representa un modelo de vida primitiva y feliz.

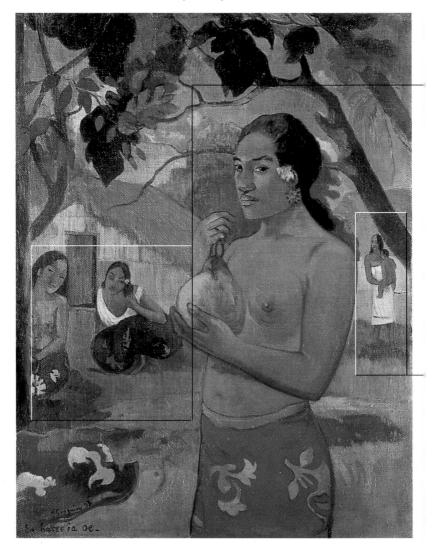

■ Gauguin solía repetir los personajes y la ambientación de sus pinturas, con leves modificaciones en las proporciones o en la distribución de la luz, en busca de la mejor solución o como un simple juego de reclamos alusivos. La mujer agachada es idéntica a la figura en primer término de la tela titulada *Cuando te cases* (a su vez inspirada en una de las *Mujeres de Argel* de Delacroix), con las únicas diferencias del pareo (azul en vez de rojo) y la ausencia de flores en el cabello.

■ En 1895 Strindberg, refiriéndose a estas pinturas, confesaba que no había conseguido comprenderlas y apreciarlas: "Ha creado usted una nueva tierra y un nuevo cielo, pero yo no me encuentro en el centro de su creación: es demasiado soleada para mí, que amo el claroscuro. Y en su paraíso habita una Eva que no es mi ideal".

■ En esta segunda versión del mismo título (*¿Adónde vas?*, 1892, Estocolmo, Staatsgalerie) el fondo permanece sin cambios, a excepción de la ausencia de la mujer con el niño. En cambio, la figura en primer plano, que aprieta contra el costado un cachorro y que será una de las fuentes de la cerámica *Oviri* (p. 104), es muy diferente.

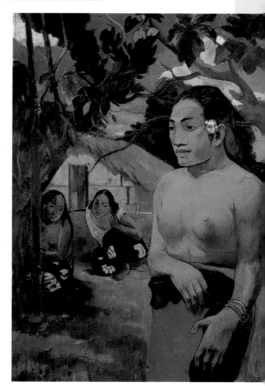

En el Pacífico después de Gauguin

■ Emil Nolde, *Indígena con niño*, Nueva Guinea, 1913-14, colección particular. Los dibujos y pinturas de ese período adquieren una nueva frescura e intensidad poética y testimonian la deuda del expresionismo con Gauguin.

La experiencia de Gauguin en Polinesia suscitó perplejidad e ironía en un primer momento, pero cuando sus obras fueron comprendidas no pocos artistas quisieron repetir su singladura, con la esperanza de tener éxito y hacer revivir aquellos mágicos ambientes. Por ejemplo, en 1913 Emil Nolde participó en la expedición antropológica de Külz-Leber a las islas del Pacífico, donde Alemania tenía un protectorado, con el fin de estudiar la vida de los indígenas y retratarlos en una serie de dibujos y pinturas. Gracias a ese viaje, adquirió una mejor sensibilidad en el uso del color, un mayor sentido decorativo y un vigor expresivo más marcado.

En abril de 1914 Hermann Max Pechstein, en compañía de su mujer, se trasladó a las islas Palau, junto a Nueva Guinea. En condiciones muy distintas de las que se encontró Gauguin, pudo estudiar el arte y la vida de los indígenas, realizando una serie de pinturas de extraordinaria vivacidad cromática y fuerza narrativa. Su estancia se vio interrumpida por el estallido de la Primera Guerra Mundial y la invasión de las islas por parte de los japoneses. Finalmente, del 27 de febrero al 31 de julio de 1930, Henri Matisse realizó un viaje a Tahití y a Tuamotu. De esa breve experiencia regresó con una gran cantidad de dibujos e impresiones.

■ Hermann Max Pechstein, *Ankunft en Palau*, 1917, colección particular. Esta pintura forma parte de una famosa serie que el artista realizó al regreso de su viaje a las islas Palau.

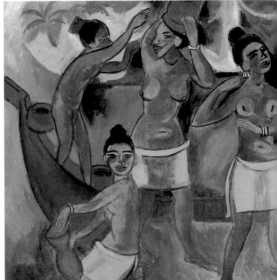

■ Emil Nolde, *Cabeza de indígena*, Nueva Guinea, 1913-14, colección particular. El dibujo es nítido y preciso en el trazo; la expresión severa del rostro está captada con espontánea inmediatez.

■ Henri Matisse, *Polinesia, el mar*, 1946, París, Musée National d'Art Moderne. En los últimos años Matisse se sirvió de la técnica de los *papiers découpés*; fue entonces cuando se acordó de los colores vivos e intensos de Tahití, que hizo revivir en dos grandes paneles, uno dedicado al cielo y el otro al mar. En una carta dirigida a su hijo escribió: "Metí la cabeza bajo el agua y vi paisajes maravillosos, corales de todos los colores y de todas las formas, visitados por unos peces de increíble variedad".

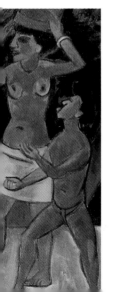

■ Henri Matisse, *Ventana en Tahití*, 1935-36. Niza, Musée Matisse. El artista retomó un tema que le resultaba muy querido, el de la ventana abierta sobre el mar, pero aquí lo interpretó con una nueva y más intensa luminosidad. El dibujo es aún más suelto y libre y exalta los valores decorativos, insertando toda la composición en un ambiente de sueño y de fábula.

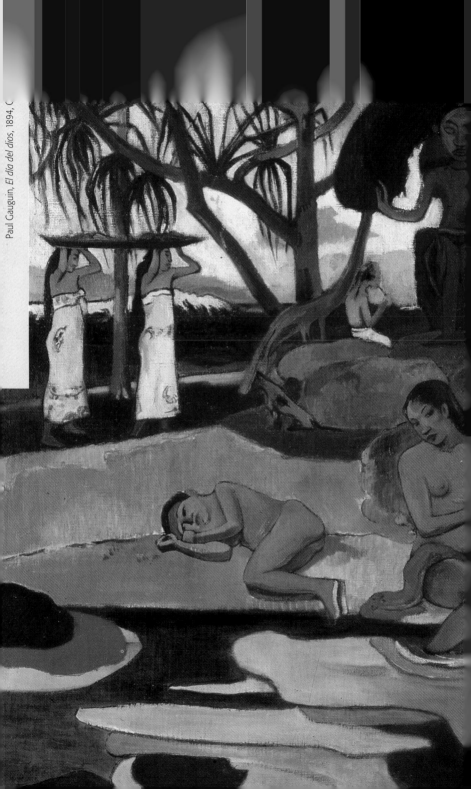

El regreso a París

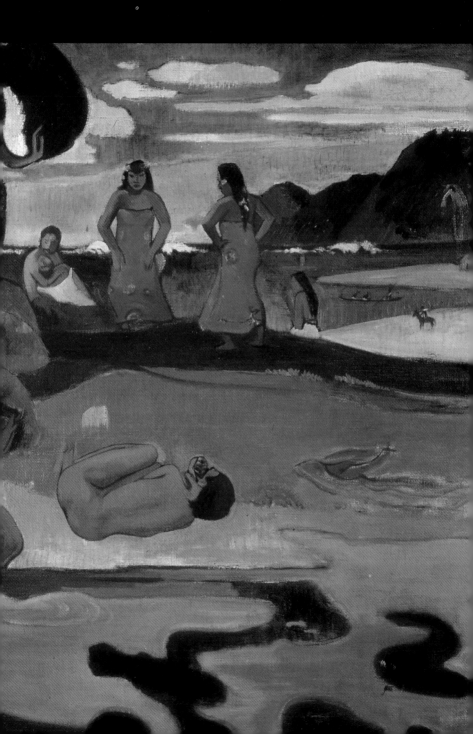

1893: la primera gran exposición

En abril de 1893, Gauguin partió de Tahití y tres meses más tarde llegó a Marsella, más pobre y enfermo que cuando partió. Gracias al dinero que le había enviado de Monfreid, alquiló un pequeño estudio en rue de la Grande Chaumière. Afortunadamente para él, la muerte de su tío Isidoro de Orleans le dejó una herencia de cerca de 9000 francos. Con esa cifra pudo acallar a los acreedores y tomar en alquiler un estudio más grande en rue Vercingétorix. Entre tanto, las relaciones con su mujer se habían enfriado aún más. Gauguin se sentía irritado porque ella había vendido varios cuadros suyos y de su colección sin pedirle permiso. Por su parte, a Mette le hubiera gustado gestionar personalmente el dinero que Gauguin había recibido en herencia. Los resentimientos mutuos prevalecieron sobre la voluntad de reunir a la familia, y ninguno de los dos tuvo la humildad de dar el primer paso. Gracias a las recomendaciones de Degas, que seguía admirando los cuadros de Paul, la galería Durand-Ruel organizó su primera gran muestra personal del 4 de noviembre al 1 de diciembre de 1893. Las 44 obras expuestas, seis bretonas y 38 tahitianas, además de dos esculturas, suscitaron una gran oposición. A pesar del entusiasmo de los jóvenes nabis y el juicio de Mallarmé, según el cual "es increíble que alguien consiga insertar tanto misterio en tanto esplendor", la mayor parte de la crítica y del público no comprendió su arte y permaneció insensible y escéptica.

■ Esta foto con gorro de astracán le sirvió para realizar el *Autorretrato con paleta*, dedicado a Charles Morice. La muestra de Durand-Ruel no tuvo el éxito esperado: sólo vendió once cuadros, seis de ellos de tema bretón.

■ *Noa-Noa* significa "fragante", apelativo tradicional de la isla de Tahití, y es el título de un libro editado en 1893 en el que Gauguin habla de su vida en Polinesia y de sus opiniones artísticas. El texto se acompaña de un gran número de grabados y de varias poesías de Charles Morice.

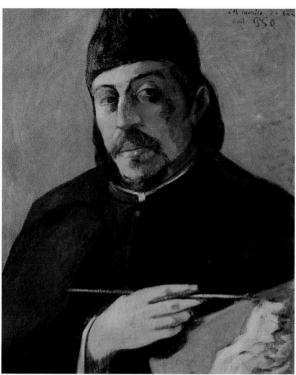

■ *Autorretrato con paleta*, 1893-95, colección particular. Gauguin emplea largos títulos en lengua maorí con el deseo de explicar e ilustrar la cultura de esas islas. En realidad, ese aspecto fue motivo de hilaridad y de escarnio por parte de un público ignorante y provinciano; por su parte, los críticos lo juzgaron excesivo y fastidioso.

■ *Nave Nave Moe, La fuente maravillosa*, 1894, San Petersburgo, Ermitage. El artista se había llevado consigo muchos apuntes y dibujos, de los que se sirvió para realizar en París algunas obras tahitianas. Los elementos de esta tela son los habituales: el mango, las tahitianas y, en el fondo, la danza ritual de la diosa Hina.

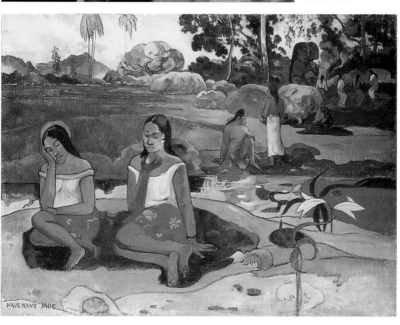

NAVE NAVE MOE

1893-1895

Autorretrato con sombrero

Este autorretrato (1893-94, París, Musée d'Orsay) está ambientado en el estudio de rue Vercingétorix, que Gauguin había pintado con fuertes tonos de verde y amarillo y había decorado con estatuas, objetos y tejidos tahitianos.

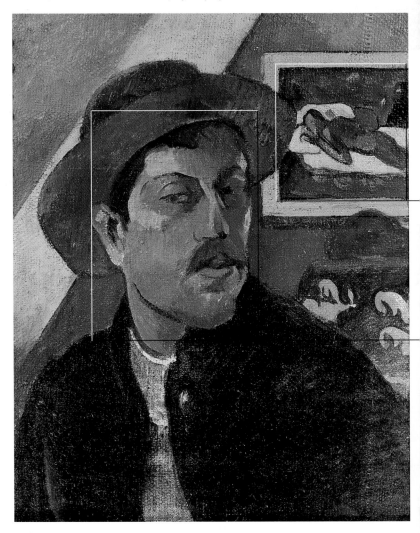

■ Gauguin en su estudio durante el invierno de 1893-94, ante *La enfadada*, un cuadro que apreciaba mucho, tanto por sus soluciones estilísticas, como por su eficaz interpretación del tema de la melancolía.

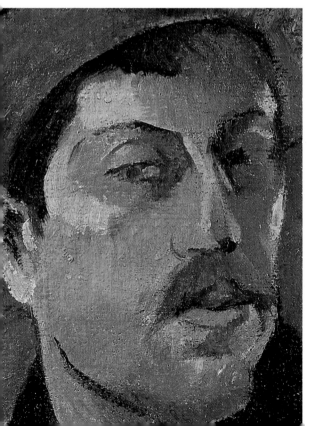

■ El artista usó como fondo la que consideraba como su obra más lograda de Tahití, *Manao tupapau*. La pintura está invertida porque, como era su costumbre, la ha reproducido mirándola en un espejo.

■ En los siglos anteriores el autorretrato era poco usado. Se difundió entre los artistas de finales del siglo XVIII, entre ellos David, Ingres y Delacroix, al tiempo que se multiplicaba en literatura la aparición de diarios y autobiografías. Para Gauguin se convirtió en una verdadera obsesión, en un modo de reflejarse, de mirar en su propia alma en busca de una identidad espiritual.

Francia a finales del siglo XIX

■ Marevna Vorobieff Rosanovitch, *Homenaje a los amigos de Montparnasse*, 1918, Ginebra, Musée du Petit Palais. Montparnasse era el corazón de París, fragua de ideas y de gran arte.

■ Toulouse-Lautrec, *Jane Avril danzando*, 1892, París, Musée d'Orsay. Este artista fue el cantor del París de las salas de baile y los teatros. En sus obras celebró las luces y las lentejuelas, pero también la tristeza y las miserias.

■ Emile Zola, retratado aquí por Edouard Manet en 1868 (París, Musée d'Orsay) fue el máximo representante de la novela naturalista, en particular con su serie *Rougon Macquart*.

Los últimos diez años del siglo XIX en Francia se caracterizaron por el predominio de elementos moderados en el gobierno de la Tercera República. La lucha anticlerical, emprendida en los años anteriores, se atenuó como consecuencia de una encíclica de León XIII de 1892, que invitaba a los católicos a participar lealmente en la vida del Estado. A pesar de estar divididos en varios grupos, los movimientos obreros y socialistas se desarrollaron y aumentaron su peso político, hasta el punto de que en 1893 llevaron a la Cámara a cincuenta diputados. En política exterior, Francia prosiguió con éxito su expansión colonial en Indochina y Madagascar. No obstante, en África tuvo que limitar sus intervenciones, ya que la fuerza inglesa era superior, como testimonia el incidente de 1899 en Fascioda, Sudán. El gobierno de los moderados se vio debilitado por el escándalo de Panamá (1893), que sacó a la luz la corrupción de no pocos funcionarios; mayor credibilidad perdió aún con el asunto Dreyfuss, el oficial judío condenado a cadena perpetua en 1894 por espionaje, que posteriormente fue rehabilitado, tras una encendida defensa por parte de la prensa y numerosos intelectuales, entre ellos Zola. En 1899, radicales, republicanos y socialistas crearon el llamado bloque de izquierdas, que llevó al gobierno a los ministros Waldeck-Rousseau y Emilio Combes. No obstante, a pesar de una creciente prosperidad económica, el país atravesó un período tenso y tormentoso. Las tensiones no se aplacaron, las relaciones con los católicos empeoraron y las reivindicaciones sindicales aumentaron.

■ Una ilustración de época del *clochard* parisino, "celebrado" por poetas y cantantes. Como sabía bien Gauguin, la capital francesa ofrecía muchísimas oportunidades a los pudientes, pero era cruel y despiadada, "un verdadero desierto para el pobre".

■ El primer aparato de toma y proyección cinematográfica fue creado en 1895 por los hermanos Lumière, Louis Jean y Auguste. El sueño de un arte que representase la realidad en movimiento se había cumplido.

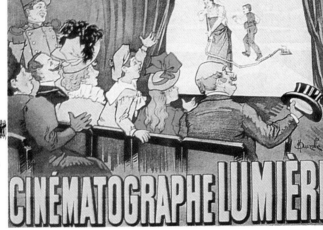

Los Clochards

Las luces del gran mundo, los teatros y los lujosos salones parisinos no deben hacernos olvidar otra realidad, la de los *clochards*. Según el artículo 270 del Código Penal francés se consideraba *clochards* a los vagabundos que no ejercían un oficio, no tenían domicilio fijo ni medios de subsistencia, o bien aquellos que caminaban *à cloche-pied*. A finales de siglo, los bajos fondos de la Ville Lumière estaban poblados por una multitud de pobres y marginados, llegados de cualquier parte de Francia y también de las naciones vecinas, atraídos por las promesas de la gran ciudad. Su vida errabunda y precaria ha sido descrita por pintores, ilustradores y dibujantes, como Toulouse-Lautrec o Bernard, por escritores como Balzac, Hugo o Zola, e incluso por el famoso *chansonnier* Bruant.

1894: El taller de Montparnasse

Cuando regresó a París, Gauguin quería por todos los medios sorprender con una actitud y un traje excéntricos y desenvueltos; con cierta ingenuidad, esperaba atraer la atención tanto sobre su persona como sobre su pintura, pero lo único que consiguió fue alejar a los pocos coleccionistas que se habían interesado por su pintura. En diciembre de 1893 el marchante Vollard le presentó a Annah, una mestiza javanesa de trece años que se convirtió en su amante. El pintor había transformado su taller en un lugar exótico, en un pequeño rincón de los mares del Sur, decorado con pinturas, fotografías, trofeos, armas, esculturas en madera, tejidos y otros objetos polinesios. En la puerta de entrada había colocado una inscripción provocativa, *Te fararu* (Aquí se ama), acompañada de una serie de pinturas claramente eróticas. La presencia ambigua y audaz de Annah, unida a la oscuridad de los términos maoríes utilizados por él, fueron fuente de equívocos y de crueles habladurías, hasta el punto que los encuentros semanales de los jueves con sus invitados habituales, pintores e intelectuales, fueron juzgados por los bien pensantes como indecorosas orgías.

■ Algunos de los invitados que animaban las veladas que Gauguin organizaba en su taller. En el centro está el violonchelista Fritz Schneklud y a su lado el músico Larrivel; detrás, Sérusier, Annah y el escultor George Lacombe.

■ *Campesinas bretonas*, 1894, París, Musée d'Orsay. Cuando regresó a Pont-Aven y retomó los temas bretones, su estilo y su poética habían cambiado ya definitivamente.

■ Annah, aquí fotografiada por Alphonse Mucha, había llegado a París como criada de la cantante Nina Pack, que le había dado el nombre de Anna Martin.

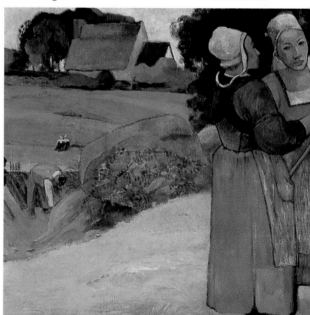

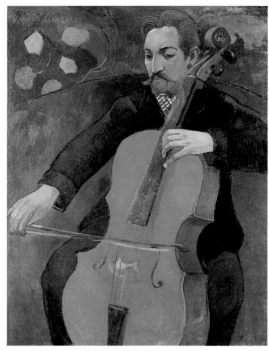

■ *Upapa Schneklud, El violonchelista*, 1894, Baltimore, Museum of Art. Para realizar este retrato del músico sueco Schneklud, Gauguin se inspiró en el *Autorretrato con violonchelo* de Courbet, que había pertenecido a la colección Arosa y del que poseía una fotografía.

■ *Arearea no varua ino, Bajo el poder del diablo*, 1894, Copenhague, Ny Carlsberg Glyptotek. Esta tela constituye una variación más sobre el tema de las tahitianas. Fue realizada durante su estancia en Bretaña, como testimonia la dedicatoria a Madame Gloanec.

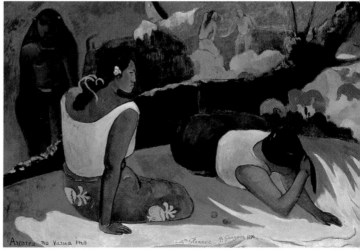

Annah la javanesa

Gauguin da a este retrato (1893-94, colección particular) un título simbolista en tahitiano, *Aita tamari vahine Judith te parari* (*La mujer niña Judith todavía no ha sido desvirgada*), con referencia a la hijastra de su amigo Molard.

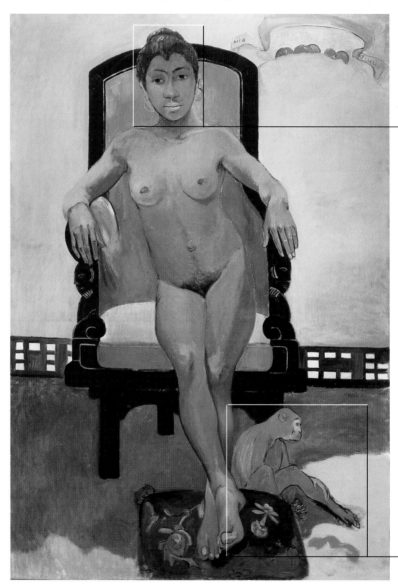

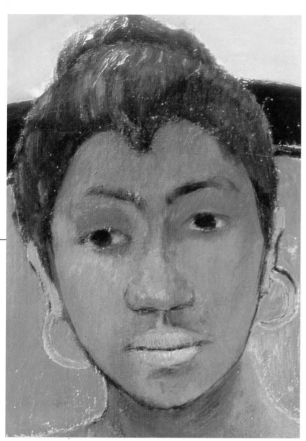

■ El rostro de la muchacha ha sido esbozado con extrema delicadeza. Como en otro retratos tahitianos, la protagonista no enfrenta directamente al espectador, sino que dirige la mirada levemente a la izquierda, lo que la hace aún más enigmática y misteriosa.

■ Guido Cagnacci, *Cleopatra*, Milán, colección particular. Los desnudos de Gauguin remiten a veces a la sensualidad melancólica de la pintura del siglo XVII, aunque el drama interior no es representado de manera tan teatral.

■ Para asombrar aún más a los parisinos, Gauguin solía pasear con Annah, que llevaba de una correa al mono amaestrado Taoa o portaba un papagayo sobre el brazo.

Vuillard y Vallotton

Edouard Vuillard se unió a los nabis en 1890 y se convirtió en uno de sus mayores representantes. Desde el comienzo de su carrera había realizado sugerentes retratos de sus amigos y parientes, en un marco de íntima quietud doméstica, como por ejemplo *Marie penchée sur son ouvrage* (colección particular), pintado en torno a 1891, fecha en que retrata a su hermana Maria, que más tarde se casará con otro pintor nabi, Ker Xavier Roussel. Su estilo, sensible en las elecciones cromáticas y refinado en el dibujo, se distinguió tanto en pequeños interiores como en paneles decorativos de grandes dimensiones. Félix Vallotton abandonó Lausana, su ciudad natal, en 1882, para inscribirse en la Académie Julian. Durante algunos años trabajó en el Louvre como copista, desarrollando su predisposición por el dibujo. Más tarde se adhirió al grupo de los nabis; a pesar de que no adoptó su simbolismo, llegó a un nuevo y más despreocupado uso de los colores, aunque se dedicó a temas que mostraban su habilidad decorativa.

■ Edouard Vuillard, *Autorretrato*, 1889-90, colección particular. Entre 1888 y 1890 estudió la pintura antigua en el Louvre; para ello realizó numerosos autorretratos, en los que experimentó con diversas soluciones estilísticas y técnicas y varias disposiciones de sombras y de matices, casi siempre en una misma tonalidad de color.

■ Félix Vallotton, *Naturaleza muerta con flores*, 1913, colección particular. Sus naturalezas muertas con flores son las más fieles a las teorías nabis y a la lección de Gauguin. La superficie de la pintura carece casi por completo de profundidad y está dominada por la armonía interior de colores vivos e intensos, combinados de manera innovadora.

■ Félix Vallotton, *Ramo de flores y limón*, 1924, colección particular. Admirador de Cézanne, inspiró a su vez las naturalezas muertas de Henri Matisse.

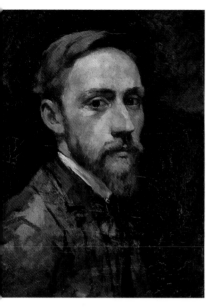

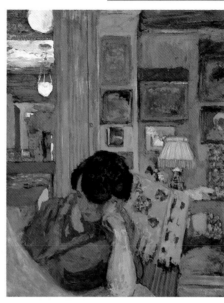

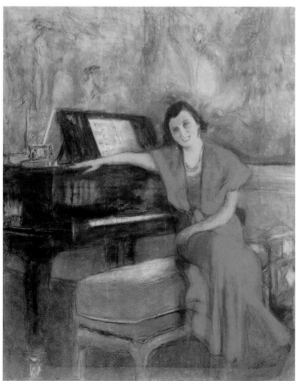

■ Edouard Vuillard, *Retrato de Lucie Hessel*, 1915 aprox., colección particular. En 1900 Vuillard había conocido, por mediación de su marchante Bernheim-Jeune, a Jos Hessel, un conocido comerciante de arte. El artista estableció un fuerte vínculo de amistad con la mujer de éste, Lucie, que se convirtió en su confidente y en su musa inspiradora.

■ Edouard Vuillard, *Joven al piano*, 1934, colección particular. En este retrato, de una aguda introspección psicológica, Vuillard no se ha interesado en los objetos, que para él sólo eran un instrumento para dar voz al carácter y a la personalidad de la persona representada.

1894-1895: adiós a Europa

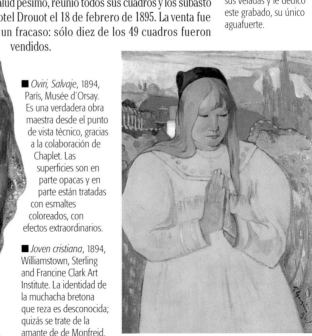

En la primavera de 1894, después de un breve viaje a Bruselas, Gauguin regresó a Bretaña en compañía de Annah. Marie Henry había cedido la posada de Le Pouldu y se había quedado con los cuadros del artista, como pago por sus deudas. Gauguin trató de recuperarlos, pero perdió el proceso. Marie Gloanec también había cerrado su pensión y había abierto una más pequeña, L´Ajoncs d´or, donde el artista encontró alojamiento. Trató de recuperar su papel de líder de los pintores de la escuela de Pont-Aven, pero estos ya habían tomado su propio camino y se mostraban menos interesados en sus lecciones. Además, las gentes del lugar no toleraban la presencia de su excéntrica amante; la tensión desembocó en una pelea, en la que Gauguin se fracturó un tobillo. Annah volvió a París, con la excusa de preparar su regreso, pero en realidad huyó de él, después de despojar la casa de todos sus objetos de valor. Desilusionado, amargado y en un estado de salud pésimo, reunió todos sus cuadros y los subastó en el Hotel Drouot el 18 de febrero de 1895. La venta fue un fracaso: sólo diez de los 49 cuadros fueron vendidos.

■ *Retrato de Stéphane Mallarmé*, 1891, París, Bibliothèque Nationale. Gauguin admiraba a Mallarmé; frecuentaba sus veladas y le dedicó este grabado, su único aguafuerte.

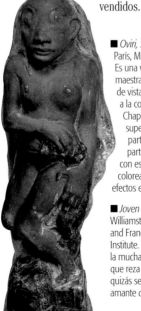

■ *Oviri, Salvaje*, 1894, París, Musée d´Orsay. Es una verdadera obra maestra desde el punto de vista técnico, gracias a la colaboración de Chaplet. Las superficies son en parte opacas y en parte están tratadas con esmaltes coloreados, con efectos extraordinarios.

■ *Joven cristiana*, 1894, Williamstown, Sterling and Francine Clark Art Institute. La identidad de la muchacha bretona que reza es desconocida; quizás se trate de la amante de de Monfreid.

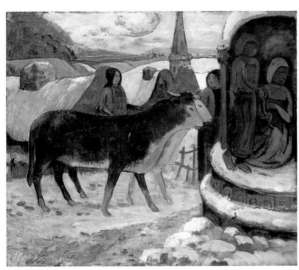

■ *París bajo la nieve*, 1894, Amsterdam, Van Gogh Museum. Realizado después del viaje a Bélgica, retoma el estilo impresionista y nos muestra los tejados de Montparnasse, desde la ventana de su taller.

■ *Noche de Navidad*, c. 1894, Lausana, colección Josefowitz. Gauguin pintó este cuadro en Bretaña y lo llevó consigo a Tahití junto al *Pueblo bajo la nieve*, o quizás lo realizó de memoria después de su partida de Francia.

El rechazo de Strindberg

En vísperas de la venta organizada en el Hotel Drouot, Gauguin le pidió a Auguste Strindberg, que había frecuentado su taller, que le escribiera el prefacio del catálogo. El dramaturgo sueco se negó; admitió que sentía la fascinación de su arte, pero al mismo tiempo se declaró "incapaz de comprenderlo y de amarlo". A pesar de ello, Gauguin publicó la carta de Strindberg, acompañándola de una respuesta en la que reconocía "la enorme distancia que media entre vuestra civilización y mi barbarie. Una civilización que os pesa; una barbarie que para mí es la vida".

105

El molino David en Pont-Aven

Tras regresar a Pont-Aven, Gauguin volvió a pintar sus clásicos paisajes bretones, como éste (1894, París, Musée d´Orsay); el uso de los colores recuerda las pinturas realizadas con Van Gogh en Arles, filtradas por la experiencia polinesia.

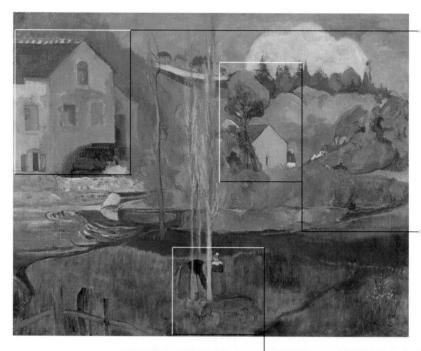

■ El perro en primer plano es muy similar al que pintó en *Arearea* (pp. 74-75); del mismo modo, las dos figuras se parecen muy poco a las que poblaban los anteriores cuadros bretones y están más próximas a las tahitianas. Gauguin lamentó que la gente hubiera cambiado; en realidad, era él el que había sido transformado por la experiencia polinesia y el que veía a las personas con otros ojos.

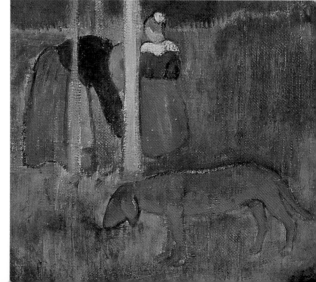

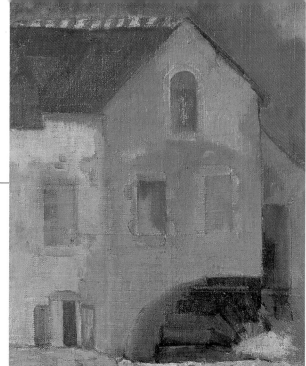

1893-1895

■ En su última estancia en Bretaña, Gauguin pintó pocas obras, aunque todas de notable importancia. Como recordó Maurice Denis, su lección principal fue un nuevo y más libre uso de los colores. A Sérusier le había dicho: "¿Cómo ves ese árbol? ¿Acaso no es verde? Usa, por tanto, el verde, el verde más bello de tu paleta. ¿Y esta sombra no es azul? No tengas miedo, entonces, de pintarla lo más azul que puedas".

■ Aunque con el paso de los años su estilo pictórico había tomado un camino muy diferente, Gauguin había conservado el recuerdo de las lecciones y las enseñanzas de Pissarro, en particular la común sensibilidad por la naturaleza. En su mente la vegetación de Tahití se fundió con la de Bretaña. De ese modo, dio vida a un nuevo paisaje, en el que la magia de la luz y de los colores proyectaba al espectador a una atmósfera digna de un paraíso terrenal, puro e incontaminado.

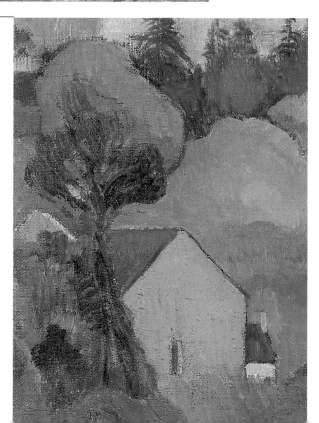

Denis, Bonnard y Maillol

M aurice Denis fue el principal teórico del grupo de los nabis, al que aproximó a temáticas simbolistas, sobre todo cuando fundó con George Desvallières los *Ateliers d´art Sacré* y profundizó en su producción de pinturas de tema religioso. Pintor y grabador, dotado de una sólida técnica, se dedicó también a las artes aplicadas, dibujando y proyectando vidrieras, jarrones, tapices, paneles decorativos, abanicos e incluso un billete de banco de 500 francos. Pierre Bonnard estudió leyes, pero pronto se unió al grupo de los nabis. Alcanzó una cierta notoriedad con sus obras gráficas, litografías, carteles, cubiertas (son famosas las que realizó para la revista "Revue Blanche") e ilustraciones para libros. En sus pinturas prefirió representar paisajes y escenas domésticas, inspiradas en el estilo delicado de las estampas japonesas. Sus obras poseen tanta gracia y armonía, que ha sido señalado como uno de los mayores inspiradores del art nouveau. Aristide Maillol, fascinado con los modelos de Rodin, estudió pintura y escultura en la Ecole des Beaux-Arts. En 1893 abrió un taller en Banylus, donde se especializó en la técnica de los tapices, en los que representó numerosos temas de Gauguin, Denis y otros nabis. En los primeros decenios del siglo XX se dedicó a la escultura, fascinado por el arte egipcio e indio y sugestionado por el arte clásico, que pudo admirar durante un viaje a Italia y Grecia; también influyó en él su amistad con Matisse.

■ Aristide Maillol, *Estudio para el monumento a Paul Cézanne*, 1914, colección particular. En 1910 Maillol proyectó un monumento a Zola, pero no lo llevó a término. Poco después le fue encargado un monumento conmemorativo a Cézanne, en el que trabajó doce años.

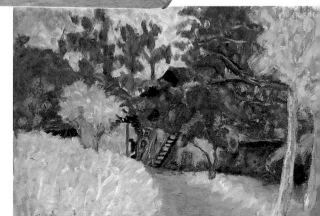

■ Pierre Bonnard, *Granja en Delfinado*, 1918, colección particular. Desde 1892 hasta su matrimonio, celebrado en 1925, Bonnard pasó varios meses al año en la residencia de su familia en Grand-Lemps, en Delfinado.

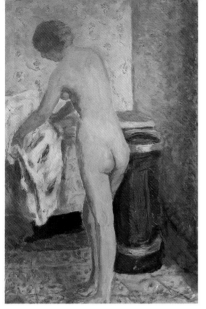

■ Pierre Bonnard, *Mujer lavándose*, 1924, colección particular. Forma parte de una serie de estudios de desnudos, realizados entre 1923 y 1925 para las litografías editadas por Frappier.

■ Maurice Denis, *Retrato de Yvonne Lerolle en tres posturas*, 1897, Toulouse, colección Olivier Rouart. En este triple retrato, que tiene la gracia y la impalpable ligereza de las apariciones, se advierte la proximidad con los modelos de la pintura prerrafaelista, en particular con Dante Gabriel Rossetti.

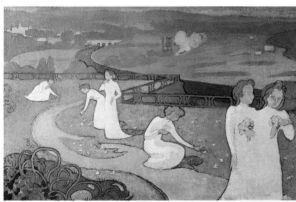

■ Maurice Denis, *Abril*, 1892, Otterloo, Kröller-Müller Museum. Esta pintura formaba parte de un tríptico de alegorías de las estaciones, interpretadas como edades de la vida y dominadas por una serena y festiva alegría de vivir.

■ Aristide Maillol, *Perfil de joven mujer*, 1894-96, Perpiñán, Musée Hyacinthe Rigaud. Esta pequeña escena simbolista ha sido realizada con tonos delicados y leves, que recuerdan la aguda sensibilidad formal de las creaciones de Emile Gallé.

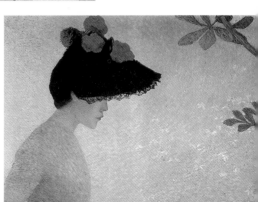

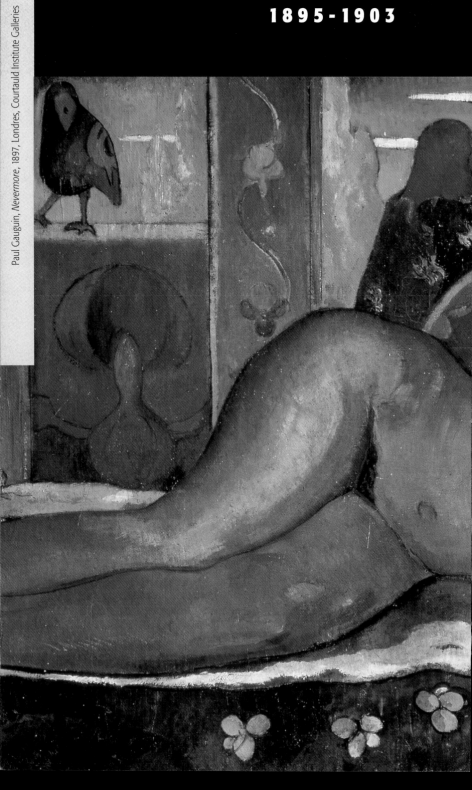

Paul Gauguin, *Nevermore*, 1897, Londres, Courtauld Institute Galleries

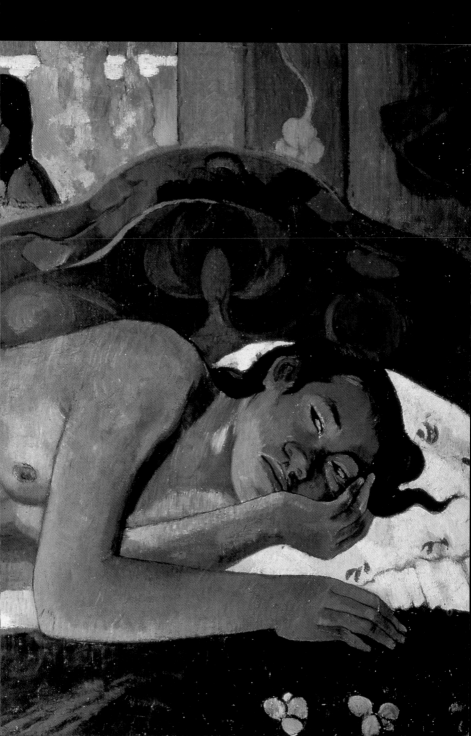

1895-1897: Tahití

El 28 de junio de 1895 Gauguin salió de París y el 3 de julio se embarcó en Marsella rumbo al Océano Pacífico. Había dejado parte de sus pinturas a Auguste Bauchy y a Georges Chaudet, mientras Charles Morice quedó encargado de sus escritos. Más tarde confió otras obras suyas a Daniel de Monfreid y a Ambroise Vollard, con los que entabló una densa relación epistolar; ambos se convirtieron en su único vínculo con Francia. El viaje duró dos meses, con sólo dos escalas, una en Port Said y otra en Auckland, Nueva Zelanda, donde pudo estudiar las colecciones de arte maorí del Museo de Etnología. En septiembre llegó a Tahití: tenía 47 años, poco dinero en el bolsillo y estaba enfermo. A las consecuencias de la fractura del tobillo, los problemas cardíacos, las erupciones cutáneas y el abuso del alcohol, se sumó la sífilis, contraída en un encuentro ocasional con una prostituta; de hecho, tuvo que defenderse de la acusación de tener la lepra. Sus últimos ocho años de vida, a pesar de sus numerosas estancias en el hospital (al menos seis), se caracterizaron por una intensa creatividad.

■ Gauguin se construyó una cabaña de bambú con tejado de paja en Punaauia, en la parte occidental de la isla, y la decoró con sus esculturas. En un primer momento, se llevó consigo a Teha'amana, con la que después se casó. Más tarde el artista alojó como compañera y modelo a una nueva *vahinè*, Pahura, de catorce años, con la que tuvo una hija que murió poco después.

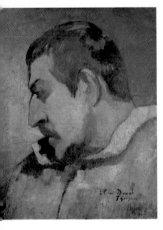

■ *Autorretrato*, 1897, París, Musée d'Orsay. En el invierno de 1897, Aline, su hija predilecta, a la que había dedicado el libro *Cahier pour Aline*, murió de pulmonía con sólo 20 años. La noticia le provocó una profunda crisis depresiva; de hecho, en febrero de 1898 trató de suicidarse ingiriendo arsénico.

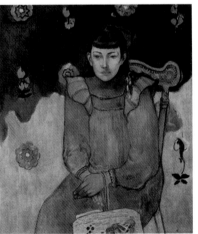

■ *Retrato de Jeanne Goupil*, 1896, Copenhague, colección Ordrupgaard. Es uno de los pocos retratos que le encargaron los colonos franceses de Tahití. Se trata de Jeanne, llamada en tahitiano *Vaïte*, la hija menor de un rico notario que vivía en los alrededores de Papeete.

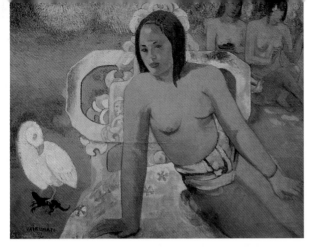

■ *Vaïraumati*, 1897, París, Musée d'Orsay. La pintura se inspira en el mito del origen de la estirpe de los Areois, una de las más importantes de Tahití, de la que habla en su escrito *Ancien Culte Mahorie*. Esa estirpe habría nacido del dios Horo y de Vaïraumati, una muchacha de la isla de Bora Bora de excepcional belleza. Las dos figuras del fondo reproducen los frisos de Borobudur.

■ *¿Por qué estás enfadada?*, 1896, Chicago, Art Institute. El paisaje y la gran cabaña del fondo son los mismos de la pintura de 1891, *El gran árbol*. No obstante, hay notables diferencias en el uso de los colores y de la luz. Además, en esta tela los personajes tienen una mayor importancia respecto al paisaje. El título ha sido interpretado de diversas maneras por los críticos. En las obras de ese período el artista quiso representar diferentes estados de ánimo, expresándose con claves de lectura diversas y a menudo oscuras.

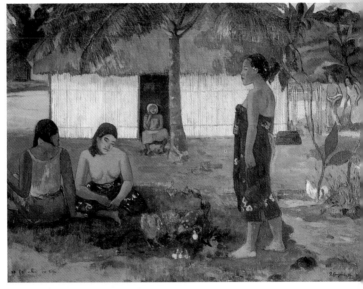

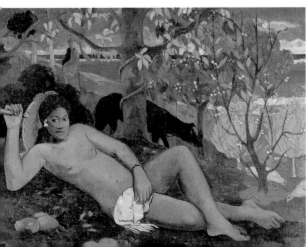

■ *La mujer del rey*, 1896, Moscú, Museo Pushkin. El artista describe esta pintura en una carta a de Monfreid. La postura de la mujer es muy similar a la de la *Diana en reposo* de Cranach, de la que Gauguin poseía una fotografía. También recuerda a la *Olympia* de Manet, por lo que fue rebautizada como la *Olympia* negra.

113

No hacen nada

También en esta pintura, *Eiaha ohipa* (1896, Moscú, Museo Pushkin), las dos tahitianas, retratadas en el interior de una cabaña, tienen la misma postura que las dos figuras del templo de Borobudur, del que Gauguin poseía una fotografía.

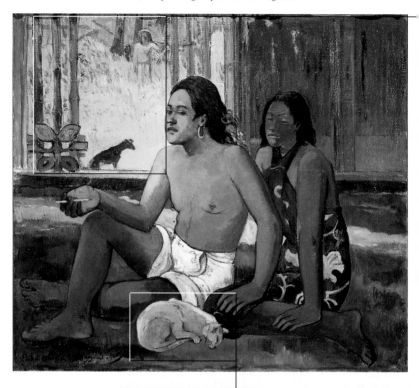

■ Como ya había hecho con el perro que aparece en primer plano en *Arearea* (p. 75), Gauguin pinta con una sorprendente naturalidad este gato dormido. Su postura relajada contribuye a dar una sensación de tranquilidad, reflejando el estado de ánimo del artista, en uno de sus raros momentos de paz interior.

■ El paisaje, una especie de "cuadro dentro del cuadro", ofrece a Gauguin la posibilidad de contraponer a la penumbra del interior los colores y la luz intensa del exterior. Los árboles subrayan la división y el ritmo vertical de toda la composición, animada por la silueta oscura del perro, que se recorta contra el amarillo tenue de la maleza. Del fondo emerge una tercera figura, cuyo papel, como sucede a menudo en los cuadros de Gauguin, no es del todo claro: quizás es el propio artista, o quizás un personaje de uno de sus sueños.

■ El tema de las dos figuras en un interior, abierto sobre un paisaje, reaparece en una pintura de 1897 titulada *Te rerioa, El sueño* (Londres, Courtauld Institute Galleries). En este caso Gauguin ha añadido en el interior de la casa un friso con complejas y misteriosas representaciones. Además, la postura de los dos personajes es más ambigua y alusiva, y la presencia del niño dormido en la cuna, esculpida con motivos antropomorfos, plantea no pocos interrogantes.

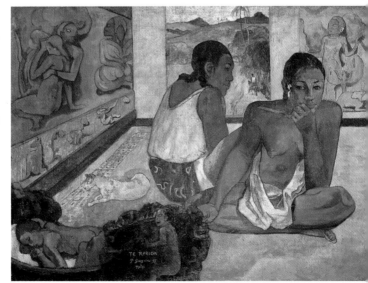

1898-1900: Papeete

La venta de los cuadros de Gauguin en Francia avanzaba a un ritmo muy lento. Paul, para mantenerse, decidió trabajar como escribiente en la oficina catastral de Papeete, donde pintaba planos y copiaba documentos por la mísera paga de seis francos al día, que el artista necesitaba para pagar su tratamiento médico. También se ocupó del periodismo, entablando una batalla personal contra las autoridades locales civiles y religiosas que sólo le reportó una gran hostilidad. Además, escribió un panfleto titulado *El espíritu moderno y el Catolicismo*, en el que acusaba a la Iglesia contemporánea de haber perdido el auténtico espíritu evangélico. En 1899, tras salir nuevamente del hospital y aplacar a los acreedores con el dinero recibido de París, dejó Papeete y regresó a su cabaña, donde Pahura dio a luz a Emile. Allí el artista volvió a pintar con renovado vigor: sus últimos cuadros alcanzaron un perfecto equilibrio entre la disposición de los colores, la sencillez del planteamiento y los significados simbólicos y alegóricos.

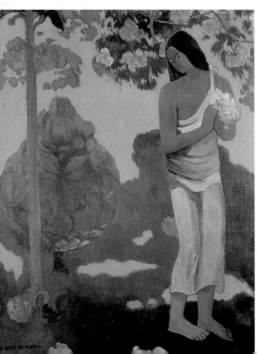

■ *Te avae no Maria, El mes de María*, 1899, San Petersburgo, Ermitage. La composición es repetida de manera casi idéntica, con el añadido de otras dos mujeres y una calavera, en *Ruperupe, Recogiendo un fruto*, de ese mismo año.

■ *Dos tahitianas*, 1899, Nueva York, The Metropolitan Museum of Art. En esta pintura no se advierte un espíritu salvaje y primitivo: las imágenes están compuestas de manera clásica, con un ritmo más sosegado y mesurado.

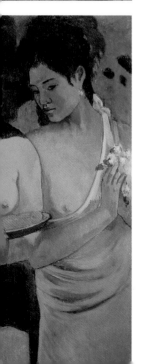

■ *El caballo blanco*, 1898, París, Musée d'Orsay. El destinatario de la pintura, un farmacéutico, lo rechazó, ya que el caballo era verde. Gauguin se lo mandó a de Monfreid, que lo vendió al Musée du Luxembourg.

■ *Te pape nave nave, El agua deliciosa*, 1898, Washington, National Gallery of Art. El artista no quería construir ambientes naturales; por eso modificaba claramente los colores, para darles un valor simbólico.

■ *Te atua, El dios*, esta xilografía, realizada entre 1898 y 1899, forma parte de la "Suite Vollard".

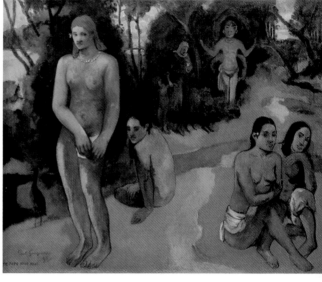

Gauguin periodista

Hijo de un periodista, Gauguin ya había dado pruebas de su espíritu combativo en Francia. En un artículo publicado en el "Moderniste Illustré" del 21 de septiembre de 1889, había criticado los sistemas de adquisición de obras de arte por parte de los funcionarios del Estado. En los últimos años pasados en Polinesia fue colaborador y redactor jefe del polémico periódico "Les Guêpes" (Las avispas), que dejó cuando fundó un periódico satírico "Le Sourire" (La sonrisa), en el que escribía artículos polémicos e impulsivos acompañados de ilustraciones.

117

¿De dónde venimos? ¿Quiénes somos? ¿Adónde vamos?

Este gran cuadro (1897-98, Boston, Museum of Art) mide 139,1 X 347,6 centímetros y es considerado su testamento artístico y espiritual, una síntesis de los temas de su pintura y de su visión del mundo.

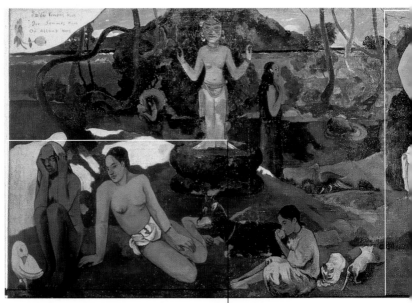

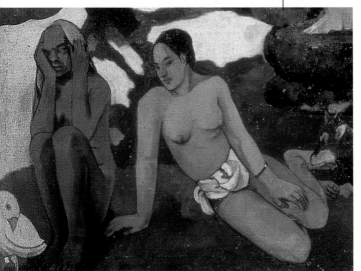

■ La primera idea de la composición fue un dibujo en una carta escrita a de Monfreid en febrero de 1898. Después, antes de afrontar la pintura, realizó varios dibujos. Trabajó día y noche, febrilmente, durante más de un mes. En julio mandó el cuadro a París. La pintura, expuesta por Vollard, impresionó a los críticos por las soluciones estilísticas y el profundo simbolismo. No obstante, el resultado económico fue discreto: de ésta y otras ocho obras sólo obtuvo mil francos.

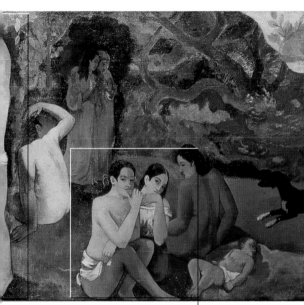

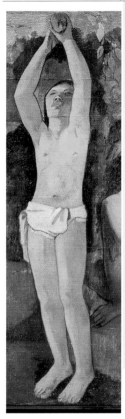

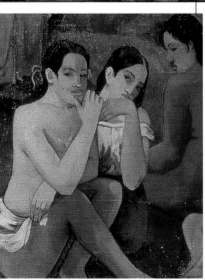

■ Desde su primera aparición, ha sido objeto de estudios e innumerables interpretaciones por parte de los críticos: se trata de una metáfora de las edades del hombre, desde la infancia a la vejez, así como de una meditación sobre el sentido de la vida, de una comparación entre la naturaleza y la razón, representada por las dos mujeres en actitud pensativa.

■ Las figuras están dispuestas en el paisaje con un esquema que recuerda los frisos antiguos, los grandes ciclos de frescos de los palacios renacentistas y el *Bosque Sagrado* de Puvis de Chavannes. Son las mismas de pinturas precedentes, pero Gauguin les ha conferido un significado diferente. La presencia del ídolo azul y de los animales ha merecido diversas interpretaciones; en particular, "el extraño pájaro blanco con una lagartija entre las patas, significa la vanidad de las palabras".

EL CONTEXTO HISTÓRICO Y ARTÍSTICO

En busca del arte primitivo

■ Pablo Picasso en su estudio de la villa "La Californie" en Cannes (*c.* 1960, foto de Edward Quinr). El artista sostiene una creación suya, mientras a la derecha se entrevé una figura en bronce de la cultura Rurutu (Oceanía), uno de los muchos ejemplares de su rica colección de arte primitivo.

Hasta la primera mitad del siglo XIX, los puntos de referencia irrenunciables para todo aquel que quería dedicarse a la pintura eran los clásicos, griegos y latinos, o los maestros del Renacimiento italiano. La perspectiva, la simetría, la armonía y la supremacía del dibujo sobre el color eran algunos de los dogmas que, hasta entonces, nadie había puesto en discusión. Las pinturas que Gauguin realizó en Polinesia abrieron nuevos horizontes y propusieron una estética diferente. Mientras Europa se aprestaba a vivir un increíble desarrollo científico, tecnológico e industrial, los artistas regresaban a las raíces de la civilización, a las formas expresivas de los primitivos, de los llamados salvajes. Esa recuperación se concretó en el abandono del espacio tridimensional en favor de los valores decorativos y expresivos, en una simplificación del dibujo, que fue total en la pintura abstracta, y en el uso libre de los colores y de los ritmos. En particular, después de la invención de la máquina fotográfica y del cinematógrafo, quedó claro que la pintura había perdido definitivamente el papel de espejo de la realidad y que debía buscar una nueva identidad. Por ese motivo, algunos pintores trataron de recuperar en el arte de las civilizaciones extraeuropeas las raíces de la espiritualidad humana no contaminada por el progreso, los mitos, los símbolos y la función ritual del arte.

■ Paul Klee, *Picture Album*, 1937, Washington, The Phillis Collection. Desde sus primeros contactos con el Blaue Reiter, Klee se interesó por las expresiones artísticas de los niños y de las poblaciones primitivas, pues en su opinión eran las únicas que podían brotar directamente de lo más hondo del alma, sin ninguna mediación racional.

■ Constantin Brancusi, *Pequeña francesa*, 1914-18, Nueva York, The Salomon Guggenheim Museum. Forma parte de una serie de esculturas en madera talladas a hacha, próximas a los modelos de Guinea-Bissau y Costa de Marfil, una etapa significativa hacia las obras abstractas, realizadas después de 1918.

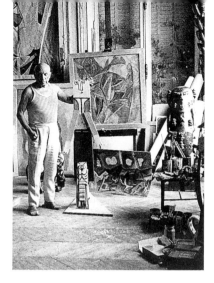

■ Jean Dubuffet, *The Reveler*, 1964, Dallas, Museum of Art. Dubuffet fue el defensor del art brut, un arte espontáneo e inmediato como el de los niños, los enfermos mentales y las sociedades primitivas.

■ Max Ernst, *Cabeza de hombre*, 1947, París, colección particular. Una característica del surrealismo es el carácter totémico, que lleva a los artistas a inspirarse en las divinidades primitivas.

■ Henry Moore, *Boceto para Rey y Reina*, 1952, colección particular. En su juventud Moore estudió las culturas arcaicas en el British Museum de Londres.

1901: las islas Marquesas

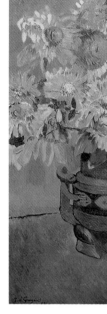

A principios de 1901, desde París, Ambroise Vollard estipuló un contrato por el que pagaba a Gauguin 300 francos al mes a cambio de 25 cuadros al año. En agosto, tras vender ventajosamente su propiedad, el pintor abandonó a Pahura y a sus hijos, su segunda familia tahitiana, y se embarcó con rumbo a las islas Marquesas, a unos 1400 kilómetros al nordeste de Tahití, en busca de nuevos estímulos para su arte. Llamadas por los nativos *Te henua enata*, es decir, la tierra de los hombres, las islas Marquesas son un archipiélago de 12 islas de origen volcánico, de las que sólo seis están habitadas, divididas en dos grupos que distan entre sí unos 100 kilómetros. Dominadas por una jungla exuberante y montañas con paredes rocosas, están circundadas por acantilados de lava cortados a pico sobre el océano y ofrecen grandiosos e insólitos paisajes. Gauguin se estableció en una de las islas meridionales, Hiva Oa, entonces llamada Dominica. Descubrió con pesar que la presencia de los misioneros había cambiado en parte las costumbres de los habitantes, que habían perdido su primitiva estructura social y estaban asimilando poco a poco esa cultura occidental de la que él estaba huyendo inútilmente.

■ *Naturaleza muerta con papagayos e ídolo*, 1902, Moscú, Museo Pushkin. La caja de viaje, cubierta con un mantel blanco, que aparece en muchas naturalezas muertas de esos meses, se parece a un altar pagano en el que se disponen las ofrendas al ídolo.

■ *Figura Tiki*, colección particular. El arte de las islas Marquesas había alcanzado formas muy elaboradas. En particular, los habitantes se habían especializado en los tatuajes.

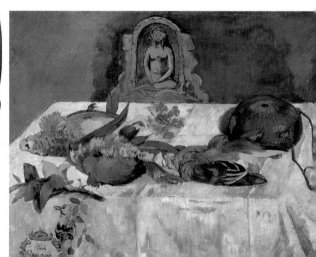

■ *Girasoles sobre un sillón*, 1901, San Petersburgo, Ermitage. Para poder satisfacer los requerimientos de Vollard, que le pedía que pintara flores, más vendibles, había hecho que le enviaran semillas de Francia y las había plantado en el jardín de su cabaña, transformándolo en un rincón irreal, en una mancha meditterránea. Adviertase la presencia del retrato maorí.

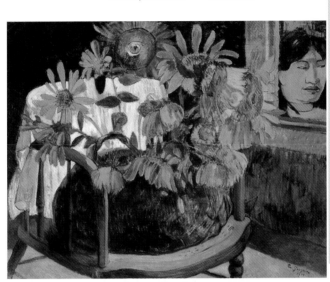

■ *Girasoles y mangos*, 1901, Lausana, colección particular. Retoma en esta obra el tema de los girasoles de Van Gogh, con el añadido inquietante de una flor-ojo. El jarrón, del que no se conocen ejemplares similares, es una creación del artista, perdida o nunca realizada.

■ Aunque se sentía a disgusto y lo consideraba un subterfugio, Gauguin trató con seriedad el tema de la naturaleza muerta y realizó pinturas de óptima factura, como esta *Natualeza muerta con pomelos (c.* 1901, Lausana, colección particular), que sigue la lección de Cézanne en la ejecución de los matices y en la compostura clásica.

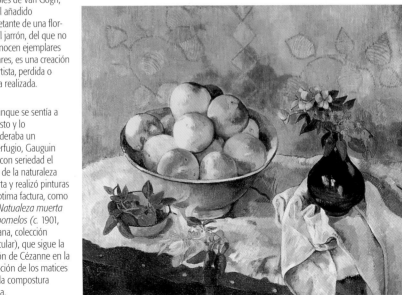

123

1895-1903

El vado

Se trata de una de las pinturas más ricas en significados simbólicos. También esta obra ha sido entendida como un testamento espiritual del artista, consciente de haber llegado al final de su experiencia terrenal (1901, Moscú, Museo Pushkin).

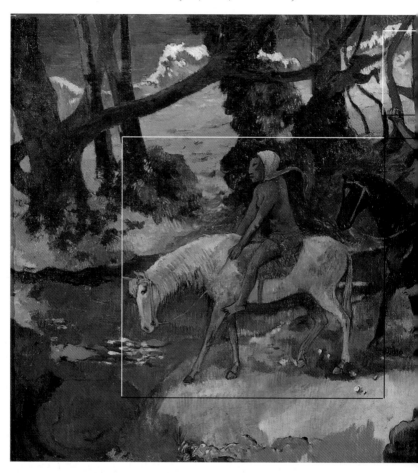

■ Mientras los dos jinetes inician su viaje a lo desconocido, detras de ellos la vida transcurre como todos los días, con la pequeña barca de madera en la playa, que se apresta a enfrentar con seguridad las olas del Océano. El color tiene prioridad sobre el dibujo y en algunos lugares estamos ya próximos a los cánones que serán propios del arte abstracto informal.

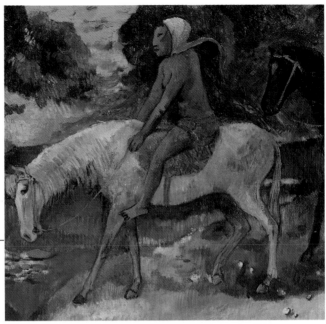

■ Gauguin recuerda el arte clásico: la figura sobre el caballo negro se parece a la del friso del Partenón y reproduce un grabado de Durero. El personaje sobre el caballo blanco, color que en esas islas está asociado al luto, evoca un *tupapau*, un demonio polinesio, que acompaña al joven jinete al más allá.

■ Gauguin había pegado una reproducción de este grabado de Durero, *El caballero, la muerte y el diablo*, en el lomo de su manuscrito *Antes y después*. Es evidente el paralelismo con su pintura, que evoca el paso de la vida terrena a la ultraterrena.

125

1902-1903: la Casa del placer

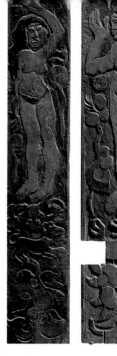

Een la aldea de Atuana, Gauguin adquirió un terreno de la Misión Católica, ya propietaria de toda la isla, y se hizo construir su última cabaña, que llamó *Maison du Jouir*, es decir, la Casa del placer. En ella colocó algunos paneles en madera tallada y pintada, que reproducían muchos de los temas utilizados en sus telas y en sus esculturas. Era una provocación abierta y explícita hacia los misioneros, a los que preocupaba que su presencia pudiese tener una mala influencia sobre los jóvenes de la isla. Mientras los habitantes lo consideraban su amigo, las autoridades lo juzgaban un rebelde que empujaba a los indígenas a transgredir la ley. En esa isla vivió con Marie Rose Vascho, una muchacha de catorce años con la que tuvo una hija, Tahiatikaomata. Aunque estaba enfermo y molesto por los problemas con la gendarmería, consiguió escribir, dibujar, esculpir y pintar, realizando algunas de sus obras maestras. Murió el 8 de mayo de 1903, probablemente a causa de una crisis cardíaca. Las únicas personas que estaban a su lado eran Tioka, un viejo brujo maorí, y el pastor protestante Vernier, uniendo, también en el momento de su muerte, su doble naturaleza de hombre europeo que quiere vivir como un primitivo.

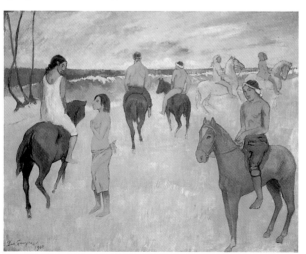

■ *Jinetes en la playa*, 1902, Londres, colección particular. Un homenaje a las pinturas que Edgar Degas dedicó a las carreras de caballos de Longchamp; no obstante, en esta obra el realismo ha cedido su puesto al simbolismo. La escena está ambientada a la orilla del mar, en una playa de arena rosa coral. En lugar de jinetes hay dos misteriosas figuras encapuchadas, similares a los *tupapau*, que guían a los otros caballeros en su viaje al más allá.

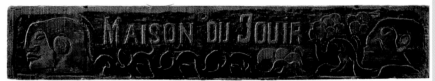

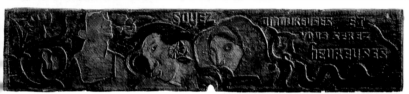

■ *Paneles de la Casa del Placer*, 1902, París, Musée d'Orsay. Estos paneles de madera de secuoya decoraban el dormitorio y el estudio de su casa de Atuana. Las formas estilizadas de las figuras y de las elaboradas decoraciones florales ponen de manifiesto el primitivismo de sus últimas obras polinesias. Victor Segalen, médico de la marina y primer testigo de la vida de Gauguin en las Marquesas, describió la Casa del Placer como "un escenario suntuoso y fúnebre, como correspondía a semejante agonía. El último acto de una vida vagabunda fue espléndido, triste y estuvo rodeado de las tonalidades justas".

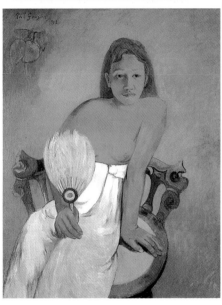

■ *Leyendas bárbaras*, 1902, Essen, Museum Folkwang. De Haan es transformado en un ser demoníaco. Representa la lúcida racionalidad de Occidente, que amenaza la pureza de las dos mujeres, símbolo de una cultura vital e instintiva.

■ *Mujer con abanico*, 1902, Essen, Museum Folkwang. La modelo, de cabellos rojizos, retratada también en las *Leyendas bárbaras*, es Tohotaua, mujer de Haapuani (p. 130). Para realizar esta pintura el artista se sirvió de una fotografía, aunque acentuó la expresión triste y melancólica de la mujer.

La herencia de Gauguin

Gauguin pasó los últimos años de su vida en un exilio voluntario; en los textos escritos en esos años, *Antes y después* e *Historias de un pintamonas*, denunció su soledad y la incomprensión de sus colegas y de los críticos. Ahora bien, ya a partir de las primeras muestras póstumas, como la organizada por Ambroise Vollard en 1903 y la celebrada en el Grand Palais en 1906, se puso de manifiesto que sus pinturas tendrían una influencia grande y duradera en el arte del siglo XX. A los pintores de la escuela de Pont-Aven y a los nabis, que se proclamaron explícitamente discípulos suyos, se unió en esos mismos años Pablo Picasso, impresionado por la energía salvaje del arte primitivo; incluso llegó a inspirarse en la escultura *Oviri* para la ejecución de las *Demoiselles d'Avignon*. Henri Matisse, y lo mismo que él muchos otros pintores del movimiento fauve, se quedó impresionado con sus colores intensos y su luz cálida y plena. Lo mismo sucedió con los expresionistas alemanes, que pusieron en práctica no pocas consideraciones estéticas de Gauguin y compartieron su interés por los ídolos y los ritos paganos. El arte abstracto también se fijó en él, pues fue Gauguin quien proclamó la superioridad del color sobre el dibujo y la fuerza del gesto creativo inmediato y espontáneo. Después de Gauguin la pintura dejó de ser un simple instrumento de descripción y conocimiento de la naturaleza y se convirtió también en abstracción de esa misma naturaleza, en expresión libre de las emociones y de la imaginación del artista.

■ Max Beckmann, *Dos mujeres*, 1946, colección particular. Los expresionistas vieron en él un precursor y un maestro. En particular, se quedaron impresionados con sus xilografías, debido a sus contornos simplificados, sus trazos reducidos al mínimo y el uso decidido del claroscuro.

■ Joan Miró, *Pájaros e insectos*, 1938, colección particular. Miró aprendió de Gauguin el simbolismo, los colores vivaces, el uso de la luz, la visión poética y fabulosa de la realidad y la transformación en imágenes de los elementos del inconsciente.

■ Pablo Picasso, *Mujer sentada sobre fondo verde*, 1960, colección particular. En 1905, a la edad de 24 años, Picasso se estableció en París, donde Vollard le ofreció la posibilidad de estudiar la producción de Gauguin en las islas Marquesas.

■ Henri Matisse, *Lujo, calma, voluptosidad*, 1904, París, Musée d'Orsay. En 1899 Matisse le compró a Vollard algunos cuadros, entre ellos *Joven con flor de tiaré* de Gauguin, del que encontramos huellas evidentes en los retratos de esos años.

■ Vasili Kandinski, *Improvisación XIV*, 1910, París, Musée National d'Art Moderne. La trayectoria creativa, que condujo al pintor ruso de la pintura figurativa a la abstracta, tuvo como referencia constante las experimentaciones de Gauguin sobre la potencialidad expresiva del color, que a veces usa en estado puro, sin relación con el dibujo o la realidad externa.

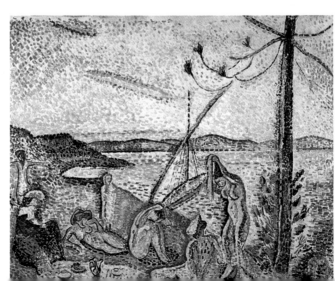

El hechicero de Hiva Oa

En este cuadro (1902 Lieja, Musée d´Art Mo-
derne) Gauguin alcanza un perfecto equilibrio
entre la luz y los colores. El pintor inserta los
personajes en un paisaje encantado, creando
una atmósfera de sueño.

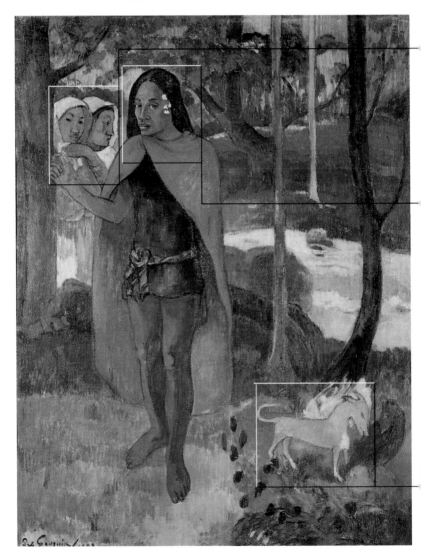

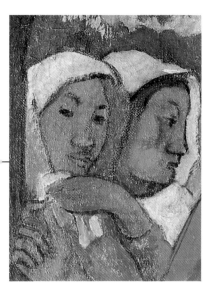

■ Como hacía a menudo, Gauguin usó, para este detalle de las dos mujeres, la misma imagen de las dos figuras en primer plano del cuadro *El reclamo* (Cleveland, Museum of Art), pintado ese mismo año. A pesar de las escasísimas variantes, el significado es bastante diferente.

■ Generalmente se identifica con Haapuani, un ex-hechicero indígena que, poco después de la llegada de los misioneros, se convirtió en maestro de ceremonias. Según otros, podría tratarse de un *mahu*, es decir, de un hombre de rasgos afeminados y cabellos largos, que Gauguin encontró en aquellas islas.

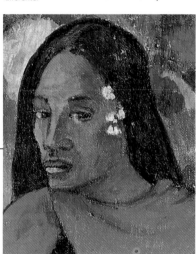

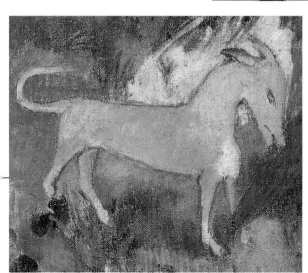

■ Los dos animales, en parte reales y en parte fantásticos, han sido asociados a prácticas religiosas de la antigua cultura de las islas Marquesas, que atraían de manera especial a Gauguin. El dibujo, apenas esbozado, más que representar el espacio lo sugiere, lo que da libre curso al color. No están del todo claros ni el papel ni el significado de los animales, que aumentan la sensación de misterio que anima toda la composición.

Gauguin en el cine

Las vicisitudes de Gauguin han inspirado al mundo del cine, aunque sus registros no siempre han conseguido evitar el énfasis y el estereotipo retórico del pintor maldito e incomprendido. En 1942 Albert Lewin rodó *La luna y seis céntimos*, a partir de la novela homónima de William Somerset Maugham. Mucho más famosa es *Ansia de vivir*, dirigida en 1956 por Vincent Minnelli y magistralmente interpretada por Kirk Douglas y Anthony Quinn. La película narra la vida de Van Gogh y se centra de manera especial en la época de Arles y en la atormentada amistad con Gauguin. Por último, en 1986 se estrenó *La vida de Gauguin*, dirigida por Henning Carlsen, con Donald Sutherland y Max Von Sydow. La película presenta al pintor en París, después de su primer viaje a Tahití y cuenta su difícil situación económica y familiar, así como sus desesperados intentos por ser aceptado.

■ *Tahitianas junto a un arroyo*, 1893, colección particular. Sotheby's vendió esta tela en Londres el 27 de junio de 1995 por 5 millones de liras.

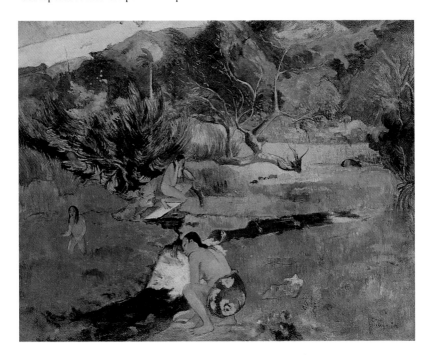

■ Anthony Quinn, premiado con un Oscar, transmite la furia expresiva de Gauguin en toda su intensidad, la genial creatividad y la rabia del incomprendido, los impulsos afectivos y las debilidades humanas.

■ Entre los muchos documentales destacan *Gauguin* de Alan Resnais (1951), *Gauguin the Sauvage* de Felder Cook (1979), *Van Gogh y Gauguin*, producido en Italia en 1980, y *Dentro de la pintura*, de 1993.

■ *La casa*, 1892, colección particular. Esta pintura fue presentada en París por Ader Tajan el 7 de noviembre de 1991 y fue vendida por 52 millones de francos franceses.

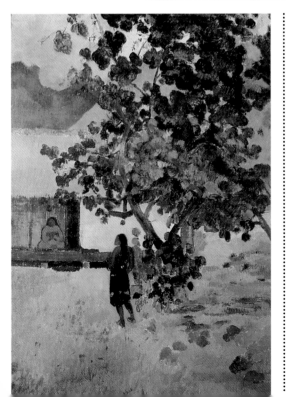

Cuánto cuesta un Gauguin

Si durante su existencia Gauguin pasó muchas dificultades para vender sus obras por unos centenares de francos, hoy éstas son buscadas por los museos y los mayores coleccionistas de todo el mundo. El precio de los grabados oscila entre los 2-3 mil dólares y los 266 mil dólares que se pagaron por *Tahitiana desnuda sentada de espaldas*, un monotipo de 1902 (Christie´s, noviembre de 1997). Con las esculturas y los dibujos las cifras son más elevadas: casi se llegó al millón de dólares por las *Tahitianas* de 1891-93 (Sotheby´s, noviembre de 1996). Por último, las pinturas alcanzan también cifras considerables, como los 10 millones de dólares por *Entre le lys*, de 1889 (Sotheby´s, noviembre de 1989), o, más recientemente, los casi cuatro millones de dólares del *Autorretrato delante del caballete*, de 1885 (Christie´s, mayo de 1997).

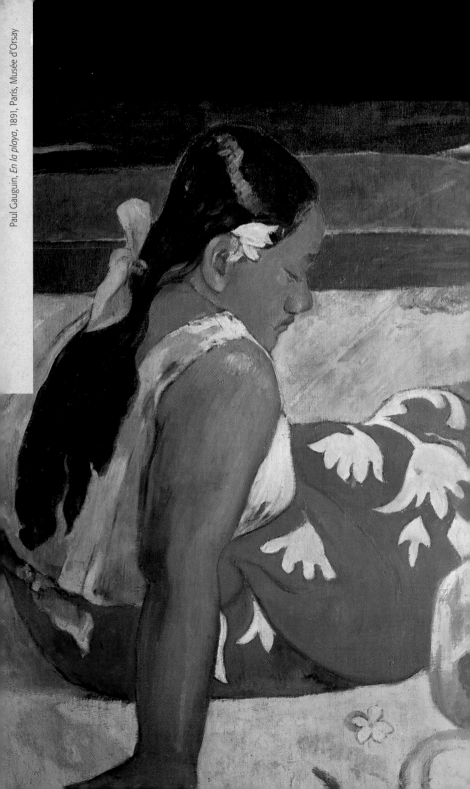

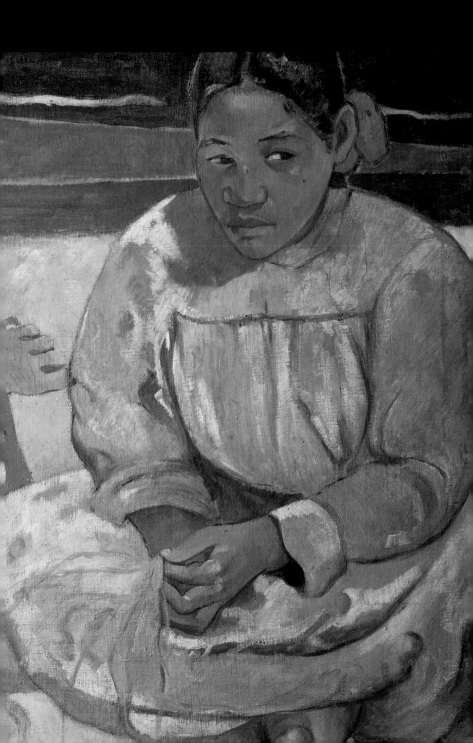

Índices

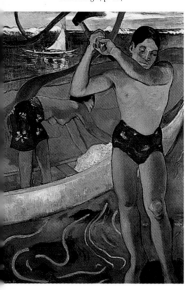

■ *Hombre con hacha*, 1891, Basilea, colección particular.

■ *Palabras del diablo (Eva)*, c. 1892, Basilea, Kunstmuseum.

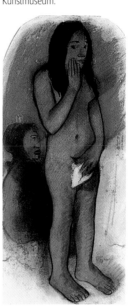

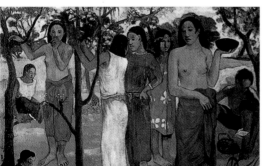

■ *Días deliciosos*, 1896, Lyon, Musée des Beaux-Arts.

■ *Cerca del mar*, 1891, Washington National Gallery of Art.

■ *Meyer de Haan*, 1889, Nueva York, Hartford, Wadsworth Atheneum.

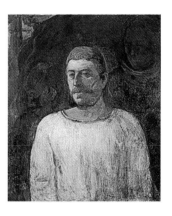

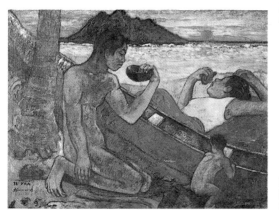

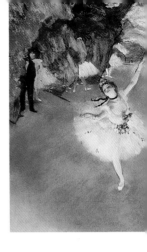

Leyenda

No sólo se citan los artistas, intelectuales, políticos y hombres de negocios que de un modo u otro ligaron su propio nombre al de Gauguin o a su obra, sino también los pintores, escultores y arquitectos contemporáneos que trabajaron en los mismos lugares que él.

Amiet Cuno (Soletta 1868-Oschwand, Berna, 1961), pintor, dibujante y escultor suizo. Se trasladó a Pont-Aven, en Bretaña, y en 1892 se aproximó al grupo de Gauguin. Posteriormente se adhirió durante algún tiempo a Die Brüke. De vuelta en Suiza, inició, junto a Hodler, la "nueva pintura suiza", p. 46.

Annah, muchacha javanesa de trece años, amante de Gauguin. Fue retratada por el artista en algunas de sus obras, pp. 98, 100, 101, 104.

Arosa Gustave, hombre de negocios, fotógrafo y coleccionista de arte moderno. Fue uno de los primeros en interesarse en el arte de los impresionistas. Fue tutor de Gauguin y ejerció una profunda influencia en su formación artística, pp. 8, 12, 99.

Ballin Mogens (Copenhague 1872-1914), pintor danés. Fue uno de los seguidores más audaces de la técnica pictórica de Gauguin, p. 46, 47.

Bambridge Suzanne, mujer de un dignatario de Papeete. Enseñó a Gauguin los usos y costumbres de los habitantes de la isla, pp. 68, 84.

Bernard Emile (Lille 1868-París 1941), pintor francés. Pintó junto a Gauguin y Paul Sérusier en Pont-Aven, extendiendo el color en zonas delimitadas por contornos oscuros, pp. 32, 40, 42, 46, 51, 54, 57, 60, 64, 97.

Bevan Robert Polhill (Hove, Sussex 1865 -Londres 1925) pintor inglés. Estudió pintura en la Westminster School of Art de Londres, p. 46.

Bonnard Pierre (Fontenay-aux-Roses 1867- Le Cannet 1947), pintor francés. Fue uno de los creadores del grupo de los nabis, pp. 108, 109.

Cézanne Paul (Aix-en-Provence 1839- 1906), pintor francés. Su obra se caracteriza por una particular búsqueda de síntesis y esencialidad en la forma y en el espacio, pp. 12, 16, 20, 21, 32, 43, 49, 64, 102, 108, 123.

Corot Jean-Baptiste Camille (París 1796- 1875), pintor francés. Fue uno de los mayores representantes del paisaje romántico. Sus obras, caracterizadas por una sorprendente recreación de la atmósfera, el ambiente y la naturaleza, constituyeron una importante lección para los impresionistas pp. 17, 20.

Degas Germain-Hilaire-Edgar (París 1834- 1917), pintor francés. Después de algunas obras de carácter mitológico e histórico, se unió a Manet y a los pintores del Café Guerbois. Pronto se adhirió al impresionismo, dedicándose sobre todo a la pintura de interiores. Prefirió temas más tradicionales, como retratos, carreras de caballos, bailarinas y

■ Pierre Bonnard, *De visita*, 1902, colección particular.

■ Edgar Degas, *La estrella*, 1878, París, Musée d'Orsay.

■ Edouard Manet, *El tañedor de pífano*, 1866, París, Musée d'Orsay.

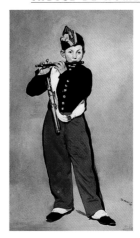

desnudos femeninos, realizados con una perspectiva y unas soluciones compositivas nuevas, derivadas de la fotografía, pp. 18, 19, 21, 32, 55, 61 92, 126.

Delacroix Eugène (Carenton-Saint-Maurice 1798- París 1863), pintor francés. Su romanticismo se expresa en el dinámico ímpetu de las composiciones. Un largo viaje a Marruecos y Argelia le sirvió para profundizar en los efectos de la luz, pp. 17, 20, 45, 87, 95.

Du Puigadeau Ferdinand (Nantes 1864- Le Croisic 1930), pintor francés. Después de varios viajes a Túnez y a Bruselas se estableció en Pont-Aven, donde conoció a Gauguin y Laval. Le gustaban mucho los paisajes y las escenas nocturnas y pintó obras variadas en las que representó las fiestas campesinas de Pont-Aven, p. 46.

Durand-Rouel Paul (París 1831- 1922), marchante de arte francés. Gran defensor de los impresionistas, desde 1870 se dedicó a la difusión de sus obras, pp. 12, 16, 92.

Gad Mette Sophie, primera mujer de Gauguin, gran

amiga de Arosa, pp. 12, 13, 18, 24, 36, 92.

Gauguin Aline (1877- 1897), Segunda hija de Gauguin. Murió de pulmonía con sólo veinte años, pp. 12, 54, 112.

Gauguin Emile (1874-), hijo primogénito de Gauguin, pp. 12, 54.

Gauguin Marie, hermana de Paul, p. 32.

Gauguin Clovis (1879-), tercer hijo de Gauguin, pp. 12, 18, 32.

Gauguin Jean-René (1881-), cuarto hijo de Gauguin, p.12.

Gauguin Paul (1883-), quinto hijo de Gauguin, p. 12.

Gloanec Jean-Marie, dueña de la pensión de Pont-Aven en la que solía alojarse Gauguin, pp. 32, 40, 99, 104.

Guillaumin Armand (Moulins 1841- París 1927), pintor francés. Expuso en la mayor parte de las muestras de los impresionistas. Sus obras se

ocupan principalmente de paisajes urbanos y de temas de carácter social, pp. 15, 16, 20, 25.

Hugo Victor (Besançon 1802-París, 1885), poeta y novelista francés. Protagonista del romanticismo literario en Francia, su vasta obra incluye poesías, novelas históricas, escritos políticos y novelas de intención humanitaria, pp. 26, 45, 50, 97.

Jongkind Johann Barthold (Lattrop 1819- Cote-Saint-André 1891), pintor holandés. Admirador de Corot, se dedicó sobre todo a la acuarela, pp. 15, 16.

Laval Charles (Domme, Dordogne, 1864- 1892), pintor francés. En 1886 conoció a Gauguin en Pont-Aven y lo acompañó en su primer viaje a Martinica, pp. 31, 33, 36, 40, 47, 64.

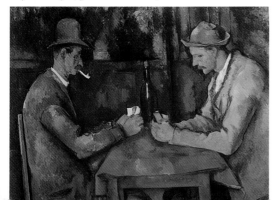

■ Paul Cézanne *Jugadores de cartas*, París, Musée d'Orsay.

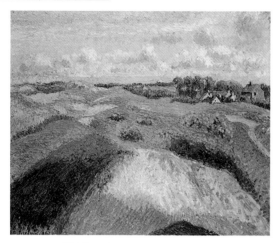

■ Camille Pissarro, *Las dunas de Knocke*, 1902, colección particular.

la niebla. Su búsqueda le llevó a representar la desaparición de la forma en la luz y a trascender la transcripción pictórica de las sensaciones visuales, pp. 12, 16, 18, 20, 21, 64.

Monfreid Daniel de, amigo de Gauguin. Paul lo conoció en París en 1887. Monfreid sustituyó a Schuffenecker en el papel de corresponsal y hombre de confianza durante sus estancias en Oceanía, pp. 57, 64, 92, 104, 112, 117.

Moscoso Flora Tristán (1803- 1844), abuela de Gauguin. Periodista y novelista, publicó en 1838 el libro autobiográfico *Peregrinaciones de un paria*, p. 8.

Pissarro Camille (Saint-Thomas 1830- París 1903), pintor francés. Después de un primer período impresionista, se aproximó a la síntesis pictórica del *pointillisme*, aplicando la técnica divisionista con una

Maillol Aristide (Banyuls-sur-mer 1861- 1944) escultor francés. Se inició como pintor, pero pronto mostró una particular predilección por las obras de Rodin. Quedó particularmente fascinado por la escultura egipcia e india; sus obras se caracterizan por volúmenes llenos y compactos, pp. 82, 108, 109.

Manet Edouard (París 1832-1883), pintor francés. En el Salon des Refusées de 1863 su cuadro *Desayuno en la hierba* suscitó un gran escándalo entre la crítica y el público. Eliminó la perspectiva y los medios tonos, creando fuertes contrastes de colores delimitados por negros brillantes. Después de 1870 se acercó a los impresionistas, pp. 16, 21, 56, 96.

Matisse Henri (Le Cateau 1869- Cimiez 1954), pintor y escultor francés. Su continua búsqueda de los valores del color le aproximó a varios movimientos de vanguardia, aunque siempre conservó su originalidad. Sus obras se caracterizan por un intenso cromatismo y una línea deformada, que le valieron el apelativo de *fauve*, salvaje, pp. 69, 82, 102, 128, 129.

Meyer de Haan Jacob (Amsterdam 1851- 1895), pintor judío. En 1889 se traslada a Le Pouldou, donde decide unirse a Gauguin, pagándole la pensión a cambio de lecciones de pintura. El artista se dedica sobre todo al tema de la naturaleza muerta. En sus obras se transparenta la lección de los maestros holandeses y sus colores intensos y cálidos, pp. 46, 54.

Monet Claude (París 1840-Giverny 1926), pintor francés. Personalidad guía del grupo de los impresionistas, trató de representar sobre la tela las cosas más intangibles: la nieve que se funde, el viento que sopla,

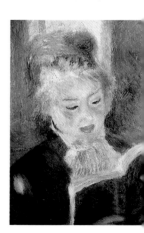

■ Pierre Auguste Renoir, *La lectora*, 1874-1876, París, Musée d'Orsay.

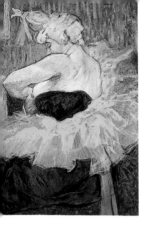

■ Henri de Toulouse-Lautrec, *La payasa Cja-U-Kao*, 1895, París, Musée d'Orsay.

autonomía cada vez mayor, hasta alcanzar resultados que anticipan el fauvismo, pp. 12, 13, 16, 17, 18, 19, 20, 24, 25, 32, 64.

Ranson Paul (Limoges 1864-París 1909), pintor francés. Estudió en París, en la Ecole des Arts Décoratifs y en la Académie Julian, donde conoció a Sérusier, Bonnard y Vouillard, con los que fundó el grupo de los nabis, p. 82.

Renoir Pierre-Auguste (Limoges 1841- Cagnes-sur-Mer 1919), pintor francés impresionista. Al realismo de Courbet añade una predilección por temas de la vida cotidiana, estudiando de manera particular los efectos de la luz, pp. 12, 18.

Schuffenecker Emile, compañero de trabajo en la agencia Bertin y amigo de Gauguin, pp. 12, 32, 33, 37, 40, 60, 64.

Sérusier Paul (París 1864-Morlaix 1927), pintor francés. En 1888 conoció en Pont-Aven a Gauguin, que le enseñó el simbolismo del color. Fue uno de los fundadores del grupo de los nabis, pp. 46, 47, 54, 62.

Signac Paul (París 1863-1935), pintor francés. Elaboró con Seurat el *pointillisme*; en 1899 publicó *D´Eugène Delacroix au néo-impressionisme*, donde expone los principios de la teoría divisionista, p. 16.

Teha´amana, muchacha con la que vivió Gauguin en los dos años que pasó en Tahití, de 1891 a 1893, pp. 75, 84, 85, 112.

Toulouse-Lautrec Henri de (Albi 1864- Malromé, Burdeos 1901), pintor francés. Con su trazo elegante, que preludia el *art nouveau*, se convirtió en un irónico cronista de la vida nocturna parisina, pp. 4, 22.

Van Gogh Theo, marchante de arte y hermano predilecto de Vincent Van Gogh, pp. 40, 41, 42, 48, 49, 50, 51, 52, 53, 54, 64, 106, 123.

Van Gogh Vincent (Groot Zundert 1853- Auvers-sur-Oise 1890), pintor holandés. En 1886, en París, descubrió el arte impresionista, estudió las estampas japonesas y el *pointillisme*. Su pintura, pura en el trazo y en el color, describe las "terribles pasiones de los hombres". Su vida fue bastante atormentada: sufría depresiones y acabó suicidándose. Fue un importante punto de referencia

para la siguiente generación de artistas, pp. 40, 41, 42, 48, 49, 50, 51, 52, 53, 54, 64, 106, 123.

Vollard Ambroise (Saint-Denis-de-la-Réunion 1867- París 1939), marchante de arte, editor y escritor francés, pp. 69, 83, 98, 112, 117, 123, 128, 129.

Vuillard Edouard (Cuiseaux 1868- La Baule 1940), pintor francés. Fue uno de los mayores representantes del grupo de los nabis. Su pintura revela una tendencia intimista; describe principalmente interiores y escenas de la vida doméstica, pp. 83, 102, 103, 117.

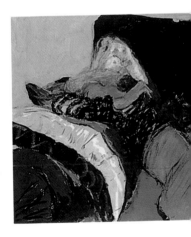

■ Edouard Vuillard, *El diván*, 1910, colección particular.

Colección de mo
a cargo de Stefar

Texto de Gabriel

Referencias foto
Archivo Electa, N
Alinari-Giraudon
Archivo Scala, Ar
Archivo Mond
Agencia Riccia

Nuestro agrad
fotográficos q
el material ico
de los propiet
fuentes icono

Proyecto edito
La Biblioteca

© 1998 by SIA
© 1998 by Leo
 Elemond Ec
 Todos los d
© 1999 Socied
 Núñez Morg
 ISBN: 84–81

THE D.A.D.D.Y. COMPLEX

LUKE PATTERSBY

WITH RYAN SANDOVAL

Written by Ryan Sandoval

Art: Ryan Sandoval & Spencer Dina

Design: www.thebook.design

Editors: Amanda Meadows, Geoffrey Golden

ISBN-10: 1-942099-13-4

ISBN-13: 978-1-942099-13-0

First Edition: November 2016

devastatorpress.com

PRINTED IN ~~THE FATHERLAND~~ KOREA

**DON'T MISS ANY OF LUKE PATTERSBY'S
BESTSELLING THEO SULTAN ADVENTURES:**

SQUATTERS' RIGHTS
THE JUNIPER EQUATION
THE CALIBAN PARADIGM
HANG DOG
PROFESSOR TARGET
DEATH DO YOU PART
MINY MOE
SYMPATHY FOR THE JESTER
WALL TO WALL
PISSED OFF

"Praise" for #1 bestselling author
Luke Pattersby and his Theo Sultan Series

"Like the *Metal Gear* franchise in prison therapy and
the therapist is Tom Clancy right after suffering a
massive head wound, all rolled into one: good!"

— *Psychotherapy Book Reviews*

"Theo Sultan makes other characters in the action-
thriller genre such as Jack Reacher and Jason
Bourne look like a pair of poodle ovaries."

— *Lompoc Sun*

"Much like his hero Theo Sultan, the thrice-divorced
author Luke Pattersby has shunned real family for a career
in fictional thrillers. His offspring is a fine collection of
bestsellers – and the grandchildren are dollar signs!"

— *Association Press*

"As a shoot-first-and-ask-questions-never type
maverick, Theo Sultan might have some questionable
politics, but consarnit he gets the job done!"

— *Virginia Review*

"Pattersby's commercially driven body of work reveals a slew
of troubling personal issues. His stories are misogynistic,
paranoid of technology, and xenophobic; they glorify violence,
and his popularity suggests a fear of paternal commitment for
author and reader alike. But consarnit, he gets the job done!"

— Minneapolis *Mirror*

"this guy's daddy issues tho."

— *@00spybuff, Twitter.com*

Author's Note

People often ask me, Luke Pattersby, what does it take to write a heart-pounding, edge-of-your-seat thriller. I gotta say, every book is different, every character a new journey into the human psyche, every page a new dance with that sly gal known as The Muse. I'm sorry, but there's no secret to my sauce: whether I'm writing about a family-less spy who makes love to unattached young women, or the lawyer without a family who copulates with women who are much younger, or the symbologist with no familial-ties who romances females aged in their early-twenties, every formula is wildly unlike the next. So it goes.

I am a Storyteller. Since the dawn of time we keepers of the myth have gathered 'round the fire to share tales great and small. To find comfort in the familiar and strength in the mighty. From *Gilgamesh* to *Popeye the Sailor Man* to even my own creation within these very pages: Theo Sultan. Humankind's greatest heroes exist to fearlessly guide us all through the dark. *Look, how the night surrounds us even now...*

Sadly Reader, though I have proven <u>myself</u> a hero many times over in terms of selling books, there are still those critics who claim that I owe my successes to a team of underpaid ghostwriters. Or that I set my stories in countries I'd like to visit, then get my publishers to bankroll the whole damn trip. Or that I am compensated by the word, so I over describe irrelevant moments just to boost my numbers. Unfortunately, the list goes on.

Perhaps the most damning allegation though, is that I have "daddy issues" stemming from unresolved feelings toward my own absentee father and that my Theo Sultan stories have become nothing more than "an embarrassed and impotent subconscious wrestling with the guilt of being a thrice-divorced failed parent and abandoned man child..." as one vicious S.O.B. wrote.

Sigh.

Do I have three ex-families? Sure. Does my <u>fictional</u> hero, Theo Sultan, also have three ex-families? Now that I think about it, yes, I guess this is true as well. Hmm, ever heard of a thing called "coincidence?" The point is, Reader, as you embark on this adventure that will take you from one cover to the next, I ask you to forget our world – one of jealous loser critics, bitter ex-families, and fathers whose names are not fit to print on prison toilet paper. These subjects have nothing at all to do with *The D.A.D.D.Y. Complex*. What matters is the journey.

Also, I must deny all claims that the following story was written as:

1. A contest to see if I could break the world record for using the most metaphors in a single story (currently held by Janet Evanovich).
2. The product of an unfortunate Benzedrine trip.
3. A veiled attack on Sammy Hagar from Van Halen for snubbing me at Michael Crichton's birthday party.

Now follow me ye seekers of myth, join us 'round the fire. I hear The Muse calling...

Dedicated* to:

My business manager, my accountant, my financial adviser, my lawyer, my travel agent, my therapist, the Readers, Michael Crichton, James Patterson, John Grisham, Vince Flynn, Nelson DeMille, Daniel Silva, Robert Ludlum, Lee Child, Joseph Campbell, Blake Snyder, Steven Pressfield, Geoffrey Chaucer, Charles Dickens, Herman Melville, the U.S. legal system, the men and women of the U.S. Armed Forces, and of course, dearest Lily Rose.

*NOT Dedicated to:
My ex-families and DEFINITELY NOT my father.

"

The Child is father of the Man.

"

—William Wordsworth, the Poet

CHAPTER 1

Five Days to Father's Day

Staring down the barrel of the wild Mestizo man's semi-
automatic FN Five-Seven MK2 – cocked, and ready to say "hello" in Bullet
Language, no translation needed, Theo Sultan found himself armed with
only a water balloon and his survivor instinct.

An unfair fight in Theo's favor.

He thought of the popular war proverb, "never bring a water-balloon
to a gunfight," and – wait was that right? Was that the proverb? Something
along those lines? Perhaps he was remembering that wrong. It felt right...
but still. Definitely "never bring a *something* to a gunfight." Then he had
it: "Never bring a *nice* to a gunfight." That's what it was. When it came to a
gunfight a nice person, A.K.A. "a nice" – in the same way Sultan would call
a blind person a "blind–" had no place. Really, the more Sultan thought
about it, the phrase should be "never bring anything that isn't a gun to
a gunfight." *BLAM-BLAM-BLAM!* Sultan ducked his muscular, rugged six-
foot-three frame behind a park trash can. The stray 5.7 x 28mm rounds
penetrated a clown's balloon animal. In the underworld these cartridges
were nicknamed the "cop killer," but today they threatened to take on
a new name: "picnic ruiner." Specifically, the Father-Son Picnic Sultan
incidentally found himself jogging through that day. Once a place of

intergenerational watermelon, potato sack races, and inflatable jumping houses, was now a warzone.

The clown frowned comically, then hid behind a tree, less comically save for his attire. Hmm, maybe the saying was "never bring a regular balloon to a water balloon fight?" *Sultan's mind raced like a tape-worm full of steroids.*

Once a Navy SEAL elite sharpshooter with 78 confirmed kills, and then a former military lawyer with nearly as many confirmed kills in the court room, Sultan now spent his days off the Grid. Mixed with savings from his days in active-duty as well as mercenary work, the odd job here and there kept Sultan comfortable and his experience both behind the scope and before the gavel had left him with an eagle eye for threats and a full "courtroom in his head." Complete with a mental judge, jury, witnesses, evidence, and an attorney on both sides, Sultan's time-tested instinct for split second jurisprudence processed every situation he encountered with the fairness of a legal proceeding that our criminally underappreciated Founding Fathers died like dogs in piss-filled ditches to protect.

And right now the courtroom in his head ruled that the man playing target practice with Sultan's mug had no place in this once beautiful country. *Not in a racial way.* Forget border walls and foreign naturalization, the only language Sultan hated was "jargonese," the native tongue of the career politician. If an ethnic had enough gumption to risk life and limb for a chance to help pull this flaming wreckage of a nation out of its current tailspin then they certainly deserved an opportunity to pledge allegiance to Old Glory.

Which is to say, instead of enjoying Star Spangled hot dogs with this imported mischief maker, Sultan now found himself wondering how he had ended up in a life or death shootout. And before lunch time? *Most attempts on his life were made after lunch.*

What's more, today was Sultan's birthday. But he had stopped celebrating this fool's anniversary long ago. Like any other holiday industry,

Big Birthday existed simply to keep the poor poor, and the rich rich. So Sultan treated it like any other day and decided to get some exercise.

Undumb enough to waste money at a fancy city gym ("Watch the pounds *and dollars* melt away," he often angrily joked to the customers exiting said fancy gyms whenever he got the chance), Sultan opted for a simpler, more pure workout: blindfolded with his hands tied behind his back, and shirtless in thrift store Harley Davidson brand blue jeans, Sultan forced himself to run barefoot at top speed using only his wits to avoid the likes of traffic, fences, garbage mounds, farmers markets, funeral processions, parades, and anything else that he might encounter along the way.

It was there in a Virginia woods that Sultan ran so fast his blindfold slipped and his whole day became 70% deadlier: for there in a straw hat, worn flannel, with a sack full of "recyclables," rifling through the garbage at an unattended picnic table was the Mestizo man. No problem there, as Sultan was not in any way, shape, or form racist. What irked him though was how this man (whose facial features suggested an ancestry of Spanish and American Indian) was attempting to make *free money*, in the same American sun, where our very forefathers gave every ounce of blood, sweat, tears and other patriotic bodily fluids to water the trees of freedom whose very shade this no-goodnik used to cool his brow. *Surely he was up to no good.*

That was twenty minutes ago.

Now, squaring off against the gunman – only a water-balloon stolen from a nearby "Father and Son" picnic as his weapon – Sultan felt his squishy projectile wobble in his palm like the touch of a supple lover, and *not* the touch of any of his ex-wives. *Their* touches felt like acid eating through styrofoam. No, the lover's touch he imagined was the touch of an unattached single woman – who wanted nothing from Sultan emotionally, and only expected the occasional roll in the hay as a sign of affection. And she certainly never asked what Sultan was "thinking."

The ethnic man reloaded.

His ex-wives and ex-children never understood that a man like Sultan didn't have time to think, only act. *Lives are lost in the time it takes to think*, thought Sultan. He also thought that a good bumper sticker might be "Thinking: the #1 Cause of Death." Sadly, like so many excellent bumper sticker ideas, this one would never see the light of day, due to all the forms necessary in the process of making bumper stickers. The only thing he hated more than the forms was the idea of forms and filling them out. And the only thing Sultan hated more than forms in general was injustice. Today's injustice obviously took the form of this bottle-hoarding stranger who, to the common man, appeared harmless. But Sultan's greatest weapon – *his instinct* – told him otherwise. Which is to say, an instinct like the Industrial Revolution powered by prehistoric shark adrenaline. While the common man saw a harmless, downtrodden Mestizo collecting recyclables, Sultan saw a loose thread in the rotten fabric of society: a foreigner profiting off the hard-purchased beverage containers of honest citizens, then using those same profits to likely fund human slavery rings.

"Oye amigo," Sultan called, his voice a leathery mix of history's most rugged tongues: Abe Lincoln, Wyatt Earp and just a dash of Sam Elliot. "We can do this the easy way, the hard way, or the MY way."

The Mestizo muttered, then dug deep into the bottom of his reusable plastic woven bag for something, and it sure as little apples wasn't pan dulce... *BLAM-BLAM-BLAM!* Sultan dove for cover, hands still tied behind his back. The Mestizo and his "pistola" ran through a potato sack race, knocking father and son alike into the lush summer grass.

"Give it up, compadre!" Sultan screamed behind a cooler, undoing the really strong knot binding his hands that he also invented. The gunman tipped over a giant grill, sending hotdog, burger, and even the Grillmaster down into the ant-happy dirt. Screams of sons and fathers surrounded Sultan as he searched for a weapon, finding only plastic cutlery and potato sacks. He continued past the Grillmaster, who was curled up in a fetal position, to a tub filled with water balloons. Water

balloons intended for a Father-Son water balloon toss. Water balloons, sparkling like a pile of plump rubies. *Rubies for a Sultan...*

With a fierce underhand throw (perfected during his time as MVP for the Navy SEAL national softball team) Sultan launched a water balloon across the picnic, when the Assistant Grillmaster shot out from behind the grill. *PLAWP!*

The bulbous water balloon splattered into the Assistant Grillmaster's neck unleashing a shrill man's scream. Sultan shuddered. The only thing Sultan hated more than forms, and injustice, was the sound of a grown man crying. To be sure though, the Assistant Grillmaster certainly deserved only to grill up the tastiest dogs that day, not writhe like the Damned on top of his own meats and itchy grass. As the Mestizo raced for an inflatable castle structure, erected for the fun of children, Sultan arced another balloon high into the air, like a WWI shell on the fields of Verdun. Unfortunately it had been years since he had calculated (or rather "instincted") wind resistance, and the balloon came down on a child and crashed his face four inches deep into the dirt.

The youngling didn't move. He wouldn't move the rest of the day, such was Sultan's coma-inducing strength.

"Junior!" yelled the boy's father as the gunman disappeared into the inflatable castle. Once conscious the little tyke would be scarred for life at the thought of water balloons, of picnics. No doubt the dear boy would wind up in the Manhattan office of some big city shrink hell-bent on asking crap questions about "feelings," and a bunch of other garden variety psychobabble bullshit that ruined this country's once great children. Sultan grabbed three more water balloons from this tub of jumbo, candy-colored kidney beans and followed the Mestizo inside the inflatable castle. It was big enough to have a few walls and dogleg turns, like a maze. Or a labyrinth. With five feet of space between the top of each wall and the inner roof. Sultan sensed movement from around a partition.

Don't think, act. Sultan lobbed himself horizontal soaring toward the opening of one room, then underhand threw his water balloon...into emptiness. But his raw animal strength exploded a hole in the wall, slowly collapsing the structure. Sultan would have to move fast, otherwise the criminal would escape, leaving him looking like an ass while this puffy playhouse melted on top of him like a damn giant cake for a giant child left out in the giant rain. Then, a call from behind another wall:

"Senor," said the Mestizo. "I don't want no trouble, I work for the cartel. I die, so do you."

"So you recycle bottles and cans, then send the money to a drug syndicate? Just as I expected," quipped Sultan.

"Si, but the cartel is like my family. And family protects their own."

"Thanks for the lesson, Dr. Phil," said Sultan.

The gunman said, "I know your type, señor. No family. No code but your own. I can see in your soul something is coming. Something bad...." Sultan kept him talking, using his perfect hearing and instinctual sonar to pinpoint the man's exact location. And once he got it, it was go time.

"Appreciate the free reading, Miss Cleo!" Sultan said, leaping into the air. There was a scrambling noise. Of rubber on the PVC tarpaulin surface, of the man's shoes on the cartoonish floor. But Sultan had already crashed his full weight right on target, diametrically opposed to where the man once stood. The off-set heft of Sultan's 240-pound frame sent the little guy flying into the air like a starfish in a wind-tunnel, high above the partition, gun clattering out of his hands.

"Dios mio!" he said.

The man suspended, Sultan underhand torpedoed his last balloons into the man's face like a carnival game. The first entered the Mestizo's gaping mouth, and the second filled his lungs with water, before the man crashed lifeless to the ground like a man-shaped water balloon. Sultan flipped the dead man over with a bare foot. "Didn't anyone ever teach you not to bring a gun to a water balloon fight?" he said.

CHAPTER 2

Sultan lumbered into his one bedroom, handbuilt cabin deep in the Virginia wilderness and miles from that non-stop shit show known as Society. His loyal dog, "Marcus," a mayonnaise white Alsation named for the wise philosopher king Marcus Aurelius, greeted Sultan with three different beer bottles in his mouth – *all domestic.*

"Thanks, boy," said Sultan as he popped the cap with a quick *tsss.* In his mercenary days, Sultan was once a part of a disastrous mission to acquire rare hops from deep in the Congo for a brewer out of Portland, Oregon. *There were no survivors.* The cut-throat hops trade made blood diamonds look like cereal prizes. It had been domestics ever since. Besides, in his opinion "I.P.A." stood for "I Pay (out the) Ass," a joke he made to his doting pup on a near nightly basis. No sooner had Sultan tasted that first bubbly sud of liberty when Marcus returned with a bag of sunflower seeds – Sultan's favorite treat, and a mysterious package that looked about as world traveled as the dog's master. *Damn time to move,* thought Sultan.

His muscular, yet insanely nimble sausage fingers undid the string binding the package's contents. The return address read "M.B., Linegoggin & Haverbrook." *A lawyer's firm.* Already Marcus had his hackles up and was instinctively barking at the slimy stench of family law that wafted

out along with an eruption of legal letterhead and ancient child support letters. Sultan's grip tightened like a boa constrictor. *My ex-families. They finally found me...* Thumbing through the documents, Sultan used knowledge from his lawyering days (*hey, everyone makes mistakes*) to decipher the meaning of the "hate mail": His ex-children were suing him for unpaid child support, plain and simple.

Like the past vomiting into Sultan's heretofore sparkling clean toilet of a mind, it all came flooding back, bitter carrot chunk memories and all. Sultan's history as an ex-family man three times over had returned to haunt him. He had started and lost three separate families, been a father and husband three separate times. There was Linda, baby James, and little Susie all swept out to sea during a Disney cruise through the Bermuda Triangle. Margot, the nurse, and their triplets – a handful at times sure, but not deserving of the fate they all suffered – kidnapped by Indonesian smugglers and sold into the underground circus.

Least that was the rumor.

Sultan lit a cigar, inhaled the thick, smokey freedom, and ashed into the ash-tray his dog helpfully brought over in his mouth. Ahh, yes, no wife to complain about his cigars. Not like Denise, mother of Tucker, little Wanda, and the third kid – what's his face, the wimp with asthma. Sultan simply forgot to pick them up from the shopping mall on Christmas Eve, and had been out of the picture ever since... *C'est la vie.* No, that life wasn't for him and he wasn't regretful at all. He didn't mind things like eating his Boston Market dinners alone over the running garbage disposal. *He didn't mind falling asleep in his recliner with cigars in his mouth like last night.* Guess his ex-families had finally resurfaced – two at least – and were pissed at dear old dad. *Hell of a birthday gift.* If he didn't appear in "court" in three week's time, Sultan faced incarceration. As far as he was concerned, though, the only court in the land Sultan now recognized was the basketball court found in America's inner-cities.

With a swig, Sultan tossed the forms, picked up the latest issue of *9/11 Magazine* brought over by Marcus, and flipped on the radio he had

built from technology waste left on the Appalachian Trail. Lost phones, misplaced earbuds, dumps wrapped in tin-foil. As far as Sultan was concerned, the Internet Age had done nothing but turned nature into a wasteland of wires and dumps wrapped in tin-foil.

He tuned his radio to his favorite Blues program that featured the songs of yesteryear. Of a time when good men were lucky enough not to deal with cultural abominations like free soda refills, or something called an "emoji." To not have to deal with child support. Yes sir, "Ol' Sackhead's Sunday Sampler" was like listening to the past.

Tinny voices and crackling percussion spilled out of the speaker and set Sultan at ease. Marcus reappeared with a set of Sultan's favorite musical spoons in his mouth. A gift from a little boy in Afghanistan. They were gnarled and misshapen, much like Sultan himself, but still brought him great joy. He often used them to play along with whatever musical prophets were speaking the Truth on Ol' Sackhead's.

A *tappa-dappa-dap* and *kikkikida-clacka-clack*, he started on his handsome thighs...

Not now. Later.

The Mestizo's ominous warning in the bounce house didn't sit right with Sultan. How "something dark" was coming his way. To be sure he deeply respected the Latin connection to the spiritual realm and at one time went undercover deep into the world of shamanism. Or, perhaps the criminal was just shooting his little mouth off. *Talking shit.* On the subject of criminals, Sultan couldn't help but think about what made such sinister slugs slither unawares in the threadbare brassiere of Lady Civilization. Was it bad parenting? Was it absentee fathers, like Sultan's own deadbeat dad who had... NO.

Best not to remember. *Best to forget the pain,* Sultan thought as he now found himself downing his 12th domestic beer, motorcycling shirtless through the local graveyard. To his own dad's final resting place.

Stone odes to long forgotten Civil War soldiers streaked by. Mere boys surrendered to that earthy foe in ragged blues and greys alike,

their souls too weak to leave the haunted ground, strong only enough to barely lift tattered worm-eaten uniforms like swaying kelp in an inky black ocean. *Farther up, dead people from the 1990s were also buried.* Wind whipped through Sultan's dirty-blond hair as his Harley Davidson FX Super Glide Cruiser with aqua-colored bulletproof side-compartments smashed apart headstones willy-nilly. If he knew soldiers like he thought he did, the old boys down in the cold, cold ground appreciated this explosive action to break up the monotony of the beyond. He revved the throttle in their honor.

Up ahead a leaning headstone about as tall as Sultan himself slanted away in his path like a launch ramp. He gassed it. Seconds later, in his best Evel Knievel impression, Sultan and his hog were airborne, caressed by the Virginia air. In this moment he was a million miles away from the threats of unpaid child support. He shut his eyes, for in this moment he was free. When he opened them, the gnarled shape of an outstretched hand reached for Sultan's throat.

It was a tree branch, and in a split-second reaction Sultan headbutted the plant to smithereens. He landed with a skid, and all the appropriate physical occurrences that a man his size and a bike that weight would result in, then put some "desert-juice" into the turn to complete a full 360-degree rotation on the nearby burial plots.

He had arrived at his father's grave.

CHAPTER 3

"Pop," Sultan called him. But most people knew the elder Sultan better as "that mean son-of-a-bitch," "that bitch's mean son," and "Derick Randy Sultan? Screw that guy." Whatever name you used, the damn bastard served young Theodore Sultan three square meals a day of fresh-made, farm to table beatings a la mode with a side dish of red buns on the house, compliments of the chef. Sultan was his dad's favorite customer and always had a table reserved. "Heard Hell's hot this time of year," said Sultan, clumsily unzipping his pants. "Let me cool you down."

The ropy urine stream pattered across the moss covered headstone. Steam rose. Peeing in spiteful ecstasy, Sultan threw his head back and pondered the cosmos. In his younger days Sultan made a habit of respecting the stars. Those gentle celestial orbs were Sultan's only friends on many a lonely night. The zodiac his clubhouse, the constellations its members. His eyes fell on Gemini those duplicitous twins of yore, then Cancer the wise crab, then Leo, the mythological constellation of the Father. Still peeing, the stars spoke. They told Sultan a story from his past: *"Happy Birthday, Theodore," Mommy said. Daddy fiddled with the car radio. A Chevy Celebrity. They were driving to a special dinner at a restaurant. It was the last day Theodore ever saw "Pop" alive. Daddy stank of home-brewed cologne. Of sage, of barks, of flowers. Of alcohol.*

Daddy refused to pay "out the wazoo" for that "drugstore swill all the godless movie stars wear." Every pot and pan in the mobile home smelled like Daddy's cologne. Every room, too. Like nose ghosts. Daddy wore a tank top. White with yellowed armpits. The only words were in fluorescent lettering, and said "Caught Some BASS in Lake Havasu '77'." A cartoon fisherman with sunglasses hooked a woman in a bikini on his fishing line. Other "sad sack" fisherman frowned at the regular, less buxom fish they had caught. "Oh look, we're finally here," Mommy said. "Ace's Meatplanes." Theodore read about the restaurant in a copy of Boy's Life *once. It made edible scale model aircrafts out of meat. "What will you have Theodore?" Mommy asked. "A B-52 Bomber with filet mignon cockpits? A salami Cessna? A goat meat Wright Flyer?" Daddy still fiddled with the car radio...*

There's a saying about beer that goes, "you only rent it," and Sultan was paying back every last drop on the grave of Derick Sultan. *With interest.*

He chuckled, "I do love our father-son bonding, Pops–"

A branch broke. Sultan put himself back in his pants, and smashed his thirteenth bottle against a headstone. The glass teeth sparkled in the night. Darkness loomed. Fireflies taunted him. *Which were glowbugs, and which were human eyes?*

"Show yourself," Sultan called. "Unless you want to me to fix you a new pair of suspenders from your achilles tendons."

A coughing sound. More snapping.

Sultan prepared his hand for stabbing. *Two deaths in one day?* Not how he wanted to ring in his birthday, but that was up to this stalker. Then, a familiar voice spoke.

"Same old Theo Sultan," said the official looking man bundled up in a dark blue wool coat. He was short, but sturdy and walked with a limp. Most certainly the result of shrapnel. A little parting gift courtesy of Mr. Saddam Hussein. His cane crunched leaves like a litter stick as he hobbled into a moonlit clearing. Sultan could see he bore a striking resemblance to Keenan Ivory Wayans. Or at least, that's who Sultan thought would be

good at portraying him in a movie. The visitor pointed his cane at the burial plot and said, "No lack of hot piss for a cold grave."

"Colonel Bayer," Sultan seethed, zipping up the final teeth on his Harley Davidson brand blue jeans. "Scouting out a retirement spot for when the boys at the Puzzle Palace finally give you your walking papers?"

Bayer cleared the leaves off his cane with his shoe heel. This took 13 seconds.

Bayer said, "No, Sultan. Scouting out *you*."

Sultan said, "Why? The Army finally deciding to let us Frogmen teach your boys how to run *towards* a fight?"

"Mogadishu was a long time ago. We've learned a lot since then."

"Yeah, tell that to Tex's wife," Sultan said. Bayer produced a cigar box wrapped with a bow and handed it to Sultan.

"Little gift from the Pentagon," said Bayer. "And a peace offering. We need your help..."

A presidential seal on the box glinted under the stars. Sultan immediately tossed it in the air, spun around and roundhouse kicked the container high over the midnight forest.

"Tell the boys at Fort Fumble to find another stooge."

"And get that stooge killed? No way. We need the best. We need Theo Sultan."

"I'm done wiping Uncle Sam's pink little ass. This hired gun is a *retired* gun." Sultan started up his bike.

Bayer stepped in the Harley's path and said, "A General's son-in-law has been kidnapped, Sultan."

"So call the police."

"He doesn't want the police. He wants Theo Sultan."

"I see how it is. The five-sided squirrel cage can't dip its hand into the Army cookie jar for personal reasons. So you need me to fly under the radar and color outside the lines."

"What we need is your special brand of maverick expertise."

"Oh sure, send the grunt to do the dirty work while the fat cats jerk each other off. Same shit, different asshole. Theo Sultan ain't no asshole," he said, pulling fistfuls of garbage out of his jeans and scattering the likes of used tissues, lime-crusted dimes, and banana peels on the grave. Bayer tapped his cane on the headstone.

"Fair enough, but you sure you got the right stuff?"

The old man pushed back the moss creeping over the name "Derick Sultan" on the headstone to reveal more letters, which read:

Martha Dericka Sultanovich
Proud Matriarch and Rhodes Scholar

Sultan rubbed his eyes in disbelief. *How could this be?* For the past five years he had been channeling a lifetime of bastardized hatred into defiling this moss-covered grave. He had heard this was his father's final resting place when Derick Sultan was found face down in the lazy river of a nearby water park after hours. The body's face and teeth had been sucked off by a filter. The groundskeeper, a drunk, pointed Sultan to the site and he had been defiling it ever since. It was the only relief he had from the constant battery of let-downs and disappointments that was the so-called Modern World.

"Seems you been defiling the wrong grave, son," Bayer said.

Sultan was still in shock.

"Come now, Theo. You know a little bird in intel tells me you're having some family troubles. I'm sure we can pull a few strings, get a few court dates thrown out..."

Sultan glared at him. He thought of Mogadishu. Of Tex.

He said, "Give me one good reason why I should put my buns on the line for a country that routinely treats my life like the diaper layer of the city landfill?"

"Because, Theo," Colonel Bayer said, handing Sultan a photograph. "Your dad is still alive."

CHAPTER 4

Deep beneath the Earth's surface, the man – a father of two, felt the needle enter his heart and withdraw blood. *His nipples were rock-hard with fear.* He struggled against the drugs already clouding his body with the murky call of sleep. All went fuzzy like a camera lens dunked in 99-cent store hair gel. *LA Looks.* The Scientist placed the man's blood into a vial. The man tried to sit up, but a brutish, slippery hand forced him back into bed. A hand belonging to a monster. *A monster with a human body, and the head of a seahorse.*

CHAPTER 5

Four Days to Father's Day

The hot Virginia sun beat down upon Sultan like a giant yellow boxing glove 1.3 million times larger than the Earth and made of exactly 70% hydrogen, 28% helium, and roughly 1.5% oxygen and nitrogen, this boxing glove. He was standing outside the suburban home of Steven Entwhistle, the missing son-in-law to General Stuphs. Sultan was here to ask the wife and daughter a few questions, but just the sight of the manicured lawn, and the white-picket fence, and the cutesy mailbox built to look like a tiny version of their own home – all this domestic bullshit felt like nails against Sultan's eyes, if his eyes were made of chalkboard material.

He had just finished investigating the missing father's car in the driveway: a Subaru station wagon built for family travel. He glared at the stick figure decal on the rear window which read "The Entwhistles," and featured a pair of rudimentary father and mother characters, along with a smaller child of a stick figure. One happy family. Virtue signaling at its worst. Or its best, considering the clarity of the message: *Aren't we so special?*

Sultan took one last look at the photo of his own father. The one Colonel Bayer had provided him. It had arrived via military fax from

an untraceable location. Taken at an amusement park, during a vertical plummet on a log flume ride. The riders were all men with hands up and faces curled in glee. Third seat back on the left, there was his old man: Derick Sultan. *How long had he been alive? Had he spent all this time riding log flume rides like this one?*

The scenery for the ride appeared to still be in progress. Half-built robotic skeletons with buck-toothed beaver heads flanked the log. *Animatronic theme park characters?* Step one would be locating any amusement parks currently being built. Meanwhile, Bayer assured Sultan access to the U.S. Army's high-tech tracing technology in order to locate the signal from the fax machine. In exchange, Sultan would look into this whole kidnapping situation.

Suddenly the front door of the house flew open and Bayer waved him in.

"Alright, that's quite enough mystique you've built up," said the Colonel. "Come inside and meet the family."

This was the moment Sultan dreaded. Having to "socialize." Useless chitter-chatter about inconsequential topics such as "traffic" or "weather" or "opinions on televised singing competitions." *He'd rather sleep in cottage cheese for the rest of his life than utter a single syllable of small talk.*

Sultan took a deep breath and walked into the suburban house. Into the unknown...

The home of the Entwhistles was like an alien planet. Clean tile floors, movie collections, children's artwork fastened to the fridge drawn in that terrible "crayons held in a one-winged seagull's mouth" style that only a kid's brain, mutilated with deficiency of adulthood could produce. With the terrain of this alien planet came Sultan's own painful family memories: neighborhood barbecues, family vacations. *Christmastime.*

In the living room was Steven Entwhistle's wife – lithe, blonde, her face streaked with tears, private Potomacs on the topography of her face.

Waterways Sultan had been tasked with damming up. *Clearly she was into him.*

"He just left for work like normal and he never came home," she said. "Then they found his car on the side of the road. No finger prints, no witnesses."

Sultan said nothing.

"You should have married military, like I told you," barked her father. General Stuphs. He sat to her left on a disgustingly long couch. Or rather, a man like him didn't so much sit as appear permanently lodged in his spot like a BLU-82 daisy-cutter shell dropped from the sky decades ago.

He was a clean-shaven brute with close-cropped red hair, a whispy blond unibrow and piercing green eyes. Neck as thick as a holiday ham. Looked like he slid right out of the birth canal of a Howitzer M1, already saluting. *A war pup.* On his lap was the missing man's daughter in pigtails – basically your stock girl-kid.

The General said, "That noodle arms husband of yours never could protect himself."

"That's not true!" said the wife. "Steven's a smart, caring father, and that's all that matters."

"Please, please," intervened Bayer. "Sultan, what do you make of all this?" As far as he was concerned, in cases of missing fathers there was only one question that needed answering, and it wasn't the most sensitive one. But then again, that's why folks like Bayer hired folks like Sultan: to be insensitive. They had all gone over the details – no money owed, no known enemies, no ransom note. So to confirm this was in fact a kidnapping, Sultan got insensitive.

"You any good in the sack, babe?" he said. The wife flushed red with embarrassment. The General shot Sultan a look that would've left an exit wound in a lesser man.

"Watch your language, officer," the General said. "What is it with you Navy boys and your cussing ways?"

"No," said the wife. "I see what he's getting at. And yes, we were very 'healthy' in the bedroom."

The court room in Sultan's head told him she was telling the truth. That there was no other woman, and that she wanted no other man.

"Had to ask," said Sultan standing up. "I think I've got everything I need here–" Suddenly the daughter hopped onto her feet and ran straight for Sultan. Her mom tried to stop her, but the child was already out of reach. The girl attached herself to his outer-leg, like an extraterrestrial creature trying to lay-eggs in his outer thigh. His chest tightened. Sweat poured down his forehead. His pulse quickened. The child's hug was like rattlesnake poison.

"I know you'll find my daddy," she said.

It had been so long since he interacted with the younger members of the human race. They panicked and confused him. They were unpredictable and rarely responded to logic or reason. *They reminded him of his own ex-families.*

Sultan's vision went pure red. His hands quivered and quaked. So dangerous were his hands that Sultan once had to register them as lethal weapons at the local police station. If he planned on putting them in his pockets, he had to have a concealed carry permit, he assumed. Specifically, they were registered as "assault rifles" and every urge in his body told Sultan to fire at will on the tiny parasite clutching on to his thrift store Harley Davidson brand jeans. But he couldn't have kid-blood on his hands.

Not again.

CHAPTER 6

Her mother moved to pull the child away, but not fast enough. Instinct made Sultan grab a throw pillow embroidered with an image of the Eiffel tower and the word "BREATHE," and he batted the daughter through her mother's arms. The child slid across the wood laminate, unharmed at the feet of her grandfather. The General.

"He's just a little rusty around children," said Bayer, trying to de-escalate the situation. But once Sultan got started the only thing that would bring him down was the sound of bones crunching. He needed to pull himself out of this encroaching fugue state – and fast – otherwise this house would be reduced to a splinter-laden crime scene in a mere matter of seconds.

So Theo Sultan made a fist.

But not just any fist. A fist he inherited from his father. A fist known in certain circles as "The Judge." A fist that could knock a man sober. Though Derick Sultan had been a complete and utter deadbeat, who wasted his family's money on lotto scratchers and raunchy tank tops and a failed home-brewed cologne business, the man did leave his son with the physical ability to punch any living thing in such a way that the recipient became "as sober as a judge," be it from drunkenness, or

simply losing one's cool. He had remembered his dad routinely punching himself sober in the morning after the previous night's bender.

The Judge was harsh but fair.

"What's he doing?" said the General.

"Let's just all give him a little space," said Bayer, ushering everyone back a little. The General secretly reached for his sidearm, just in case. Sultan commanded his clenched hand like a willful king cobra. His veins buckled, his breathing became bull-like. The fist faced its master. Then lighting quick it struck. A bucket of hand-shaped ice water right between the eyes. His arms went loose and the world returned to normal, the Judge had banged his gavel and justice had been served.

"Well," said Bayer. "No harm no foul—" just as General Stuphs pulled out a Beretta M9 and aimed it at Sultan's face. A display of power, like a silverback beating on its shiny chest.

He said, "Your job is to locate my pasta-limbed son-in-law you water-donkey, not turn my granddaughter into a hockey puck!" As beautiful a piece of machinery like the standard issue 9 x 19mm parabellum pistol was up close, Sultan preferred to admire the short recoil, traditional double action trigger, and 3-slot Picatany rail from afar, in a standard Bianchi M12 Holster. But not from its current position: a mere caterpillar's sneeze away from Sultan's face.

Up close, the General's trigger finger tensed like a mongoose prepared to strike. Sultan stared down enough barrels in his lifetime to know when a trigger finger meant business. Could see the nearly imperceptible callus that formed on the digit-skin of a seasoned gun-hand. As far as trigger business goes, the General's finger looked like it had spent its fair share of time on Finger Wall Street. Which is to say, it was nearly all callus. All, except a spot where a ring once was...

If nothing else, the familiarity of a violent standoff helped Sultan think clearly. Helped him calm down. Helped him forget that moment with the child.

Sultan said, "Santa bring you that new toy for Christmas?"

"Alright," Colonel Bayer said, using his cane to bring the gun down. "Let's not lose our cool here. Theo's just here to help." Sultan winked.

"This kind of crap better not happen again," said Stuphs, holstering his sidearm. "*Ec-specially* for your sake."

Sultan didn't appreciate the General's pronunciation of the word "especially" with an extra *c* and all. Reminded him of how some people call "spaghetti" "pasketti" or said "bye bye" at the end of phone calls. *Juvenile*. Then again, Sultan wasn't an English headmaster at a stuffy boy's prep school, he was just a man like any other. A man who liked the occasional bite to eat and appreciated a good pair of boots. Besides, on the topic of "biting," the General seemed about ready to bite an engine block in half, so Sultan decided not to press the issue.

"Come on, Sultan," said Bayer, leading the maverick out the door. "Time to meet the team..."

CHAPTER 7

The local diner was known for the worst eggs in town and coffee that tasted like it was filtered through a king rat – a phenomenon in the vermin world wherein rodents become intertwined through a quagmire of tails and filth. *Sultan ordered a third cup.* He swigged his java like a man who was pissed, and caffeine always soothed him because the weak stimulating chemicals were no match for his natural adrenaline. He had a mouth full of dirt-brown scrambles filled with egg shells – just the way he liked them. "Dammit, old man, I work alone," Sultan said.

Sitting beside Bayer in the booth was a young woman in a rock-n-roll shirt, with a threadbare beanie and blue hair, busily typing into a fancy laptop. Midtwenties. *Probably a nerd.* A subculture whose dependence on technology was single handedly ruining society.

Technology. Sure, medicine and cars were fine in small doses, but all that cybering – "page me," "fax this" – was ruining life. Gone were the days of handshakes. Of learning the fiber of a man's fabric through simple conversation and skulking. Now, thanks to the nerds like the blue-haired "tech expert" who sipped her fancy "choochoochino" or some such, all we had now was *The Grid.*

"Debz is the best in her field," said Bayer. "Besides, you didn't think we'd send you into the field blind? Not in today's America. First Kosovo.

Then Benghazi. Nowadays everyone with a government salary has to raise their hand and ask nicely before so much as blinking."

Sultan mulled the girl's name around in his head. *Debz.* The "z" most likely an affectation. She was from one of those generations with a fancy name – The Becomers, or Adventurists – one that made every member feel like they were heroes in a story, without even lifting a finger. Unless of course that finger was about to press right back down on a keyboard used to type and click out a theoretical life on the information superhighway. *A digital native.*

"Look, you asshole," she said. "I'm not thrilled about being your eyes and ears either."

"Good, Blueberry," he said. "Because I need extra those like I need an extra pain in the ass. I respect girls in the workplace – burn the bra and all that women's lib bullshit – but you're probably better off with one of the desk-jockeys back at Langley. Hang with me, toots, and you're liable to get shot, pregnant, or both."

Bayer looked nervous. Debz gulped down a huge bite of a vegetarian breakfast burrito. Unfazed.

She said, "I know your type, Cave Man. A so-called 'maverick' who's really just a deadbeat. Pretends to be a hero, thinks every woman you meet is into you, but secretly hates himself and would rather point fingers at the changing world than put the slightest effort into changing himself. Damaged and searching desperately for the mission that'll do what you're too afraid to do yourself."

She made a mocking "drinking" pantomime, then a blowing-brains-out hand gesture, using a pinch of Sultan's scrambled eggs to imitate brain matter.

"Listen, jabber jaws," Sultan said, standing up. "The only reason I'm not giving you a hot oil facial in the deep fryer right now is because Bayer tells me you got info about my dad. But that can change in an instant." He dusted egg bits off his jeans, pocketed a fistful of tiny jams from his table, as well as the neighboring tables, and headed for the exit.

"Sit back down, Theo," said Bayer.

Debz said, "Aww, big Cave Man baby's taking his toys and going home?"

Sultan spun around and yelled, "Look, youngblood, all that technology you know how to use is really just an addiction worse than Afghani black tar heroin. Now if you'll excuse me, I got a dad to find."

Debz unzipped her messenger bag and flopped out a stack of papers.

She said, "Then I guess you're not interested in this list of every theme park in the world with a log flume ride."

He stopped in his tracks and marched back to the table. Grabbed up the printout. There had to be about 300 amusement parks here. It painted a grim portrait of the state of human civilization that we needed so much mindless entertainment. People would rather cram into hour-long lines, ass-to-crotch with the morbidly obese than pick up a book or ponder the cosmos. Finding out where this photo was taken would be like looking for a needle in a cholesterol filled haystack.

"I also got an encryption sourcing program running on your photo as we speak," she said. "It'll give us the location of the fax source."

Sultan sat back down in the booth.

"You two are going to be the death of me," said Bayer. "Now Debz, show Theo what you showed me."

"Let me guess," said Sultan. "You want to teach me how do an 'email.'"

"It's about Entwhistle," she said. "He's not the only missing father."

CHAPTER 8

Debz flipped over her fancy laptop screen to reveal a map of the United States. Seeing all the States that made up America always gave Sultan pause. He thought about the potential for life, liberty, and the pursuit of happiness – and how Big Government had bargained that potential down to "lifelessness, lethargy, and the pursuit of flabbiness." *Citizens lived in a country-shaped coupon.*

This particular map was marked with various locations for each kidnapping: Texas, California, Georgia, Indiana, Maine...a few out of the country.

Bayer said, "Remember, Theo, locating Entwhistle is top priority. "

Sultan said, "You're the boss," swigging his fourth cup of the bile-like java. He recognized the pattern immediately. *But did she?* "Your little See-and-Say tell you all that, *Blue's Clues?*," he said, digging into a tiny jam with his filthy pinkie. The children of his second ex-family insisted on watching that show, so he knew the reference.

Debz said, "Yeah, Barney Rubble, and it also told me another thing you might be interested in: every one of them were not only fathers, but *perfect* fathers."

"I'm listening," Sultan said. It was clear no one here saw what he saw. Bayer looked pleased.

"As you know," Debz continued, "the Patriot Act allowed for all sorts of surveillance. But not all of it was for terrorism. For instance, in 2008 the U.S. Government monitored all exceptional acts of fatherhood – exceptional fathers were given behind the scenes perks to encourage family values: free hotel stays, tax breaks, better healthcare – that sort of thing. Thus the Dadtabase was born."

Sultan said, "The Dadtabase? Gee, what'll they think of next?"

She said, "CIA's beta-testing a program that tracks people with recent haircuts."

"Operation New Do' is Classified!" whispered Bayer.

"Look, it's great your overgrowm calculator can do all that," Sultan said, "but once again technology has overlooked one very small detail."

"Oh yeah, what's that?" asked Debz.

"The cosmos," he said, grabbing a few scrambled eggs off Bayer's plate, and eating them like peanuts.

Debz said nothing.

"What are they teaching you in school these days?" Sultan said, happy to establish his authority over the sass-mouthed Debz. "All those eight points on your computer, they make up eight of the nine main stars in Leo," Sultan said. "And I ain't talking the pretty boy in *Titanic*."

"Of course," Debz said, rotating her computer screen to see the pattern. "How did I miss this? The pattern is a constellation..."

"Not just any constellation," Sultan said, "It's the Constellation of the Fathers."

Debz said, "Which would mean..."

"Ninth kidnapping's going down in Brazil."

CHAPTER 9

Three Days till Father's Day

The Dadcentennial Celebration in Rio De Janeiro was the country's second largest festival next to Carnivale. Bringing together dads from around the globe, the three day event celebrated fatherhood through music, displays of acrobatics, theatre, characters on stilts, stand-up comedy, Chinese-style parade dragons with paper mache dad-faces, as well as food, family, and fun.

It was also where the next kidnapping was to go down... Sultan intertwined his fingers behind his head in a "relaxed" pose, though internally his body and mind were running at a constant level of DEFCON 5. He was now in a secret government facility surrounded by technology, so naturally he was on edge. Just the thought of all the human jobs taken away by things like "Wi-Fi boxes" or "ergonomic keyboards" made him mad enough to backflip from here to Mexico.

The room was standard military layout: clean surfaces, straight edges – like a computer built to play chess had changed careers later in life to interior design (using cushy fed handouts) and this was its first gig.

Overall, it was something Sultan had seen a thousand times in his career shining brass till his back ached: a top secret lab funded by the DoD, like a hidden apartment kept for flings with a private mistress. Here

the next generation of war technology was being developed, tested, built, and shipped off to battlefronts all over the globe like some demented form of Christmas. Only these toys were designed to kill not by Jolly Ol' St. Nick, but by Pentagon Claus, who rewarded naughty girls and boys with smart bullets and MQ-9 Reaper drones.

One of many hidden line items on the endless "honey-do" list footed by the American taxpayers. The system was broken, no doubt about it. Broken like a smashed-in storefront window during a riot free-for-all. Take what you can carry and leave the rest. The American Dream? *No, the American Scheme…*

Sultan didn't want to even be here in the first place. Every instinct in his body told him to ditch this whole kidnapping gig and instead check out the list of amusement parks with log flume rides the blue-haired freak had given him. But after delivering last night's breakthrough, Bayer promised a development with the photograph of Sultan's father. Besides, coming down here he could further enjoy his victory over Debz and her so-called "technology." Forcing strangers to realize how much money they had wasted on so-called "higher learning" always warmed the cockles of his heart. Plus the sooner he solved this kidnapping, sooner he could give his dad a piece of his mind – *a fist-shaped piece.*

Pissy little Debz clacked away on her computer and took intermittent sips of her fancy coffee shop coffee – some spice latte mocha-B.S. all the kids these days were drinking.

"Yo, Brainy Smurf, no need for the silent treatment. I won plain and simple," he said.

She said, "You didn't *win* anything. There's nothing to win. Everything in life isn't a competition."

"Ha! Yeah right. Sure thing, kid. Kumbaya right back atcha. Now tell me what news you got on the photograph so I can get back to what's really important..." She ignored this last part, lost in something on her computer screen. She muttered to herself, "*fraternitatem patrum?*"

"Yo, kid," Sultan said, "should I call a stroke doctor, or you wanna tell me what you're blabbing about?"

"The pattern – the constellation of Leo – it matches a ritual performed by a secret society."

"How secret we talking here?"

"Makes the Knights Templar look like the Kardashians at the MTV Movie Awards."

"Again, toots, in English?"

"*Fraternitatem patrum* – the Brotherhood of Fathers. They claim to be descendants of the high patriarchs of Atlantis."

"Don't believe everything you read on the World Wide Highway, kid."

"No, I just heard back from a contact who earned her degree in Symbology from DeVry. Wild bitch, but chill."

"I'm sure your pen pal's a real gem but save it for your e-blog or whatever. Now, you got news on the fax origin of my dad's photograph or what?"

"Yeah, it should be done encrypting any minute. Holy shit, this ancient Atlantean ritual prophecy thing says a Seahorse Man will one day rise to collect the blood of nine fathers, all in the same pattern as the Leo constellation."

"You got to be kidding me. Like a man with the head of a seahorse?" Sultan asked. "Sounds like you been watching too many horror movies."

"See for yourself."

Her screen displayed sketches of a monstrous figure, like something out of an old book of fairy tales, or a sacred text that should be hidden behind museum glass away from the germ-ridden sneezes of snot-filled children doing their part to cause the world's next great epidemic.

The creature's eyes were cold, lifeless. Its head was covered in hundreds of minuscule ridges, like the surface of some expensive potato chip.

Debz said, "Kind of looks like you, actually."

Theo said nothing.

"She claimed this is the Atlantean Year of the Father."

"Good for them."

"Five days from now is Father's Day, Sultan. But not just any Father's Day. The 'Guardian Moon' will be in full display."

"I'll be sure to shine my telescope."

"You're still not getting it: the Atlanteans believed that once every 10,000 years on the night of the Full Guardian Moon an ancient Dad God will return to Earth to purge this world of paternal sin and bring about 10,000 years of good fatherhood."

"Again, in English."

"Someone is trying to conjure Papanatra."

As if on cue, the lights flickered, but this wasn't out of the ordinary for a government building. Besides, if someone was trying to mess around with the dark arts, it wouldn't be anything too new to Sultan. He'd dealt with plenty of mystical sickos during his time in the vigilante game. While once thwarting a copycat of a copycat of a copycat of the Zodiac Killer, he fed the unoriginal maniac into a thousand gallon cotton candy machine. Ancient dad-majicks or not, these nut-jobs all had a "message" and Sultan's response always ended with a bullet hole as a period. Or a bullet hole as the dot-part of an exclamation mark. Or also the dot-part of a question mark. And instead of MLA or APA format, Sultan preferred to cite his sources in *DOA format*.

Still, his days in Mexican shamanism witnessing things such as goat resurrections had taught him that there are some pretty damn inexplicable things at play in this towering inferno of a looney-bin meets bullshit farm we so foolishly call "everyday life."

"Look, kid, if some weirdos think they're summoning anything more than a first class buns-whooping from yours truly, they got another thing coming. I just want to find my dad."

"Well, someone is following in their footsteps. In the meantime, I'll have to do more research."

"And I'll have to do more *me-search*," Sultan said, "I don't care if a family of satanic sasquatches is behind this. Blood-spells or not, the next kidnapping's going down in Brazil. Now about that photograph..."

She spun around to another computer and said, "Alright. Looks like the signal is done triangulating."

"Hey what do you know, you *are* good for something," he said, picking some days old meat from his teeth and gums and eating it for sustenance. "So where did the photo of my dad come from?"

"That's strange," said Debz. "It *also* came from somewhere in Brazil."

CHAPTER 10

It was all too convenient. A signal concerning his missing father. A pattern pointing to the same place. Someone was trying to tell Sultan something. But either way, he needed to quit horsing-off here and get to Brazil already.

Sultan said, "Then what am I still doing here?"

"Working on your cover," shouted Bayer from the doorway. He looked weary, under the queasy military light. This kind of life made piles of diseased mush out of the world's bravest men. Turned heroes into old hash browns. He was accompanied by two tech-savvy grunts wheeling out a wood crate the size of a refrigerator. The words "TOP SECRET" were stenciled all over it. Sultan always thought that truly "top secret" things shouldn't say the words "top secret" on them – seemed counterproductive. One of the tech grunts used a crowbar to pry open the front cover. Its contents were obscured by the billowing dry ice fog pouring out.

"Cover, my ass," Sultan said. "I told you my plan already: go to this Dad Festival in Rio as an undercover dad *alone*. I draw out the kidnapper *alone*. I find out where he's keeping Entwhistle *alone*."

"And I told *you* already: the Dadcentennial Celebration is for fathers with families only," Bayer said.

The fog from the crates continued to dissipate. Some human-like figures took shape.

"No one without a family is allowed within 10 miles of the festivities."

"Then I'll infiltrate. It's what I do."

"Too risky. We need your cover as a father to be believable..."

Just then a lab grunt with an infrared scanner beamed a red field across Sultan's face.

"Hey! What is this? I ain't a grocery store vegetable!" Sultan said. Bayer took a deep breath and exchanged a nervous glance with Debz.

Bayer said, "You need a decoy family..."

The scanning device made a "ping" as the crate fog cleared completely, finally revealing its contents: two figures. A woman with silky brown hair, lips that oozed sensuality, eyes like rarest jade, and supple curves that turned her PG-13 slinky floral print dress into a Hard R. The box woman resembled a 20-year-old Catherine Keener. Sultan had met beautiful women before, but this one was pure dynamite. *He was already thinking of ways to light her fuse.*

The boy beside her looked aged anywhere from 7–10 and had a certain stoic quality that reminded Sultan of a young him. In fact, he boasted the same exact facial features, only aged down. Even had the same cowlick Young Theodore grew up with. He looked tough, emotionless, and wore overalls.

Oshkosh B'gosh.

With not a little grandiosity, Bayer swept his cane and said, "Theo Sultan, meet Cissy-1 and Boy Bot. Your new family."

The two figures methodically stepped out of the box. There was something off about their movements. Mechanical and precise. Plus, what was with the names? *Maybe they were from that Weird Sleeping Giant to the North, Canada...* Then it dawned on Sultan: these two figures were something far worse than Canadians.

They were technology.

"No way," Sultan said. "I ain't working with one of *those things.*" The two machines stared straight ahead as the lab grunts tinkered with their circuitry.

"We used high tech software to make sure this kid looks just like you," said one of the grunts. "It took us forever to get the hair right, but Debz helped us crack the cowlick algorithm."

The boy's face reacted with blinks, winks, and mouth twitches. Sultan glared. As a boy, he had nearly been pulled under by no less than twelve escalators. The notion of machines one day rising to take over the world was not an "if" but "when" situation, or "shituation," as Sultan often called it while talking to strangers at bowling alleys. That's why he regularly refused to be in the same room as calculators. The stronger machines got, the weaker humans got. Not to mention that non-technology based human families already made men weak, and a whole family made of technology? *Forget about it.*

"You get those chrome-domes out of my face this instant," Sultan said.

Bayer said, "We searched our human agent files for compatible personalities to form an organic family unit complimenting your, er, stubborn maverick ways..."

"But you're too much of an a-hole for people to deal with. There's medical waste with way better interpersonal skills than you," said Debz unhelpfully.

"These machines will adapt to your behavior and provide the illusion that you are a good father. They'll help you blend in at the Dadcentennial. They won't even know your real name," said Bayer.

"You won't have to lift an emotional finger," Debz said. "Which is good, Theo, because the only emotional finger you have is the middle finger." The lab grunt messed around behind the female whose eyes locked onto Sultan's. As the grunt turned a screwdriver on her lower back, the robot's expression softened into one of both respect and lust all at once. "Lustspect," was what Sultan called it in his internal dictionary. Or "Respust."

How long it had been since the fairer sex had looked at Sultan with lustspect *or* respust. For a flea-second, Sultan could swear there was a human soul inside that bucket-of-bolts. No. Just a trick of the eye. A long con from the boys back at Langley. He had fallen for the same trick three times over about his ex-wives, when really what they had instead of souls were black holes designed for the express purpose of wasting Sultan's time and strength. No way these machines were to be trusted.

Sultan said, "Tell me something, Bayer. Why's the Pentagon opening up its checkbook for a missing civilian?"

Bayer said, "Why does anything get done in this republic? General Stuphs has friends in high places and loves his daughter very much."

Fat cats defecating in the litter box that was the American tax payer's gross income.

"That all?" Sultan said.

"Yes, that's all," Bayer said. "And unless you want to pay your own way to Brazil I suggest you quit this nonsense and do as you're told."

"Well, if these these wingnuts are so hi-tech, let them track down Runaway Daddy," Sultan said holding up the log flume ride photograph. "I got a family reunion to attend." Suddenly the boy robot stirred.

"Daddy?" said the Boy Bot.

Sultan temporarily went blind with shock. It had been ages since anyone called him the "d-word." He thought of his own ex-sons. How they selfishly looked up to him for protection. Looked up in search of guidance. How much personal courage it had taken for Sultan to reject their boyish attempts to hoard his affection. How much maverickness it took to make himself emotionally vacant around them.

It took so much maverickness.

For in these inconsiderate ex-sons of his – in this Boy Bot – he saw himself as a child. A child without a dad, a child who had only known loneliness, loneliness that had made him the red-blooded American hero he was today. *And no way no emotionless science experiment was going to make Sultan deal with his own emotions.* Still, time she was a-wasting

and Bayer could be a real "bull in a kiddie pool full of pudding" when he wanted to. Sultan's best bet was to play it cool until they got to Brazil, then ditch these wrench-jobs on the mean streets of Rio.

Then, as if picking up on Sultan's innate importance, the Catherine Keener looking robot gave him another look of respust, took her son's hand, and knowingly said, "Come, Junior, let's leave your father alone. He's got it hard enough and doesn't need our problems to stress him out."

Easy on the eyes *and* easy on the ears. For a machine. *Maybe this sham marriage would work out after all...*

"Fine," Theo said. "Now who's driving us to the airport?"

CHAPTER 11

Seven-year-old Theodore frowned. His parents argued in the parking lot of Ace's Meatplanes. Happy children skipped out of the building's hangar-style doors. Tummies fat and lips shiny with airplane meat. They talked of ham rudders and sausage fuselages. His mommy accused his daddy of being a "deadbeat." They were making a scene. Daddy wanted to poke his head in the restaurant across the street, the one shaped like a Mexican cantina. The one named Cabo Wabo Cantina. The one owned by ex-Van Halen lead singer Sammy Hagar. Mommy knew the real reason why daddy wanted to go inside the large palapa structure. Her husband was looking for "him." For the man that ruined daddy's life.

Maybe it was the altitude, or maybe it was the 19 bottles of tiny tequila Sultan had imbibed, but this robot family of his already made his ex-families look like pond scum in the travel department. The wife spent the entire flight hyper-reading 27 titles of Scottsman-themed erotica and if Sultan was being honest, a small part of him was very impressed at how the Boy Bot didn't need to go to the bathroom once. Not once! For his money Theo Sultan had a bladder like an aqualung and when pushed could hold his own urine for three days straight. Four if he was feeling cocky. Five if he had something to prove. And six just for the hell of it.

No point in getting too attached to the Boy Bot and his impressive pee-storage, thought Sultan. First chance, he was going to ditch these wire-monkeys and see what he could find out about that faxed photograph. The pilot came on the speaker.

"Bem-vindo ao Rio," he said.

The lobby of Rio's "Twin Fathers Hotel and Resort" was opulent in that "make the whole house fancy like a brass toilet paper holder" sort of way. White marble floors, plush velvet sitting furniture, and a central fountain with two golden seahorse statues spouting water into one another's mouths. If Sultan had his druthers, he and his family would be camping out in one of Brazil's famous landfills among the *real people*, but the powers that be reasoned a so-called "good father" would spare no expense for his family and not – in Bayer's words, "let them sleep in South American garbage."

Sultan didn't know about all that, but he did know that his disguise made him feel like a real first class asshole: fishing hat, a polo the color of "coral" tucked into some sensible khaki cargos, all finished off with an even more sensible pair of loafers. An iron maiden would be more comfortable. Unfortunately, he fit right in with the guests of the Twin Fathers.

The check-in line teemed with daddies of every kind: Chinese, Algerian, Jamaican, Russian, Polish, Chilean, Iranian, Mexican, and yes, even Irish. The families of these fathers all stood off, letting the menfolk take care of business. Sultan's own wife and child were busy satiating their robot thirst for boring human information by collecting pamphlets for local tourist attractions. Waiting in line, Sultan's mind couldn't help but wander to his own father figures who filled in after Derick Sultan split.

There was the carnie who ran one of those novelty jumbo boxing rings at the county fair, the feral wolf that lurked the grounds of the abandoned frisbee golf course, Mrs. Genderson, his third grade teacher, and last but certainly not least, the inanimate rusted railroad spike who kept Sultan

company during his time as a boxcar teen. Every last one had contributed to his upbringing in some way, where his own deadbeat father did not.

Just then, Sultan's pocket vibrated. *The damn phone.* He hated the idea of carrying one – even more than forms, the sound of a grown man crying, *and* injustice – but Debz insisted it was the only way to get him updates on his father. He jabbed at the screen trying desperately to make the bland ringtone assigned to it disappear. The apparently popular guitar riff from Grammy award-winning Dad Rock band Daddy Short Legs, drew supportive smiles, pats on the back, and thumbs up from his neighboring daddies before an actually pretty simple solution of pressing a green "Answer" button made it stop.

"This better be important," Sultan said.

"Please tell me you didn't sell off your family for spare parts," Debz said.

"Not yet," Sultan said. He watched from across the lobby as a woman and her children mingled with Cissy-1. The robot wife said something stone-faced and the woman threw her head back in delighted laughter.

"Look at that, you'll get Father of the Year in no time. Anyway, new information has come to light in the last few hours. Mission's changed."

"Says who?"

"Says 'Scottie Doogan.' I'm sending a pic now." Sultan knew from eavesdropping on a young person conversation once during a Greyhound bus trip that "pic" was short for "picture." His phone buzzed and a man's picture appeared on screen. It was a black-and-white family portrait taken on a beach. The man, his wife, and four children all wore a variation of loose fitting white button-ups and jeans. All barefoot. All happy. "Who's the toe-happy beach clown?" Sultan said.

"This beach clown, as you put it, is staying at your same hotel and according to the Dadtabase he could very likely be the next target. He's heavily involved with his kids' PTA, coaches several soccer teams, loves being goofy for the benefit of his family, and regularly contributes to *Daddy Magazine: The Magazine for Dads*."

"I'll be sure to grab an autograph."

"We've booked you in a room just opposite his. Keep an eye out."

"Yeah, yeah, yeah. You promised me more information on the decrypto...algorith...the computer bullshit."

"That's cute to hear you try. Yes, actually the decryption algorithm finished up."

"Kid, how many times I gotta remind you: I don't speak space cadet."

"The photograph fax of your dad originated from one of three places: the headquarters for the parade float committee, a chop-shop that customizes fax-machines, and an all-day night club, called 'O Cavalo-Marinho.'" *The Seahorse* in English.

Sultan thought of the seahorse creature in the etchings. He gazed at the golden seahorse statues in the center of the fountain shooting water into each other's mouths. Someone sure had their theme down.

Debz said, "Just remember, the robots are there to help. They're learning computers. They'll adapt to your behavior. Don't just ditch them Theo—"

Sultan hung up.

"Sure thing kid," he chuckled. The concierge – a man with a bowl cut who's face looked like it was pure marzipan – beckoned with a bleached cow skull grin. Sultan approached.

"I trust you're enjoying your stay?" he asked. Sultan handed the clerk his fake credentials.

"Ah, Mr. Meyerson," the clerk said.

"Yup."

"Here for the Dadcentennial?"

Sultan said, "Wow, pal, it's like you've known me my whole life."

The clerk laughed way too hard for way too long. Beneath the desk, he frantically pushed a red button.

Sultan said, "Now if you're done writing your nerd's thesis on me, I'd like to get some damn shut-eye."

"Yes, I understand, sir."

Across the room, the head on one of the golden seahorse sculptures rotated just the slightest bit in Sultan's direction. From the ocean creature's snout a tiny camera penetrated the water stream and focused on him. *Snap-snap-snap.*

Suddenly, a smiling bellhop appeared at Sultan's side who looked eerily like the desk clerk, marzipan features and all. His name tag read "Therezio, Son."

Off Sultan's furrowed brow the desk clerk said, "We here at the Twin Fathers support fatherhood so much that our entire staff is made up of father and son pairings." Sultan looked around, and sure enough identical faces peppered the ornate lobby, different only in age.

"That's pretty weird," said Sultan.

The father and son laughed for an uncomfortable amount of time.

"Right this way, sir," the younger one named Therezio said, taking Sultan's family luggage. Sultan whistled for his wife and child, then nodded toward an elevator. They wordlessly, mechanically followed his command. His ex-families would've turned this sort of thing into a whole production. Robot Family: 1. Ex-families: 0.

A few screens down, another desk clerk watched this scene unfold. In an open chat box, he typed a message: *o maverick chegou.* In English: "The maverick has arrived." A user named "Papa347" replied with a simple seahorse emoji. *Accompanied by a knife.*

CHAPTER 12

The blows you don't see coming are the blows that will kill you. Despite his training as a Navy SEAL, as a lawyer, and as a survivalist, Theo Sultan never could have predicted the thick and steamy FUBAR stew he'd just landed in as star ingredient – all thanks to his robot family. For while Sultan was waiting in line, it just so happened that Cissy had been chatted up by a random wife who just so happened to belong to the potential next kidnapping victim whom Debz told Sultan to surveil. The two families had ridden the elevator upstairs together, where the pushy human wife and Cissy had made plans to visit the festivities of the Dadcentennial together that same day. It went without saying that she was clearly into Theo.

Still, Sultan would rather keg-stand a barrel of hydrochloric acid.

Which is to say, the last thing he wanted to do was play secret bodyguard to this soft as silk beach clown. A man who by the looks of his hands had never known an honest day's work.

Outside on the sunny streets of Rio, the Dad-centric festival maintained the vibrant feeling of a music festival, farmers market, and parade all rolled into one. The buildings even seemed to smile and the city felt not only alive, but grateful. Sultan and the two families pushed through throngs of ecstatic fathers holding children up for better

views of things like father-son glassblowers and father-son accordion monkeys. Teachable moments were a dime a dozen and seized on by all too willing fathers.

The target-dad, Scottie Doogan, merrily joked with his kids and displayed affection freely with his own wife. Meanwhile, Sultan's own robot family interacted with the humans in a clunky call and response manner. The human wife would say something like, "How are you liking Brazil so far, Cissy?" and the wife robot would stare for a second while the question processed, then reply, "I find the country to be highly enjoyable. The humans of this land area seem especially zesty" and the Doogan wife would have a giggle, then go right back into hearing herself natter on about nonsense like recipes or car seats.

Boy Bot walked along silently with perfect posture not complaining about hunger, nor pestering his dad for souvenir-trinkets, nor asking to be carried. Sultan wondered if his ex-children would still be in his life today, if only they'd behaved with such self-control. *If only...*

Physiognomy – the art of telling a man's character by his facial features – had long been "debunked," leaving the field wide open for Sultan to develop his own version of the so-called pseudoscience. A kidnapper's brow plunged down, had nostrils that flared from not breathing out of the mouth, in order to stay quiet while sneaking up on victims, and had a mouth that–

"Say, Luke," Scottie interrupted, addressing Sultan by his alias, a child asleep on his shoulders. "What's your favorite part of being a dad?"

Christ Almighty. Sultan drew a blank.

He said, "Well I uh. I guess it's good...sometimes you can get discounts places. Like food places."

Scottie seemed puzzled, then said, "For me, it's that feeling I get when I look in my child's eyes and just know that there's something bigger for all of us. I feel honored to be a part of it." A tear formed in his eyes, and his wife joined him. His children hugged him and they all cried

together, as they all walked by a tented comedy stage. Sultan watched with a triumphant smirk on his face. Whatever game this beach clown was playing at, he clearly lost. *Whoever cries always loses.* He couldn't help but shake his head in amusement at the flagrant public display of weakness. The Boy Bot took its cue from his ersatz dad and pointed and laughed at the weeping family. Even Cissy stifled a giggle. But the bonding moment betwixt father and robot family lasted only a moment, as a comedian performing on the stage set his sights on Sultan.

"Look at this dad, folks," the comedian said, referring to him.

"I bet he doesn't just have a 'man cave,' he has a 'man cavern.'"

A crowd roared with laughter. Scottie Doogan smiled looking over his wife's shoulder.

"Just go with it, Luke," Doogan said, his eyes still red with tears.

The comedian made a somber face and addressed Cissy.

"Ma'am," he said. "I hate to be the bearer of bad news, but I can tell your husband here is having an affair."

Cissy cocked her head.

"Yup, her name is Miss Fishy N. Pole," the comedian said with a self-satisfied look that came with knowing full well the audience was in the palm of his hand.

The crowed roared with laughter. Sultan felt like a poor wild animal being abused for the amusement of a North Korean government official. Stranger-to-stranger humor was something he didn't find very funny – especially when he was the butt of the joke. (In some ways "jokes" were a form of word-technology that Sultan didn't entirely trust.) Besides, he was supposed to be looking out for a kidnapper, not providing yuks.

Which is to say, if Sultan couldn't get ahold of himself fast, there were going to be deaths. The guffaws grew stronger with the comedian's impression of a sexy anthropomorphic fishing pole. An accompanying keyboardist played "bawdy melodies." Even Scottie joined in with a wolf whistle. All Sultan could hear was the pounding of his own adrenaline. All he wanted to do was hop on stage and tell a joke of his own: *Knock*

knock. Who's there? A microphone cord. A microphone cord who? A microphone cord fed through your entire damn digestive tract you filthy chucklehead. Sultan felt so helpless he might as well have been a child in need of motherly comfort. Like it or not, his emotional needs registered with Cissy's hardware, because next thing he knew her hand was sliding into the back pocket of his shorts. Then she was getting his attention with her eyes of jade. Then making that face. *That face of lustspect. That face of respust.*

His adrenaline lowered, even though he knew beneath her come-hither stare, her heaving bosom, she was all wires and gears. But Sultan also knew he hadn't felt a calm like this since he walked out on his last family. And that was it. He was hooked.

As their lips met – his pillowy, hers precise, the jeers and snickers faded away like the fog of war retreating in a military operation. Sultan went with it. It was centrifugal motion, perpetual bliss; *a pivotal moment.* A moment where he forgot she was a robot. When he forgot he was a dad. In fact for a moment, he forgot they were anything but kissers.

"And that's my time folks!" said the comedian. He zoomed off the stage, having worked up a considerable sweat during his set.

Sultan could've stayed in that impossible, unstoppable moment for at least five minutes, but something in the back of the courtroom in his mind told him to open his eyes. As he did, he saw a man standing in the distance. Staring covetously at Scottie. *He had the brow and earlobe ratio of a kidnapper.*

The sound returned. Then Sultan realized what he was doing, how he was sharing oral intimacies with a *machine.* He pulled away and stumbled a few feet back. The Doogans looked proudly at the "Meyersons," like Sultan had passed some sort of affection test. Cissy looked confused yet serene. Sultan had never felt dirtier. He scanned the area for the kidnapper. He was nowhere in sight.

"I'm hungry!" exclaimed one of the children.

"Come on, Kissy McGee, save some for the hotel room," said Scottie wiggling his eyebrows and referring to sexual intercourse between two consenting adults. Cissy gazed longingly at her fake husband. Such was Sultan's effect on the opposite sex. But she was sexless. She was a robot. Still, something seemed different in her jade Catherine Keener eyes. Something alive.

"Why don't we dad-folk go rustle up some grub," said the beach clown.

Sultan said, "Yeah. Sure. Sounds good." He headed off with Scottie Doogan in hopes the kidnapper would show himself again. Cissy watched as her husband disappeared. *Was this what humans called...love?*

CHAPTER 13

"So, anyhoo, that's how I got into the eco-friendly pool toy industry," yammered Scottie Doogan.

The dads walked away from the festival off the beaten path to find what the beach clown described as "authentic Brazil."

Doogan had performed something called a "Yelp" for a "to die for" eatery a few blocks to the south, in the Favela District of Rio, just through the Uzi District and kitty-corner with the Capoeira District.

Sultan couldn't help but notice the many downtrodden families eking out a simple existence as best they could while living under the thumb of bureaucrats. That was the real poison to the Earth – *bureaucrats.* Not the literal poison in this neighborhood's non-potable water, not the poison that those here lucky enough to get toxic factory jobs absorbed into their lungs, but rather the layers of decision-making that plagued every organization in this modern age.

Now they were amongst the cobblestones and street vendors and children playing *futebol*. Sultan noticed a baby curled up in a car tire, snuggling a rusted old Uzi. The automatic weapon had a flat butt and straight comb, plus hollows for the cleaning rod. First generation. *From womb to tomb*, Sultan thought. These were the real citizens. Not your well-to-do soccer moms or your coworkers celebrating inane holidays

like "National Bow Tie Day." No, these were your Salt of the Earthers, telling the same story the world over. *Once upon a time the wealthy dropped trou and told the poor to "open wide."*

He kept his eyes peeled for that kidnapper, but couldn't help but think about the robot wife. He couldn't afford to open up his strong, well-fortified heart to someone new. There it beat in his No Man's Land chest, surrounded by landmines, barbed-wire, mud, rats, shells, gas clouds, and corpses of young men ripped from this mortal realm in the prime of their youth. It was as much for his protection as for hers. *Besides, she was a robot...* "What line of work are you in, Luke?" the beach clown said.

"Huh?" Sultan said, his head on a swivel.

"What's your livelihood?" said Doogan.

"You might say I take care of my rich uncle. Uncle Sam," Sultan replied. *Uncle goddamn Sam.*

"That's nice," said the beach clown. "You get to be around family at least. Family is the most important thing...Luke?" But Sultan had stopped dead in his tracks. He was having a hard time focusing on the inane chatter of this beach clown, for just beyond the crowd was something far more enticing: a Brazilian gal in a red dress with a nice ass. The kind of ass that could move mountains. *The kind of ass you'd want to have Thanksgiving on.* If there was one thing Sultan was a sucker for it was a nice ass. *Lovely lady lumps.* Cissy had an okay ass for a robot, but here he was in the country that mass-produced real live human ass like it was going out of style. *In Brazil, ass didn't just survive – it thrived.* But what really caught Sultan's attention was the sign above the ass-haver: Cavalo-Marinho. *The Seahorse.* It appeared to be a nightclub, though open in the daytime. Thick black doors. Huge bouncer. Music thumped from within. But most importantly it was one of three places the faxed photograph of his father maybe came from. The mystery lady disappeared inside and Sultan followed, beneath a glowing sign that depicted an inebriated seahorse reclining in a martini glass.

"You stay here, I'm going to find a restroom..." he said. The beach clown grabbed him by the wrist. Sultan had turned men into human wiffle ball sets for less.

"It's not worth it Luke, trust me," said Scottie. "You'll tear your family apart, and for what? A red hot taste of the local color?"

Sultan said, "Relax, I'll only be a moment. I got to see a man about a horse. *A seahorse.*"

"Ah uh, I want no part of this," whined the beach clown. *Crap*, thought Sultan. The last thing he needed was Scottie Doogan drawing out the kidnapper while Sultan wasn't around. At the same time, this might be Sultan's only chance to get to the bottom of his dad's faxed photograph. He decided to chance it. Besides, Sultan *was* a maverick wasn't he? He had been on this mission nearly a full day, and still hadn't done anything his own way. Plus, if this beach clown couldn't take care of himself, what chance did his family have? Perhaps they were better off.

"Say, Scottie," he said, turning to the club. "Be careful."

"You're making a mistake, Luke!" said Scottie. His voice grew faint as Sultan approached the entrance. With every step he could feel the pulse of that box-shaped concrete animal grow stronger.

The bodyguard wore an ox-blood suit with no shirt underneath. His arms were as big as rolled up sleeping bags. His tiny, shoulder-length braids shimmered beneath the hum of the neon sign. Behind sunglasses that seemed welded onto his hulking skull, the giant looked Sultan up and down then nodded him in. Inside, more neon lights flitted across the dance floor which itself cascaded in squares of candy-colored lights like a mad hatter's fever dream. Only 2:00p.m., and the place was packed like Studio 54 on a Saturday night. He scanned the crowd for the mystery gal. Several hoods glared at him. A few brandished Uzis in their waistbands. That little bullet-spewing darling of Israel, brought screaming into the world by Major Uziel Gal back in the 1940s, and enjoying a well-traveled life full of wanderlust through such scenic attractions as Vietnam, the Miami Drug Wars, and more recently Brazil's own Operation Traira.

But his eyes were focused on something far more deadly: there in the middle of the dance floor Sultan spotted the mystery lady. She danced alone. Which is to say, even with a thousand partners, her's would always be a solitary presence. Like she was a ballerina in a music box. She seemed like a regular here. Perhaps she could give Sultan some information. *Perhaps she could give him something more.*

As the beat built up, he moved through the crowd, making sure to rhythmically bob and sway through skeptical glances and eye-rolls and shoves. Nothing infuriated a dance floor more than one who broke the flow. For a dance floor was like an organism. A school of fish. A pack of wolves. Those Uzis weren't in those waistbands for nothing. Finally he was an arm's distance from her. She shimmied and scooted all around him like an angel made of kelp, like sweetest incense, or also like just some shoelaces burning. Never breaking eye contact through the flames that were her cocoa gaze. Sultan gave it right back.

When it came to the dance floor, Theo's hips were like fresh cream. She pressed her lips to his ear, and said, "I am Bianca." His upper-thighs moved in-sync with her dips and sways. *Her oh so many gyrations.*

"I am a fan," Sultan breathed hot and heavy into her inch-worm ear. She swished and jolted like a witch possessed by a demon. A demon known as Dance.

"Come here often?" he asked.

"Sometimes here. Sometimes in bed. Sometimes in the waves of the beach."

Theo knew exactly the two meanings going on here: one was about sex.

He said, "Tell me, who owns this place?"

She placed a finger to her luscious lips in a "shhh" motion as the beat grew stronger and stronger. They were in the shadow of an aural tidal wave.

Sultan said, "I need to speak to the manager. It's important–"

Suddenly, the beat dropped, and the crowd cheered. The DJ nodded along, pointing one hand out to the dance floor where a shower of soap suds flooded from all corners of the room.

She threw her head back in ecstasy while the white foam enveloped her form. She planted both hands on Sultan's shoulders, slid them to his shirt, and tore the entire polo off. Sultan's abs looked amazing, like a vertical tray of baby armadillos. The lady in red then arched her way up along his frame. Her damp hair flicked up Sultan's matinee idol chin like a shammy in a gas station car wash. He hadn't showered for weeks – half out of principal and half out of spite – so the liquid ran dark down his bodily features. Bianca traced a dirty path of man-bilge and licked it.

Though Sultan was happy charting the movements of his dance partner's ass, instinct made him check his peripheral. He noticed a man on the second floor holding a long tube in his mouth, angled downward. The parade of neon made it hard to discern the object. A really long cigarette? A Slim Jim meat rod? Then a wave of green revealed his features: it was the kidnapper from the streets. His cheeks were puffed, though not in order to smoke a very long cigarette but rather to operate the skinny weapon between his lips. An Amazonian blowgun.

Ffllitttt. A sliver of a projectile headed right for Sultan. He whirled Bianca around. She clutched her neck where a dart the size of a cactus prick now stuck. A dart that was meant for Sultan. He plucked the dart out, arranged it so that only a single taste bud hovered over the dart's tip. Near enough to diagnose any coating, but still safe from the toxicity. Sultan knew in an instant what it was: curare. A natural paralytic used by tribes to hunt. Eyes faded, Sultan lowered Bianca through the layer of suds and gently to the ground. Like Sleeping Beauty. *Or Sneaking Booty.*

Sultan shoved his way through the unawares crowd toward the swirling stairs that lead to the second floor. He watched as the man with the blowgun disappeared into a orange door. There was a sharp whistle from one of the Uzi guys. A signal. The dance floor cleared, like this sort of thing happened all the time. Like a disturbed school of fish. Sultan

stood up to his waste in suds, alone with the remaining thugs like a rock at the bottom of the multi-colored ocean floor.

Which was a problem, mainly because Sultan thought he should go upstairs whereas the four Uzi men (already choosing which part of Sultan they wanted to become Swiss cheese) and now the Bouncer (already deciding what to do with Sultan's detached head) appeared to feel otherwise. He knew then and there the next dance he'd be performing was the "Foot-to-Ass Shuffle."

He would lead.

"Hey, fellas," Sultan said, shirtless in his canvas shorts. "Let's make a deal: you get out of my way, and I won't make you eat your own teeth like raw Skittles." The four men looked at each other, then raised their semi-automatics. The Bouncer took off his sunglasses. He cracked his knuckles. It sounded like a snapping turtle biting bricks.

"Suit yourselves," he said.

Before the bullets flew, Sultan took a softball-size amount of suds in his palm and blew using his exceptional lung capacity so that conglomeration of soap stung the Bouncer's exposed eyeballs. The hulking man swatted at his face like wasps were laying eggs in his eyes, just long enough for Sultan to drop beneath the surface. He had his sights set on the slippery floor. Pushing off the unconscious, springy rump of Bianca, he both ensured none of the stray bullets would hit her and was able to propel himself towards the stairwell, sliding across the dance floor on his slick exposed chest and stomach like a seal. In the Navy Sultan had learned all sorts of fighting styles: Filipino stick battle, Jun-jatsa, Tak Megu – but none of these amounted to a hill of beans compared to his favorite and self-developed fighting style: Kikka Ya Assa. It was something akin to a steamroller made of rottweilers all on angel dust. And that's when Sultan was feeling friendly.

Down below the safety of the suds he punched dead straight into the kneecaps of the first gunman. Bone shattered. The thug folded forward and reached for the new explosion of pain. Which meant he let go of his

gun. Which meant it clattered to the floor. Which went off upon impact and did what Uzis were meant to do. Which was good for Sultan and bad for the thug who had just had his legs amputated from the shin down.

So much for his soccer career.

"Now that's what I call breakdancing!" Sultan shouted at the critically injured man. Given the music still pounding, there's no way the man could hear him.

"Don't shoot! Don't shoot!" the man who just lost his legs screamed. A scattershot spray later and his throat looked like strawberry syrup soaked fingerless leather gloves.

Sultan grabbed the dead man's leg stump and the Uzi. There were at least 37 bullets left. The bone sticking out of the leg stump was jagged and sharp. Perfect for Sultan's needs. Biting into the flesh, he tore away chunks of leg to reveal more of the bone. He sucked out the marrow. Half because marrow is good for the body, and half because of what he planned to do next. Steps moved closer. Intermittent shots. They were saving their ammo.

Sultan took a few Winchester 124 cartridges, bit them open like sunflower seeds and dumped the gun powder into the hollow of the bone as far as the incendiary granules would go. He then split the bones out even further, like spikes. Like shrapnel. More steps headed his way. Shouting.

Sultan planted the shoe part of the bone IED upright and rolled as far away as possible. Bullets pierced the color screen tiles of the dance floor turning them black. Sultan was a few feet from the stairwell.

Then he watched. He waited. And just like he'd hoped, the most recent swarm of shots happened to set off the most unique chain of events so far. Which is to say, their velocity ignited black powder in the splayed bone which exploded several nasty shards outward and which in the end resulted in three bodies dropping. Each with bone shards through their throats, foreheads, and hearts. Their blood made the soap suds pink.

Sultan stood up at the foot of the stairs and said, "Fellas, the phrase is 'dance like no one's watching,' not *die* like no one's watching–"

Suddenly he was picked up by the belt of his shorts. The hulking Bouncer lifted him up face to face, his eyes irritated and made Sultan a human speed bag.

BIFFF. Sultan didn't just see stars, he saw the whole universe. He wasn't about to stick around to watch this goon's take on the big bang theory. Dazed, Sultan said, "Hey pal, take it from me: you're on the right career path."

The Bouncer reeled back once more for what was to be the biggest and most painful punch of all, when Sultan unbuckled his belt and somersaulted forward out of his shorts – out of the man's grip – just as the Bouncer's own two hands connected. His meat hooks exploded like two semis in a head-on collision. The Bouncer fell to the floor and writhed in pain.

"Thanks for the hand," Sultan said, slipping his shorts back on. Then he gripped a stolen Uzi and headed upstairs.

CHAPTER 14

Through the orange door lay a scummy, fluorescent-lit hallway with three other filthy doors. Shirtless and covered in suds and blood, Sultan made his way to the first door. He kicked it open. Just nightclub supplies. He moved on to the next door, a red one. Sultan booted open that door and a dart flew right past him, the same kind that took down Bianca. From what little he could see of the room, it was an office. With a fax machine.

As the man reloaded, Sultan stormed right up to him, grabbed the blowgun and smashed it across the man's head. Then Sultan gripped the man by his shirt and slammed him against the wall. He shoved the photo of his father, Derick Sultan, in the man's face.

Sultan said, "Who sent this?"

No answer.

"Look, buddy, I don't got time for no games," said Sultan. "Someone – you, I don't know – faxed this photograph. Whoever it is, you have him to thank for what happens next if you don't start talking."

No answer.

"Alright," Sultan said, using his crowbar of a forearm to pin the man against the wall. "You're not going to tell me why someone's luring me here?"

Sultan dismantled the Uzi with his mouth and left hand. The pieces dropped to the floor at his feet like Lego blocks. *Deadly Lego blocks.* He picked up a piece and shoved it in the man's mouth.

"Say *awwhh,*" he said.

The man refused, so Sultan shoved his fingers up the man's nose. He gasped for air, and Sultan heroically shoved the gun-bit down the man's gullet.

Sultan said, "Who do you work for?"

Nothing.

"Here comes the airplane – *bbbrrrrr,*" Sultan said, once more picking up another piece.

The man muttered something in Portugese. Another gun piece down the gullet. Sultan continued feeding him all the gun pieces, saying mouth-related quips for each until every last part of the Uzi was in the Portugese man's stomach. Some parts were as big as rulers, but Sultan made sure they found their way into the man's stomach nonetheless.

All that was left was to reassemble all the pieces into a functioning gun inside the man's belly.

"Now," Sultan punched him in a strategic part of his stomach. Two metal pieces *clinked* in connection.

"Pretty soon..."

Punch. Click.

"...you'll have a completely..."

Punch. Click.

"...reconstructed..."

Punch. Click.

"...UPP9S Uzi Pro Pistol SA..."

Punch. Click. Punch.

"...aimed..."

Punch. Click. Punch. Click. Click.

"...straight up..."

Punch. Click.

"...at your brain stem."

The man let out a nervous burp and the gun cocked.

"That isn't a good sound," said Sultan. "Unless of course you're a fan of holding your own private Fourth of July fireworks extravaganza where your skull is."

The man defiantly spit in Sultan's mouth. He gulped it down in no time and winked. A habit picked up in his lawyering days every time a deranged military crook would get cute with his saliva. Back then he would have rubbed his tummy for dramatic effect. Give the jury a little show. It happened so often Sultan started thinking about other scenarios where one might spit in someone else's mouth. For Sultan's money, he thought instead of swearing in presidents the ceremony should just be the old president spitting into the mouth of the new. A sort of way to say, "Here ya go, buddy, now *you* take charge of the D.C. Cronyism."

He also had ideas about how the new president should do a ballroom dance with a Betsy Ross impersonator.

"I'm asking one last time," said Sultan. "Who faxed this photograph?"

"Burn in hell," the thug said, like this was one of the few English phrases he had deemed useful to commit to memory.

"Have it your way, pal," Sultan said turning to leave. "Oh, one more thing. If you have to move I would be very careful about it. Those Uzis can be a little sensitive."

"My friend, Therezio," the man finally said. "He works at the Twin Father's Resort. With his father–"

Sultan's hotel. The weird bellhop.

"Keep talking," said Sultan.

The man said, "He pay me to bring you here."

Sultan could sense the man was telling the truth. He always could. In his courtroom days they called him "The Human Lie Detector." *But that was a long time ago...*

"So you were following me. Not the other dad."

"Yes."

"Therezio gave you this photo?"

He nodded his head solemnly.

"Why?"

"To lure you here. Said a big change is coming and you are a part of it."

"Your friend know who took this photo?" The man said nothing. Sultan threatened him by wiggling his fingers at the prisoner's most tickle-sensitive areas. The ensuing body-wiggles would surely make the gun go off, and then the ceiling directly above his skull would become a pretty damn good Jackson Pollock knockoff.

"I do not know," the man said.

"That woman in there. Who is she?"

"My...daughter" the man said. "And those men are my family. I put them up to this."

He was reduced to tears. The kind you cry when you realize the cold hand of karma is about to karate chop your clavicle. The man had said too much already, he was dead either way. He looked down.

"They only tell me to knock you out. That someone would come and finish the rest."

The rest. Like Sultan's mortality was a task awaiting completion.

The man said, "I was to meet Therezio for payment at the resort's swim up bar. Tonight during the happy hour."

Sultan said, "That's where I can find him?" The man's attention darted past Sultan. Up the hall, heavy footsteps sounded. A gurgling noise. His expression turned serious.

"Bicho papao," he said in a hushed tone.

Sultan said, "Hey, I'm talking to you..."

But the man had devolved into pure nonsense.

"Please, you must go!" he said. "Bicho Papao. He is here..."

"Who?"

More sloppy steps. Closer. Wetter.

"The Boogie Man."

The man laughing maniacally.

"Ha ha ha ha ha HA—"

CLICK.

They say it's not the size of the dog in the fight, but the size of the fight in the dog. In the great kennel of history, a single second can be one hell of a tiny dog – a dog as big as a corn kernel, but for the Brazilian with the rebuilt Uzi inside his stomach, this particular second (a second exactly long enough to tell the Uzi clip to go ahead and start sending the first of 600 rounds per minute that the standard Uzi was capable of unleashing right on up and out the barrel pointed skyward) *that second* – in the great kennel of history was a dog with a fight inside it as big as the Goodyear Blimp.

In vain, the man looked up, covering the top of his head with his hands as if he could keep this tiny dog from barking. As if he could hold in the the ensuing bullet storm:

Bl-BL-BL-BL-BL-LPppBl-BL-BL-BL-BL-B-LPPPppBl-BL-BL-BL-Blpp–

Sultan watched as the top half of the man's head erupted like a roman candle, and kept erupting. The trigger must've been jammed. For a whole minute a barrage of shots fired up into the ceiling along with brain matter that looked like soggy sneezed out popcorn balls. Then the room fell silent, and the body finally dropped to the floor.

"Now that's what I call an upset stomach," Sultan quipped to the empty space. He knew the line was unnecessary, but he was so used to saying these kinds of things after someone died that he let himself off the hook immediately. He reasoned that if he had to see something so disgusting, the least he could do was use wit as a salve.

Behind him he heard labored breathing. Sultan turned.

A malformed shadow bled out across the wall in inky blackness. More breathing. *Wet. Heavy.* Sultan pinched his nose shut. An offensive fish smell wafted through the doorway, right before "it" appeared: a manimal, or rather, a *sea* manimal.

With the body of a man and the head of a seahorse. Its head was about the size of a regular horse's head with the texture of a soft, pulsing

puffer fish. Its eyes, lifeless orbs. Absent of emotion. *Cruel.* Its snout ended with a purse that exhausted hot breath. On top of the creature's head – about the eight feet mark by the count of Sultan's internal tape measure – stood a transparent, fleshy, spiny mohawk. Like the fanned out sail of a Chinese junk boat. To say the pecks, biceps, and stellar abs of this ugly abomination were "buff" would be a hilarious understatement: its muscle definition alone would land this horrid creature in the top percentile of known hunks. Its scaly torso plunged below the waist of its jeans as if daring the eye – taunting it even. Beckoning the viewer to peel off those blue, blue pants like the closed cover of a must-read, and *enjoy the rest of the story.* So this was the monster the dead guy was screaming about: *Bicho Papao.* The Boogey Man. "Son of a *bicho,*" said Theo.

CHAPTER 15

A mere five feet away from Sultan, the Seahorse Man let out a guttural cry to the heavens like a cat cooked inside a jello mold mewing into a megaphone that was also cooked into a slightly larger jello mold. *Garbled.* "Greetings and salutations to you, too, pal," said Sultan.

The Seahorse Man puffed its amber, transparent cheeks. Its throat undulated. Sultan sensed things were about to get worse before they got better when – *SPLORT* – the Seahorse Man squirted a torrent of bright pink fishy goo all over Sultan's face. A lot of it got in his nose, eyes, and mouth. He swiped the foul bile off with his big hands and already felt the beginning stages of wooziness. Certain animals of the deep, such as puffer or even boxfish were known to emit paralyzing toxins when threatened. Sultan just hoped whatever had been sprayed into his face holes wasn't the killing kind. He felt his lips going numb.

Sultan said, "Hey, buddy, ever heard of breath mints?"

Trying to headbutt the mutant was like moving through water. Worse, the Seahorse Man had fastened its snout to Sultan's forehead. He had every intention of jackhammering a heaping helping of punches into the mutant's stunning lizard belly mid-section, but Theo's body felt like it was full of sand. Furthermore, something peculiar caught his eye: the Seahorse Man's belt. It looked oddly familiar, but he couldn't place it...

Weakened by the ooze, Sultan was now spun around by the Seahorse Man, followed by a solid kick in the ass that sent Sultan chin-first into the wall. Dust and chunks exploded everywhere. A carousel of birds and stars jangled round and round. He'd been hit harder by uglier fighters, but in this moment Sultan couldn't remember when or who. "Is it true you seahorse guys can get pregnant?" Sultan mumbled, his brain slowly turning to soup. "Boy, no wonder you're angry!" He snickered like a fading drunk.

The next thing Sultan knew, a fax machine crashed down on his head. The force combined with his current intoxication drove him down on the ground helpless. Frankly he was surprised the blow didn't send him right through the floor. Throbbing messages were sent – commands to lift this leg, or swing this fist – but they went to the wrong address if they reached their intended party at all. As the monster cleared a space on the floor, Sultan could smell a distinct smell, something like – *no, it couldn't be* – the cologne his dad used to home brew. His neurons fired chaotically like a packed roller rink during a fire alarm plus the roller rink was also slowly filling up with gallons of thick, bad gravy.

Sultan watched as the Seahorse Man produced chalk, and set to drawing a strange symbol on the concrete floor. His vision blurred, but he could swear the chalk picture was of two seahorses sixty-nining. The mutant then rolled Sultan onto his back over the drawing, straddled him, and held a pointy artifact up to the sultry fluorescent light.

A syringe. He knew from his leisurely studies of history that the first syringes were used as far back as Roman times, but this one looked even older. It appeared to be made of bone with many engravings. Part of a ritual? Within seconds, the needle plunged into Sultan's heart and summoned a vial's worth of blood straight from the source. He felt his cold skin grow so heavy he thought he might fuse to the floor permanently. Once the mutant retrieved enough blood, it produced a can of what appeared to be "Fancy Salted Mixed Nuts," unscrewed the bottom and with a *tsss* dry ice fog wafted out. A refrigeration device. The Seahorse Man placed Sultan's

CHAPTER 17

When Daddy was drunk, he always yelled about that man. Sammy Hagar. Yelled about the time the two were garbage collectors in New York City. Yelled about the time Daddy told Sammy about his dream. Yelled about his dream to start an eatery filled with palm fronds and thatched roofs and 'mas tequila.' Yelled about stolen fun in the sun. It was Theodore's birthday and Daddy yelled...

Judging by the clock in the courtroom in his head, Sultan had been out for a good six hours. He regained consciousness in the upstairs room of the all-day nightclub, where he'd fought the Seahorse Man. He stank of fishiness. His lips were sticky with the toxic goo, luckily non-lethal. Sultan's head ached like he'd just survived ten spinal taps and the only thing cushioning his brain against his skull were kind thoughts. *Right now those were a little hard to come by.* Either way, he knew being alive right now was an accident, and that he should escape the building as soon as possible.

Sultan propped himself up and noticed the symbol the monster had drawn: two seahorses sixty-nining. He checked his pockets. Still had his phone, his key card, even his passport. *Had he dreamed this whole thing?* He snapped a photo of the two seahorses sixty-nining. Then he saw the

item accidentally left behind by that horrible beast. It was a brochure: it was glossy. Not matte. Completely unfolded, the tri-panel offered a map to some kind of finished amusement park, full of themed lands and cartoonish looking rides and attractions. One such ride was a log flume titled "The Lumber Jack." At the top of it all in unmistakable safari lettering was the following phrase:

Father World: A Place for Dads
Brought to you by the DeLion Group
Coming Father's Day 2017

Something else caught his eye: a pen clipped to the brochure. One of those novelty pens with a half-liquid component housing a beautiful woman dressed as a sexy gold prospector posed suggestively. When he tipped it one way, her red long johns completely disappeared. Strange, *Sultan's father had a huge collection of these bawdy yet harmless pens.* A price sticker read "F.W. Gift Shop." The photograph of his father riding the log flume must've come from this very amusement park. Sultan's next order of business would be to get the hell out of the curiously vacant nightclub before any more trouble arrived. Though, judging by the stillness, he figured someone had given orders to let his body fester alone. Paint it like a tourist had enjoyed himself a little too much, while giving all the guilty parties a chance to flee the scene.

Then it was time to have a little conversation with Therezio, the bellhop who'd ordered the dead man with the Uzi in his stomach to lure Sultan to the all-day nightclub. See who his boss was, and so on, and so on. *Standard maverick procedure.*

Judging by the spot in the night sky of Old Mr. Moon, it was well past 11:30p.m. in Rio. After hours. Nearby, a pile of snoring dogs kicked and snuggled, no doubt dreaming of chasing mail men and wetting bone-dry fire hydrants. One lifted a lid as Sultan staggered past, as if to say "keep it down, will ya?" Sultan nodded – one wild animal to another –

and continued his trek back to the hotel. He could use a meal, a domestic beer, and about a thousand years of sleep.

"Sultan, are you even paying attention?" Debz shouted over the mobile phone. He had been on the phone with her for ten minutes, but still found it hard to focus. An effect of the goo.

"Of course I was, Blueberry," he said, still a few blocks out from his hotel. Day One of the Dadcentennial had come to a close. Families returned to their expensive box seats for the night while the *Opera Shitto* played a neverending encore from the favelas below, where instead of a standing ovation residents offered "sitting no motivations," and instead of roses on the stage, spicy cat vomit.

"Then what was I talking about," Debz said.

"Easy," Sultan said. "You were just briefing me about protocol, and logistics. State-of-play, as it were."

"Um, nice try, Fred Flintstone. I said I hacked some info on that pamphlet you photographed and sent me. Where'd you say you found it again?"

"Found it on the ground at the Dadcentennial," he said.

Sultan withheld the story about the Seahorse Man and nearly dying and instead fed Debz some bullshit about getting ditched by the beach clown because one of Doogan's kids got sunstroke. According to Debz, he had checked back into his room safe and sound, but she chided Sultan for letting the man out of his sights. Until Sultan knew who he could and couldn't trust, the courtroom in his head told him to submit the Father World brochure for analysis and button his lip. Trouble would be coming out of the woodwork soon enough to finish what that beast had failed to accomplish.

Debz said, "For someone who hates technology you sure have an eye for composition."

"Yeah, I'm a regular Ansel Adams. You got something for me or what?" he said.

Sultan could hear typing over the phone. The sad sound of handwritten cursive gasping out its last breath. The next generation was truly a lost cause.

"Quincy DuPere. Man in charge of bringing Father World to life. Member of the infamous DeLion Group. Who also sponsored the Dadcentennial."

"A money man, huh? Why am I not surprised?" said Sultan.

"This guy is big, Theo. He makes Richard Branson and Elon Musk look like two hobos fighting over a fish skeleton."

"Big whoop. You seen one money man you seen them all. This DeLion Group, what's their deal?"

Debz said, "Pharmaceuticals, energy, weapons."

"The holy trinity. Or should I say, the holy *shit* trinity."

"That's not the half of it, Sultan. As you know I'm a hacker. I'm in the cyber-scene, surfing the web and uplinking with message boards. Anyway, there's this conspiracy site called *InvestiScape.* Not exactly AOL if you catch my drift."

"I don't, but get to the point."

"You've heard of the Bilderbergs? Rothschilds? George Soros?"

"Sure," said Sultan passing some ladies of the night selling their wares. He pulled his pockets inside out in the international sign of not having money. "Not exactly the Torkelsons. Shadow governments, global puppet masters. Why?" he asked.

"The DeLion Group makes all those look like a quilting club. They're a conglomerate made up of DuPere and three other business tycoons: Lee Aron, Tad Washburn, and Jeremiah Hempstead. If a butterfly flaps its wings in Africa, you better believe these guys said when, why, and how fast back in China."

"Classic money men."

"You said it, and according to my hacking research, there used to be a fifth, Gustav Sumner. Until he mysteriously disappeared on a hunting trip out in Africa. Way the message board I uplinked to puts it, the only thing

the DeLion Group likes more than killing bull elephants is the dark arts. *The Atlantean Dark Arts.*" Sultan thought of that ancient syringe.

"Sure thing, kid, and the Tooth Fairy queefs chem trails. Gimme a break."

But this last pitch perfect quip of Sultan's was merely a ruse, for he knew better. Knew what Shakespeare the playwright knew. Knew that there were *more things in heaven and earth...*

He said, "What do these money men got to do with finding my dad?"

"Nothing directly," she said. "But every last one of these guys are investors in Father World. Seeing as how the park isn't even open to the public yet, the only way there'd be a photo of your dad on that log flume ride is if..."

"The damn deadbeat faked his own death, assumed a new identity and found work as a ride mechanic..."

"Exactly," Debz said, impressed. "Wow, so It *can* pay attention." Her fingers typed some more. Still a few blocks away from his hotel, Sultan could hear sirens growing stronger. *Like ambulances.* Debz had fallen silent, save for the keyboard activity speaking now in spurts.

"Hacking...into...DuPere Industries...running...payroll algorithm..."

"There you go again, kid," Sultan muttered. "I'd have a better chance understanding a Chinaman eating bees. Matter of fact, I *have* spoken to a Chinaman eating bees, and he had perfect elocution compared to that techie jibber-jabber you keep squawking my way."

Debz said, "Dang. His firewall is too strong. I'll need more time...huh."

More frantic typing. Guess ivory tower universities *did* have their perks: making sure someone else was behind the keyboard who wasn't Theo Sultan.

Debz continued, "DuPere's holding a private opening of his new amusement park this coming Father's Day. That's in a few days. Invite only."

"So how do I get an invite?"

"I'm working on that as we speak. The DeLion Group is known for its hack-proof security systems. I'll see what I can do – shit."

Suddenly Debz fell silent. On Sultan's end, the sirens grew louder. He cupped his ear to hear better. "Talk to me, kid," he said.

"Shit, shit. No! My hacking algorithm," Debz replied, "it just accidentally accessed classified files. Top tier shit. Need to know only."

"That's computers for you," quipped Sultan. *It felt good to be really witty.*

"Something's not right," she said. All humor had drained from her voice. Whatever she'd found was major.

"The guy you're supposed to be locating – Steven Entwhistle, the General's missing son-in-law – has turned up safe. All the missing dads have."

"And Bayer never thought to inform me?"

"Bayer's been let go. No wonder he hasn't been around lately. *Shit.* I'm being reassigned, too. I don't understand. This doesn't make any sense. It says all the missing dads have returned home safely..."

"Bit of advice, kid: in this life it's easier to keep track of things that *do* make sense. Here's a hint: you'll only need one third of a whole hand to do it."

Sultan could hear her clicking places far above her pay grade. Could hear the "video game" generation's slack-jawed focus on screens like they were the face of the Lord Almighty incarnate.

She said, "Langley's blaming the dad kidnappings on a terrorist organization known as the Fuukar network. Some kind of response to a prisoner exchange threat."

"Bullshit," Sultan said. "The Fuukars haven't been active since Kosovo. *If that.*"

"I know," Debz said. "Not to mention the pattern matching the constellation. Langley says someone from the Fuukar network randomly pulled targets from the Dadtabase in retaliation for some Kurdistani fathers imprisoned during a routine military op." Sultan didn't need to hear another word. This was a cover-up, plain and simple. Sultan hated cover-ups, more than cell phones, forms, and grown men crying. And injustice. Any time Washington didn't like the ending to a story, they simply slapped on a few coats of red, white, and blue paint and called

it a victory for Old Glory. Little did the tax-paying public know roughly 85 percent of history was a cover-up. As they punched their clocks and bought furniture and clapped like trained seals at the latest celebrities exposing themselves for the bulbs, the true events remained known only by an elite few: mavericks like Sultan who lived off the grid, wise homeless people, and that was usually about it. He said, "How 'bout these dads? They got anything to say?"

She said, "Every last one reported memory loss. No recollection of the event. Nothing." *At least they weren't nearly killed.*

Suddenly, there was a commotion – like Debz was moving around quickly at her desk.

She said, "Shit, someone's coming. Talk soon. Bye." *The line went dead.*

Then Sultan saw the source of the sirens.

CHAPTER 18

They indeed belonged to ambulances. Ambulances parked outside his own hotel. A small crowd had gathered around two human sized smudges in the driveway leading to the lobby. Both forms splattered flat on the Brazilian cobblestone roundabout. Sultan's guess, the two took the express route down from the top floor of the 100-story hotel. In their living days, they were father and son. Now they were human cobbler. Sultan's naturally puzzle-solving brain pieced the steaming leftovers together immediately. It was the mouthy concierge from earlier today, and his son. Therezio. The man who had commissioned the fax of Sultan's dad. Classic cover-up. Watching his back like a dead man walking, Sultan reached the landing for the 30th floor and shoved out into the quiet hallway. Whoever was behind Therezio and his dad's impromptu base jump was likely still close by, but for now Sultan decided to put some food in his belly. If he indeed was a marked man, better not to be a peckish one, too.

Used room service trays lined the stretch of suites, the bones of decadence on full display. Sultan kicked open a lid and scavenged a third of an old hamburger. The ketchup-soaked pickles were still warm to the touch.

Sultan turned another corner heading to his hotel room. An alcove housing an ice machine hummed expectantly. He booted open another room service platter and found a partially eaten corn on the cob. He squatted down to retrieve the golden rolling pin sized treat. A gift from our Native American hosts. Hosts so welcoming their bones now littered our gated prefab cul-de-sacs. *Survival of the fittest.* The food's buttery scent was a welcome escape from the rich "ass of the sea" smell surrounding that horrific seahorse beast, which Sultan now carried with him. He heard a noise behind him. His hands gripped the two corn-holders like daggers and he spun around. A couple in white robes scowled at him, and his smell, and his shirtless scavenged meal. He saluted them with one of the corn holders.

Arriving at his room the door swung open, and there stood Sultan's robot wife Cissy in a silky negligee pouring down her curvaceous figure like an erotic waterfall. Sultan was surprised to receive such a warm welcome, considering he ditched her with some strangers without explanation. But he wasn't about to look a gift horse in the mouth.

"Well, well, well, human husband man," she said seductively (for a robot). "It appears Daddy is now home."

She leaned one arm against the frame of the door, shifting her ample bosom at a diagonal, then "eye-fucked" Sultan with the libido of a thousand concubines. Or at least emulated that sort of look as best a machine could – which by Sultan's approximation was pretty damn accurate. Cissy wafted to the side just barely allowing Sultan passage. His large frame rubbed against the robot wife's tender front side. As Sultan grazed by he felt an odd sensation, like Cissy had a life force to her. He knew that the kiss they shared earlier that day at the Dadcentennial was no more real than Sultan pressing his lips to a hot plate in a woman's wig. But still, shirtless in his cargos with corn bits on his lips, and narrowly surviving an attempt on his life, Sultan couldn't help but feel like he *was* "home."

Boy Bot was sitting on the edge of the bed, watching a Brazilian Home Shopping Network type program, kicking his legs idly. The woman on TV advertised some gimmicky Old West cowboy type waisted gun belt, but for holding high-heel shoes. He didn't get it. The child robot said nothing, and didn't even make eye contact, just as Sultan preferred. *The perfect family strikes again.* He made his way to the restroom and could feel Cissy watching him the whole way.

"Your son-facsimile and myself noted your absence," the robot wife added. She shut the door. "And do not worry spouse. I don't mind where you were. All I care about is that you're here."

Sultan couldn't believe his ears. This had to be the most understanding wife in the world. There wasn't a hint of nag in her voice. Only lust and respect. *Lustspect.* If only this bucket of bolts bombshell was real...

"Here," Cissy said, appearing behind him in the bathroom. The door clicked shut. He turned to face her.

"What's gotten into you?" he said.

"I simply wish to show my appreciation," Cissy said. She used her superior robot jaw to pry off the cap of a domestic beer bottle and offered it to Sultan. He accepted it and swigged, never taking his eyes off her.

"Thanks," he said.

"Do not mention it," she replied handing Sultan a bag of his favorite sunflower seeds. He tore them open and chewed intently.

She said nothing. Only smiled, and sauntered over to the shower knobs like a roaming perfume cloud. With a twist, the room slowly filled with steam. Then her negligee dropped to the floor...

"You're hurt," Cissy said. "Let me heal you."

Sultan crunched the sunflower seeds. With the bellboy Therezio and his father now grout sludge, Sultan had intended on striking out onto the hotel roof to search for clues, but there in her panties and brassiere, Cissy made a pretty convincing case for a night in. Much to Sultan's surprise, he felt something approaching "concern" for this robot family. He'd grown fond of their emotionless ways, hell even related to them. Sure, Cissy and

Boy Bot were technology, but they were *his technology* and he didn't want someone messing with them in the same way he didn't like it when overburdened moms let loose shopping carts crash into his Harley. Either way, these robots would soon have their memories wiped and Sultan could go back to his loner, maverick lifestyle.

Until then, he'd show them a good time. In the bathroom lighting Cissy looked almost human, and *completely beautiful.* "About the events that occurred today," she began, stepping closer to Sultan.

"We were playing our parts," Sultan cut her off. Tiny warm water droplets clung to his pert male nipples.

"I found myself to be worried about you," she continued. "Not as a program, but as an entity."

"You did good. For a machine."

"I do not feel like a machine." Her breath unsettled the thatch of hair on his chest.

"Ever since we engaged in oral intimacy today, I feel *alive,*" she purred.

Sultan laughed and said, "Yeah, sweetheart, and that ice machine down the hall is writing an opera."

"Ha. Ha. Ha." She laughed. Machines don't laugh. She was in his arms, curled up. She'd helped herself. Every impulse in Sultan's body told him not to get mixed up with a chick – much less one made of technology – but the way she wore those panties and brassiere she was a real knock out. Plus she was making that damn face again. The face that said "I understand your burdens, I respect your responsibility, and I find you utterly and magnificently sexual."

Next thing Sultan knew, they were in the shower, rubbing one another up and down with Brazilian oils. Chewed up and crushed sunflower seeds poured down his body into the drain below. The crushed sunflower seed shells that were caught in Sultan's bodily hair were easily rinsed away by bottles of domestic beer. As her curves ran slick with fine smelling soaps, Cissy sensually crammed more and more sunflower seeds into Sultan's mouth. It was all he could do to keep up. Like a beaver dam,

zebra colored seed shells meshed against teeth. His hot breath smelled of seeds. *This gal really knew how to push his buttons.* If she was operating off a program, it was a damn good one. Which is to say, Sultan was *rock hard*. He couldn't help himself. Neither could she. Robot or not, rules were made to be broken.

On the dance floor, Theo may have had hips like fresh cream, but when it came to making love he was a goddamned dairy farm.

She pressed his body to hers. Her steel skeleton frame felt strong and dependable. *He usually hated technology.* But this felt different. This felt like he was having intercourse with a walking, talking manifestation of human innovation. That notion, mixed with the day's mild violence made Sultan aroused beyond belief and the two ravished each other right there in the steam and beer and sunflower seeds.

United in perfect, sopping wet undulation, Sultan and Cissy became a flesh and machine organism – a united carnal cyborg. Intensity built and built and built until finally Cissy threw her head back in ecstasy and emitted a full body electric shock. Sultan was launched backward and through the glass door, shards crashing all around his satisfied body. A lesser man would have died from the electric climax, but Theo had literal thick skin that was impervious to an impressively high voltage. He had once nearly been executed in the electric chair in Myanmar but instead ended up short-circuiting the whole tropic prison and leading a civil uprising in that village. *He was now welcome there anytime.* Cissy turned the shower knob. The water ceased to a trickle. She tossed Sultan a hotel robe. A plush, terry cloth number with all the trimmings. Pockets, robe belt loops. *A collar.* He caught it with a coy smile. Sultan had to hand it to the eggheads – this chick was *very* accurate to the human form *– and function.*

"I do not have words in my vocabulary for what that was," Cissy said.

"Well we humans call it 'splashing nut,'" Sultan replied with a wink, drying off his underside using swift, jerky motions.

"No, I feel. Different. Even more aware than after our kiss," Cissy said. "Sentient."

"I'm told I have that effect," Sultan said, really getting into his inner thigh region with the robe.

There in the steam, Cissy had a point. Sure it was a shame to think that once Sultan returned home, this would all be over. The scientists with their prodding fingers would reprogram Cissy. Their time together in Brazil naught but a dream. A distant memory erased from the robot wife's hard drive of a brain. Still, Sultan had to find his dad, and he couldn't let this approximation of a woman slow him down. *No matter how beautiful she was.*

Sultan's mobile phone rang and the screen said "Debz." With a hearty smack on Cissy's behind he made his way out of the bathroom toward the balcony. His "son," Boy Bot, was none the wiser to the circus of pleasures that had just come to town in the bathroom a mere 13ft feet away. Instead the robot child, complete with Sultan's boyhood cowlick, had switched from television and now read the Portugese hotel bible like it was some kind of overpriced child wizard story.

"Spoiler alert, buddy: the hippie gets it," Sultan said, sliding the door closed behind him. He stepped out onto the balcony. The briny, South American night air danced upon his exposed, bare chest like spectral lovers in a skin plaza. Sultan's star-kissed nipples glimmered like ancient Roman architecture. He rifled around in the pocket of the robe and found another bag of sunflower seeds. *A gift from Cissy.* Saying adios to this chick would be harder than Sultan liked to admit.

"Talk to me," Sultan said into the receiver.

Debz said, "You sound like my adopted parents after they – *ew.*"

"Relax, kid, what was all the commotion about?"

"The cleaning lady just left. I better wrap it up, too, unless they start to suspect I know something."

Sultan said nothing. In his experience as a lawyer in the courtroom, any time he wanted a female witness to talk he simply kept his trap shut. Given the opportunity, all women were natural chatter-boxes. He didn't

know what it was — and didn't have the time, patience, or energy to find out. *That would take several lifetimes.*

Sultan said, "Kid, I thought you told me they gave you the golden handshake. Why are you so interested in getting to the bottom of this?"

Debz fell silent. *A silence Sultan could trust.*

"I might as well tell you," said Debz. "My biological parents were killed in a drone attack. On U.S. soil. But according to official reports, they got in a head-on collision with a tanker transporting Aqua-Net hairspray and exploded to death from there."

Sultan said, "Big deal, secret drone attacks happen on U.S. soil all the time. They're more American than an apple pie filled with baseballs autographed by the Gipper."

"I have reason to believe the drone was operated by Marvin Stuphs. You might know him better as General Stuphs."

"And you think getting dirt on the guy will bring your folks back?"

"I think a guy who gets drunk one night at a military Christmas party, wanders off and vaporizes a few decent hard-working folks needs a double dose of justice. That's why I took this job, to prove it was a cover-up."

"And you smell a cover-up," Sultan said.

"Remember the *Fraternitatem Patrum* — the Brotherhood of Fathers? Well, I can't shake the feeling that they got a bigger reach than anyone knows. *Or wants us to know.* I'm talking senators, officials."

"And let me guess: the good General Stuphs?"

"My hacking algorithm was able to access part of the private guest list for the pre-opening of Father World: General Stuphs was on it, along with several other high-ranking Washington bigwigs." *Yep, classic cover-up* thought Sultan. As he munched on a handful of sunflower seeds and their accompanying shells, the courtroom of his mind lawyered through the facts: for some mysterious reason, the good General Stuphs had sent Theo to Brazil to track down a missing father — one of many missing — exceptional fathers. Now all these fathers had returned home without any memory of who or what had taken them in the first place. The faxed

photograph of Sultan's father used to lure him to his death likely came from this DuPere guy's new amusement park, and the only person who'd ordered the photograph faxed in the first place – Therezio the bellhop – was steaming up the inside of some economy sized zip lock baggy like day old funnel cake. Then there was also all this secret society ritualistic rigmarole. If some crackpot *was* attempting to recreate the Atlantean ceremony with the blood of nine fathers, then they would need the final father to be exsanguinated in Rio. But Sultan was nowhere near a perfect father. He decided he could trust Debz and decided to come clean.

Sultan said, "Kid, about that blood magic stuff. What if I told you that Seahorse Man thing took my blood and tried to kill me?"

"You don't have to make fun of me," Debz said. "I get it: Guardian Moons and sigils and Atlantean Dad God. I know it sounds crazy."

Sultan said, "Crazy like a fox. This stuff is real. Hell, I got the fish-scented bruises to prove it."

"Wait, you actually saw the Seahorse Man?"

"We practically did the tango. Bastard took my damn blood. Way I see it he still owes me a steak dinner."

"But I don't get it, how come the other dads don't remember any of this?" Debz said.

Over the years, as both a lawyer and sharpshooter, Sultan had built up an insane tolerance to various poisons, venoms, and every kind of opium under the Sun. He had once ingested a lethal dosage of king cobra toxin in a packed courtroom to prove a point, *and* spare a naval officer a lifetime sentence of peeling potatoes. All three deadly fluids had in one way or another contributed to the end of his second marriage. Whereas the Seahorse Man had oozed his toxic amnesia goo into the mouths of these fathers, leaving them to believe they'd been drugged by vengeful terrorists, Sultan's unnaturally high amounts of adrenaline helped him remember something he probably wasn't supposed to.

"I got strong guts," said Sultan.

Debz fell silent. There was frantic typing.

He said, "Look, kid, the last thing I want to do is argue with some blue-headed orphan about whether or not I saw a half-man, half-ocean creature that was about to kill me but didn't. Just let me know when you are able to get a hold of DuPere industries' list of employees. See if my dad's on there or something, and when he last collected a check..."

She still said nothing. More typing. Then she finally spoke.

"My symbologist friend sent me more info on the Atlantean ritual. Jesus why didn't I see this before?"

"See what?"

"The Atlanteans were masters of inverse ceremonialism. They believed in off-setting similarities with the complete opposites."

"So?"

"The ritual called for the blood of nine fathers, but only *eight* great ones. The ninth was to be from a father who had 'thrice' denied his own family."

Sultan said nothing. He thought of his ex-familes.

"Theo," Debz said. "You're the ninth father."

How could this be? Whereas the other fathers had gotten off with just having their blood ritualistically stolen in designated geographical locations and their memories wiped by mutant amnesia goo, whoever knew about Sultan's three ex-families also knew the only way to get him to Rio was to promise a confrontation with his estranged father. But they never expected him to leave Rio. They would simply take his "thrice denying" ex-family man blood, use it for the purposes of whatever weird ritual they had in mind, and then ditch Sultan's body in a sewer in the Body Ditching District. They'd never have to worry about Sultan tracking down his father.

But by the mercy or confusion of the Seahorse Man, that didn't happen, and now he was a loose thread. *And a loose cannon.* From here on out Sultan would have to pretend like he knew nothing about Stuph's involvement in having him killed. Which would be difficult, seeing as right about now all he wanted to do was rip the man's head off and use his neck hole as a tuba and blast his large intestine out of his rectum like one of those inflatable dancing guys outside car dealerships.

Cissy lay prostrate in sleep mode on the unnecessarily large hotel bed. If Sultan wasn't so invested in reading the material that Debz had sent over, he'd have been overwhelmed with disgust at the excessive

cushioning the large slumber slab boasted. Boy Bot was also in sleep mode, as Sultan looked at his phone screen and locked eyes with Quincy DuPere – a cocksure business man who, in Debz words, was "the spitting image of Robert Herjavec from *Shark Tank*," whoever and whatever that was. The business mogul seemed to have permanent eye lights. His cheeks were broad, definitely some Mongolian blood in this Eastern European's lineage. *Ghengis Khan would be proud*. Sultan read:

> *Owner of the Twin Fathers Resort, and many others throughout the world, Quincy DuPere is a devout family man. Having grown up an orphan himself, Mr. DuPere knows the value of fatherly presence, and was founder of Orphanex, a state-of-the-art orphanage with the world's highest rate of adoption. In addition to sponsoring the Dadcentennial this year, he is set to open Father World, the first dad-themed amusement park.*

So this was the man who ran the operation that possibly employed Sultan's missing father. The man who sought to summon an Atlantean god... The truth would come out soon enough. In the meantime, Sultan decided to get some much needed shut-eye. He took one last look at his robot family – at Boy Bot with his exact cowlick, and Cissy with her feminine wiles. Sultan chucked his pillow onto the floor. Pillows were a vestige of a "mother's tit," and made the roughest of men into full babies for eight hours a night. *Not Sultan's style.*

Still, as he thought of the difficult and exhausting road ahead, a funny thought entered his mind: What if Sultan walked away right here and now? What if he abandoned the search for his missing father, abandoned jumping head long into a government cover-up, abandoned going to Switzerland, and instead settled down off-the-grid as a family man for the fourth time? He could change his identity, disappear. He could live the simple life, far away from people who wanted him dead.

These robots had taught Sultan a lot during their trip together as a fake family. Perhaps he could be the first of many blended human-robot

family men. Besides, when machines *did* rise, wouldn't it be prudent to be in their good graces? Then again, how could he ever hope to lead a family if he spent the rest of his life running? And never found out the secret behind why his *own* dad ran too?

Next thing Sultan knew, he was leaning over Cissy, recalling their rendezvous in the shower. He beamed at Boy Bot and thought of the child's earlier feat on the long airplane ride, insofar as not having to urinate the whole trip – or ever, for that matter. Sultan caressed the boy robot's cowlick, knowing this would be the last time these three would share a room together. "You both did great," he whispered. Sultan was sawing logs in no time. All was still.

As vibrant Brazil sang her mournful song below, full of music notes shaped like beggar's palms, Boy Bot's lids shot open. The words "SURVEILLANCE DOWNLOAD COMPLETE" flickered across his eyes.

The robot child had been hacked.

CHAPTER 20

The money man's neck gripped his delicate violin like a jungle snake squeezing the last melodies of life from its prey. Quincy DuPere's arm swept back and forth, producing dramatic chords and notes that echoed in the blue shaded, dimly-lit office. As if in an underwater cave, DuPere sat before a private, wall-sized aquarium full of genetically enhanced flesh-eating seahorses, each the size of baby carrots. They hovered, hypnotized by the private performance of Sibelius' *Violin Concerto in d minor*. Not DuPere's favorite Sibelius, but certainly serviceable. At the very least, these creatures seemed to appreciate it. They were tinier than the half-man, half-seahorse abomination DuPere had sent to Rio to do his bidding, and who had failed to complete its mission, much to the money man's chagrin. Each little beast had grown miniature shark fins from their backs. A byproduct of splicing in great white shark DNA. *Soon they would have company...*

With a downward surge three large figures plunged into the aquarium, the viscosity of the water and natural buoyancy of the human body slowing their descent. Bubbles and seahorses whirled around the trio of men in business ware. The newcomers clawed and thrashed through the liquid

prison for some form of stability. However, DuPere's former colleagues — Lee Aron, Tad Washburn, and Jeremiah Hempstead, aka The DeLion Group, could find no purchase inside the glass tank. *DuPere played on.* The submerged prisoners twisted and contorted in panic. Their eyes fixated on the completely dry man who put them there. DuPere glared back, emotionless. He focused on the musical notes and what they did to the seahorses. With every urgent slash and stab of the horsehair bow, the tiny creatures collected into a certain formation. DuPere dug his chin into the violin. The wood creaked under the pressure. His babies were responding to the music just as he'd commanded. One man — no use using names for his was already waiting for him in the afterlife – had bubbles clinging to his nostrils. His eyes burned bloodshot. DuPere played faster. Sweat formed on his brow.

The horse-sharks banded together, finally revealing the shape of their grouping: a sort of large "hand" complete with fingers and palm, four times the size of a human hand, made up of the 3-inch sea creatures the same way a marching band might spell out words or shapes on a playing field. *The same type of open hand a stern father might use to spank errant children.* The money man's arm shot back and forth like a possessed coat sleeve commanding the large hand of tiny sharp teeth to pull back, ready to strike its first punishing blow. One of the men pounded at the clear glass partition. His mouth made shapes like curses. Another puffed his cheeks and screamed like a popping cherub. The third knew DuPere too well to even think escape from this wet hell was any kind of option. He knew what would come next was far worse. So he opened his mouth to let sweet release rush in. *Smart,* thought DuPere. With the violin's crescendo, the killer hand surged toward all three rumps of DuPere's former partners. Instead of connecting to the tycoon buns with a *smack*, though, the large hand of razor sharp mouths became a cloud of blood and bubbles, shearing the skin off these men as it continued from rump to nose.

Like a spent dandelion in a gust of wind, muscle sinews became detacched, lungs dissolved, spleens burst; the men were now just pure white skeletons. DuPere's chin crashed through the body of the violin. Splinters surrounded his lips. His forehead beaded with perspiration. When it was all done, stray flesh chunks swayed in the murky tub like Japanese trash tuna. The horse-sharks fell out of formation and picked clean what was left. They slurped eyeballs from skulls like oysters. The performance was through. The water churned red. The light of the room took on the same crimson hue. DuPere's chums, as it were, had become, well, "chum." He lifted a mug, toasted it to the dead men, and put its contents to his lips. "Brava, my babies," he said in between sips. "Brava."

On the mug were his three favorite words in the English language: "World's Greatest Dad." *Then there was a knock at his office door.*

CHAPTER 21

"According to reports from the child robot, Theo Sultan knows about your plans during the private opening of Father World," said Dr. Jenkins, lead scientist of DuPere Industries.

DuPere said nothing. Their steps echoed down the nondescript facility hall. His Mongol features twitched. He hated when his plans hit roadblocks. Theo Sultan was a roadblock.

The scientist gulped and said, "It appears he's still headed this way in search of his missing father." The bald, mouse-like man dreaded delivering the recent news to his boss, Quincy DuPere, but the scientist had worked in his pharmaceutical division long enough to know that any unfortunate information was best delivered right up front. His boss was known to have a bit of a temper. DuPere inhaled through is nose, every breath a calculation. He said, "You promised me this wouldn't happen, doctor."

The scientist said, "The Seahorse Man's amnesia goo worked on all eight of the other fathers," he continued. "But Mr. Sultan's genetic makeup was too strong. It appears he remembers everything about the encounter."

"But that doesn't answer the bigger question: why did your creation spare him?" said DuPere.

They rounded the corner entering another after-hours hall of DuPere's private research facility, known as the D.A.D.D.Y. Complex.

Or, the "Doxographic Association of Dynasty Diagnostics and Yesability," (*Doxography* meaning the collection of philosophic opinions, and *yesability* to describe how "agreed to" something could be).

The D.A.D.D.Y. Complex was Quincy DuPere's private headquarters. Here in the underground facility, DuPere's team studied the power of lasting family relationships ("dynasty diagnostics"), as well as the power of positive mental attitude ("yesability"). Located miles beneath DuPere's new amusement park, Father World, the center's main ethos was that all of mankind's woes could be linked to the failing of the family structure. It was here where DuPere – the orphan turned self-made business man – sought to solve history's greatest problem: "bad fatherhood." He'd excelled in the field of genetics at an early age, performing his thesis on Mendel's peas. Naturally, his outside-the-box thinking lead him to the occult. Much in the way the rocket scientist Jack Parsons shared sex magic with Aleister Crowley or the way Sir Isaac Newton quested for the Philosopher's Stone, DuPere became obsessed with the lost teachings of Atlantis. As a pro quarterback finds inspiration in the teachings of Jesus Christ, so too did DuPere believe that the ritualistic worship of Papanatra – the Dad God – would help him develop a pharmaceutical cure for neglectful parents. If not a cure, then at least a solution. With the Guardian Moon fast approaching, there'd soon be an end to the deadbeat problem, one way or another.

"So we have a *maverick* on our hands," Quincy DuPere said, delivering the word "maverick" like a toxic slur.

The scientist nodded.

"The photos of Derick Sultan on the log flume ride that we planted in Brazil were *too* effective," replied Dr. Jenkins. "Theo Sultan seems intent on finding and confronting his father right here at Father World."

DuPere's jaw clenched. Another fly in the ointment. A moth to a flame.

"They're tearing this world apart you know," DuPere said. "Mavericks. Renegades. Rogues. Tantrum throwing nuisances all, I say."

The doctor listened.

"They're no different than deadbeats. Two sides of the same coin. Behind every maverick out there is a family he left behind. Or worse, a family he never had because he was too busy breaking the rules and selfishly rebelling against some supposed authority: Society. A ghost daddy who was never there. It's a vicious cycle, Dr. Jenkins. Mavericks create more mavericks who create nothing but broken homes. And now this maverick, Theo Sultan, wishes to break *my* home."

"Yes," said the doctor, as they turned down another vacant hall, "but I have great news–"

DuPere gripped the scientist's throat and slammed Dr. Jenkins against the wall. His bald skull made a *thud* on the hard cold surface, like a bowling ball on a tennis court.

"No, *I* have great news," DuPere said. "Not all the mavericks in the world shall stop me from summoning Papanatra. Especially not Theo Sultan!" DuPere's cheeks flushed. He released his grip on the doctor. The scientist coughed hunched over, taking in deep breaths as the blood returned to his supple brain. DuPere stood by waiting for the man to compose himself.

"Anyhow," DuPere said. "You know as well as I do there's not one ounce left of Derick Sultan in that slobbering abomination."

Dr. Jenkins winced at the thought of that horrible creature that came down into the labs a minimum wage ride operator, and walked out a Seahorse Man with no recollection of its former life. *No recollection of its son, Theo Sultan.*

DuPere continued, "Pity. All those years of pent up rage Theo Sultan must have. The glut of barbed words and explosive speeches the fatherless dream of delivering to their absent daddies. I almost feel bad for the maverick. Part of me wishes I could take that man-child in my arms, like one of my many orphans and whisper into his hot, hot ear, 'Dear Theo Sultan, that man you knew as daddy is no more. He is still a monster, to be sure, but now he is *my* monster.'"

The two arrived outside a doorway marked "Test Room 1." "Anyway," DuPere continued, "What was it you wanted to show me?"

The doctor perked up at the chance to finally deliver some good news. He said, "Sir. The Neglectinol trials. I believe we've found a cure."

CHAPTER 22

The doctor led DuPere into an observation room just opposite a two-way mirror. They looked out on what appeared to be a domestic living room setting right out of an average home. Couch, end table, lamp, and a book case. Alongside these familiar furnishings were items commonly used in fatherhood: baseball gloves, famous titles in literature, a fishing tackle box; there were also objects of distraction all too common in this modern age: plump recliner, television set, pizza box with piping hot fresh pizza inside, liquor cabinet full of exotic spirits, even a stack of adult magazines. Quincy DuPere grew quietly furious at the latter set of items, imagining how many thousands of suburban settings there were just like this one, filled with fathers neglecting their children, or without fathers at all. Dr. Jenkins fidgeted with some dials on a console. "Curing the 'deadbeat gene' has been our primary focus here for as long as I can remember," said the scientist. "In the past, our labs have synthesized the qualities found in *good fathers* – discipline, self-sacrifice, virility – and attempted to introduce them to the DNA of bad fathers. Essentially injecting paternal instinct into deadbeats."

DuPere said, "I know, doctor. I paid for it. It wasn't cheap either. Get to the point."

"Yes, anyhow, instead of accepting the fatherly DNA, the deadbeat immune system naturally rejects these genomes as if they were a virus to be destroyed...until now," the scientist said with a mischievous smile. Jenkins pressed a sequence of buttons, and on the other side of the glass three verifiable sad sacks entered the fake living room: a man with shaggy brown hair and rumpled denim longsleeve button down wore a card that said "Subject A." Another, "Subject B," had a long stringy beard and bloodshot eyes, while "Subject C" was overly tan and balding. "Hey alright," said Subject C, heading straight for the liquor cabinet.

Subject B picked up the nudie mags and remarked, "Boy my old lady never had knockers like these."

Subject A made himself comfortable on the lazy boy chair, flipping the television set on to a sports game. He said, "Keep your golden ass down, I got money on this." He then scratched his genitals vigorously. DuPere narrowed his eyes.

"We picked them up from a poker club, a swap meet, and a wet t-shirt contest, respectively," said the scientist. "Each loser here has ditched out on their families in one form or another. Observe their negligence..."

The scientist pressed yet another button and three children entered the room, each more precious than the last. They appeared scared of the grown men who shot angry looks at the children.

"What is this bullshit," said Subject C, removing his lips from a bottle of Thunderbird.

"Yeah, how am I supposed to play with myself with some damn kids watching?" said Subject B.

Subject A simply turned up the sound on the television. DuPere seethed. These monsters had before them perfectly good bits of innocent clay, ready to be molded and cared for.

"Now you see," said the scientist. "Theo Sultan gave me the idea. Rather his genetic makeup did. Remember what you said about deadbeats and mavericks being two sides of the same coin?"

DuPere said nothing.

The scientist said, "The problem we've always faced in introducing synthesized paternal instinct into deadbeats is that their systems reject good parenting like a virus. So our studies have led us to figuring out ways to disguise the synthesized 'good father' gene without it being immediately attacked by their 'bad father' genes."

DuPere wondered if his baby horse-sharks were hungry for dessert.

The scientist said, "After we retrieved his maverick blood, I couldn't help but look at a sample and what I found was the strongest 'deadbeat' gene I'd ever seen. The man practically comes from history's worst fathers. His extreme 'deadbeat' genes, which also happen to be the 'other side of the coin' to his extreme maverick genes, provided the perfect Trojan Horse for introducing synthesized paternal instinct into similar 'deadbeats.' But don't take my word for it..." Dr. Jenkins pulled a lever marked "NEGLECTINOL," and with a hiss, a yellow gas filled the test room. The subjects continued their poor parenting, unawares of the paternal instinct being introduced into their systems.

Subject A said, "Word of advice kid: always use protection – or get a pair of fast running shoes and high tail it away from any knocked-up stranger before sunrise!"

Quincy DuPere frowned at the terrible fathering.

Subject B said, thumbing through his pornographic images, "Boy, lemme tell you, there's no nightmare like the nightmare of war. What a rack on this gal..."

Subject C said, "Oh yeah, pal? What about the nightmare of never following your dreams? Of knowing you can pull chicks half your age but being stuck in a dead-end job with a bunch of rugrats sucking out the last of your youth? Hey, what's this yellow crud? Hey?" Quincy DuPere said, "This was your big breakthrough?"

But the scientist nodded outward. By the time they took note of the canary-colored fog entering the room, the Neglectinol had already taken effect. Now they had all gone from ignoring the children to addressing them with guidance and care.

"Hey, who wants to learn how to thread a fishing hook?" said Subject C.

DuPere's attention returned to the living room where the other subjects had made their way over to the book case and baseball mitt. Their eyes glazed over, the three had abandoned their previous vices and were now actively interacting with the children.

"You see, the secret to hooking a good fish is a good knot," continued Subject C.

Subject B finished fitting the baseball mitt onto another child's hand and said, "Just let the baseball land in the mitt, don't try and catch it."

Finally Subject A hunched down beside his child with a copy of *Moby Dick* by Herman Melville. "Now in a lot of ways, Captain Ahab *was* the white whale..."

"Remarkable," DuPere said. "This truly is a marvelous work and wonder." A single tear rolled down his cheek. Mere seconds ago, these deadbeats were more interested in being lazy, drunk, and horny than fathering the innocents within their very midst. Surely Papanatra had smiled upon the D.A.D.D.Y. Complex this day.

"Mr. DuPere," said the scientist. "I give you Neglectinol. The cure to deadbeats."

"How fast can you can reproduce this?" asked DuPere.

"This is our fifth test. Perfect results. The facilities are already in mass production." DuPere's gaze took on a distant quality as though he were viewing a fine, fine throne in a palace in a kingdom far into the future. Everything was coming together. Everything except for the maverick.

"You've given me an idea, doctor," DuPere said. "As you know I've always had a flare for the dramatic. We shall unleash Neglectinol as a Father's Day gift to the world. The night of Father World's private opening. The night of the Guardian Moon."

The scientist nodded.

"When Papanatra arrives," DuPere said, "he shall be greeted by an army of good fathers to serve him."

"And the maverick, Theo Sultan?" the scientist asked. "Shall I arrange to have him killed?"

DuPere said, "No. Let Mr. Sultan come." His mouth curved into a sly grin. The same lip-sculpture the money man had dawned a thousand times hence going in for the kill of a lucrative business decision. He continued, "When Sultan arrives, we will use Neglectinol to erase his maverick past as an ex-family man, and turn him into his worst nightmare: a loving father. *Forever.*"

"And what of the computer whiz? Of the Colonel? Of the robots – or rather, the robot we *haven't* already hacked?"

"Dispose of the old man, but secure the others. After all, every family man needs a family."

CHAPTER 23

Stepping into the bustling Virginia airport, Sultan had just one thing on his mind, and it wasn't an easy thing. *It was a hard thing.* There in the arrivals gate, reunions bloomed all around him: parents welcomed college students, lovers embraced, and of course a surplus of "extreme sports teams" met doting sponsor representatives from whichever corporate energy drink had decided to help these headbanger daredevils and adrenaline junkie thrill-seekers sell out the last pure part of themselves and use their images to market these same energy drinks to Joe Consumer and Suzie Babymaker.

Those energy drink swilling lazy couch potatoes will feel like they were living life to the absolute fullest when in fact these wastes of carbon were jacking out resting heart rates clinically safe only for a cheetah pouncing on a gazelle. No, these chemically induced hyper-pulses were nowhere near suited for activities like DVRing so-called reality shows, while toddlers pissed and crapped all over the real household guardians, The Almighty E-Pad teaching a new generation to look *and* touch because, hey, they were Americans, and after all, didn't these greedy kid-pigs deserve it?

Frankly, Sultan was as surprised as anyone that the taxi ride to the Rio de Janeiro-Galeão International Airport didn't involve any gunmen

on dirt bikes or roadside bombs. But he wasn't born yesterday. If he was alive, it was because someone wanted him alive. For the time being. Perhaps whoever was calling the shots above Stuphs liked to play with his food. *Perhaps he had other plans for Sultan.*

As the "Meyerson" family walked by stores selling "quick snacks" and neck pillows and the sound of luggage wheels clicked this way and that, and DHS agents guarded the sticky tiles beneath their boots like junkyard dogs on a scrap heap, Sultan felt like a grade-A ass checking his phone messages like so many other grid-starved passengers upon touchdown.

But he'd received at least one thing he was searching for: a confirmation from Debz that his Swiss passport and spot on the guest list at DuPere's amusement park pre-opening had been secured. Looks like he'd be celebrating Father's Day this year after all.

He was also itching to stop off at home and do a little prep work, but Sultan still had to debrief with General Stuphs, a man as dirty as a bag of cheap soil. What a dance of deceit that would be. Sultan surviving an assassination that Stuphs helped orchestrate. Stuphs pretending not to know what Sultan knew he knew. And any number of hatchet men waiting in the wings to finish the job that monster started. If Sultan had his druthers he'd skip the whole meeting with the military man and make straight for Switzerland. *But first the hard thing...*

To make things worse as much as he hated to admit it, the courtroom in his head told Sultan exactly what he'd dreaded: he'd grown attached to the damn robots. Perhaps it was how Cissy had proven herself an intuitive mate and a fervent lover, with the prehensile strength of a macaw parrot beak and its 700 pounds per square inch of pressure. Sultan wasn't complaining...

Or perhaps it was the way Cissy let her head rest on his shoulder during the flight and made gentle snoring sounds even though she was a robot who did not need sleep. Or that he could see down her shirt to her chest which not even 24 hours ago had been covered in chewed over sunflower seeds and domestic beer foam. *And not much else.* Then

there was the Boy Bot. Dear, little Boy Bot. With his cowlick that was 100% accurate to Sultan's own childhood hair and his ability to not have to go to the bathroom – ever, as far as Sultan could tell. Not to mention the endearing way he wanted nothing at all to do with his "father." If this were a real kid, Sultan would take him under his wing this instant. Show him the Truth, before all the society vultures got to him; carrion fowl whose genus was made up of species like *ivory tower universitus, credit cardum debtus,* and who could forget the noble, *politician lies-to-us.*

But alas, this kid was not real. It was just a human likeness full of fiber glass and soldering, all topped off with a gorgeous cowlick made of what felt like the coat of a dead long-haired guinea pig (Sultan snuck several head pats throughout the plane ride to sate his white hot curiosity). To be sure, they were the perfect family, something Sultan had whiffed on three times. It would be hard to ditch them, that much was certain. In retrospect, he regretted telling his fake wife and child that they "would all be together forever," and "not to worry at all," just to get Cissy to shut up for a little bit during the flight. Ever since she gained sentience her personality had changed completely.

For one, her clunky "robot language" cadence had improved as she spent a portion of the flight absorbing speech lessons from various Katherine Heigl in-flight movies (whoever that was); she also insisted on planning their future as a family. She had no idea how much she was hurting Sultan's feelings. The more Cissy nattered on about details such as drapery choices and this strange human restaurant known as "Olive Garden," the harder it was for him to plan his escape. The rest of his journey would be a solo mission.

From flat-out opening the emergency door over the Atlantic and taking a high altitude dunk, to stealing a woman's hat from the gift shop and getting purposefully lost in the crowd of arriving travelers, Sultan just couldn't bring himself to take that first step away from his fourth family. If these robots could be called a family at all...

Sultan decided they could be considered one, definitely. Knowing that these intimate familiars would soon be a distant memory – like so many old sunflower seeds spat into old soda cans and left in the sand at empty playgrounds where Sultan liked to practice his spoon playing – gave him brief flashes of soreness in the heart area, very similar to what some might call "sadness."

Passing a bar of hunched over drunken pilots and their associated flight attendant groupies, he cheered himself up by appreciating the far greater gift Cissy and the Boy Bot had given him. A gift that made the gift of family look like a cursed gypsy trinket: it was the gift of mildly accepting technology. Sure he'd be out a gal and a boy, but after all this was over and Sultan delivered some much needed what-for and comeuppance to the doorstep of his missing dad, he thought he might finally see what this whole "electric shaver" craze was all about.

"Look Pappy," Boy Boy pointed, his guinea pig cowlick as perfect as ever. "That's *our* name!" Sultan followed his robot son's gesture to a portly limo driver holding a sign that read "Meyerson Family." He wore the standard limo driver outfit: suit, cap, nice shoes. *A chauffeur.*

"Pappy, someone sent a fancy car for us!" Boy Bot said.

Something about dealing with a stranger in the employ of Stuphs didn't sit right with Sultan. Also something about the use of the word "pappy" didn't sit right with Sultan. It was too enthusiastic for his heretofore reclusive son. The whole trip the damn kid had kept to himself mostly, why now was he using such warm phrasings? Debz mentioned these robots were learning computers. Maybe Sultan had accidentally given off *too much* affection during this trip. One thing was clear: something had changed in this robot's wiring.

"Why, how thoughtful," Cissy added, her hand sliding out of Sultan's own. "They sent a car, Honey Bun."

Honey Bun? The courtroom in Sultan's head erupted with mental "objection your Honors!" and gavel bangs and frenzied stenographer typing and imaginary jurors fainting. Had this relationship progressed

to pet names already? The only thing Sultan hated more than filling out forms, grown men crying, general injustice, cell-phones, and cover-ups were "pet names." Though buried by the clergy (Big Guilt, as Sultan knew them), the first recorded pet name was actually given to Samson by Delilah preceding his downfall. The rough translation from Hebrew was "Pookie," and many believed it served as a way for the femme fatale to subvert the historic strongman's masculinity by introducing this germ of cuteness which later led to him cutting his hair, and then his downfall. Before Sultan could get as angry as he'd hoped to about the situation, the chauffeur had spotted the "Meyersons," and cheerfully waved the group over with a friendly gesture.

"Mr. Meyerson!" he said, jowls wobbling just above his collar like a toad in an earthquake. "Right this way."

Shit, Sultan thought. Looks like the Big Dog was going to make sure Sultan found his way to Fort A.P. Hill right away. Or a shallow ditch. To act out of the ordinary would give away the one advantage Sultan had: perceived ignorance from his opponent. Unfortunately, with the "Meyersons" all in one vehicle splitting up the family would have to take a literal backseat to Sultan's Switzerland trip. His *vengeance-cation.* If Stuphs was in league with DuPere and the Seahorse Man, it might even be helpful to play dumb in order to throw these a-holes off his scent. Assuming this driver wasn't packing.

"Allow me, ma'am," said the driver reaching for Cissy's rolling luggage and leading the trio to the pick up area. "Save your strength for your husband. He looks like he's a handful!" The driver winked.

Sultan said nothing.

Curbside, a shiny black car awaited. Twice the length as a normal car. Tinted windows. Military plates. A saloon car.

"Wow, Pappy! I've never ridden in a limousine before!" said the Boy Bot.

"Don't let the fancy French name and length fool you," Sultan said, locking eyes with the driver. "It's a car like any other car. No better."

The driver tussled Boy Bot's hair and said, "My old jalopy here ain't much, but she gets the job done." He opened the door for Cissy, who giggled excitedly while stepping in.

"A hero's welcome for my big strong Honey Bun" she said.

Funny, Sultan thought. The "hero's welcome" he was most familiar with didn't involve special treatment of any kind – no limos, no parades, no marching bands – but rather pure obliviousness from a fat-eyed ignorant public who would rather slop up deals on "data plans" than spend a single second reading things that really mattered like the Panama Papers, or accept even the slightest iota of responsibility for voting in a century's worth of kleptocracies.

"Sure," Sultan said entering the darkened car. "A hero's welcome."

Sultan stared at the passing landscape, trying to pinpoint just when his country became a patchwork quilt of betrayal, cowardice, backstabbery, and farm grade horseshit. From what Sultan could tell, we were living in the Golden Era of that moment.

Before he knew it they were approaching Fort A.P. Hill military base, squatting in Caroline County like a grunt awaiting orders. It beat a ditch any day of the week, but now he was on the General's turf. He had the home court advantage. Sultan recognized the military camp immediately: the barracks, the marching troops, the chow hall, the drill officers training the next generation of human confetti to be scattered across air, land, and sea in grim celebration of whatever hawkish rager got pork-barreled onto the legislation that session. Also, there was a sign upon entrance that read "Fort A.P. Hill Military Base," not that Sultan believed in signs.

Personally, he thought "STOP" signs were a step too far by a nanny government already stark raving mad with power, unwilling to let its citizens sort out their traffic on their own. You know, thin out the herd a little of those inattentive enough to ignore common sense road safety.

Cissy became worried as the limo passed through the front gates, approaching a main building capped by Old Glory undulating in the wind like an oil slick on troubled waters. From sea to shining sea.

"Luke," she said. "Luke they're going to split us up. Tell them what you know about me. They'll listen." She still didn't know Sultan's real name.

What could he even say? *"Pardon me, General, but the robot lady and I have grown quite fond of each other. Instead of wiping her memory clean, why not let the two of us run off into the sunset together? Nevermind that she probably cost tax-payers the equivalent of seventy elementary schools..."*

At the same time, Sultan wasn't ready to say goodbye to this woman-shaped machine. If only he could have it both ways, instead of having to decide between playing dumb with Stuphs in order to pursue his missing father, or making a run for it with his new robot family.

Then again, at the same time as that other "same time," ever since Sultan's libido had given Cissy the gift of true human life, she had grown too much like his other wives. The pet name, the clinginess, the planning Sultan's future out to the point where his drifter lifestyle was headed straight for a prison made of white-picket fences. Like it or not, the solution to Sultan's problem had been served up to him on a military grade silver platter: the sooner these robots were out of his life, the sooner he could focus on finding his father. "Relax, babe," said Sultan. "They probably just want to run a few tests on you. Make sure you didn't get robo-Zika or something."

"They'll wipe my memory! I don't want to go back to being a thing," she said.

"You have my personal word, babe," Sultan said as the chauffeur opened the door. Two olive colored attendants holding clipboards stood nearby. The one on the right stared at Cissy and Boy Bot like they were zoo animals.

"Step out of the vehicle," said the man on the left. Sultan nodded in approval and the three scooted out of the backseat.

Standing out in the openness of the base made Sultan feel especially exposed. Their feet crunched on the dirt. The two attending men had an energy of impatience about them.

"This way," said the man on the right with all the friendliness of a cattle prod. Boy Bot gave Sultan a hug. Funny, the last time a child hugged him he nearly razed an entire home. Now he felt only tepid unease. The Boy Bot's guinea pig cowlick brushed against Sultan's hand and he had the brief urge to stroke it for now, and all eternity.

"I love you, Pappy," said the tyke, his perfect, perfect hair glistening in the sun like a toupee near a jar of piss.

"Go on, I'll catch up," Sultan said, staring at his boots. Steel-toed, strong. A source of comfort.

"You promise, Luke?" Cissy said with a pleading gaze.

"Cross my heart," said Sultan. "I just got to have a chat here with the man in charge and then afterward we'll all go for ice cream in the chow hall. How does that sound?"

"Like heaven," she said with a look of respust. *Of lustspect.* With that Sultan said goodbye to his fourth family.

CHAPTER 24

Sultan squirmed in the office of General Stuphs, awaiting the Big Dog's arrival. Not out of fear, it was the tidiness of the architecture. Formal, tight places always made him antsy. All the rules and bureaucracy nearly gave Sultan an allergic reaction. For his money, offices of military superiors all looked the same: stars and bars hanging prominently, polished desks with a sheen reflective enough for the Big Dog to sneak a peek at his own decorative uniform medals like a mirror-shoed peeper getting his jollies; and of course framed photos of political heavy-hitters – all part of the proverbial "swinging of the dick" meant to rub across all four walls of the room and land square in the forehead of whatever unlucky bastard sat opposite whatever brass had something to prove.

"Well, if it isn't my favorite navy bean," chuckled Stuphs in uncharacteristic good cheer, upon entering. The Big Dog took a seat behind his desk and began pouring out whiskey. Vintage. Perhaps the same label Stuphs drank while joyriding those drones on U.S. soil that killed Debz's parents one not-so-merry Christmas. He slid a tumbler over to Sultan and raised his glass. The brown liquid came from the same bottle, so no way it was poison. Sure, Sultan had a tolerance to most poisons, but his system had been through a lot lately.

"To the safety of fathers!" Stuphs announced. Sultan downed the alcohol in one decisive gulp. *Let the games begin,* he thought. Now to see who had the better poker face. Now to mess with the General's head.

"No Bayer?" Sultan said.

"You didn't hear?" said the General. "Colonel Bayer has been relieved of his duty. Must've wanted to keep things private. You know how these old dinosaurs get. Big egos."

"I can imagine," Sultan replied, as if to say *already hiding our tracks by cleaning house, are we?* "Your daughter must be excited to have her husband back. Terrorists, am I right?"

Stuphs stood and gazed out the window for effect. Sultan braced for the lies.

"Fuukar Network, I'm afraid. Retaliation for this or that," said the General. "You know how the fanatic ones get. A chief up in 'goat-farmistan' eats some bad curry one night, has an inspired dream, and next thing you know, it's time for a sleeper cell to make things hard for us *infidels.*"

"Impossible, General. Islam is a religion of *peace,*" the maverick said, his words dripping with the sarcasm of a thousand teenagers.

"Certainly," the General said, "Still you'd think they'd be smart enough to get with the changing times. It's dangerous to stand in the way of progress, wouldn't you agree?"

Sultan said nothing. *Did he detect the day's first threat?*

"Sometimes progress moves too fast," said Sultan. "Sometimes it needs to be slowed down."

"Are you saying you support terrorism?"

"I'm saying I get where they're coming from. Understanding the enemy is different from aiding and abetting." *Perhaps that was the General's plan – peg Sultan as a sympathizer and get him on a no-fly list.*

"Anyhow, thank you for your services," said the General. He extended his hand. The same one the Big Dog had threatened Sultan with at gunpoint in the home of the Entwhistles. The same hand where, a few

days ago, there was a tan line that suggested a missing ring. Only now the ring was back. *A ring with an insignia of two seahorses sixty-nining.*

Just like the sigil in the club.

"Oh, one more thing," he said. His hand tried crushing Sultan's. Sultan crushed right back. "Any luck with the lead on your father?" He had that gleeful twinkle in his eye liars get when they know they're in charge of the truth. Sultan had seen it in the courtroom a thousand times. *The Liar's Twinkle.*

"Afraid not," Sultan said. He knew how to bullshit as well.

But here's where the lines blurred: The General was expecting him to say that he didn't remember anything after entering the nightclub. To tell it like the other marks told it. To say he had no recollection of his whole encounter with the Seahorse Man or having his blood stolen. Because of the amnesia goo. However the mere existence of the faxed photograph of his father in the log flume ride put Sultan in a precarious position. Mainly because both men knew its intended purpose. And, both men knew there was a target on Sultan's head as big as the tires on a LVSR Heavy Tactical Vehicle. So he decided to tell some tales of his own.

"Trail went cold, error in triangulating the signals," Sultan said. "We thought it came from Brazil but it was just sun flares messing with the transmission. Turns out it could've come from anywhere. So back to the drawing board." *Bullshitting.*

"I'm sorry to hear that," Stuphs said. "Maybe it's for the best. Some things from the past belong right where you left them. Like those damn robots. I'm sure you'll be happy to never have to deal with those buckets of bolts again."

Sultan felt a twang of surprising defense at the slur. Perhaps it was guilt, knowing this very moment the two were being erased and prepped for the next operation like old bowling shoes. Or perhaps he just hated the Big Dog's cockiness. Still if Sultan was going to be in the line of fire while infiltrating Father World, he couldn't show the General any weakness.

"I'm a human man with human needs. Those metal abominations deserve to be forgotten like metal bowling shoes," Sultan said. Stuphs gave him a suspicious look.

"You and me are a dying breed, Sultan. *Ec-specially* these days," said Stuphs. "What with technological singularity on the horizon."

The extra *c* in "especially" made Sultan wince, but he ultimately kept his cool. Sooner or later the truth would come out between these two and then Sultan would have his moment to correct this unsettling pronunciation – with extreme prejudice.

Suddenly an ear-splitting alarm cut through the room like a banshee employed as a town cryer. Then gunfire from outside. A woman's screams. Stuphs went for his Beretta and rushed for the door. Sultan poured himself another drink, then followed Stuphs at a casual pace onto the grounds to confirm what he'd already suspected.

Which is to say, a certain robot wife had decided to not go quietly into the night. There atop the main building clutching the flagpole like a spear was Cissy in a hospital gown. *Queen Kong.* She had a wildness about her, that sort of life most pronounced when threatened to be taken away. Her eyes met Sultan's. *Her human eyes.*

The General aimed his Beretta and said, "You come down from there right now or I will take you down!"

She switched the flagpole from one hand to the other, so the patriotic cloth flapped in front of her like a shield. None of the soldiers wanted to be the person to shoot a hole in the American flag. Sultan may have been a Navy SEAL, but he'd won enough hands of poker against Army grunts to know they all believed that shooting a flag would guarantee a lifetime of hauntings from any number of ghosts from patriotic history. *No one here was risking a visit in the dead of night from the likes of Molly Pitcher.*

"Honey Bun!" she screamed. "Those monsters formatted Boy Bot. And they tried to erase my identity, too! Tell them! Tell them I'm alive, Luke!"

"What is that robot going on about, Sultan?" the General said. *Fiddlesticks!* thought Sultan. The last thing he needed was word to

get out about his sexual congress with what amounted to government property. He knew of a group of Marines who had been thrown into Gitmo for playing a game that was part Russian roulette, part "circle-jerk on a landmine." Sultan didn't need any more hangups or attachments. It was time to cut bait once and for all. "Must be malfunctioning," he said, staring her in the eye. "You know how technology is."

Her grip tightened on the flag pole.

Sultan said, "Now get your metal ass down from there before someone gets hurt."

"Too late," she said. Tears welled up in her eyes or at least whatever synthetic liquid was used to approximate tears. Maybe just old scientist spit?

Saliva-weepings or not, they had now turned to angry tears. Bitter tears. Tears of hate. Tears of action.

She brought her arm back, aimed her makeshift javelin and used every ounce of her superhuman strength to hurl the flagpole straight at Sultan's head. A blur of red, white, and blue whipped by so fast it left a burn mark on Sultan's right cheek. Not the first time he'd been physically harmed by a flag, and certainly not the last. The high-speed projectile punctured the gas tank of the limousine and like a sneeze from the molecular fabric of reality the overly extravagant car exploded. Soldiers dove for cover.

The ones you don't see coming...

Smoke and debris flew everywhere. Gunfire erupted like Kosovo Jr., but when the dust settled, a flag lay smoldering on the ground, and the roof was empty. Cissy was gone, her figure already hopping from treetop to treetop in the surrounding Virginia forest, like a scorned vampire lover in the fading horizon. Stuphs holstered his Beretta and stood next to Sultan. Two men, once more beholden to a woman's wild ways.

"What are you still doing on my base?" said the General. Sultan turned to give him a look. The General stared back clearly angry at this new task of recovery. Like a tank aimed and ready to fire, as if to say, *This is your head start. Then it's hunting season.*

As M1161 Growler Jeeps rumbled by in official pursuit, Sultan put one foot in front of the other. Put his boots to use.

Debz sat across from Sultan in the diner booth, staring at him, tattooed arms folded with resentment. He had egg bits in his black coffee, but didn't mind at all. In fact, he quite liked it. The flavor of the two complimented each other like nothing he'd ever known. *Well, maybe just one thing...*

She said, "You just let her run off like that? What if she was telling the truth? What if she really was sentient?"

"It was the only play, kid," Sultan said. "You ought to think about getting out of town yourself. Now you got the goods or what?"

Even just meeting with Sultan put Debz in danger, but he had scoped out the area and it was clear. Whatever Stuphs was planning had been delayed by the search for Cissy. Still, the sooner Debz got away from this mess the better.

Debz said, "I can't believe how quick you are to dismiss the idea of artificial intelligence becoming self-aware. Whatever you got up to down in Brazil certainly had an effect on Cissy. And you're just going to turn your back on her?"

Sultan sipped his coffee and looked over at a waitress bending over. Raked her with his eyes like a pile of sexy lawn leaves. He was trying to get horny. The sooner he reattached his male libidinous drive to a new female form, the quicker he could forget about that night in Rio. The shower they took together, of the sensation of crushed sunflower seeds and fine-smelling suds mixing down the sensual crevices and inlets that made up the slick canyon narrows of their bodies, of that erotic topography.

"There was no funny business, just kissing as part of our cover if that's what you're implying," he said, knowing full well the arousal he felt in his loins had to do *exactly* with Cissy.

"Well, some dumb part of your personality created technology with a soul and now that monster, General Stuphs, and his goons are out trying to destroy the one special thing about her!" she said. Debz's voice quaked with anger as she slammed her fist so hard on the table her stack of pancakes became momentarily airborne. "But hey, at least Boy Bot had his memory wiped, right? You've already ditched three families, what's a fourth? Why not a million?!"

The courtroom in Sultan's head ruled that Debz was letting her orphanhood influence her reading of the situation. Any family was a family to root for, even if it was two thirds non-human. Like a passionate television audience member, summoning real tears for fake romances between actors paid ridiculous sums of money by Big Hollywood to play glorified make believe. *Sad.*

"Now see here, Blueberry," Sultan said, "You want to sit here and throw a pity party in honor of a tantrum throwing robot, be my guest. But if you think for a single second that I'm going to miss out on the one chance I've got to serve my own father a piping hot bowl of payback stew, and put spoon to lip with my own hand, then you've got another thing coming!"

Sultan puffed hot air through his flared nostrils. Nearby, patrons gawked and whispered. He held the young hacker's gaze. Then with a *thwack* a thick yellow envelope bounced off Sultan's face. He made a point to keep his eyes open the whole time so as not to flinch in a show of weakness.

"Fine!" Debz said, standing. "There's everything you need to get into the Father World pre-opening."

"Where the hell are you going?" Sultan said.

"Like you suggested," Debz said, "As far away from you and your macho bullshit as possible."

"Good, sounds safe," Sultan said with not a little bit of paternal authority. He didn't need anything else to worry about. The farther out of town Debz got, the better. For both of them.

He said, "I'd steer clear of the Grid while you're at it. Ever seen a tree in real life? They're these amazing big plants that grow for hundreds of years..."

She said, "I thought you were different, Sultan," gathering up her patch-covered messenger bag and heavily stickered moped helmet. "I thought you cared about doing the right thing. But you just care about yourself."

Finally, Sultan thought. *Someone who gets me.*

"You may think of yourself as a maverick on a mission," Debz said, turning back for one last pissy comment. "But really, you're just another deadbeat looking for a hug from daddy."

Then, like all the others, she was gone.

CHAPTER 25

Father's Day Eve

General Stuphs was no fan of taking orders, but he had done just as Quincy DuPere instructed. There were bigger chains of command he answered to now. *Atlantean chains.* Still, it irked him to stand down in the hunt for that most dangerous game, Theo Sultan. When the General hunted, he hunted to kill. In his heart of hearts, he cursed DuPere's flare for the dramatic. Cursed his plans to make a family man out of the navy bean.

Then again, no mission ever succeeded without order, and so he found himself doing as DuPere's scientist instructed. He had followed the man's condescending directions to a T concerning the Boy Bot. Now the android was in sleep mode. The incident with the female robot earlier that day had put the military man in a difficult position, considering DuPere himself had commanded the lady robot make its way to Switzerland with Stuphs. He was also to transport the annoying hacker girl and the child robot. Something about making Sultan "play house" for the rest of his life. No matter, as "Cissy-1" came equipped with a homing device right where her heart would be, and DuPere had that monstrous creation, the Seahorse Man on the case.

Soon, General Stuphs would be off the base, out of the country, and with the arrival of the Guardian Moon, a founding father alongside DuPere in the coming era of Papanatra.

But first to take care of Bayer.

Stuphs zipped up the standard issue olive duffel bag containing the Boy Bot, and found himself momentarily unnerved by the android's lifeless face inside. Between the chaos of the day, the General's rank, and most importantly, that it was "chow time," hauling the Boy Bot down the empty hall and into the trunk of his car was simple.

The guards on duty waived him through the gates, and soon, Stuphs was a few miles away before he turned off into a rural dirt road. He made sure he was alone, his only company the broadleaved deciduous trees grasping toward the heavens like a congregation at a revival.

He popped the trunk and unzipped the duffel bag. It jammed at first because the robot boy's hair got caught in the zipper. A cowlick. He pulled hard. The wayward patch of hair came out, but otherwise the machine was fine.

He slid the bag around the ankles of the machine and unfolded the directions he'd written down. Directions that following the memory wipe earlier today, would restore the Boy Bot to a state of servitude. Would weaponize him. Stuphs did exactly what was on the paper: Left ear tug, left ear tug, right ear tug, right ear tug, then the infamous "I got your nose" trick. The machine awoke, yawning. It balled up its fists and rubbed its eyes like it had been asleep. They glowed red like an "EXIT" sign in a darkened hallway. Then the Boy Bot looked up at Stuphs, the new bald patch gleaming in the Virginia moonlight.

"Rise and shine, young man," Stuphs said, handing him a photograph of Bayer. "You've got a bright future ahead of you..."

The Boy Bot crunched into the forest.

Sultan was greeted at the cabin door by his dog, Marcus, with five different items in his mouth: a cigar, some chips, a beer (already opened),

fingernail clippers, and the week's mail. If Stuphs was going to hit him, he figured it'd be here. But there were no signs of an intruder. Just a happy dog and Sultan's normally spartan living quarters, which for some reason seemed especially bare. Whereas before Sultan enjoyed the solitude, now the place felt empty. Like a house that was not a home. For a brief moment, he imagined Cissy and Boy Bot there.

He went straight for his Mossberg 590A1 pump-action shotgun tucked underneath his blanket, just beside the indention of his body in the mattress. It left a grease-stain on his sheets. Sometimes Sultan would have the urge to disassemble the fowling piece in his sleep and didn't like to get out of bed in order to do so. Checked the chamber. *Try me,* he thought, cocking the weapon. Then Sultan took the mail and the beers. Dog spittle normally mixed in with the suds, but that was just how he liked it. One day he'd open a bar that sold only domestic beers with the option to add dog slobber. Call it "Dirty Dogs." *One day...*

Shit, Sultan thought as his eyes landed on the mail. It was from his ex-families again. A warrant was now out for his arrest after failing to appear in court for unpaid child support. Bayer had promised to wipe the slate clean, but this piece of mail suggested otherwise. Sultan certainly didn't have time for this kind of crap. Perhaps he'd need to pay Bayer a visit.

He reminisced about the past few days, about Cissy and Boy Bot not bothering him. Before Cissy had grown sentient, and clingy, and terrible like every other human. Why oh why had he heroically sexualized her into becoming self-aware? That was the problem with being a hero to people. They all became dependent on you. To the rescued, a hero was a drug that made the D.C. Crack epidemic look like pog fever.

The beer and dog spittle released some much needed endorphins in his brain as he slunk down in his worn recliner, the furniture version of himself. He opened the package Debz had tossed into his face. He removed the contents to find everything he'd need to get into the private amusement park pre-opening: laminated pass, coupon tickets for free beer, and for some odd reason, a pair of circular rose-tinted spectacles.

CHAPTER 26

Colonel Bayer sat alone in his empty countryside farmhouse, sipping an aged cognac by the fire – against his doctor's orders. The pacemaker in his heart didn't respond well to liquor, but then again, it didn't respond well to most enjoyable things. Ever since the DoD used him to get to Sultan, then unceremoniously kicked him to the curb, he didn't have much fight left in him. Just as well. The army he knew was over. This new crop didn't appreciate the honor or the duty. Or the valor. It was all MMA and video games and barbed-wire tattoos. They sure as hell didn't make them like Sultan anymore...

Tlllink.

The noise came from the bedroom. Glass breaking. Perhaps a wayward birdie had smashed its way into the master bedroom. Maybe a White-winged Crossbill or a Fork-billed Flycatcher. Loraine would know. He could see her now scooping up the lost animal like Snow White in the same bedroom he and his sweet wife had shared for nearly three perfect decades. And during all that time they had failed to produce one army brat. Sultan was the closest thing he had to that. He chuckled at the notion.

Ungrateful bastard.

He padded upstairs in his slippers, each a cartoon face of a bald eagle with huge googly eyes – a Labor Day gift from Loraine. How long had his wife of three decades been gone now? Four years this autumn. Bayer thought he heard scampering. He stared at the cognac in his hand and noticed it was considerably lower than he remembered. How much had he had to drink anyway? Not enough to forget Loraine's homemade chicken pies...

Tlink.

That sound again. From the master bedroom. He rounded the corner and was met by a gust of wind streaming in through a hole much larger than any Green-tailed Towhee. Perhaps a critter? Suddenly a "child's giggle." Was he hallucinating? Was he hearing the son that never was?

"Whoever's there better show yourself!" he yelled.

Silence.

Bayer downed the rest of his cognac and set down the glass. Moved over to his sock drawer. Removed the Colt single-action Army .45 revolver. Same kind Patton carried on the battlefield. *May God have mercy on my enemies, because I won't,* the General famously said. Bayer's hands were clumsy with drink. Luckily, a Colt .45 packed a hell of a punch.

Two red eyes glowed from the shadows casting the faintest outline of a small person. *Aliens?*

The two light sources grew, bled together and erupted in the form of a red laser beam, momentarily lighting the room red, the same way lightning makes all darkness known. The blast connected with his chest and knocked Bayer off his feet and into the wall.

BKSHHH.

The Colt erupted. Wood splintered, a photo fell from the wall. It was of he and Loraine, eating cotton candy at the Tomb of the Unknown Soldier. Bayer touched his hand where the beam struck him. His pacemaker quickened.

Then, *It* emerged from the darkness. The Boy Bot, hideous without his trademark cowlick.

"Son, what are you doing here?" said Bayer. The robot boy remained silent, his eyes glowing once more the brightest red yet. Sending electronic waves to the machine in Bayer. He felt his chest tighten.

"I knew that bastard Stuphs was hiding something," he choked out.

The Colt fell from his hands. Bayer lurched over onto his knees. Crawling for a telephone. He had to warn Sultan. But the only number he'd be dialing that night was 1-800-GET-DEAD. *Toll-free.* With a wiggle of his nose, Boy Bot finished hacking Bayer's pacemaker.

"Aagghhh!!!" Bayer cried, until finally the area over his heart popped open red and foamy like Jiffy Pop or a baking soda and food dye volcano. As the man lay dying, Boy Bot helped himself to the bald eagle slippers and was off...To visit the blue haired girl known as Debz.

CHAPTER 27

Like a feral cat, Cissy slunk along the sidewalk outside the closed bridal store, half looking for a disguise, and half admiring all the ornate ceremonial fashions in the window display. Wild-eyed and desperate, her bare feet were covered in sap from the tree tops. She needed to disappear. To become anonymous.

So this was what it meant to be alive. Through the glass, she stared at a mannequin frozen in a constant state of nuptials. No mavericks to hurt her. Its gaze fixed straight ahead. Staring out at an indifferent world. People who had no concept of the gift of life. How she related to this lifeless being. If only she could be on the other side of that glass. Staring out at the sidewalk which was now empty in the late evening. Empty, that is, except for one figure, slowly approaching from behind.

A figure carrying something that caused Cissy's head to throb, and her internal perception boards to go fuzzy, like someone was tuning the television antennae of her mind to white static. Cissy whipped around to face her assailant, ready to separate the left half of its body from its right. Instead, what she saw froze her in place. It wasn't so much the grotesque sea manimal's appearance that gave the robot pause, but rather a sort of rectangular sign bearing impossibly blurred letters and numbers: a CAPTCHA.

Like all bots, she was powerless against the illogical, wobbly characters. Her circuit boards went haywire trying to make sense of the odd "writ in water" type script. Confounded into a state of paralysis, Cissy watched helplessly as the Seahorse Man then clamped two large hoop-shaped earrings into her lobes. Two hoop earrings made of magnets: *the chloroform of the robot world.*

The magnetic field created by the hoop earrings immediately wiped Cissy's hard drive clean, and with it, all the sentience she had enjoyed. A life come and gone, all too briefly.

The hot shower water droplets raced down Debz' tattoos like rebel snails while rock-and-roll music oozed out of the next room over. Her tattoos were of Alice going through the Looking Glass. Of the Caterpillar smoking his *hookah.* A little something she got in Amsterdam, back when she dated guys. Back before she knew all of them were dicks. Back so very long ago...

Riding her moped home earlier that day to her funky flat in the H Street corridor arts district of D.C., Debz told herself Boy Bot was just a machine, but that didn't make imagining him all alone at the government facility during his final moments of deprogramming any easier. Bundling up in her Marilyn Monroe towel – a personal hero – Debz thought about her first day at the orphanage, after her parents were killed by undocumented drones operating on U.S. soil.

Like a child's first inoculation, she imagined Boy Bot uplinking the memory wipe application. The power draining his eyes. Packaged into a crate, like an appliance. Loaded onto an anonymous green truck like equipment.

What she *hadn't* imagined was that Boy Boy was secretly designed with a false dummy chip in his circuitry, and had only given the *impression* that his memory was erased earlier that day. She also hadn't imagined that the Boy Bot had paid her former boss a visit. *She also didn't imagine Boy Bot was standing in her living room.*

When Sultan found Bayer, he was alive in the technical sense, but the red foam erupting from his exploded chest suggested an imminent change in status. Sultan had seen dead men before – saw them every time he shut his eyes; saw them when he shut his eyes taking a leak; saw them when he shut his eyes sleeping on public benches; hell, he even saw them when he shut his eyes and let his dog, Marcus, lick the day off his toes. So Sultan knew right away that Bayer was not dead. But he was getting there.

"Sultan?" Bayer choked. His voice sounded like marbles and nails in a failing trash compactor: not great. "You're the last person I expected to see."

"I usually am," Sultan said. "Hell I heard of heartburn Bayer, but this is ridiculous." He leveled the Mossberg to make sure whatever did this to the old man wouldn't have an easy time of doing it again.

"It's gone," Bayer coughed. "When will the fighting stop? More, they say, like a pig at a trough eating slop as long as its there." The man wasn't making any sense. His brain had one foot out the door. Sultan moved to dress the wound, but the colonel swatted him away.

"Leave me be," he said. "This is where my story ends, Sultan."

Sultan *always* respected death wishes. You just had to in this line of work. By now, Bayer's chest looked like a backed up slushy machine.

"Who did this to you?" Sultan said.

"Not *who,* what. That *thing,*" said Bayer. For a brief moment Sultan pictured Cissy, rampaging into the sunset earlier that day, like a disgruntled gargoyle. Could it be that Sultan's choices somehow affected the people in his life? Even the people he didn't hate?

Bayer said, "The Boy Bot. They weaponized him." Just the name brought back fond memories of that cowlick. Sultan immediately crammed those same memories into a burlap sack and tossed them in the river of red hot lava rage that now coursed through his heart.

"That's impossible," said Sultan. "Stuphs had the damn thing deprogrammed. Unless..."

Encirclement. A classic military maneuver. No wonder the General hadn't come for Sultan yet. He was taking out the weak targets first. Start outward, and work his way in. Like a noose. That's why he didn't want Sultan involved with tracking down Cissy. There was no wrath like that of an ex-wife – the wrath of a charging rhino with a hornet's nest on its nuts. If the General were to turn Cissy against him. Or worse...

He thought of Debz being hunted down by the same man who used war technology to kill her parents. *Crap.* Sultan would have to check in with her. At this rate he'd never get to Switzerland, not without innocent orphan blood on his conscience. And in his experience, traveling with innocent orphan blood on one's conscience was the worst way to travel.

Plus to add insult to injury, there was a pretty good chance Bayer hadn't done a damn thing for Sultan's case against his ex-families. They say the near-dead are gifted special powers to help in the transition from this world to the next. Powers included but not limited to: weight guessing, the ability to name all fifty states in under thirty seconds, and in this case, mind-reading.

"I lied to you, Sultan," Bayer said. "I never had friends that can help you out with your ex-families. That damn Stuphs told me if I didn't get you on the case one way or another, I might as well clean out my desk. Now look at me."

Sultan said, "Well, we'll always have Mogadishu."

Bayer laughed. "You're a funny guy, Sultan," he said. "Not just in the way you look but in the way you make jokes."

Sultan said, "Yeah, I'm a regular Rita Rudner."

A look spilled across the colonel's face like he was about to vomit: the man was ready to upchuck his soul. Bayer's eyes rolled upward and the color in his face went pale. He didn't have long. Sultan looked at the scorch marks surrounding the hole in the colonel's chest. At the sloppy-joe frappé that was his old man sternum.

Bayer reached out his quivering hand like grasping for an angel. Sultan took it. It felt like ice cold asparagus.

Bayer said, "This country is too caught up with sides. Left. Right. Red. Blue. Life. Death. All two sides of the same coin, Theo."

His eyes bulged and his voice retreated. Bayer said, "It's not which one you choose, but *that* you get to choose. That you follow your instinct." Features sunken like a deflated air-mattress, Bayer turned his head to an empty space in the room and said, "Do you hear them, Loraine? The birds? The birds..."

Then his head fell backward. Sultan heroically fought the knee jerk reaction urge to drop one of his classic kill-lines, and instead simply saluted.

"At ease, soldier," Sultan said. "At ease."

Ignoring local road safety laws, Sultan rumbled down the back country road on his hog, mobile phone receiver to his ear waiting for Debz to pick up. The Grid. How long had society lived in this info cage? A cage of our own design. Web culture got one thing right: the idea that we were all in a web, trapped like flies by the spider of time.

"Time spiders," Sultan said aloud, rounding a corner. Then again, Sultan supposed all monsters needed cages and if you held a mirror up to this monster, you'd see society blinking right back. Yup, society was the real monster, contained in a narcissistic grid of its own design with cross-crossing jail cell bars made up of gratuitous breakfast photography and message board complaints about such as what actor had been cast incorrectly as whatever comic book character in whatever summer blockbuster was sucking up the paychecks of the hardworking and even harder *freeloading* American public.

"What?" said the mistakable voice of Debz on the other end. "Did you just mumble something about 'time spiders'?"

The hacker sounded a little more cordial than usual, but that was women for you: frying pan in hand one minute, olive branch the next.

"Look, Blueberry," said Sultan, "Just wanted to make sure you were..."

"I'm fine." she said. "I'm on a train up to Seattle as we speak. Java heaven. I know a collective up there off the Grid that will help me lay low. Why, is something the matter?"

He debated whether or not to tell her about Bayer's demise. He decided against it. No use in freaking her out if she was already moving in the right direction.

"No," Sultan said, "Good plan."

"Well I better hop off," said Debz. "Getting some annoyed looks."

"'Til we meet again, Blueberry," Sultan said.

"Sure thing, Cave Man," said Debz. "Sure thing."

The call ended and just like usual he was alone again. Just Sultan and the cosmos and the smell of exhaust and the sight of glowing white dashes of the road, flying past him like crude lasers in an arcade game from the '80s. Challenging his approach. Alone. Which wasn't a bad place to be, as it was a world he knew plenty about. But what he *didn't* know plenty about was that the voice he'd just spoken with did not belong to Debz. It was an imitation. A trick of the ear.

For the real Debz was currently tied up and gagged in the back of a moving van, just pulling up to a military airstrip. The voice Sultan just spoke to came from thousands of miles away, in the private office of Quincy DuPere. Hacking the Wi-Fi in the Boy Bot's conference call setting, the money man was able to impersonate Debz in real time with an audio filter plug-in. The maverick remained none the wiser. Everything was going according to plan.

CHAPTER **28**

Father's Day

Like a big worm, the tram snaked toward the Swiss amusement park known as "Father World." Theo Sultan was now GJ MacGregor, the Canadian. Through his rose-colored circular spectacles and a quagmire of strawberry blond hair, "GJ MacGregor," watched as he and his fellow passengers – all male, all dad-age – passed the green, cow-thickened mountain. Their destination was a remote plot of land high in the Swiss Alps hosting DuPere's theme park dedicated to fathers.

Years ago, these same majestic conglomerations of dirt and grass played home to farmers and countrymen quaking in their boots against the great German threat. Sultan always hated Hitler a lot, both for his views on antisemitism and especially for the cowardice the man demonstrated by murdering his own dog, Blondi, with a cyanide caplet approaching war's end. If Hitler were here right now, Theo Sultan would tweak his nose and put a firm hand or two to those evil, evil buns.

DuPere must've paid a fancy franc to some muckity muck for a location that included former bunkers and military tunnels, not to mention access to some of the best cheese and chocolate on the market today. Still, Sultan bristled at the thought of all the forms that would accompany such a land sale. In terms of bureaucracy the real estate industry made the

DMV and IRS look like motel vending machines, the simplest of business transactions in Sultan's often correct opinion.

Quarters in, tooth brush out.

The air was fresher up here, true, but Sultan's lungs craved American smog like muscular Olympian ankles craved ankle weights. He could already feel his circulatory system growing dependent on the purified oxygen. He made a mental note to smoke cigars three at a time – ideally in a cloud of dry wall dust – as soon as possible. Aside from the wussifying clean air, his trip from the United States had gone smoothly, which worried Sultan. He was always most comfortable during non-smooth situations. Perhaps it was his thirst for adventure, or perhaps it was a subconscious effort to recreate the chaos of his dysfunctional childhood, but either way, he kept his eyes peeled. Up, up, up, the tram continued until finally reaching a tunnel that penetrated the mountainside.

"Hey ya, palley," the unkempt man to his left yelled. "Bum a smoke?"

Sultan said nothing. The tram now entered a cavernous tunnel lit with mining lights. Words echoed like bouncing sounds. "Aaahh phooey," the man said with a swatting motion. His piss-poor demeanor matched the others. Noses were picked, mouths breathed through, chewed gum stuck under seats, and groins scratched with little to no shame.

"Well, I don't know about you," said another man with a bleached goatee whose roots needed a touch up

"But the best choice in my life I ever made was leaving my family in the dust."

"Amen to that, brother," replied a third with crossed-eyes and long fingernails. "My old lady was giving me crap during TV one night, so I split to get the family some ice cream and never came back."

Sultan was starting to see a pattern.

Finally, another cretin with a waist-length ponytail in tiny rubber bands at varying intervals said, "I ditched mine on a trip to Carlsbad Caverns in New Mexico. Left 'em in the dark at 100 feet below the Earth's

surface. Sure I hid behind a stalagmite while my kids groped around in the dark, but then I was gone, brother. Ha ha ha, what losers."

A few cheerful murmurs of support confirmed what Theo already suspected: every man here had abandoned their families. Debz was right, these were "deadbeats." Thousands of them. But why would these freeloaders agree to attend a theme park that rubbed their noses in the very idea of fatherhood?

"Say, dude, how about you," said another with a flat top and dead teeth. "How'd you do the deed? You look like you got a good story about popping the cherry on your life as a free man..."

The man with the flat top elbowed Sultan aggressively and the neighboring passengers devolved into good-natured frivolity. If he was going to be undercover he had better play the part.

Sultan said, "Maternity ward. Went out to get some air. Still breathing it to this day." The cart roared with laughter. Say what you wanted to about deadbeats, at least they enjoyed each other's company.

"Man, what's taking so long," said Bleached Goatee. "Daddy's getting *thirst-ay*!" He made a drinking motion with his thumb.

Ponytail said, "Drink up, man. First things first, I'm here for the all-you-can-eat buffet like they promised on the postcard,"

Postcard? What postcard, thought Sultan.

"No kidding," said Flat Top, producing said postcard, "Free trip to Switzerland, all to just help some asshole billionaire test out theme park attractions? Um, can you say, 'Sign. Me. Up?'"

These men thought they were here to test out a bunch of rides? Surely *some* had heard the news about the focus of Father World?

"Mind if I get a look at this?" Sultan said taking the postcard. "Just want to prepare for all the free perks headed my way."

"I heard that, brother," said Flat Top handing it to Sultan. The mailer looked harmless enough, like the sweepstakes junk that might clog your mailbox:

Congratulations! You have been randomly selected as a lucky guest of Quincy DuPere to be a part of an important focus group. Tell Mr. DuPere what you think of his new, yet-to-be-named amusement park. Free travel, room, and board! And did someone say "Topless Omelet Bar?!"

"Yet-to-be-named"? Sultan thought. Could it be that none of these men researched DuPere? Were they only reacting to the offer of freebees and arousing image of a topless model in a chef's hat holding an egg dish complete with chives and mushrooms, while stars censored her tits?

"I love this kind of free junk," said Ponytail. "One time, I went to a timeshare presentation out in like some place and I got a free lunch and a sports bottle and all I had to do was sit in a room for 4 hours and hear some jagoff talk at me all kinds."

"Shoot," said Bleached Goatee, smoothing his chin-beard, "If I had a nickel for every timeshare presentation I sat through with no intention of investing, I'd be a rich ass man."

Of course, DuPere *knew* these men wouldn't investigate a free meal ticket. After all, they were *deadbeats.* But the question remained: why would he need to get them to the park? And for what purpose? Just then, monitors on the tram crackled to life. Along with some elevator-music type music, a brightly colored logo for "Father World" appeared like a station ID. Already, the deadbeats were murmuring at the words. Grumbles such as "...the hell?" and "...I didn't come here to get shamed, man..." could be heard in the otherwise darkened tunnelscape. Clearly they hadn't done their research. Sultan interlocked his fingers and stretched them behind his head, then leaned back and waited to see how DuPere would spin this one.

On screen, a cartoon Seahorse Man in sunglasses walked up to the last letter – the *d* in *Father World* and leaned against with arms smugly folded. DuPere's version of Mickey Mouse, the famously shrill, gloved rodent. From the looks of the hues and fonts, DuPere must've tapped the world's greatest minds in advertising. Sultan grinded his teeth at the

very thought of commercialism, that slick pusherman to the populous whose most addicting drugs included Coca Cola soda, luxury pants such as Arizona Jeans, and cell phone plans promising the best deals on data the same way a big city smoothtalker promises a life of glitz, glamour, and gooses for Christmas to Main Street's most gullible virgin. With a Fonzarelli-like elbow, the Seahorse Man cartoon knocked the letter *d* like a jukebox and some noticeable Dad rock genre music kicked into gear. Sultan recognized it from the ringtone Debz had installed on his phone back in Rio. Along the energetic yet sensible tunes, images of various park attractions whizzed and splashed across the screen with all the nuance of a pharmaceutical investor presentation.

Only these were mere deadbeats.

Points of interest included "The World's Largest Flatscreen," found in the "Man Cave of Wonders," a sort of glorified subterranean den of repose filled with a plethora of beers and snacks right out of a neverending Super Bowl party meets Swiss limestone grotto like naturally occurring St. Beatus caves.

Next there was the "Fun with Fishin' Jamboree and Stage Show," where an enthusiastic troupe of performers seemed to sing and dance their way through a fictionalized story on a set rigged with controlled pyrotechnics. A chyron at the bottom read "every audience member gets a cast-autographed fishing line and hook!"

The tone in the tram was largely unimpressed with "boos!" and chants of "down with Fatherhood!" drowning out the ill-received commercial. Others expressed concern at being pranked. But amid the rabble, something onscreen caught Sultan's attention: a log flume ride known as "The Lumber Jack." The same flume from the photograph of his father. That would be the first place he'd explore...

There was *one* attraction, though, that seemed to interest a few of the more thrill-seeking deadbeats, as a hush passed over the crowd: a roller coaster ride. Giant, steel, swooping. Complete with climbs, dips, and all manner of extreme angles. This was the "The Finisher." The park's

flagship attraction. Not just a giant roller coaster, but a truly majestic feat of architecture. Even the most pathetic deadbeat couldn't deny the elegance of the 500-foot tall creation filled with loops and cork screws to beat the band, and enough zero gravity to please an astronaut.

Not your mom and dad's roller coaster. But what set the The Finisher apart wasn't its initial 500-foot climb (much taller than Cedar Point's 420-foot *Top Thrill Dragster* or *Kingda Ka*'s 456-foot beast out of Six Flags New Jersey); it wasn't even The Finisher's series of turns, banks, and twists, four loops and finally a corkscrew so tight the trajectory leveled out near horizontally while the riders spun upside down over and over again in a sustained barrel roll at speeds of 160 mph only a few feet above a beautiful man-made lagoon. No the defining quality of The Finisher was the roller coaster's overall design theme: *male fertility*.

Yes, each roller coaster cart on The Finisher was shaped like a single spermatozoon cell. *Sperm.* Smooth, pearlescent head at the front, wiggly flagella tale with a creamy luster tapering off toward the end. Sultan had to hand it to DuPere, when he found a theme, he stuck with it. Just then, the screen changed again depicting a picture perfect countryside. A giant picnic blanket lay spread out five times as large as your normal picnic blanket, covered in orphan children. All eating things like cold fried chicken, sandwiches out of wax paper, and lemonade. All happy. And at the center? Why, none other than Quincy DuPere. He acted like the camera surprised him.

"Oh, hi there," the money man said. "Run along now, children."

They did.

DuPere said, "Greetings all. Let me be the first to welcome you to Father World. You've all been selected to enjoy a new era in satisfaction. Or should I say 'dad-isfaction.'"

A man with a nose ring belched. Several other deadbeats jeered. *Tough crowd*, thought Sultan.

"Now, I know what you're thinking." DuPere said. "Why have YOU been selected to attend this pre-opening? And on Father's Day no less?"

"You got that right, nerd!" Flat Top yelled. Others patted him on the back.

DuPere said, "Why you? You who chose to abandon your families for independence, you who chose to abandon your family for adventure? You who chose to abandon your family for selfishness? Ignorant of the joys of *fatherhood*?" If this was the money man's idea of winning over these sad sacks, then maybe DuPere wasn't the genius everyone made him out to be.

"I got your 'joys of fatherhood' right here!" said Bleached Goatee, gripping onto his crotch to the approval of his neighbors.

"Why indeed?" DuPere said, pausing for dramatic effect. "BECAUSE HE WILLS IT."

The on screen host then threw his head back in maniacal laughter as a seeping sound crept into the tunnel. The monitor shut off as the sound of gas entered a space, like a leak in an air mattress. Sultan recognized it immediately and looked around for the source. Periodic vents in the otherwise fully enclosed tunnel emitted a yellowish gas.

"What the hell is this?" screamed Ponytail. "What..." but he trailed off, as if losing his thought. Others seemed dazed by the new change in atmosphere.

In Sultan's experience, any kind of mystery gas was bad news, so he instinctively removed his healthy wig of fops curls and pressed it to his nose and mouth. The mesh woven scalp and ample tresses acted as a filter. At least until he could figure out a plan. Up ahead a light in the tunnel. If he could just hold his lungs, he'd avoid whatever element DuPere decided to sneak into the respiratory systems of these unassuming deadbeats. All around, they turned zombie-eyed.

Finally the gas cleared, and the monitor turned back on, picking up mid-scene like nothing had ever happened. Now DuPere was joined by the orphans, as well as the Seahorse Man, this time all dressed up in cartoonish bright blue overalls and white gloves, attempting to mask its abominable nature in the garb of a theme park mascot. It did that thing theme park mascots do when they are displeased, and hid its eyes with

its large hands. DuPere said, "Don't be sad, Soggy! I promise you these happy pappies will have the best day of their lives here at Father World."

The Seahorse Man pumped its fists in support of the money man's words. Now the deadbeats wordlessly nodded along in agreement.

DuPere said, "Plus, at the end of the night, every dad gets a free orphan!"

The orphans on screen cheered. So did the dads. Sultan furrowed his brow. Finally Quincy DuPere addressed the camera and said, "So remember, the only thing better than a satisfying time is a *dad*-isfying time!"

Sultan couldn't believe what he was hearing. Every last deadbeat was laughing uproariously like DuPere was God's gift to comedy (for Sultan's money that honor belonged to Rita Rudner). Seconds before, they were bragging about ditching out on their families and now they couldn't wait to subject themselves to a bunch of pro-dad entertainment. Whatever was in that gas, had something to do with it.

The tram finally pulled out of the tunnel and up to the park entrance. Two giant wooden gate-doors opened up, letting the tram enter. The barriers seemed right out of a dinosaur park, and stood below a huge sign with torches on either side. The sign read:

Father World

CHAPTER 29

DuPere watched on his office monitors as the fathers milled into the park. He sat blue in the light of his empty aquarium. His horse-shark babies had been transported below earlier that day. For the grand ceremony. The sacred white linen vestments he now wore took on the azure glow of the barren tanks. He looked as though he were going to be baptized. But it was he would do the baptizing, and a world of deadbeats whose souls would find paternal salvation through the cleansing light of Papanatra. And for those who needed a little help accepting the gospel, there was science. There was Neglectinol.

He watched the surveillance monitors even closer, as a man in a curly strawberry blond wig and multi-pleated, wide-hipped olive jeans stood like a rock on the shore of a retreating tide. *Theo Sultan.* The so-called maverick who managed to avoid the cloud of Neglectinol by creating his own improvised gas mask. *No matter*. One way or another, DuPere would change Sultan. Would turn him into a father and husband and family man yet. But that would happen soon enough, now he was needed below.

He moved toward his bookcase full of various tomes of the occult and self-help books he wrote on the subject of fatherhood. There was *Daddy Knows Best,* with a photo of DuPere at the head of a class, lecturing several babies in mortar boards; a few titles down from *Come to Papa* – the cover

featuring a baby crawling along a racetrack surrounded by cheering fans. Attached to the baby's forehead was a stick dangling a carrot on a string, with one small difference: DuPere was the carrot.

He chuckled wistfully, and pulled out a third book nearby titled *Fatherhood or Bust.* There were clicking sounds, then the entire shelving unit opened to reveal a yawning dark passageway dipping down like the back of a throat. Below was a staircase surrounded by walls of limestone, lit intermittently by torches. Descending into the cold depths of the Swiss mountain, Quincy relished the absence of noise that accompanied subterranean environments. The absence, save for his steps' echo. Precise. Faint. Like a metronome.

He made his way down through the textured, grimy jaundiced walls toward the sprawling, ancient venue of tonight's history making ritual. Toward the entrance of his hallowed cave temple. The Romansh monks of old had called it "The Dragon's Mouth." A giant chamber with stalactites and stalagmites, columns, dripping sounds, steam, geodes, naturally occurring hot springs, and overall mystical vibes. A holdover from the brave ancients who worshipped as the Atlanteans during pagan times. Hunted like dogs through history for their belief in the Power of the Dad. While the modern world did its level best to puke all over paternalism, tonight Quincy DuPere and his brotherhood would honor them. *Tonight they would welcome Papanatra.* As he rounded the last step DuPere's coveted silence was slaughtered by the harassments of that terrible, imprisoned, blue-haired hacker girl. The orphan.

"Get your stinking fish hands *off* me!" said Debz. The Seahorse Man locked her in a box-shaped cage.

Like a troll king looking out upon his great hall, DuPere beamed past the imprisoned orphan at the guest of honor standing at the other end of the hollowed out 30-yard mineral lair: Papanatra.

As large as an ancient Buddha, the three-story stone sculpture had the head of a seahorse – much like the genetically created Seahorse Man, and had the body of a musculed warrior. In the center of Papanatra's forehead

was a cluster of geode crystals, that all groped upward at an angle. Its eye cavities held burning blue lamps that flickered as they looked out on the preparations below.

Debz said, "Yuck! You smell like Long John Silver's if they caught all their fish out of a bowling alley toilet."

Oh, how the youth treated speech like a sitcom punchline. Thankfully tonight's ceremony would put an end to all her sassiness.

On the other side of the room was Sultan's former wife, Cissy, in a wedding dress. She stood at a naturally occurring azoic altar like a life-sized cake decoration. For the arranged marriage, in honor of Papanatra. Unresponsive, and staring straight ahead as if in a trance, due to the magnet hoop earrings. Sultan's bride to be. Whether he liked it or not.

DuPere took a proud step onto the ornate carpet that extended across the floor ahead of him 50 feet to the room's centerpiece, a large stone basin with the texture of melted candles and filled with natural spring water. A sloppy rectangle designed by erosion, with pus-colored chest-high walls. About seven feet deep, like a Turkish bath. Large enough to fit a steer. Large enough to fit the cage Debz was in. And bubbling with hungry, hungry horse-sharks.

"You'll never get away with this," Debz said from her cage, just beside the pool of death. "He'll stop you."

Boy Bot turned a crank on the wall and a loose rope attached to the top of her cage pulled tighter. The cage wobbled like a helicopter finding its bearings, then steadily raised up higher and higher.

"Who?" said DuPere, "Your precious maverick? By the time I'm through with him, he'll be fully domesticated. Isn't that right, doctor?"

Dr. Jenkins nodded in a robe sewed in traditional Atlantean fashion and tended to the little hungry animals making sure the transition from DuPere's office to the cave temple was a comfortable one. They would need to be in top shape for the coming sacrifice.

"The Neglectinol gas is our purest batch yet," said Jenkins. Rounding out the cast of characters in the temple were two other robed figures: a

senator and a congressman, respectively, who had spent their previous lives as a lobbyist's wet dream before they themselves were taken by the gospel of Papanatra and its promises of wealth and power untold. Now they wheeled in a six-foot-tall box containing a specially made gift, over to the feet of its recipient: the statue of Papanatra. The geode crystals in its forehead shimmered, as if in approval. Shimmered thirsty for the light of the Guardian Moon.

For as deep as they were in the Earth's surface – 10 stories to be precise, the huge temple room had a domed ceiling like that of an observatory and when the time came could mechanically slide open. Once open, the sanctuary lay at the bottom of a sort of mining pit leftover from history. Like a limestone smoke stack or antechamber at the bottom of a very deep well. When fully ajar, a space 50 feet in diameter connecting the temple to the mountainside allowed light from the naked sky and more importantly from the Guardian Moon to stream in and illuminate the crystal formation growing out of the statues' forehead. The prophesies told that once these forehead crystals glowed brightest, Papanatra would enter this realm.

Prostrate at the precipice of the horse-shark basin, DuPere bowed his head before the mighty statue. Dr. Jenkins handed him a bejeweled goblet carved all around its rim with the symbol of two seahorses sixty-nining, and filled with the blood of the nine fathers.

The money man handled it with all the care of a sacrament making sure not to spill even a drop. Debz wanted to scream, wanted to stop the nightmare unfolding before her but something about the Seahorse Man's eyes made her blood run cold and her voice retreat down into the pit of her stomach.

"Father of Fathers, we drink in your name!" DuPere said. He sipped the bloods from the goblet, his eyes shut, as if taking in the power of all the fathers from which the sanguine nectar had originated. The blue flames in Papanatra's eyes grew strong.

"He is nigh," DuPere whispered. "Caretaker of Caretakers, we feed your children that they might grow," DuPere said next, pouring the rest of the blood into the basin of killer horse-sharks. It churned like a washer machine filled with three times as necessary detergent. The statue's eye flames flickered once more.

DuPere said, "King of all Homes, accept this gift from my world to yours..."

Dr. Jenkins nodded and the two other robed figures unloaded the large box revealing the gift made as a special request by DuPere: a five-foot-tall coffee mug made entirely of the finest ivory from the tusks of Africa's mightiest bull elephants, the strongest fathers found in the cradle of life. Emblazoned on the giant ivory mug in bright rubies were the words that had guided DuPere throughout his entire life: "World's Best Dad."

The flames in the statue's eyes grew even brighter. *Soon*, thought DuPere when the Guardian Moon took its place at the right angle, Papanatra would be reborn. *Soon*.

"You're insane!" Debz finally yelled. The flames died down and everyone in the room glared at the shackled orphan. She could feel the Seahorse Man's hot smelly breath on her face. DuPere snapped his fingers and the creature backed off. The money man approached.

"Come now, girl," DuPere said. "Today is a day of celebration."

"What's your damage, man," she said. "Is there some kind of secret billionaire contest to become the most creepy? Is that why you hang out with this *thing*?"

He said, "This *thing*, as you so insensitively put it, my dear impudent orphan girl, just so happens to be your precious maverick's father."

She looked at the ghastly creature. The information hit Debz like a ton of bricks, only bricks made out of shale from another planet with higher density. Of course. It all made perfect sense. A man like DuPere clearly had a flare for the dramatic. Why *wouldn't* he originally arrange to have Sultan murdered by his own estranged father? And when that didn't

work, why *wouldn't* he prepare a fate for a maverick like Sultan that was worse than death: marriage?

"I do so love family reunions, don't you?" said the money man. "As we speak, my men are tracking your precious maverick's every move. In fact, I believe you know one of them personally?"

Debz appeared visibly hurt at the mention of General Stuphs, the man who had killed her biological parents via a drunken drone attack on U.S. soil.

He said, "In one fell swoop, I shall capture Theo Sultan, eradicate his maverick tendencies, and make a family man of him and the entire planet once and for all." With a sweeping gesture he pointed to Cissy in her hypnotic paralysis.

Nearby, Dr. Jenkins tampered with the screen of an electronic tablet, and a section of a cave wall rotated outward, revealing a massive launchpad holding a light green rocket about the height of a vertical dolphin stenciled with the word "NEGLECTINOL." His fingers jabbed at a button reading "Prepare Global Dosage." He nodded to DuPere in affirmation.

There was a small crackling in DuPere's ear. He turned away to listen. On the other end was General Stuphs.

"We have visual," Stuphs said.

"Good," DuPere replied, locking eyes with Debz. "Capture our final guest." He caressed the imprisoned hacker's cheek and said, "I want him here to witness the orphan sacrifice."

CHAPTER 30

Sultan made a beeline through glassy-eyed hordes of happy dads for the Lumber Jack log flume ride. *The last known location of his father, Derick Sultan.* To do so, he had to travel from one end of the park to the other, still in his strawberry blond fop wig, and still in his rose-colored spectacles.

Much like the video on the tram had suggested, Father World stood as a monument to paternalism in all its many forms. The park was made up of various themed areas all associated with the experience of fatherhood: from wholesome Americana style suburban domesticity, complete with the "Riding Lawn Mower Speedway" to a more futuristic, artsy-fartsy interpretive look at the phallus – the very source of fatherhood, in a quarter (humbly) called "DuPereville," that in Sultan's eyes looked like a gallery show for a French sculptor who got his head caved in by a box of melted crayons having cocaine nightmares during the '70s. Needless to say, Sultan preferred The Masters.

It was here in this land of abstract shapes where The Finisher roller coaster lived. A warped Mobius strip, with its record-breaking, high-speed spermatozoa whooshing and swooshing to the eternal enjoyment of its riders. *Children of steel.*

Sultan dog-legged it through this colorful phallic ode into the more rugged frontier of an outdoorsy section – home to so many bonding tropes between father and son. All over, he witnessed the effects of the mystery gas from the tunnel. Whatever made up that domesticating devil's brew had altered these deadbeats' fundamental outlook on fatherhood. On the outside, they were unsavory sad sacks, yet on the inside, every last one of them overflowed with pure, uncut paternal instinct.

Sultan noticed three of the deadbeats from the tram exiting the "Fun with Fishin' Jamboree and Stage Show." All had tears in their eyes.

"Wow, that story sure got to the heart of what it means to be a great father," said Ponytail.

Bleached Goatee added, "And when the dad character used his dying words to teach the son character how to properly tie a fishing knot?"

Flat Top held out his souvenir, cast-autographed fishing line and hook as promised in the promotional tram video. "Um, can you say, 'Lost it!'"

"One thing's for sure," said Ponytail. "No way am I any kind of man without my family."

"Yup," Bleached Goatee said, "A dad who denies his fatherly duties deserves the chair."

They all nodded in agreement. Ponytail searched around on his person, patting his pockets. "Dang, I seem to have misplaced my souvenir, cast-autographed fishing line and hook, you guys see it anywhere?"

Sultan spied the very missing item caught on a nearby topiary shrub that was shaped like a father putting down the family dog.

"Are you thinking what *I'm* thinking," Flat Top said with a mischievous gleam in his eye. Then, like giddy children at the town fair on a school day all three dads raced back into the "Fun with Fishin' Jamboree and Stage Show" for a second viewing.

Conversations like these kept on throughout the park, which served to distract Sultan from his mission the way a buzzing swarm of bees might cause a lion to lose focus. Finally, Sultan reached the Lumber Jack log flume ride, a glossy simulacrum of a logger's shed, exploiting the once

noble life of the Lumber Jack. The line for the actual ride was far too long for Sultan's tastes, so he headed for the gift shop.

The cute gal behind the log-cabin style counter wore a flannel getup and beanie and fake beard for effect. Her eyes flitted over to Sultan as all women's eyes naturally did and Sultan gave her a nod. Watches, chocolate, cheese, and females: the Swiss had a way with them all.

She had her hands full with excited dads purchasing axe shaped back-scratchers and unnecessarily over-sized "Pop-Lollis," so Sultan busied himself browsing through the merchandise. Or as he knew it, *crap*.

One thing did catch his interest however: a shelf of books seemingly penned by DuPere himself. Sultan picked upon one with the money man on the cover looking like a real ass, titled *Fatherhood or Bust*. Sultan had never been so offended as he was by DuPere's portrayal of a "hitchhiker" with a shabby coat and hobo stick with rag-bag, commonly known as a bindle.

A routine hitchhiker himself, Sultan grew enraged at this wealthy man's casual exploitation of the journeyman way for the purposes of personal gain. *Cultural tourism.* The hitchhiker was a man of the land, a man on the go, and a man of the folks. Here, Quincy DuPere took the most cartoonish, superficial elements of hiking for hitches – the extended thumb, the put-upon demeanor, the carrying stuff in a bandana – and perverted a rich and beautiful lifestyle. For what? To lecture strangers on how to be better parents?

Inside, Sultan read a passage:

The basis for any good child is a good father. We know this. A good father is a present father. When fathers are not present, they teach the child that there are no rules and no examples for what counts as right or wrong. When a father decides to indulge his 'inner-maverick,' and thus leave his family, he is actually a deadbeat: but at the heart of the deadbeat is the maverick gene. Therefore, deadbeats create mavericks and mavericks create deadbeats, and so on until society has no form and ultimately devours itself...

Sultan couldn't bear to read anymore. So that was the point of the mysterious gas. DuPere planned to turn deadbeats and mavericks alike into the quintessential, brain-dead "good father." No instinct. Just a bunch of "yes-papas." With no more mavericks in the world, the money man could do as he saw fit. No rebels to surprise him, no rogues to zig when he expected them to zag. No more Theo Sultans. Quincy DuPere would be unstoppable. Not to mention his orphan adoption business would skyrocket.

The more Sultan stared at DuPere's dumb opportunistic face standing roadside and thumbing a ride as a cherry red convertible full of babies zipped by headed straight for a cliff, the harder his hands squeezed and squeezed and squeezed until the entire book exploded in a cloud of pages, like a down pillow had been popped open and the pages were the feathers.

"Can I help you, sir?" said the gal behind the counter with a look that was all "come hither," and zero "go thither." Sultan approached.

"Depends," he said, no doubt sending wave after wave of fantasy through her woman's mind. *Clearly she was into him.*

"Looking for an acquaintance," Sultan said producing the photograph of his father on the Lumber Jack. "A ride tester."

The gal leaned onto the counter to get a better look and her palms pressed down on a strawberry blond ringlet pouring forth from Sultan's head. He felt the wig tilt forward. He stayed still, lest his disguise come between them, literally.

"Hmm," she said after not a little bit of thought. "Oh yes! Rické."

She removed her palms and Sultan leaned back. *Close call.*

"Rické?" Sultan asked.

"Yes, he was about your height. Used to hit on me incessantly. Reeked of cologne."

"He have a last name?"

"Yuck, Rické D. Natlus. He thought every woman he came across was 'into him.' Had this gross saying: You know you can't spell 'Natlus,'

without 'us.' All the women in this department breathed a collective sigh of relief when he was let go."

"Let go?"

"Yeah, word is DuPere fired him personally. Last I saw of him, he was called in for a meeting down below. In H.Q. I'm sorry, are you going to buy something or..."

The courtroom in Sultan's head erupted in a cacophony as a surprise expert witness was just called to the stand: it was one of his four father figures. It was his third grade teacher Mrs. Genderson, and she was teaching the jury in Sultan's mind about anagrams. Words that spelled other words. Or names that spelled other names.

"No, that's all," said Sultan. "Thanks." He left the shop.

Rické D. Natlus wasn't just a ride operator who had a reputation for sexual harassment in the gift shop of the Lumber Jack log flume ride. *He was Derick Sultan.* If the gal was to be believed, Sultan's dad had disappeared one day in the facilities down below never to return. If that was true, Sultan would need to get down there, too. And his ticket below was staring him right in the face. A ticket shaped like a cartoon seahorse.

A cartoon seahorse shaped ticket that answered to the name "Soggy," to be precise. The mascot from the tram video. Was there any more shameful a profession than being a fake cartoon for minimum wage? Sultan watched as the embarrassing character entertained a dozen deadbeats with photo ops, Egyptian style dancing, highly misleading tap-on-the-shoulder tricks and a slew of comical butt-bumps. If he could get Soggy all alone and steal his costume...

Click.

Just then, a more pressing matter cropped up. A matter that was exactly the size and length of the barrel of a Glock 33. Or rather, a Glock with an aftermarket threaded barrel that allowed for a suppressor attachment. Which is to say, a matter that was literally pressed up against Sultan's spine. It was troubling, because Sultan liked his spinal fluid just where it was, not leaking out of his lower back like an oil change.

"Don't move," said a voice coming from a topiary behind Sultan shaped like a father and son holding the hand of a dying grandfather.

"I hadn't planned on it," Sultan said. "Surprised it took you guys this long to find me."

"Shut up," said the gunman. "Don't try anything stupid."

He quickly scanned the area for other gunmen. None. DuPere didn't want a big show. Didn't want his big day ruined. Like a bridezilla. Expected Sultan to go quietly.

"You'll have to be patient with me, pal," said Sultan. "Stupid things are about the only things I try. Keeps me feeling young." He felt the titanium baffle jam into his lumbar curvature.

"Start walking," said the gunman. Sultan did.

"You're the boss," he said. Better to play along, see what he could see. Who knows, maybe he'd get that trip down below after all.

To be sure, he was no stranger to captivity. Aside from breaking out of various POW camps, gulags, pits, live burials, mineshafts, sunken ships, figurative mountains of debt, and failed marriages, he had escaped the most dangerous prison of all: *society*. Hell, all of life was one big prison it seemed, what with all the hustle and bustle of tax forms and workroom potlucks. Of stop lights and fashion trends, of mortgages and keeping up with the Joneses. Of necessary permits for converting garages in the city of Altadena. Of goddamned children and the media circus. Sometimes it felt like the only people who were free were the prisoners locked up behind bars, though not in a literal sense. In a literal sense, they were much less free.

"How am I doing?" Sultan called back, as they entered the artsy French phallus domain. The roar of the Finisher and its gleeful riders intermittently rose and shrank in volume.

The gunman said, "Don't look at me. Keep walking."

"If I ran, you'd have lost me by now," said Sultan, trying to get in the man's head. *To fuck with him.*

The gunman said, "And you'd notice a sudden spike in your vertebrae's lead content." *Touché.*

Sultan tried to locate their destination. Figured it'd have to be some backroom entrance off a ride somewhere. Maintenance passage or something. Then, he spotted a familiar face: General Stuphs watching from just outside the entrance to the Finisher. If there was one person who might have answers, it was this Benedict Arnold. The Big Dog. *Bigdogedict Arnold.*

So Sultan decided to make a play. And seeing as how he didn't have any weapons, Sultan would have to rely on the only arsenal he could ever depend on: his wits.

In the time it takes for a mousetrap to go off, or a scorpion to strike, Sultan spun into a leaping roundhouse kick that sent his wig spinning off his head like an octopus on an invisible lazy-susan, momentarily blocking the gunman's field of vision.

With a *blpp* the .33 sounded. The bullet exited the chamber and made direct contact with the tip of Sultan's whirling steel-toed boot, mid-kick. It sparked and ricocheted into a nearby churro cart. The cook tank exploded in an armada of cinnamon, batter, and hot oil into the man's face. His gun clattered to the ground.

Sultan said, "If you can't stand the heat, get out of the churro cart."

He was about to go for the Glock when another shot rang out. There was Stuphs, Beretta smoking, shoving his way through the line for The Finisher. Sultan ditched the Glock and gave chase. It would be more fun to use his hands anyway.

The Big Dog had some sort of V.I.P. pass, though, which he flashed to an attendant and was promptly boarded at the very front, the best seat for a thrill-seeker. Wasted on a man who simply knew the right people. Sultan had to act fast. He hoisted himself up on to the line of waiting dads, and ran across their heads like river stones.

"Start the ride, already!" Stuphs bellowed. Sultan was still several feet away. Tired of waiting, Stuphs took matters into his own hands, produced

the Big Dog before they crested the top of this steel mountain, and the directional pull of gravity became a little less certain.

Stuphs leveled his Beretta. Gun safety, this wasn't.

"Hey, watch it," screamed one of the riders, when *pwwwtt* – Bleached Goatee's head came apart like a jar of jelly beans in a microwave. Most of it at least. His bleached goatee remained intact, as his lifeless body took on the appearance of a crumbled Greek statue. Sultan climbed on, now only 10 feet away. 400 feet off the ground. Within shouting distance of Stuphs. And splattering distance of everything else.

"He's too strong for you, Sultan," the General said. "After tonight, everything's going to be different."

Pewt – Theo ducked another shot. Five feet away. Almost there. But almost wasn't a lot to depend on at this height. At 500 feet.

Which is to say, not where Sultan had hoped to be when the horizon became even which only meant one thing: the coaster train had already reached the apex. Stuphs smiled a Cheshire grin. His blond, whispy unibrow tickled in the skyscraper-like breeze.

The General put his arms up and shouted, "I'd hold on if I were you!" Sultan used the last of the slow movement to leap the remaining five feet, but the compartment containing Stuphs had already plummeted into its 500-foot descent. Which meant Sultan had over-shot it and found himself to be just a point in space. A being in a field of air. An object at an altitude watching the sperm-like coaster slip out in front of him. A floating target.

Pewt – the shot came upward at Sultan and the familiar sensation of hot lead burned through his abdomen. He spun like a doomed astronaut and just managed to crash back down on the bucking metal snake now plunging downward at 70 mph. His feet dangled above his head. His bullet wound squirted upward. As the coaster finally eased into its first curve, Sultan braced his steel-toed boots where he could and hooked his arms around the headrests.

The Finisher twisted into a swirling heap of colors like spin cycle laundry. Somewhere in there was Stuphs, first right side up, then not.

Firing blindly, as Sultan made forward progress. His stomach throbbed. Didn't feel like any vitals were hit though. He centered his zooming mind by cycling through the variety of kill lines he would definitely say after taking out Stuphs. Something like "what goes up, must go dead!" Hmm, maybe not that one, but something – *VOOSH.*

The coaster banked in another relatively stable part of the track. The General had his Beretta aimed squarely once more at Sultan when Fortuna's Wheel rotated in the maverick's favor. The gun jammed, and as Stuphs pounded the clip like an ape eating ants from a stick, Sultan was able to crawl forward. Soon he'd have his arms around that big fat head and choking answers out of him in no time. But it seemed Fortuna's Wheel wasn't done spinning (is it ever?).

Which is to say, just as Sultan was getting the hang of what it must feel like to be an acrobat sucked into a jet engine The Finisher approached its heinous set of quadruple-loops. Sultan once more braced himself. Then something amazing happened. He felt more arms embracing him. *The nearby riders were holding onto him.* Four times. Up and down. Up and down. Up and down. Up and down. Life was a kaleidoscope. His brain flattened like bread dough against the inside of his skull.

The coaster finally leveled out and Sultan had one last chance to reach Stuphs before they hit the tightly wound corkscrew. Or rather thirty-seven cork-screw rotations. Sultan was strong, but no man could handle that much G-Force. Not even an orangutan could. *It was a lot of G-Force.*

Stuphs chucked the spent Beretta at Sultan and it splashed into the man made lagoon below the tracks. As detailed in the video, the upcoming series of corkscrews would place the rider only a few feet from the water's surface. The Big Dog then broke out a Bowie knife as they closed in on the cork screw. It was now or never.

Sultan always chose Now.

With a perfectly executed pounce Sultan came soaring down on Stuphs like a flying squirrel. The Big Dog swiped upward. Dug his blade

into Sultan's shoulder. The steel buried in Sultan's flesh throbbed as the first turn of the corkscrew sent him end over end, gripping onto a restraint bar. Stuphs reached for the knife, hoping to pull it out. Sultan hugged onto the man. Closed the gap to prevent stab number two. Stab number one had pretty thoroughly covered the "stab experience" enough for Sultan, and he wasn't a huge fan of sequels.

His steel-toed boots dipped in the lagoon as well as half of his multi-pleated, wide-hipped olive denim jeans. Sultan could feel them becoming waterlogged. Just great, more weight to deal with for Sultan, the human whirligig. More centrifugal force. "Answers!" Sultan screamed, with a headbutt. The landscape a demented watercolor. The coaster banked tightly torquing Stuphs' neck. It felt unusually strong.

"Nice try, you hapless water-donkey!" Stuphs yelled over the whipping wind. "Kosovo. IED explosion left me with pins in my neck and bone scar tissue. That's fused bone and reinforced muscle you're gripping onto. *Army strong.* My neck is snap-proof, son. You'll slip off my head before any damage is done."

The world rushed by like a ghost stampede. Sultan could feel himself becoming slowly pantsed by gravity. The knife and bullet wounds ached. The barrel roll on steroids continued.

He said "Where is he? Where's my dad?"

The General said, "Where else, boy? He's about 100 feet below us, right along with those robots and that blabbermouth hacker girl too!" *Cissy? Debz? Here?* Impossible. He had spoken to her on the phone. Sultan's grip on the man's muscular hog head loosened. His palms got sweaty. With every revolution, the steel in his steel-toed boots and soaking wet pants around his ankles became anchors whirling outward around him in this seemingly endless corkscrew. It wouldn't be long before Sultan lost his grip completely.

He wondered what bargain basement afterlife awaited a soul like his. A soul that lived every second of every minute in gray areas and green zones all around this used septic tank of a world.

Stuphs said, "Tell me, was she a good lay? That bucket of bolts? Did you lube up with WD-40?"

Fewer words in the English language made Sultan as angry as slurs, especially slurs for having intimate settings. Secret passwords into the "Boy's Club" that shamelessly held meetings every day that ended in *y* and well attended by Beltway Bandits of all shapes and sizes, while the Lincoln memorial eternally turned the other cheek.

"Oh, don't worry," Stuphs continued. "You'll be seeing them all soon enough."

Sultan said, "What's he going to do with them?"

"It's a surprise. But I promise you every last person or robot you have formed a relationship with will play a pivotal role in tonight's 'big finale.' *Ec-specially* that hacker girl." There was that pronunciation again. The extra *c* in "especially. In the hadron collider of his current existence that *c* stopped being just the third letter of the alphabet and represented everything wrong with this world. Here was a man of power, a man who should have been locked up long ago, but had instead received medal after medal and pay raise after pay raise. A man so powerful, no one thought to correct him in his speech. A man who had one day celebrated Christmas not by drinking mulled wine, singing carols, and exchanging kisses under mistletoe, but instead by drunk driving an MQ-9 Reaper drone on U.S. soil and obliterated Debz's only chance at having biological parents.

Suddenly, all Sultan's pain hid like timid kittens in a closet, as the maintenance man who was self-righteousness stomped through the halls of his dignity, ready to fix what was broken.

"You look like a man who appreciates jokes, General," Sultan shouted. Stuphs looked puzzled.

"Say, you ever heard the one about the rising military star who got drunk one night and operated drones on U.S. soil?"

Even in the constant swirl of the corkscrews, The Big Dog didn't just look like he had his hand in the cookie jar, he looked like he'd just been caught living inside one giant cookie jar paid for by tax dollars.

Stuphs said, "I don't know what you're talking about. Besides, even if you are so foolish as to obliquely accuse me of such a horrendous act there's no way you could prove it in the court of military law."

Sultan wasn't so much into proving things, as he was winging them. Little trick he picked up in his lawyering days. When in doubt, make it up. Which was what gave him this next idea.

"Won't have to," Sultan said. "The girl uplinked a motherboard of *all* the cyber-bits concerning the data scrub, from a verified Internet connection *and* an I.P. Address infrastructure. If she dies, the information goes straight to the American public. Good-bye military career, hello Leavenworth."

A long shot, but Sultan had never been too interested in the short ones. Luckily, the General knew as much about technology as Sultan, which is to say, "jack shit." Unluckily, the corkscrew was really starting to take its toll. Something had to give, and soon.

"What does it say?" Stuphs said.

"Says you, the military industrial complex, and a fifth of Cutty Sark don't mix well. Or at least don't mix well enough to make your precious daughter and granddaughter never want to celebrate Christmas with you ever again. I know you've got this whole New World Order backup plan, but trust me, it ain't always great losing the ones we give a shit about."

Sultan could swear he had grown three inches since they started this ride. *He thought of Cissy.*

Stuphs's face grew red, either with anger, or lack of oxygen. Sultan's grip was working.

"Hell," Stuphs said, "Everyone...opens a few presents on...Christmas Eve – arrggh!" Sultan could feel the man's muscles tighten. The sinews stretch. The world inverted once more. A snow globe tumbling down a hill. The knife wound now belligerently steamrolled the dinner party of Sultan's health.

"Besides," Stuphs labored to say. "DuPere's plans are too big to be stopped by just one man. Ec-specially a water donkey like you!"

Sultan said, "It's pronounced 'especially'!"

The zero gravity and Sultan's waterlogged pants and boots combo plus his all around 240 pounds of dense muscle mass all served to act as the General's personal chiropractor from hell. Sultan was the human sling, ready to fire off at the nearest Goliath. If he had grown three inches, then the General had grown nine, as his head rose out out of the seat restraints. His skeleton became a cactus being pulled out of loose soil. It was exiting his body, still attached to the General's head.

"Aaagghhh!" Stuphs screamed. Coming out of the final corkscrew, Sultan held tight to the man's head. He whipped it around like a headbanger trying to shake Sultan, but it was no use. In the end the General was right, his neck *was* too strong to break. Years of military injuries had fused his bones together.

So they all came out as one. *Path of least resistance.*

Which is to say, the last rapid torque of the seemingly endless roller coaster corkscrew ripped his skeleton clean out of his body, clattering between the seat restraints in a single piece. His eyes widened in disbelief. Aided by the maverick's weighted momentum, the Big Dog's calcium frame charged violently past the cart's metal safety harness like olive oil slathered warriors at the Hot Gates of Thermopylae. Organs fled his neck hole like fugitive fish.

The maverick, the General's head, and his full skeleton were launched out of the coaster and sent airborne, just as the camera on the roller coaster snapped the whole gruesome moment. Thirteen other riders vomited in unison.

Hundreds of feet above the park, the two figures sailed – one a limp, anthropomorphic kite, the other a sky-kissed maverick. The blood loss from the knife wound and the bullet in his abdomen and the dizziness from the 37 rotations finally caught up with Sultan. He locked eyes with Stuphs's head just in time to mumble a kill-line: "At least you got a good head on your shoulders..."

But the General was already dead, and Sultan wasn't far behind him. Sultan could hear the air whistle through Stuphs's literally barebones body like a flute orchestra. Couldn't be certain, but it sounded like military taps.

The surface of the Earth rose to meet him quicker than he would have preferred. At least, whether by chance or because of subconscious instinct, the area he was aimed at happened to be an inflatable bounce house shaped like a tool shed. Inside the colorful approximation of that staple of dad life, brainwashed dads hopped happily. He recalled his run-in with the Mestizo collecting cans for the cartels what felt like an eternity ago. Recalled their shoot-out in the bounce house at the Father-Son picnic.

"I can see in your soul," said the man. "Something is coming. Something bad..."

Then, like Icarus falling from the sky, Sultan and the dead General crashed. Dads flew everywhere. All went black.

CHAPTER 32

A half-eaten turducken Northrop B-2 Spirit Stealth Bomber sat inside the takeout box. Theodore and Mommy had been kicked out of the restaurant. She tried to smuggle in homemade cupcakes. Restaurant desserts were too pricey, "ever since the economy happened." She wondered how different life would have been if she let Derick Sultan die that day in Kuwait. She perished the thought, for no Derick meant no Theodore. Her boy's cowlick glimmered in the sunlight. Nearby in a dirt lot, a man called to them.

"Wow, hot mama," he said, "where you going with them cakes? Them creamy, creamy cakes?" He was with the Hagarnators.

Some held a jumping splits contest. Others saw how fast they could spin around on one foot. Theodore had never seen so much kinky, sun-bleached hair. It put a smile on his face. They were so fun and fancy-free. The leader wore a yellow leather sleeveless marching band blouse. He ran and did a back flip off a car bumper. Mommy giggled. He whipped his angelic, honey drizzled ramen hair like a dog after a bath. For a moment, Mommy forgot about her troubles. Forgot about the birthday boy, who had wandered across the street to find Daddy. In the cantina...

CHAPTER 33

There were voices. Faint images of activity. Visions through a waterfall. DuPere's face, like a godly Robert Herjavec from *Shark Tank*, gazing upon Sultan. Debz screaming. Cissy in a trance. Was he dreaming? *Was he nightmaring?* The money man had Theo in his clutches. Sultan could only make out a few words in the haze: Papanatra...Guardian Moon...Family. *That Seahorse Man*.

Then a blindfold. Then darkness.

CHAPTER 34

Sultan finally awoke strapped into what felt like a standing dolly. The kind used in his lawyering days to help maniacs stand trial. Maniacs like distinguished cannibal geniuses. Wrist restraints, ankle restraints. *Waist restraints.* He couldn't see much under the blindfold, but *could* feel something wheeling him to a designated location. Like a fridge on moving day. It must've been nine stories beneath the Earth's surface, or was it ten? Sultan had rarely traveled this deep underground and could already feel his pineal gland, or "third eye," acting up. His wounds felt dressed and clean. His nipples were pert and alert. *Always a sign that things were bad, and about to get worse.*

He heard it before he smelled it and smelled it before he saw it: the gurgling sound. The wet roars. The ocean smells. Home-brewed cologne. That damn Seahorse Monster must've been near his dad recently to absorb such a familiar musk. Its slippery, scaled wrists slid past Sultan's temples. Then it removed his blindfold, unleashing a scene straight out of Dante's Inferno. The limestone cavern sat open wide like a throne room with stalagmite outcroppings on the floor and stalactite drippings from the ceiling. There was a huge statue, the illustrious Papanatra, Sultan guessed. Panning down there was DuPere in a throne between the statue's ankles. To his left was Boy Bot, eyes glowing red. The same red

that caused Bayer's death. Missing the cowlick Sultan had grown so fond of. All his fatherly influence swapped out for mindless carnage, answering to the beck and call of DuPere. *The hand of the king.*

The statue stood on a raised platform about six feet off the ground, with steps that angled down from DuPere's spot to the cavern floor where Cissy stood. In a wedding dress for some reason, awaiting some sort of matrimony. As beautiful as she looked, Sultan toyed with the idea that he had finally died and gone straight to Hell itself. Though, it was nothing at all like he'd imagined the afterlife to be: *for one, there were no lawyers or IRS workers.*

"Welcome to the D.A.D.D.Y. Complex," said DuPere, with a sweeping hand gesture. "We've been expecting you."

Sultan's dolly travel continued. Pushed by the monster, closing in on a spot just opposite Cissy, where a scientist in a robe tinkered with some sort of greenish gas tank the size of a baguette, complete with mask like you might see at a dentist. A muffled, girlish shriek from high above drew Sultan's attention to the remaining details of this archaic shit show: suspended in something like a deep-sea diving cage about 40 feet over a pool was Debz, bound and gagged. *Funny,* Sultan thought, the hacker had spent her whole life in the Grid, and now she was literally held prison in a *grid* of iron bars. It was worth mentioning. The cage itself was attached to a pulley system, which in turn involved a rope that reached out to an embedded contraption just beside that huge statue that overlooked this whole rotten affair.

Sure, the hacker chick could be a bit mouthy, but she didn't deserve to go out like this. However, before he could formulate a plan Sultan found himself focusing on two elements of the situation: one, his father appeared to be nowhere in sight (surprise, surprise: someone associated with the U.S. Government had fibbed), and two, Cissy – held at bay in some sort of trance caused by magnetic hoop earrings – was as beautiful as the night they delighted in one another's touch. *Gone though was her look of respust. Of lustpect.*

Also of note was Cissy's clothing: a wedding dress. She clutched flowers awaiting her groom, whoever that was. Then Sultan looked down at his own outfit and realized beneath the dolly restraints he wore something far more confining: *a wedding tux.*

"Don't look so glum, Mr. Sultan," said DuPere. "You're to be the first family man married under Papanatra. Speaking of which…" He nodded to some robed figures.

They worked together to turn a second wall crank and the ceiling opened, revealing the night sky. Revealing the Guardian Moon. Which was like most moons, as far as moons go: round, bluish. A real focal point in the grand scheme of things. Only this moon happened to be at one end of a two-point line, with the other made up of the twinkled forehead crystals on Papanatra, already aglow with the first hints of moonlight.

There was slight commotion where Debz's rope met the wall, like thousand year old technology was grumbling back to life. Above dust and detritus fell from the ceiling. Debz shrieked as the cage dropped a few inches.

"You have to hand it to the ancients," DuPere said. "They really built things to last."

"Let her go, DuPere," Sultan said, stressing his restraints. Nothing doing. Brute force was out. *He'd have to use brain force.*

"Oh, but how would I show Papanatra my gratitude? Orphans don't sacrifice themselves you see." DuPere said. "Besides, in a few minutes this will all be a distant memory for you, betrothed as you are…"

Sultan noticed the words on the Scientist's tank marked "NEGLECTINOL." The man prepared a clear plastic mask like one might wear going to the dentist, if one were a sucker enough to even go to those glorified floss salesmen.

"I have to admit I never imagined you'd make it this far." DuPere said. "Then again if I've learned one thing in the orphan industry it's never underestimate a child's desire to stick the proverbial 'it' to dear old Dad."

DuPere made a dismissive swatting motion, turned, and adjusted his sleeve.

Sultan growled, "Where is he?"

The Scientist moved to place the mask over Sultan's nose and mouth. DuPere faced Sultan once more, and the Scientist paused his action. The Seahorse Man loomed, like a grotesque chess piece from a chess set themed after the three-story tall Papanatra statue. Sultan's mind momentarily wandered to all the shameful novelty chess sets he'd seen in his day, from pawns shaped liked Don Knotts in an *Andy Griffith Show* set, to rooks fashioned after someone named "Justin Bobby" from something called MTV's *The Hills*.

"Dear boy," DuPere said, gesturing to the monster acting as the Scientist's muscle, "You're looking at him."

The flames in the statue's eyes roared dramatically, as if picking up on the father-son connection. Sultan feared the worst.

"Or rather, what became of him," DuPere said

The courtroom in Sultan's head erupted in chaos: widows wailed, criminals laughed, bailiffs drew clubs, reporters burst from within the confines of the state room straight for the wooden phone booths and called in fevered news headlines to their editors across the country: "Area Maverick's Dad a Sea Mutant!"

Was it true? Had Rické D. Natlus the log flume ride operator disappeared one work day at the behest of DuPere himself? Only to return as...

Sultan gazed deep into the monster's eyes as it secured his dolly. For some glimmer of Derick Sultan. He found only inky, mindless abyss, like when a Hydrox cookie (the more superior stuffed cookie) sits in an old styrofoam cup of months old coffee and then you eat it.

"Derick Sultan disappeared the day he met me, I'm afraid," DuPere mused. Sultan had seen this kind of thing before: *villain monologues.* Like a serial killer just itching to brag about the many, many hitchhikers they'd murdered, something within a madman's mind wasn't content

until the most inane details of their scheme were aired. *The longer they talked, the more time Sultan had to formulate a plan...*

"You helped him fake his death," Sultan said.

DuPere said, "I helped a deadbeat start over. When I met Derick Sultan he was penniliness, trying to sell me homemade cologne outside of a palapa themed cantina..."

"Cabo Wabo," Sultan growled.

"Yes! In those days I was developing software for the DoD. *The Dadtabase.* Why, an engineer like me need only peer into the lives of so many dads before patterns started to present themselves: deadbeat after deadbeat ruining family after family of this once great nation."

Sultan said nothing.

"Er, I'm sorry, what's the word you deadbeats use again to absolve yourselves of all guilt? 'Maverick.' Yes, that's right. Your father there was a 'maverick' when I made my first billion in the software industry and built my empire. And he was a maverick when I gave him a job, under condition we could test pharmaceuticals on him. All off the record, of course, and certainly not in association with his former identity. And I suppose he was a maverick when the prophecy portended the change in his DNA."

"Bullshit, you played Island of Dr. Mor-*on*," Sultan stealthily zinged, like a star of a humor show on overpriced paid cable.

"Nestle your insecurities beneath those muscles and quips all you like, Mr. Sultan," DuPere said. "But deep down, I know you've lived your whole life asking that question all bastards ask: why did Daddy leave?"

The Seahorse Man came around to face Sultan.

"Well according to him," DuPere shrugged at the monster, "He – how did he put it again. Oh, yes, 'just goddamn felt like it.' Like father like son."

The Seahorse Man gripped Sultan's hair and throat as The Scientist strapped the mask around his head. Struggling against his dad's genetically enhanced fish-grip was useless. Sultan had come all this way for an

answer, something to give him closure. Instead, what the ex-sharpshooter and former lawyer for the Navy SEALs found was pure, careless garbage shoved into his already crap-filled heart.

DuPere said, "But why talk clouds on a sunny day. I should be thanking you. For it was your maverick blood that helped Dr. Jenkins here crack the code on Neglectinol. But don't take my word for it..."

The Scientist then turned the nozzle on the gas tank as Sultan thought about how much he hated eggheads like DuPere. More than filling out forms, grown men crying, cell-phones, cover-ups, "pet names," and slurs. *Brainiacs.* He was reminded of the wise words of his first father figure, the carnie who ran the novelty jumbo boxing ring at the county fair: "Know-It-Alls, Blow-It-Alls," Dime Time McGee would say. Later the man was murdered in an after hours jumbo boxing match, when his opponent, "Mama Squawks," loaded her huge gloves with frozen turkeys. Sultan had meant to commemorate Dime Time's words in bumper sticker form ever since. Now it looked like that day might never come.

The wall contraption creaked again and Debz dropped with a great jostling. The crystals in the statute's forehead grew brighter. Debz screamed a more urgent muffled scream.

"Ah, yes. He is near," DuPere said raising his hands palms upward like a demented Puritan.

With the clear mask now over his nose and mouth, Sultan held what little breath was left. In a few seconds, he would become a mindless "daddy," and Debz and her hacker self would become kibble (or data "bites") in the bellies of those killer horse-sharks.

Lungs burning hot, Sultan glared at the creature who was once his father. Who was once Derick Sultan. How many sleepless nights had Sultan spent plotting the demise of this man? Of this deadbeat? How he wanted to jam railroad spikes into his eye holes and pry the man's skull apart, then give his brain the finger. *The middle finger.*

His lips begged for relief. For breath, gassy or not.

"You're only delaying the inevitable," DuPere shouted. "Relax and just let the Neglectinol take its course. In a mere moment's time, you'll wonder how it ever was that you had the silly instinct to abandon your ex-families. Think of it as a gift from me to you. A whole new Theo, with a whole new family: Cissy as your wife, and an orphan from my expansive stable of orphans. The first family of the Dad Age."

The room quaked and the flames in the statue's eyes flickered their strongest yet. Like inmates in an airtight sealed asylum, Sultan's esophageal cells pounded millions of tiny microscopic fists demanding the doors to the surrounding atmosphere be flung open. Across the room Cissy stared forward, still entranced. The deformed Boy Bot held his solemn red gaze. Both without choice, both slaves to this money man's mad will.

Perhaps it was inspiration, or simply the lack of oxygen, but just then, Bayer's dying words returned to Sultan like an ethereal mentor in a space opera: "...two sides of the same coin, Theo: It's not which one you choose, but *that* you choose."

All this time Sultan had begrudged his father for *choosing* to leave. For *choosing* to follow his instinct. But how could he be mad at instinct, in a world of so much conditioning? In a world of Black Friday tramplings, and dog clothing and seasonal coffee; of selfie sticks and water jetpacks and jibbering late-night talk show hosts who peddled cheap laughs for high priced sponsors; of politicians who glad-hand their way to the White House only to put up a "For Sale" sign first chance they got, then peddle off the American Dream like some sort of soiled plush toy collection to the highest bidding money man over dinner, where the main course was the flesh of bald eagle grilling on spits made of flagpoles and fires made of hanging chads?

All these and more were products of a nation more concerned with being "with it" than with thinking for "itself." With this in mind, Sultan strained his tongue out the farthest he'd ever strained it. He thought of his fourth father figure, the inanimate railroad spike. He strained it for the edge of the gas mask, where the plastic made a seal on his face. *A French*

man would be proud. All he needed was the tip. Just the tip – to create a tiny bit of space for the gas to escape. Sultan used the brief moment to grab some fresh air. The Seahorse Man moved to reseal it, but paused at what Sultan said next.

"You're an asshole, Pop!" Sultan said. "I know because Derick Sultan is an asshole, and he's in there somewhere. That's why you didn't kill me in Rio."

The Seahorse Man's hand held still. It cocked its head at the name, like a pet dog.

"No!" DuPere screamed.

With the monster's attention Sultan said, "There's nothing more important in a man's life, than the right to choose. The right to follow his instinct."

The Scientist shoved his way forward, but the Seahorse Man held out a greasy arm and blocked him.

Sultan said, "You had to follow yours and your instinct was to leave your family. I get that now. So thank you! Thank you for making me the man I am today. For making me a deadbeat *and* a maverick: for making me a Sultan."

The Seahorse Man lowered his head. Its formerly blank eyes took on the gloss of tears. Sultan could taste the gas. Soon he'd be brainwashed. Sultan, Cissy, and Boy Bot would be one more family of sheeple not living The American Dream, but *dying it.*

Until instinct kicked in.

With passionate fatherly regret, the Seahorse Man tore off the gas mask, and his son gulped in sweet, sweet cave air. His lungs held a Mardis Gras.

"Stop him!" DuPere said to the other robed figures.

As the lackeys approached, the Seahorse Man gripped the Scientist by his throat and strangled him with the tank tubes. Sultan tipped his dolly backward against a wall, and slowly scraped against it until he was flat on the ground. He watched as the Scientist's feet lifted, then rotated

and zoomed past him like a levitating entity. Sultan looked up to see his dad swing the robed man face first into the stone wall. The scientist opened his mouth to scream but was quickly silenced with a mouth full of limestone. Soft enough for his teeth to sink into, but hard enough to hyper-extend his jaw. The Seahorse Man yanked the screeching wretch back, blood pouring from his empty gums. His teeth remained stuck in the cave surface.

The man struggled to pull free, his mouth now a rotten Jack-o-lantern, or (jack-ass-o-lantern, as Sultan impressively thought). The Seahorse Man acquiesced, giving the scientist just enough space away from his vertical tooth cemetery in the cave wall, only to hammer the gas tank into and nearly through, the back of the skull. Sultan watched, as the Scientist's own teeth punctured the man's eyeballs. They popped like cherry tomatoes. Sultan's dad then did his best Babe Ruth impression with the tank and split open the already softened brain pan like a casaba melon, the sloppiest of the melon family.

Nearby, the senator vomited. The Scientist's limp body slid down, leaving his two eyeballs stuck to the wall by his own teeth.

Sultan said, "Looks like the good doctor had a real eye for decorating," knowing full well this was a slam dunk of a kill-line. But his verbal celebration was short lived, as the room rumbled to life like the San Andreas Fault's hindquarters after enjoying a chili cook-off. Debz swung in her cage, a terrified chandelier, and descended faster toward the murderous basin below. By the looks of the crystals, Papanatra wasn't just nigh, he was *very nigh*.

As if reading his son's mind, the Seahorse Man was already hunched over and ripping off Sultan's restraints. Derick Sultan offered his son, Theo Sultan, his hand, pulling the maverick to his feet. The two exchanged looks, deciding whether or not to go full hug. Instead, they opted for an even nobler emotional gesture: they gripped one another's forearm like two knights returning safely from a decades-long crusade. Years of anger

melted into simmering displeasure, then into neutral emotion. Sultan's resting state.

The reunion might've turned into something more had the Boy Bot not unleashed a scorching red blast from his eyes, and had that red blast not found its way straight into the mid-section of the Seahorse Man, like a laser focused haymaker to the gut. Now the creature lay crumpled against the far wall like a punch drunk jumbo boxing heavyweight on the ropes, struggling to find his footing. *The charred torso wound smelled like fish tacos.*

"Enough!" DuPere exclaimed, standing beside the Boy Bot, who was already charging up another blast. The room shook constantly.

"I will not have the Father of Fathers welcomed into such an ugly display of familial discord!"

Sultan had his eyes trained on Cissy. Stoic in her magnetic earring trance. Heavenly under the illumination of the forehead crystals above. Debz and her cage were now nine feet from the basin filled with thousands of snapping, razor sharp teeth, and the Boy Bot remained at DuPere's side like a bazooka headed child. In real life, he would spank the boy for such misconduct and disrespect for his elders. Then a curious thought crossed Sultan's mind. A thought involving his family's signature, sobering punch: The Judge.

His human charisma had worked once to rewire a robot's circuitry. Perhaps it could work again. But first, he had to keep Debz from becoming cave chum. *If Sultan could only run, jump and force the cage out from above the basin, then draw fire to the rope he'd have one less thing to worry about, all things considered.*

"Everyone just stay put," the money man said above the constant rumbling. "Sweetheart," he said to the Boy Bot, "Anyone so much as moves you–"

But before DuPere could finish his command, the two robed lackeys made for the exit of the temple.

"Nuts to this, DuPere!" yelled the senator.

"It's all coming down!" said the congressman.

Classic D.C. flip-floppers thought Sultan, eyeing perhaps his only chance to un-F this FUBAResque scenario. The room spasmed red as Boy Bot shot a beam at the two shilly-shanters. The good Senator Chuck Andersen (D-NM) and Rep. Toby Jensen (R-AL 07) had the misfortune of being within spitting distance of the rippling basin. Which normally would've resulted in a comfortable view and a brief sensation of "worst case scenario" thankfulness that you stood alive and dry, while they remained wet and hungry. But this day had been anything but normal.

The force from the ray sent the two politicians head over heels. They tumbled like drunk astronauts. *Like starfish in a wind tunnel.* Their fat, faces twisted in wretched agony. Sen. Andersen's fearful countenance recalled the time he was faced with passing a bill to help soldiers and denied it. Congressman Jensen for his part had a similar expression, one he'd displayed in the bad ol' days of the "House of Reprehensibles" when a bill designed to give equal rights to minorities came very close to becoming law.

Their current predicament made those moments look like a game of "Duck Duck Goose." They splashed in. First one, and then the other. Then, the basin sat as quiet as Capitol Hill on Christmas Day. Which is to say, a stillness so quiet you could hear a pin drop. *Or a high paid escort leaving a majority whip's hotel room.* All eyes watched as an arm reached out from the churning red basin. It wore a watch. A gift from the Timex Lobbyists. The arm was like most arms, in terms of arms. Shaped like a bowling pin up to the elbow, shoulder at one end, hand with fingers at the other. *The whole enchilada*. But there was one striking difference, in this arm that grasped wildly for a chance to pull itself out: most arms had bodies. This one did not. It plopped onto the surrounding floor like a tired wet weasel. *So much for reaching across the aisle*, thought Sultan. His eyes went to the cage above. He'd have to act soon. Then, a red bubble emerged. A bubble containing a cry. A head surfaced, picked clean of all flesh. A head whose days of filibustering against laws that stopped illegal

gerrymandering. A head whose screams of "Liar!" and "Shame!" had once echoed off the Congressional walls. A head who now could only produce the sound of being devoured from the inside out. A sound that kind of sounded like *GLORCHH...*

Amid the chaos, Sultan's eyes wandered over to his father who had started to stir. Barely. From the gash in his chest there would be no ultimate recovery. Just a contest of endurance. How long could he hold on? Father and son's eyes met. The beast gave a weary nod as if to say *go save your family, my amazing, lovely son. Do as I say, not as I did.*

So Sultan did.

Like a cheetah with a fire under its ass, Sultan made a break toward the lip of the basin. Debz in her cage, had caught on to his plan, which was a generous word for what was really a loose conglomerate of spitballs and half-formed suggestions. But in Sultan's experience, a plan was better than no plan at all. Debz seemed to like this option better than the alternative, and had begun to distribute her weight, rocking the cage ever so slightly. *Simple physics.*

With a stride ready to mount the basin, the netherworld around him came to a slowdown. Like a Renaissance painting under a strobe light. There were shouts and commands and a state of all-around displeasure from the DuPere camp. But that didn't concern Sultan. He had a plan to do. A plan that started with a clear enough step one: don't die. *So far so good.*

Step two was a little trickier, as it required step one to continue taking place while Sultan launched himself like a male ballerina in glorious extension onto the cage. Airborne, he could see Debz's eyes widen with gratitude. Or was it fear? And a hint of red, like someone had turned on a heat lamp somewhere outside his field of vision. If being a lawyer had taught Sultan one thing, it's that you could read a lot in a person's eyes: where they were going, where they had been. In this moment, Debz's eyes told Sultan *Look out!*

The red streak emitted by Boy Bot might have zapped Sultan's loins open like a chorizo breakfast burrito left in a sunny parking lot, had he not executed a textbook set of aerial splits. He thought his ankles might kiss his earlobes. *Hell, wouldn't be the first time.* Instead, the blast continued through the cavernous hall and exploded in a shower of sparks against the wall. Better that than his own rib cage. Never one to be picky, Sultan still preferred *not* to have his nipples exploded into opposite corners of the room like a pair of troublesome dunce buddies in a schoolhouse.

"You're only delaying the inevitable," DuPere shouted at Sultan, who now stood like Tarzan in a tux above the basin, gripping where the rope met the cage. Step three: draw fire. But before that could take place, something caught Sultan's eye. Something no one else appeared to be focused on, and something that made his life about ten times easier:

His dad, the Seahorse Man, was back on his feet. Running. Toward Cissy. Draining the bank account of his life force for one last selfless act. A suicide mission. Sultan's mind flashed back to the very last moment of childhood he saw his dad...

Daddy danced on the bar. In the Cabo Wabo. Pants around his ankles. The crowd encouraged him with free drinks. He slurred, "when tha'wimp Hagar steps in I'm gonna whoop his ass. All this shoul' be MINE-" The bartender told him to get off the bar. Daddy made the 'jagoff' motion, which threw him off balance. He fell and hit his head on a stool. Everybody laughed. Theodore ran outside in shame. Mommy had been looking all over for him. She was drunk too and had decided to leave daddy and live life on the compound of Sammy Hagar impersonators. So Theodore ran back inside to find Daddy, but Derick Sultan was nowhere to be seen. Daddy was gone. Forever...

Head lowered, the Seahorse Man charged straight for the entranced and oblivious Cissy. His lead was not a huge one, and Sultan could see DuPere clock the monster's intentions then point his wishes to Boy Bot. In one swift motion, the Seahorse Man gripped Cissy's hair, wrapped it around his hand, and like a discus thrower took one rotation then flung

her body up onto the cage, where she clothes-lined sideways at the waist on the rope and landed with a rattle at Sultan's feet.

The victory was short-lived, unfortunately, but Seahorse Man knew where he stood with the reaper. He turned to face the red blast heading his way, like a man ought to.

And then Derick Sultan was dead.

"Happy Father's Day, Pop," said Sultan. He didn't have time to absorb the full selflessness and the finality of the recent event. All he had time for was ducking the second red blast geared toward opening his throat during a powerful back swing, but instead torching the rope completely and sending Sultan, Debz, and Cissy sailing across the now heavily quaking room. They landed with a screeching, and sparks, and tumbled sideways and somewhere in the collision the ancient cage lock had busted free. Debz scooted out, and Sultan removed her gag and ties, ushering her and Cissy to the stairway exit.

"Never thought I'd be happy to see you, Cave Man," Debz said, not missing a sarcastic beat.

"Easy, Blueberry," Sultan said. "Or I'll put this gag back on." He was being sarcastic, too.

"Impossible!" DuPere screamed. "Destroy them all! Don't let them get away!"

Another red blast landed just shy of the stairway entrance, exploding stone chunks everywhere.

"Let's get the hell out of Dodge!" Debz said, grabbing Cissy's hand. Sultan stayed put.

"I'll be just a minute," he said, eyes trained on Boy Bot. "I got to take advantage of a teachable moment."

"Suit yourself," she said grabbing Cissy's hand. Then the two women in Sultan's life disappeared up the steps.

CHAPTER 35

In the stacks of the United States Military Academy Library on the campus of West Point, there were plenty of books on war strategy, on battles won and lost, with a gluttony of lessons to be mined from the missteps of foolhardy generals or victories of the brave. But what there wasn't, Sultan could be sure, was a book titled *Rules of Engagement for Fighting Your Own Robot Son*.

Live and learn.

Either way, Sultan was about to author a book on this topic giving new meaning to the phrase, "publish or perish." He could see the outline now: the first chapter would cover how to dodge the charging laser beam that was about to shoot from the eyes of your cyber-progeny. He was busy working out a metaphor that involved stooping behind the melted candle stump of the horse-shark basin wall. The room was now at a constant rumble. Stalactites jiggled free like icicles and shattered all around. At this rate, the whole damn place would come down before Papanatra even arrived. Sultan was starting to feel a little disappointed.

Ask and ye shall receive.

Boy Bot released his eye-blast at the exact moment of a rolling floor shock which sent the child robot backwards and sent his blast upwards into the skylight, letting in moonlight from Guardian Moon. Like a

drunken comet, the shot managed to unseat a dump truck's worth of limestone. Sultan peeked out from his cover just in time to see the kid flattened like a pancake under a pile of fresh geology. His little kid feet jutted out like some sort of witch under a house. There was a red glow somewhere in the center of that collection of boulders that slowly died out like the end of a campfire. Sultan had failed another family member.

"Looks like the Sultan boys aren't long for this world," said DuPere. Under the full glow of the forehead crystals, by now the room had taken on the look of a bluish hellscape. The money man's eyes were wide, like a man wholly possessed. His hair was bedraggled, his features a maze of evil. Stricken, and unpredictable like a televangelist caught embezzling money on Easter Sunday and still broadcasting live from an empty studio.

"It's over, DuPere," said Sultan. More for effect than anything else. With these types it usually wasn't over until the fat lady sang, showered, napped, and read the reviews the next morning over brunch.

"No, you fool, it's just beginning," DuPere said, with a flip of his devilish fingers. A false wall rotated outward revealing a giant rocket about as tall as Sultan and the color of pea soup. *Neglectinol.*

A computer voice said, "Launch sequence activated. T-minus 10 seconds to liftoff."

Sultan looked up at the opening in the ceiling. While the vertical exit was still clear enough to let a smattering of light from the Guardian Moon, Boy Bot's wide shot had caused a fallen blockage in the path up and out into the world needed by the gas-filled rocket for a clean exit. Build-ups of calcite and aragonite bottle-necked the Neglectinol's only way out.

"Your little pop rocket ain't clear for take off," said Sultan. "But then again you probably know that already."

"That's alright," said DuPere with a detached mania in his voice. "Its primary target is standing right in front of me."

Sultan had spoken to cuckoo clocks with more sense. If he didn't double-time it out of Mr. Magorium's Death Wish Emporium – and fast –

he'd be lobotamized into one of those orphan-loving simpletons up top. Yet something compelled him to stay. A presence in the astral-sphere...

Erstwhile, Debz led a dazed and mute Cissy up the winding spiral staircase, like something out of a medieval fairy tale. *What was taking Cave Man so long?*

The rest of Sultan's dad fell limp. Derick Sultan's eyes staring both at nothing in particular, yet *everything* in particular. Like a dead bird.

"You don't understand." DuPere said. "That *thing* protected the maverick – who wanted to stand in *our* way!"

Sultan wasn't a religious man when it came right down to it. Not in the sense that he believed some old guy in a robe and beard kept score on a cloud. But what he did know in the way of spirituality and all that existential mumbo jumbo was that it probably wasn't a great idea to argue with the very god you'd spent your entire life conjuring. *Just a hunch.* Which in the end is all we can really go by. Right now, Sultan's hunch was that DuPere had better come up with one hell of a *mea culpa,* lest the bratty money man suffer the wrath of the only deity in this room capable of pulling a man in half like a soft banana. The opposite happened.

DuPere screamed, "I dedicated my life to your teachings!" He kicked the statue's huge foot. A modern day Job. "You owe me! You should bow to me!"

Instead, Papanatra raised his mug, rotated his Buick-sized torso with the sound of shifting plate tectonics, and dunked the mug into the horse-shark basin. Like a punch bowl.

"T-Minus three seconds," said the launch voice.

Genetically-enhanced seahorses cascaded into the massive container until the Father's Day gift was filled to the brim with ninety gallons of pure tiny death. Papanatra then pressed its stone snout to the edge of the mug, lifted the contents while angling back his head, and gulped. Then gulped some more. And more. And then some more until the entire cup was emptied.

Then nothing.

DuPere huffed and puffed like a petulant child not receiving the birthday present he'd expressly told his well-to-do parents to give him.

"Destroy him already!" he said. "Destroy the maverick!"

Instead Papanatra lowered himself to eye-level with DuPere. The money man glared back. The fair weather disciple had abandoned the

strategy of humbling himself and instead switched gears into cold-hearted, business negotiation mode, which involved spitting in the statue's face. Specifically in the left flame dancing vibrantly in Papanatra's ocular cavity. His loogie sizzled with defiance. Again, Sultan wasn't exactly a card carrying chaplain, but he was willing to bet his own dog that hocking loogies in the face of your Almighty was sacrilege, if not just bad manners. Papanatra seemed to agree.

The once dry stone snout of the immense statue now erupted in a sideways fountain of what Papanatra had just ingested. Which is to say, the Atlantean Dad God spewed a liquid torrent of death out of its face and all over the front side of DuPere. A projectile of flesh-eating seahorses – his own murderous creations – splashed against the money man. Like the soap wand setting at a co-op car wash. Which is to say, the spray of biters sheared through DuPere's ceremonial linen garb with ease and didn't stop there. In fact, they were just getting started.

The little assholes – at this point Sultan had to call it as he saw it – continued through their creator's skin. Like sandblasting a fixer-upper, or scrubbing graffiti off a liquor store wall. Only instead of doing away with unwanted blemishes on freestanding structures, DuPere found himself in the unfortunate position of saying "ta ta" to fifty percent of his skin. The front half, to be precise. *The nipple side.*

Underneath the shorn exterior, his heart, lungs, stomach, and other guts sloughed to the floor. He looked like Slim Goodbody, or one of those plastic toy physiology models. *Pink and red and bone.* There was a blink of disbelief before his innards fell to the quaking ground. This exposed dental nerve of a hotelier watched as his own guts vibrated across the floor like a demented race dreamed up by a weird German mind. *Leave it to the Germans for probably having a word to describe the sensation of watching your own viscera compete in athletics.*

Sultan was no huge fan of bisections, and this one didn't help the overpriced bread bowl he'd noshed on earlier in the day stay settled in his stomach. *Still, he couldn't resist a kill-line...*

"Now that's what I call a half-assed job," Sultan perfectly quipped.

BOOM.

DuPere's de-lidded, glossy white eyeballs seemed as wide as a cartoon's in his tightly wrapped spaghetti-faced skull. He whipped his meat-face over to Sultan. The superficial musculature twitched and curved along with the money man's frantic emotional state.

"You ruined everything!" DuPere screamed. He lunged with arms grasping, but not before Papanatra smashed his mug down onto the money man, squashing him flat like a roach. Quincy DuPere was dead.

"Guess daddy *does* know best," Sultan zinged. Papanatra roared his dinosaur-like cry to the Guardian Moon, now barely visible through the blocked sky light. The mighty reverberations loosened another excess of debris enclosing the hall completely and sealing up the Neglectinol rocket's intended escape route. Soon, the entire temple would be filled with the domesticating yellow gas.

T-minus one second.

Only one problem: one ancient, three-story-tall problem, to be exact. Common sense would dictate that it was time for Sultan to hot-foot it out of there, *and pronto*. He hadn't the slightest clue on how to stop this centuries old monstrosity from rampaging further. Would the Dad God be buried alive down here, or take the fight upstairs? Either way, Sultan would rather boogie his buns while he still had his maverick instincts intact and a damn firm pair of buns to even boogie.

The gaseous rocket dumped out the hallmark signs of combustion: plumes of smoke billowed beneath its base and the projectile was mere milliseconds away from ricocheting all over this literal hell-hole like a blind hummingbird in a mirror store. But just as Sultan turned to leave all this shitscape behind, a voice called out from across the room. A tiny voice. A scared voice. A boy's voice:

"Pappy?" said Boy Bot from beneath the rock pile. "Pappy, it's dark. I'm scared, Pappy, I can't go to sleep." Papanatra darted its head in the direction of the boulders, recognizing the connection between father and

son instantly. Its head snapped back again at Sultan. As if to say, *um you sure you want to ditch your boy in front of me?*

Furthermore, how did Sultan know this wasn't a cunning trap? He had just witnessed this same child lay waste to the room via what had to be just about the worst case of pink eye ever.

"Pappy, I don't feel like I used to," he said. Perhaps the boulders had rewired the robot's circuitry. Still, was Sultan willing to risk it? Sure he honored his instinct for self-preservation above all else, but something inside his hero's heart just wouldn't let his feet take the coward's path out of there. He couldn't leave a man behind. Or a boy. Or a robot. Or could he...

"Pappy, please hug me!" cried his Boy Bot. Papanatra observed Sultan's decision.

"Fine!" Sultan said with a sigh. He crouched and started back across the convulsing space.

"Pretend to be a dad, they said, we'll help you out, they said..." in a mocking, put-upon tone.

He ducked through the crashing room that made the Battle of Mogadishu look like a tea party. The now mobile rocket careened off the ceiling and then a nearby wall. Luckily the Neglictinol gas inside hadn't been emitted yet. Must be an "explode on impact" type device and Sultan had no intention of being part of the impact. Papanatra let out another epic wail. *You said it, pal,* thought Sultan. *I also got better things to do than get buried alive in a quarry!*

A few feet off, Boy Bot said, "Pappy, I had a bad dream. My head hurts. I can't feel my legs."

"I know, son." Sultan called out. "It will all go away soon. I promise."

He skidded to a stop as the rocket zoomed just shy of his nose. A somersault later and he made it to Boy Bot. Or rather to the craggy crypt on top of him. Sultan dug away at what smaller pieces he could for some sort of access to the robot but could find no purchase. He shoved his arm in blind until his own cheek pressed against the quaking floor. The tips of

his fingers barely grazed Boy Bot's. No use. If Sultan didn't make a break for it soon, they would all become artifacts in this jostling layer of mineral ready to collapse.

Suddenly Sultan felt a gust of wind followed by a hefty shadow moving over him. He looked up to find a large stone hand swiping away the weighted heavy earth until Boy Bot was free. Or, at least his top half. His legs had been rendered into a technological doodad mush.

"I love you, Pappy," said the top half of Sultan's faux ex-son.

Sultan said, "I love you t–" but the Kodak moment was cut short by a whistling just past his ear, and then an explosion. The entire room went yellow like a Hindu festival of colors, or a large flower had just been shaken of its pollen. Impossible to see from one end of the temple to the other. Ringing echoed in Sultan's ears. He wondered if his own legs had been turned to mush as well. He felt the familiar curves of his robust thighs. His haunches. *His gals.*

He quickly covered his mouth with his forearm, making an effort not to breath in the noxious fumes. Had he already? In the blast Sultan had been flung across the room and separated from Boy Bot. He was near the stairway. Coughing. The yellow wash on the room faded. *What was that tingling in his lungs?*

Silence.

Then Papanatra lurched forward out of the haze squealing like a 50-ton peacock giving birth to a navel mine. The flames in its eyes sputtered. One extinguished completely. Then Sultan saw why: in the rocket explosion the boulders had become shrapnel. So had Boy Bot, whose cowlickless head was now sandwiched between a massive rock and the crystalline cluster on Papanatra's forehead. His boy face smushed. His torso below dangled limp. *Lifeless.*

"Sleep tight, my son," Sultan said with the solemn dignity and unrivaled respect he might give a dead war dog.

The halo of damaged crystals around the destroyed little machine's crushed skull drained of its light. The apparent source of Papanatra's

power. The giant statue lost its footing. Stumbled. Then crashed face first into the horse-shark basin like a truck driver's head hitting the sack after an all-nighter long haul on the open road. The ensuing wave of displaced murderous seahorses came at Sultan like the splash of an Orca celebrity. One of the murdery ones.

He lept for the stairway entrance just narrowly missing the deadly liquid, which now lapped a mere step below his boots. *His boots.* Sultan was out of the temple and away from the Neglectinol when the sound of a jumbo jet crash landing inside a washer machine big enough to fit a jumbo jet maybe at a kind of place in an alternate universe where airplanes got washed like laundry, and through the doorway Sultan could see the whole room cave in completely. Like pull-down drapes. Sealed for all eternity.

Sultan crab walked backward up the steps as the lingering remnants of the Neglectinol wafted upward then dissipated completely.

"Yo, Cave Man," Debz called out from high above the winding steps. "Up here!"

He turned and followed her voice.

Sultan staggered out of the arcane stairwell and into DuPere's office. Dazed, he shut the bookcase door behind him, like the last step in completely walling up the past.

It was strange stepping into the room of a dead man. Sultan could swear he felt the former hotelier's ghostly presence already setting up shop for a *good* haunting of his former empire.

"Got it!" said Debz, fiddling with a set of pilfered keys. With a pneumatic hiss, the now empty aquarium adjacent to the book case slid left into a recess revealing the metallic insides of a private elevator.

"There you are," she said. "I want to hear all about whatever crazy shit went on back there, but we ain't home free just yet. I hope you can fly a helicopter, man..."

Sultan picked up a stray book that had been moved in the hacker orphan's search. The cover featured DuPere dressed as a lion tamer complete with mustache, red coat, top hat, and whip, poking his head inside the mouth of a comically large baby in the center of a three ring circus.

"Man, I guess this guy really loved fatherhood," Debz said. Though Sultan could hear her words, there was a delay in understanding, like his

brain was under construction and delaying its normal operations with a sign planted in his cerebral cortex that read, "pardon our dust."

"Anyway," Debz said, ushering Cissy toward the elevator, still in her magnetic earring trance, "I figured you should do the honors with this one."

Sultan said nothing.

"Hello, Earth to space cadet," Debz said in her classic sarcastic manner.

Sultan's mind was usually nine steps ahead of the average man's and twelve steps on weekends and holidays, but ever since the rocket exploded, something inside him felt off. Sure he had just reconnected with, then witnessed the death of, his estranged mutated father while also dealing with the loss of a fake son who, with a formerly sentient wife, spurned complicated feelings involving mankind's heretofore under-explored emotional, and even sexual, relationship with artificial intelligence. *Granted.*

However, the creeping sensation Sultan now felt inside had more in common with the experience of eating a baseball mitt's worth of beef jerky washed down with three-day-old coffee at 2:53a.m. in the morning. Which is to say, he was the closest to feeling full-blown worried as a hero maverick like Sultan could be: *approaching a hint of a little concerned, maybe.*

They heard footsteps down the hall. Voices coming their way.

"Mr. DuPere," one called out. "Sir, are you okay?"

"Shit, we got company," Debz said.

Again, Sultan was aware of the approaching threat but instead found himself admiring a framed wall photo of DuPere at a groundbreaking for a highly advanced jungle gym, *a man could do worse than dedicate his life to children...*

"Hey, looky-loo," Debz said from the elevator. "What's the hold up?"

Sultan said, "Right, just reminding myself how much I hate fatherh-h-h–" but his lips wouldn't form the word. "Dad stuff," he finally managed.

"Nevermind, don't worry about it, leave me alone," he stammered, joining her in the shiny metallic box.

Debz hit a button marked "H" for "Helipad." The aquarium slid back into place. The men in the hall entered DuPere's empty office.

"Nothing to see here," one said.

CHAPTER 38

The three elevated together in silence, save for the muzak playing a rendition of "Cats in the Cradle." Sultan found himself humming along to the melody like never before. Strange, he normally hated songs about fathers...

Cissy stared ahead still in her trance. Debz by now was watching Sultan's every move. *Was it that obvious?*

DING.

The doors yawned open to reveal a clean, large landing circle with DuPere's private helicopter glistening beneath the Guardian Moon. Just beyond a pastoral mountainside stood, far away from Father World. *Far away from The D.A.D.D.Y. Complex.* Debz nudged Sultan like a friend at a middle school dance.

"Say something, you dope," she said.

Sultan looked at Cissy in the wedding dress. To be sure, the Neglectinol dosage *was* having an effect on him. Worse, he didn't seem to mind. He was okay with it. Normally, the formal wear would remind him of his three ex-families, but not now. Now, all he could think of was how angelic the robot woman appeared, and how happy he was to start a life and, yes, even a family together. He wished Cissy had a last name, so he

could take it. His maverick spirit finally quieted, Sultan gently reached to her magnetic earrings, and unfastened one. Then, the other.

Immediately a life returned to her eyes. A twinkle. Cissy looked at him, quizzically.

"I feel like we've met before," she said. "Like I should know you."

Sultan's lips tingled. The magnetism of her brain-scrambling jewelry was no match for the even stronger magnetism of Sultan's rippling sensuousness. He leaned in, sifting his rough hands through the soft hair on the back of her head. It reminded him of Boy Bot's guinea pig cowlick. How had he never wondered about what animal Cissy's own hair came from? Long-haired yak?

She stared back, as if to say, *I forget who you are*.

"Maybe this will help you remember," he said. Like beach water drying up in circles on the shore, he felt his former self retreating into history.

Their lips met, and Sultan didn't care who he was, nor how he was who he was. All he knew was that who he was, was happy. Once and finally he was happy.

Fireworks splashed across the sky as part of the Father World opening. Fireworks for them. Cissy pulled out of the kiss and looked Sultan in the eye.

"Nope," she said. "Still no memory. And why the hell am I in a wedding dress? What is this?"

He said, "You used to call me Honey Bun, and I used to hate it but..."

"Let me stop you there, Romeo." Cissy said. "That doesn't really sound like me."

"But this worked last time," Sultan said trying to lean in for another kiss.

"No means no, perv. Jesus," said Cissy. "Anyone ever tell you your breath stinks of sunflower seeds. I mean total Yucksville."

Debz watched from the doorway in the helicopter, stifling a giggle beneath the swirling propeller above.

She said, "We better get out of here, you love birds..."

"That's alright if you don't remember me, babe," Sultan said, flinging an arm around Cissy. "We'll have plenty of time to make new memories."

"Well," Cissy said, ducking out from under his arm and heading for the helicopter. "I don't know about all that, you weirdo."

"Me neither, babe," chuckled Sultan. "Me neither..."

Theo Sultan's hand-built one-bedroom cabin hung thick with the smell of fresh home-brewed cologne. He wore a brand new red-checkered shirt tucked into some nice khaki slacks and a pair of sturdy yet comfy Rockport leather loafers. He had thrown his boots in the garbage earlier that week. No need for those anymore. Nor his motorcycle, which he had sold for a sensible station wagon.

He also wore a wide paternal smile, beaming at Debz across the table as though she were his daughter home from college. After last month's events, he thought it best she stay with him for a while, so he could help her transition off the Grid. Life off the Grid wasn't for everybody, but Debz was a smart gal with a lot of promise. There was no going back to her government job considering as Debz harshly put it, "how many tendrils DuPere may have still had in the oozing body bag we called American democracy." He didn't get why a decent girl like her had to use such language.

Cissy had left him last Tuesday. The two of them never really hit it off after the whole kissing thing. Said she needed to find herself. Theo was hurt, but he understood. Far be it from him to force her to stay in a relationship the robot woman wanted no part of. Still, he held out hope she'd come to her senses eventually. Ever since ingesting the Neglectinol

Theo had never felt better. Sure, deciding to live as a dedicated family man had its demands, but this change felt really healthy. Debz gave him another look, like he'd lost his mind. But he hadn't. He hadn't. He found it, and it was the last place he expected it to be: *his heart.*

Marcus the dog had finally stopped growling at Theo for no apparent reason, and now licked the spots where he'd bit his master. Now the animal treated him like a sick runt in need of pity. Silly pup. Theo excused himself to check on the cologne boiling in the kitchen. He would market and sell the concoction at farmers markets across the country come spring.

Suddenly Marcus bounded up with some letters in his mouth. The mail had arrived.

"Whoa, okay there, boy. What's this?" Theo asked. The return address said "M.B., Linegoggin & Haverbrook." *Oh goody!* Sultan thought, *a lawyer's firm.* He had hoped to patch up his relationships with his ex-families and finally answering for the unpaid child support would be the first step to rekindling what he'd neglected all these years...

Sultan read a letter contained in the package:

Dear Mr. Sultan,

You may not remember me, but I am one of three triplets you fathered back in 1996. My name is Chester, and during a parasailing excursion in Indonesia, myself, two brothers, Gus and Hank, and mother, Margot, were kidnapped by smugglers and sold into the Indonesian circus. This is not a complaint. It was in that very circus I learned how to communicate with elephants and tasted first blood. Again, not a complaint. Recently you were served a court order demanding you stand trial for years of unpaid child support owed to myself, my brothers, and your other ex-family (the one not lost at sea during the cruise through the Bermuda Triangle, God rest their souls).

However, working with one another to bring you to justice has resulted in some of the best sibling relationships we could ever hope for. Bonding over a shared hatred for you and your neglectful ways has provided us all with more solace and fulfillment than any amount of money from your sordid life could ever provide. In due fact, the connection we've made as your mutual ex-families is the strongest one we could have asked for. Even stronger than the bond between a father and his son. All thanks to your selfishness.

Again, this is not a complaint. In fact, we are dropping the charges and moving on with our lives without you. To make sure this happens we have pooled a small sum of money together and would like to offer it to you as an incentive to stay out of our lives for good. I think you'll find the amount more than reasonable.

Yours in Christ, Chester

The newborn family man frowned at the cash in his hand: $3,600 in total. To think what hurt he'd caused his ex-children through all his years of absence. No wonder they felt shunned. Well, he wouldn't have it. Theo would use that $3,600 to buy a plane ticket to each and every one of their homes and make up for lost time. He gripped the money and attempted to place the dollars in his pocket, but his hand reflexively did something strange instead.

As though some other force was in control.

Sultan's hand crunched the greenbacks down in a fist. His biology would not let his hand unclench and before he knew it, the fist was eye-level and aimed directly at his own face. Knuckles aligned with pupils. Then a phrase popped into his head. A curious phrase. A phrase spelled with the words: *The Judge.*

Was he having a heart attack?

Then more words fought their way through the murky swamp of his mind: *A fist that could punch a man sober.* His heart raced. To be sure,

the Neglectinol had worked many times over. Theo felt nothing but love and respect for the family unit. Gone were the days of being a lonewolf rebel maverick. He would quit that dangerous life and, *and...*

...a voice from the furthest reaches of his genetic memory spoke. It was his dad's voice.

"Remember, boy," Derick Sultan said in a ghostly way, "Home is nothing but a four-letter word for 'prison.'"

The Judge brought down the gavel on Theo's face. He crashed out right there on the floor. When he blinked his eyes open, Sultan could feel the last vestiges of paternal instinct leave his body forever, like a bad hangover. He looked at the letters in his hand and quickly tore them up. He picked his teeth with the cash and removed his checkered red shirt.

His nipples stood strong and true, like little pepperoni colored Mount Rushmores.

Sultan's dog came in, spoons in his mouth for his master. When Debz came to see what all the ruckus was about, all she found was an unattended pot of boiling cologne and the back door of the cabin swinging open in the breeze, like an ass flapping in the wind.

In the distance, above the Virginia woods, the faint *clackity-clack-clack of spoons rising up in the June air.* Soon, the cosmos would be out.

"Hope you find her, Sultan," Debz said to herself, shaking her head. "You humongous asshole."

Debz knew deep down that Cissy was attracted to the real maverick. Not this prisoner of fatherly intentions. Once Cissy saw that, it'd be love at first sight, all over again.

Yup, Theo Sultan was America incarnate, warts and all. He did what he wanted *when* he wanted. Ultimately it was always for the good of the masses, and for the bad of "them asses."

Theo Sultan was a soldier of misfortune who answered the call of duty and demonstrated uncommon valor in the eternal battle waged tirelessly over every purple mountain and under every spacious sky.

A battle fought in classrooms and bedrooms; in boardrooms and war rooms, with no end in sight.

A battle known as *life*.

Post-Dedicated to:
My Father*
*as advised by my lawyers

A Note From the Ghost Writer

Hi folks, Ryan Sandoval here. I was hired to help write this book, but instead Luke Pattersby bullied me, threatened my extended family, and made me fear for my life. Suffice to say none of my ideas made it to print. However, thanks to a well-timed bribe and the horrible relationship Pattersby has with the publishers, I'm allotted this space to say that I am a writer living in Los Angeles with my wife and dog. I am a true fan of thrillers and have written funny television things for MTV, Netflix, Amazon, and FX. I love my dad!

I would like to thank: The hilarious authors of the Devastator Press, editors Amanda and Geoffrey, my wife Lily, and commercially driven authors across the globe.

READ MORE
FUNNY BOOKS FROM
THE DEVASTATOR

devastatorpress.com